Seeking Truth and Hiding Facts

Seeking Truth and Hiding Facts

Information, Ideology, and Authoritarianism in China

JEREMY L. WALLACE

OXFORD
UNIVERSITY PRESS

OXFORD
UNIVERSITY PRESS

Oxford University Press is a department of the University of Oxford. It furthers
the University's objective of excellence in research, scholarship, and education
by publishing worldwide. Oxford is a registered trade mark of Oxford University
Press in the UK and certain other countries.

Published in the United States of America by Oxford University Press
198 Madison Avenue, New York, NY 10016, United States of America.

© Oxford University Press 2023

Library of Congress Cataloging-in-Publication Data
Names: Wallace, Jeremy L., author.
Title: Seeking truth & hiding facts : information, ideology, and
authoritarianism in China / Jeremy L. Wallace.
Other titles: Seeking truth and hiding facts
Description: New York, NY : Oxford University Press, 2023. |
Includes bibliographical references and index.
Identifiers: LCCN 2022021546 (print) | LCCN 2022021547 (ebook) |
ISBN 9780197627655 (hardback) | ISBN 9780197627662 (paperback) |
ISBN 9780197627686 (epub)
Subjects: LCSH: Transparency in government—China. |
Authoritarianism—China. | Information policy—China. | Quantitative research—
Political aspects—China. | China—Politics and government—2002–
Classification: LCC JQ1509.5.T69 W35 2023 (print) | LCC JQ1509.5.T69 (ebook) |
DDC 320.951—dc23/eng/20220809
LC record available at https://lccn.loc.gov/2022021546
LC ebook record available at https://lccn.loc.gov/2022021547

DOI: 10.1093/oso/9780197627655.001.0001

1 3 5 7 9 8 6 4 2

Paperback printed by Lakeside Book Company, United States of America
Hardback printed by Bridgeport National Bindery, Inc., United States of America

Seek Truth from Facts

—Book of Han, 111 BCE

天高皇帝远.
Heaven is high, and the emperor is far away.

—Chinese expression from the Song Dynasty

Society isolates everyone, the better to dominate them, divides everything to weaken it. It reigns over the units, over numerical figures piled up like grains of wheat in a heap.

—Honoré de Balzac, *Le Curé de village*, 1839

CONTENTS

ACKNOWLEDGMENTS

Many people and institutions have helped me as this book's journey stretched out over time. I wish to thank them all and apologize to those not named. All errors, as always, are solely my responsibility.

This book began, as many do, out of a bit of frustration. Having written a book that explored Chinese political economy using Chinese statistics, I was often asked about their trustworthiness. This minor irritation birthed a paper on GDP manipulation in Chinese provinces, which formed the core of a research proposal that, thanks to Allan Song's guidance, the Smith Richardson Foundation generously funded as a Strategy and Policy Fellowship Grant. Colleagues far and wide helped me cultivate my ideas on ideological and informational politics under authoritarianism. At Ohio State, thanks are due in particular to Sarah Brooks, Vlad Kogan, Marcus Kurtz, William Minozzi, Irfan Nooruddin, Zachary Peskowitz, Philipp Rehm, Amanda Robinson, Alex Thompson, Sara Watson, and Max Woodworth. It was a pleasure to think through and write with Michael Neblo about the political implications of the COVID-19 pandemic, comparing the United States and China. At Yale, I enjoyed and learned from many generous conversations, especially with Quintin Beazer, Ana De La O Torres, Alex Debs, Susan Hyde, Stathis Kalyvas, Ellen Lust, Jayson Lyall, Nikolay Marinov, Nuno Monteiro, Ellie Powell, Frances Rosenbluth, James Scott, Milan Svolik, and Tariq Thachil.

I received excellent suggestions from presentations at UC San Diego, Stanford, Chicago, Harvard Business School, Yale, Nankai, Tsinghua, Toronto, Syracuse, Notre Dame, Columbia, UC Irvine, Maryland, and SAIS. Thanks to Jean Oi, Ben Lessing, Dali Yang, Claire Adida, Molly Roberts, Deborah Seligsohn, Meg Rithmire, Lynette Ong, Dimitar Gueorguiev, Kyle Jaros, Karrie Koesel, Joshua Eisenman, Andy Nathan, Sara Wallace Goodman, Samantha Vortherms, Margaret Pearson, Andrew Mertha, and Jonas Nahm. In particular, Junyan Jiang grilled me on an early analysis of Xi's neopolitical turn, discussions

of which grew into collaborative research on the interplay of informal networks and falsification. Maura Cunningham's edits made the manuscript more concise, clear, and compelling. Thanks to my research assistants, particularly Jayan Nair, Wang Weihang, Shuyu Song, Zihan Ma, Marika Levidow, Joshua Zhang, Andres Loretdemola, Lin Le, Shiqi Ma, Jiwon Baik, Denny Lee, Victoria Liu, Kailai Xiong, Madeleine Chang, Lynn Hong, Arianna Dang, Isaac Herzog, and Cole Crystal. The book also benefited from conversations with and the work of many others, including Yuen Yuen Ang, Bill Bishop, Jude Blanchette, Henry Farrell, Mary Gallagher, Yasheng Huang, Scott Kennedy, Kaiser Kuo, Melanie Manion, Abe Newman, Kevin O'Brien, James Palmer, Jen Pan, Liz Perry, Rory Truex, Lily Tsai, James Vreeland, and Yuhua Wang. Tom Bernstein, Dorothy Solinger, Greg Distelhorst, Kyle Hutzler, and Edmund Downie all read sections of the manuscript and gave excellent feedback.

My Cornell colleagues have been immensely helpful as the book slowly came into its final shape. Cornell's Center for Social Sciences collaborative project allowed our China's Cities team—Panle Barwick, Eli Friedman, Shanjun Li, Jessica Chen Weiss, and myself—the very rare opportunity to have space and time to reflect in ways that proved critical for this book. Cornell's intellectual community, especially in the Government Department, has been a consistent source of intellectual stimulation and assistance; I'm particularly grateful to Nick Admussen, Amelia Arsenault, Richard Bensel, Alex Cirone, Gustavo Flores-Macias, Eun A Jo, Sabrina Karim, Alex Livingston, and Bryn Rosenfeld, as well as students in my Authoritarianism and China's Next Economy courses. Lisa Blaydes and Martin Dimitrov joined Val Bunce, Peter Katzenstein, Tom Pepinsky, Ken Roberts, Allen Carlson, and Jessica Chen Weiss in an incredibly helpful book workshop in November 2019. The COVID-19 pandemic added yet another twist to this book's long development. Dave McBride at Oxford University Press found excellent reviewers who gave precise advice about where to trim the manuscript of fat and where to bulk it up.

Sharat Raju and Valarie Kaur pulled me out of its vortex and pushed me to see the book through. Matthew, Laura, Karen, and Dave always bring joy. Jessica Chen Weiss continues to stay beside me, making the writing and the years ineffably better. Our twins, Rae and Lee, will be happy that there's a new book in the house that has their baba's name on it. My thanks for their patience. Finally, thanks to my parents, Ron and Mary Ann Wallace, who have always stood with me. It is to them that I dedicate this book.

A Numbers Game

Figures often beguile me, particularly when I have the arranging of
them myself; in which case the remark attributed to Disraeli would
often apply with justice and force: "There are three kinds of lies: lies,
damned lies, and statistics."

—Mark Twain, *Autobiography*

On March 5, 2013, Wen Jiabao, outgoing premier of the People's Republic of
China (PRC), delivered his final Government Work Report (政府工作报
告) before an audience of thousands of National People's Congress depu-
ties and millions on television.[1] The speech echoed dozens that had preceded
it during China's Reform Era since it began in the late 1970s. Wen catalogued
achievements from the past five years: total gross domestic product (GDP)
moving up to rank second globally; government revenue increasing from 5.1
to 11.7 trillion renminbi (RMB; also "yuan"); per capita disposable income of
urban residents rising annually by 8.8%, and for rural residents by 9.9%; and
grain output growing for the ninth consecutive year. In summarizing the effec-
tiveness of the regime's 4 trillion yuan stimulus package as a response to the 2008
global financial crisis, Wen listed the following construction projects: "18 million
government-subsidized housing units"; "19,700 kilometers of new rail lines," in-
cluding 8,951 kilometers of high-speed rail; "609,000 kilometers of new roads";
and "31 airports and 602 shipping berths for 10,000-ton ships."[2] Premier Wen
continued at length, explicating the administration's successes and laying out
the tasks for the future, but at no point did he mention any living individuals—
neither politicians nor citizens—until his final sentence, which included a

[1] Wen 2013. Regarding the epigraph: amusingly for a statement about truth and lies, Mark Twain
is the pseudonym of Samuel Clemens, and he attributed the quote to Disraeli when the true origi-
nator of the phrase remains unclear (Lee 2012; Martin 2018).

[2] Wen 2013; China Real Time 2013. The 4 trillion yuan stimulus package contained only around
1.25 trillion from the central government.

Seeking Truth and Hiding Facts. Jeremy L. Wallace, Oxford University Press. © Oxford University Press 2023.
DOI: 10.1093/oso/9780197627655.003.0001

reference to "the leadership of the Party Central Committee with Comrade Xi Jinping as General Secretary."

When Xi Jinping visited Hebei province just six months later, the tension was palpable.[3] In contrast with Wen's anodyne number-filled speech from Beijing, a leader personally directed an inspection in the provinces intending to name names. In the months since Wen's retirement and Xi's ascent, local Party and state officials had been on the receiving end of thousands of public comments and complaints. These lists of personal errors served as the basis for dozens of self-criticisms during Xi's visit to Hebei. Over two days, in four marathon "democratic life meetings," officials on the verge of tears admitted their failings to Xi.[4] However, these apologies were not kept private within the backrooms where Party-state elites often make decisions; instead, China Central Television broadcast the dramatic scenes for all to see.

Zhou Benshun, Hebei's top Party official, made admissions of carelessness, laziness, and bureaucratic thinking, then apologetically added, "I cared very much about development speed and economic volumes but not as much about people's own interests."[5] This part of Zhou's confession signaled that Xi had led a stunning about-face within the Chinese Communist Party (CCP): for a Chinese local official to care *too* much about GDP growth appeared oxymoronic after decades of statements and reports like the one that Wen had delivered only a half-year before. The work of Chinese officials during the Reform Era had seemed mostly to entail increasing the size of the economy and standing in front of audiences of other Party members, talking about reaching economic benchmarks. These statistics were the principal face of Chinese politics to the citizenry, the investors, and the outside world.

An explicit attack on the quantitative metrics of performance that had dominated the discourse for more than three decades—especially in the context of open, emotional displays of conflict within the Party-state—points to serious changes in the form and content of Chinese politics. Indeed, these broadcasts were but one of a series of similar public presentations introducing a new normal to officials, the people, and the world.

A few numbers came to define Chinese politics, until they did not count what mattered and what they counted did not measure up. This book argues that the Chinese government adopted a system of limited, quantified vision in order to survive the disasters unleashed by Mao Zedong's ideological leadership, explains how that system worked, and analyzes how problems accumulated in

[3] "大胆使用批评和自我批评有力武器," 2013; 央视网2013. See also "Critical Masses" 2013; Huang 2013a; Zhang 2013.

[4] On emotions, see Pearlman 2013; Hall and Ross 2015.

[5] "Critical Masses" 2013.

its blind spots until Xi led the regime into a neopolitical turn. Xi's new normal is an attempt to fix the problems of the prior system, as well as a hedge against an inability to do so. While of course dictators stay in power through coercion and co-optation, they also do so by convincing their populations and themselves of their right to rule. Quantification is one tool in this persuasive arsenal, but it comes with its own perils.

The Successes and Failures of China's Limited, Quantified Vision

For most of the past four decades of what is referred to in China as "Reform and Opening," development (发展) has dominated Chinese politics almost like a religion.[6] Officials competed for promotions based on comparative developmental track records, while the regime justified its rule to its citizens and to itself through development. The incessant litany of figures, statistics, and numbers all pointed in the same positive direction toward increased wealth and power for China and the Chinese people. The popular information and ideological environment was one of policy success without presentation of alternatives, or even the articulation of the possibility of alternatives beyond some technocratic details. This quantified discourse had dominated Chinese politics since Chairman Mao's death in 1976.

How did a revolutionary Communist Party come to justify itself through a limited number of statistics, and why is it currently shifting away from doing so? The economic and social disaster of the decade-long Cultural Revolution that preceded Mao's death made pragmatic politicians and ideas attractive to an elite and a population tired of the turmoil of constant ideological upheaval amid persistent poverty. Tight central control and planning failed to produce growth, so the regime remade itself, decentralizing, experimenting, and marketizing. Keeping watch on just a few metrics of critical importance greased the wheels of performance. Decentralization with limited oversight unleashed individual initiative under state capitalism. Initially, economic reforms did much to aid many without harming others.[7] Limited but real vision into localities gave incentives for local growth while allowing local officials to profit personally.[8] The country's dramatic economic development, reflected in the impressive growth of economic aggregate statistics, improved the lives of hundreds of millions of Chinese.

[6] Ferguson 1994.

[7] Lau, Qian, and Roland 2000.

[8] See Ang 2020 on access money, Chinese corruption, and growth.

The regime's leaders rarely made an explicit case for what is often referred to as "performance legitimacy," that is, the idea that the regime based its claim to rule legitimately on its economic performance and that this claim was accepted by the population. Implicit claims to performance legitimacy, however, were common: leaders and the propaganda apparatus regularly trumpeted a particular new statistic showing growth, development, progress.[9] The constant production of such a chorus of statistics and the lack of an opposing narrative implied that the regime was competent and popular.

However, over time, reforms came to erode the livelihoods of millions of Chinese, most notably workers at industrial state-owned enterprises that failed to succeed in the newly marketized economic environment.[10] Tens of millions of these workers watched their "iron rice bowls" crack as jobs and benefits they had thought would last a lifetime vanished, while the circumstances of hundreds of millions were bettered as the country industrialized and urbanized. After two decades of reform, the daily lives of most Chinese stopped improving at the pace they had become accustomed to, despite the continued skyward trends of the aggregate numbers summarizing the state of the economy. The numbers' weaknesses came to the fore. People cannot eat numbers. The lungs of children cannot breathe them.

Limiting its vision of localities to just a few numbers—GDP, fiscal revenue, investment—produced excellent performance on these measures and negative externalities elsewhere. This limited quantified vision did not see important problems that came to plague Chinese society: most notably, corruption, pollution, and debt. With increasing regularity, cases of officials juking the stats—that is, fabricating data—came to light, undermining internal and external faith in the reality of Chinese economic growth. Even the limited set of closely watched numbers were moving in the wrong direction; most worryingly, growth was slowing and debt-fueled stimulus became a less tenable response.[11] Over time, these negative externalities came to threaten the country's economic and political pillars.

In response to the inadequacy of the center's limited, quantified vision, the dictatorship has centralized power, more closely observing and controlling the actions of the lower-level politicians and bureaucrats who carry out its rule, and

[9] This number-based politics evokes a prior generation's "Stakhanovism," although their numbers aimed to motivate workers, where here numbers numbed the people and motivated cadres. On the Stakhanovite movement, see Shlapentokh 1988.

[10] Solinger 2003.

[11] Such moments of "dissatisfaction with sluggish economic growth" tend to be associated with reform. See Van de Walle 2001, 43.

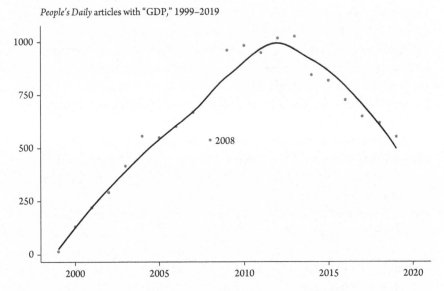

People's Daily articles with "GDP," 1999–2019

Figure 1.1 The Rise and Fall of GDP Supremacy. Source: data.people.com.cn, 13,138 instances

shifting the ways it justifies its continued rule.[12] As seen in Figure 1.1, *People's Daily* headlines that included GDP rose throughout the 2000s but have been declining since Xi's arrival. Xi has personally taken the reins on policy issues that had been left to lower-level political elites under previous leaders. Under Xi, the regime initiated a massive anticorruption crusade and enhanced the institutional power of the Party's chief disciplinary agency, the Central Commission on Discipline Inspection (CCDI).[13] Private corporations have been made to establish in-house Party branches with unclear powers.[14] Officials inside the CCP from Xi on down increasingly remark on political conflicts and call on officials to govern with virtue and morality.

One dimension of the regime's response to the problems of its *limited* quantified vision has been to attempt to quantify everything. Centrally supported big data initiatives, including the "social credit system," try to track and analyze the digital detritus of companies and contemporary lives. The regime has been expanding the list of relevant statistics that it collects and evaluates—for

[12] I use "limited, quantified vision" rather than the more common term "GDPism" because even outside of GDP, facts that could be expressed in simple quantified ways became politically compelling, such as PM2.5. Thanks to a reviewer for pushing on this point.

[13] The CCDI is also the heart of the new National Supervision Commission and Supervision Law of 2018 (China Law Translate 2018).

[14] While the monitoring power here is obvious, the Party branch's ability to suggest or veto specific strategic decisions of firms remains an open question.

instance, in air pollution alone, cities have dozens of ground-based stations monitoring particulates, factories have live surveillance on filtering equipment, and satellite-based imagery extracts estimates of particulate matter. These technologically enhanced efforts at quantification in part aim to satisfy citizen demands for greater oversight of the business sector that is often seen as untrustworthy; they also endeavor to generate citizen compliance by suggesting a government that is always watching.[15]

The most striking example of the Party-state reasserting its control over the lives of Chinese citizens comes from the western region of Xinjiang. Described as a "21st-century police state" in 2017, with checkpoints along highways, iris-scanning machines, facial recognition technology at gas stations, police searching phones for banned applications, and omnipresent security forces, the situation became only more grim afterward.[16] A vast system of "re-education centers"[17] has been constructed, where hundreds of thousands of Uyghurs and other minorities (almost all men) appear to be detained without criminal procedures, cut off from others outside the centers, held in the prison-like facilities with barbed-wire fences and gun towers, and forced to endure and regurgitate propaganda. Beyond Xinjiang, mosques around the country are being remodeled with Chinese characteristics and their religious practices curtailed.

These responses can be seen as attempts at both a fix and a hedge of China's growth machine. They represent a fix in that they are attempting to rekindle the economic fire that corruption and waste have diminished and pollution has smothered. They represent a hedge by offering the beginnings of a new justifying discourse of strength and traditional morality through true leadership in difficult times.

Convincing and the Words of Dictators

Coercion and co-optation alone do not hold authoritarian regimes together. The words of dictators matter, as do the symbols they use to generate compliance from citizens and the regime itself. In her study of Assad's cult in Syria, Lisa Wedeen argues that the resources the regime expended on it were substantial, and that analyzing the symbolic actions undertaken helps us to understand the nature of not only Syrian politics but also authoritarianism more broadly.[18] The

[15] For example, Liang et al. 2018; Kostka 2019.

[16] Rajagopalan 2017.

[17] 教育转化工作; Zenz 2019. The Chinese government has also referred to "re-education centers" as "de-extremification (qu jiduanhua)" centers (Zenz 2019).

[18] Wedeen 1999. See also Wedeen 2019.

people of Syria did not believe the content of the cult, yet it still held power over them and through them. At one level, throwing resources into the cult provides a signal of strength; if the regime's hold on power were more precarious, it would not spend so much spreading these messages.[19] Wedeen goes further and argues that by having people act "as if" they believe in the substance of the cult, they "substantiate" it. Saying the words builds habits of action and of mind that can make building on these cult-based "as if" habits easier and can make defying them harder. Formal models can show that even if no one directly believes in a set of messages, if they believe that others are credulous and likely to act in accordance with such beliefs, then they too will act "as if."[20]

These are both the most basic and most extreme versions of such symbolic actions of dictators. Propagating messages demonstrates strength; any government or regime that finds itself unable to do so quickly slips into irrelevance, which is why those attempting coups seek to seize control of the mass media (radio, television, newspapers, internet) posthaste. On the other hand, that this messaging signals strength even when its content is ignored or ridiculed delimits the terrain. Most symbolic production justifying the rule of an authoritarian regime is taken up, at least to some extent, by those exposed; its vocabulary becomes their own; even cynical expressions play with and reify these symbols.[21] The rhetoric of authoritarian regimes signals strength, generates habits, presents justifications, frames worldviews, and shapes interests for both ordinary people and elites. Control over the information environment pairs with the "triple ignorance" that authoritarianism abides to dominate perceptions and understandings of those living under it.[22]

A dominant perception for many is that mass revolutions represent a key threat to dictators. Yet careful analyses of regime survival demonstrate that the principal proximate threat facing authoritarian regimes comes from other elites. As such, much recent theorizing on authoritarian politics has an elite-centric character.[23] The most common proximate risks to authoritarian regimes may come in the form of coups or intra-elite maneuvers, but elite politics is shaped by the relationship between the regime and the population, including the economic, social, and political contexts.[24]

[19] Huang 2015a.

[20] Little 2017.

[21] Wedeen 1999; Thornton 2007; Holbig 2013.

[22] Schedler 2013, 40.

[23] For example, Svolik 2012; Geddes, Wright, and Frantz 2018; Egorov and Sonin 2011.

[24] This is not to deny the reality that the regimes or individuals within them can also mobilize the population to pursue particular ends (Ekiert, Perry, and Yan 2020).

Even the most repressive of dictators have been interested in and pursued popular support, attempting to convince through justification and information controls. As Hannah Arendt wrote, "neither [Hitler] and Stalin could have maintained the leadership of large populations, survived many interior and exterior crises, and braved the numerous dangers of relentless intra-party struggles if they had not had the confidence of the masses."[25]

Ordinary citizens make political choices inside authoritarian regimes. They can choose to tacitly or more actively support the regime, choosing to vote for it, invest in it, or even join it; they can choose to exit, or they can choose to join the opposition, by either voting for opposition parties, participating in protests, or taking up arms.[26] These choices hold significance at the individual level for the people making them but also aggregate up into forces that change the politics of countries. Elites time actions as quintessentially elite-driven as coups based on their beliefs about the probability of citizen support.[27] Beatriz Magaloni refers to the hegemonic-party regime's "monopoly of mass support" as its "pillar," with "over-sized coalitions" acting to "generate an image of invincibility in order to discourage party splits."[28] Support from the masses papers over many issues.

Political economy models of authoritarian politics tend to ignore ideology and justification or collapse these issues into one of competence.[29] In many ways, this perspective echoes the choice of many regimes—most notably the Chinese regime in the Reform Era—to equate competence with aggregate statistical measures of economic performance and to utilize a demobilizing rhetoric of quantified politics. What such claims miss is that debates about competence are multidimensional and that political actors attempt to select the dimensions of discourse for their own purposes. A society that is experiencing rapid increases in overall economic activity but also rising income inequality can portray itself as competent at promoting development yet could also be portrayed as betraying values of equity. A regime attempting to signal "competence" raises the question "Competence at what?" Regimes are often interested in generating hegemony, as David Laitin defined it, "the political forging—whether through coercion or elite bargaining—and institutionalization of a pattern of group activity in a state and the concurrent idealization of that schema into a dominant symbolic

[25] Arendt 1973, 306. What is true of dictators is true of the broader regimes that they lead.

[26] For voting, investing, and joining, see Magaloni 2006; Blaydes 2018; Svolik 2012, respectively. On exit, many of the East European Communist regimes and contemporary North Korea restrict emigration. For opposing, see Geddes, Wright, and Frantz 2018, 186. These choices are the result of beliefs and shaped by the information environment.

[27] Geddes, Wright, and Frantz 2018, 178, but on p. 30 there is an acknowledgment of a role for mass politics.

[28] Magaloni 2006, 15; Reuter and Szakonyi 2019.

[29] For example, Guriev and Treisman 2015. Again, Schedler 2013 is an exception.

framework that makes sense."[30] But the nature of that forging is contested, particularly in moments of change and reform.

Convincing matters in authoritarian politics because it shapes the lives of the individuals inside the regimes themselves—literally the words they are speaking and actions they are undertaking—as well as those of the citizens that they rule. The dictator's quiver is full of different rhetorical arrows for persuasion. The next section focuses on one such arrow, quantification, its utility and its weaknesses.

Quantification as an Authoritarian Tool

States cannot rule over their territories without using some numbers. The very word "statistics" is derived from the states that needed numerical data to help understand their own increasingly complex territories. As a political technique, quantification—"the use of numbers to describe social phenomena in countable and commensurable terms"—has numerous benefits, perhaps especially for an authoritarian regime.[31] Quantification conveys an aura of objective truth, transparency, and scientific authority to decisions. It organizes and simplifies a complex reality into something concrete and digestible. Quantification appears to aid accountability, without democracy, by generating commonly understood numerical benchmarks and facilitating comparisons, yet it simultaneously empowers the elites who create the metrics under evaluation. Even as it simplifies, it complicates debates by pushing discussion into measurement issues rather than more emotionally resonant fights over values.

Quantification is one tool that authoritarian regimes can use to justify and maintain their rule. While coercion and co-optation remain critical to generating compliance and keeping order, dictators also do so by aiming to convince or persuade themselves, their populations, and the world at large of the necessity and successes of their rule. Regimes have attempted to legitimate themselves through calls on tradition, ideologies, performance, and processes.[32] Quantification itself is not an ideology but rather a practice that is core to what has been described as technocratic neoliberalism, which pervaded post–Cold War governance under democratic and nondemocratic political systems alike.[33]

[30] Laitin 1986, 19. Laitin's forging is predominantly *across* different cultural subsystems over which will be hegemonic and how, whereas the forging here is principally *within* a particular cultural subsystem—the Party-state—about the bounds, symbols, and ends to be pursued. See also, of course, Gramsci (Gramsci and Hoare 1971).

[31] Merry 2016, 1.

[32] For example, Gerschewski 2013.

[33] Global trends in quantification and neoliberalism are discussed in Chapters 2 and 8.

Quantification has been core to the Chinese regime's information and ideological practices. Studies of information inside authoritarianism tend to focus on institutions, principally parties, elections, and legislatures; claims generally fall into comparisons between regimes, with these institutions having "more" information and thus a survival advantage when contrasted with regimes lacking these institutions.[34] Some studies of Chinese politics, such as Rory Truex's and Melanie Manion's examinations of People's Congresses and Martin Dimitrov's work on complaints in China, present more direct evidence that these institutions do convey information to higher levels of the regime.[35] While these institutions inform the Chinese Party-state, the primary channels of information within it are formal statistical reports and the cadre evaluation system alongside the informal channels formed by networks of connections.

Visits of Beijing elites to provinces for inspections, like Xi's 2013 visit to Hebei, complement the empowerment of the CCDI and its new state partner, the National Supervision Commission,[36] as exemplifying the center's increased attention to monitoring the activities of lower-level actors and its justificatory rhetoric of clean governance. As the center generates more information about localities, it attempts to grab greater control over their activities—both to constrain corruption and other "bad acts," as well as to push the center's priorities to be implemented at the grassroots. Increased oversight might also lead to decision-making paralysis, as local leaders fear to misstep and instead stick with the status quo. An additional potential consequence is that with more central penetration into local administration, political difficulties at all levels will more directly reverberate up and down the system rather than the center being insulated by its distance from grassroots decisions.[37]

The current increase in monitoring inverts decisions made four decades earlier, at the start of China's reforms. Like the current change, that prior reform altered the relationship between the Party elite, lower-level officials, and the broader bureaucracy. All dictators rely on agents to implement rules, laws, edicts, and decisions, and those at the top need to watch their agents to ensure that

[34] Many studies look at information—namely as a potential mechanism by which institutions such as elections and legislatures may affect politics (e.g., Blaydes 2010; Truex 2016; Manion 2016; Gandhi 2008; Magaloni 2006). Geddes, Wright, and Frantz 2018 discuss internal security agencies in addition to elections and legislatures.

[35] Truex 2016; Manion 2016; Dimitrov 2019.

[36] Horsley 2018b.

[37] Beazer and Reuter 2019. The height of China's COVID-19 crisis in February 2020 provides a crucial example; see Chapter 8.

they pursue the regime's ends.[38] The arrival of official approval for private wealth accumulation in the 1970s and 1980s complicated the job of monitoring for the Chinese regime. It opened a door by legitimating noncollective, non-Party motives, and made observing local behavior even more critical because of the increased personal incentives to deviate from central desires. Yet the center intentionally chose to restrict its own vision into localities, believing that focusing on a few statistical indicators would be adequate. Under Xi, the dictatorship is now centralizing power, more closely observing and controlling the actions of the lower-level politicians and bureaucrats who carry out its rule. Changing the information relationship within the regime and between the state and society entails altered economic and political incentives.

The current Chinese leadership's decision to more closely observe its own agents at local levels provides information to analysts about the threats that elites perceive. Spending funds on military equipment to combat internal or external enemies reflects a perceived balance of threats different from a dictator lavishing such valuable resources on residents in the capital city through food subsidies. While dictators—or scholars—will never have a completely accurate assessment of the balance of threats that they face, more exploration about the efforts that regimes undertake to learn about and mitigate them can improve our models of authoritarian politics.[39]

Yet information's role in the politics of authoritarian regimes is not a one-way street. Regimes constantly send signals about themselves, their intentions, and their priorities to internal and external audiences; they shape the information environment by putting limits on the press and the ability of the opposition to organize, censoring speech, and publicizing their own spin on events.[40] China's current centralization of information is accompanied by ideological shifts in the regime's presentation—to itself, the public, and the world. More than merely a new slogan, the regime is leaving behind its prior incarnation as helming a technocratic growth machine that minimized politics and taking a neopolitical turn, with more overt political claims to true leadership, demonstrations of its coercive power at home and abroad, and emphasis on traditional morality and responsiveness. Assessing changes in information and ideology provides a new avenue for authoritarian scholarship.

[38] Lower-level politicians and bureaucrats are agents of the center, but they themselves also possess agency (Chung 2016).

[39] While the official statements about the actions, pronouncements, and self-presentations of dictators may not be objectively true, they provide information about the self-conceptions of regimes and the threats that they believe they face.

[40] Chinese internet censorship has become the most studied of these domains; see especially Roberts 2018.

Who, How, and Why?

Asking what constitutes a threat to a dictator in the first place leads us to consider the "who," "how," and "why" of a dictatorship. Who is the regime? How does it rule? Why is it interested in holding power?

The revolutionary communist fire that brought the CCP to power in 1949 had diminished to an ember by September 1976, when Mao died.[41] Infighting over the country's future course and who would take the helm erupted immediately and was not extinguished with the arrest of the "radical" Gang of Four in October. The planned economy had ground to a halt, and China seemed as far as ever from returning to its historical place as a global center of wealth and power.[42] Infighting between Mao's appointed successor, Hua Guofeng, and Deng Xiaoping and their allies revolved around the regime's purpose and the acceptable paths to achieve it. Deng emerged victorious and launched a series of policy and rhetorical moves that legitimated wealth accumulation, decentralized authority to local levels, and installed a system of state capitalism under collective leadership. Deng and his supporters hoped these reforms would spark individual initiative, reinvigorate the moribund production of goods and services, and reduce the chances of policy mistakes emanating from personalized rule. The country's leaders continued to be CCP members, but their words and deeds drifted far from those of the Party under Mao. The ship of the Chinese Party-state was not just rebuilt piece by piece but sent off on a new course toward quantified, globalized capitalism.

Authoritarian regimes have contested identities across the core questions of power: who rules, how, and why. Authoritarian regimes are comprised of individuals who operate within institutions, hierarchies, and networks and exist in intellectual and ideological (imagined) communities.[43] They do this at particular moments in time, suggesting both that learning from the past is possible and that examples and currents of the moment can matter. They are fallible and commit errors, making decisions on limited information under conditions of pervasive uncertainty.[44] This contested identity framework attempts to unpack the overly tidy models of authoritarian politics and respond to the call for

[41] While the man may have had moral authority in the eyes of his fellow CCP elites, his passing exposed sincere dissatisfaction with the policy and political environment that he fostered over his final decade.

[42] See Schell and Delury 2013. Eisenman 2018 argues that China's agricultural sector was less of a disaster by 1976 than generally believed.

[43] See Schedler 2013 on authoritarian performances for various audiences and Anderson 1983 on imagined communities.

[44] Schedler 2013.

"broadening analyses of authoritarianism to incorporate alternative bases of regime stability."[45]

Research Design

The book's chapters interweave national-level narratives of policy and politics with statistical analyses that help to clarify the argument vis-à-vis competing accounts by examining its observable implications. China is an extreme case, and comparing it—as a country, a civilization, a culture, or a regime—with others can be a stretch. Yet it also is a developing country with an authoritarian party regime, like dozens of others that have existed around the world in the past century.[46]

While China's extreme nature is a cause for concern about the generalizability of the analysis, it is simultaneously a reason to produce the analysis in the first place. China's very size—demographically, economically, and geographically—makes it significant. Further, whether or not one sees China's current regime as "exporting" a "model" of authoritarianism for other countries, it is clear that its actions, performance, and rhetoric are observed by leaders and populations around the world and serves as a point of comparison for them.[47] Beyond observation, the Chinese regime's control over its own domestic information environment increasingly stretches far past its own borders.[48] Most authoritarian regimes are not as long-lived as the CCP Party-state, but that endurance and the history of the challenges it faced, the opportunities it pursued, and reforms it undertook can provide analysts with analogues of political experiences in other societies under different regimes that can improve expectations.

On the specific aspects of information and ideology that are a core part of the book, the Chinese regime is a maximalist case. It likely collects and analyzes more total information about its economy, governance, and citizens today than any authoritarian regime in the history of the world; on the other hand, due in part to its size, the central leaders ensconced in their Zhongnanhai compound are further away from their citizens and likely face greater difficulty in comprehending the complicated situations they face compared to other authoritarian regimes. The CCP-led regime takes ideology, justifications, and ideas more seriously than most other contemporary authoritarian regimes, with only other Communist parties as ideologically inclined.

[45] Levitsky and Way 2012, 880–1. Also Glasius 2018 on authoritarian practices.
[46] See Pepinsky and Wallace 2016.
[47] See, e.g., Weiss 2019 for more on this debate.
[48] Extraterritorial censorship is discussed in Chapter 8.

To clarify the meaning of some of the terminology used in the framework and book, here I define "idea," "ideology," and "regime identity." Ideas are "formulated thoughts expressed in a particular language," per Sinologist Franz Schurmann.[49] Ideology is a complicated construct with more abstract and concrete components. In this book, I define "ideology" as a set of political ideas—values, assumptions, principles, and arguments—designed to give a coherent worldview and guidance about instruments for action as well as the discourse about that ideology.[50]

I define "regime identity" as the perception of the regime along the three dimensions of *who*, *how*, and *why*, as well as how it sees, what it chooses to observe, how closely it makes those observations, and its practices of interpreting what is observed.[51] "Regime," following Geddes, Wright, and Frantz, is defined as "the set of very basic formal and informal rules for choosing leaders and policies." Regime types—democracy and nondemocracy—are divided between those countries where leaders come to power through regular free and fair elections and countries where leaders achieve power through other means.[52] My focus is on nonelectoral authoritarian regimes.[53]

The second chapter develops the theoretical argument, investigating how an authoritarian regime convinces itself and others that it should rule. Regimes have contested identities along dimensions of who rules, how, and why, and individuals embedded in these regimes attempt to build justifications for their rule and the actions that constitute it. Quantification is a rhetorical device central to many authoritarian justification strategies, with a variety of features attractive to such regimes. Quantification tends to engage the deliberative rather than the instinctive mind, taking the heat out of potentially emotionally charged political

[49] Schurmann 1966, 19. However, whereas for Schurmann language in this definition is "Marxism-Leninism" or something like it, I take a broader view and do not restrict ideas to thoughts that come out of or are from a particular ideology. "Language" in Schurmann is closer to what I, following Wedeen and others, instead refer to as "vocabulary," meaning the ideas, tropes, symbols, and rhetoric of a particular ideology.

[50] This definition of ideology combines ideas from Schurmann 1966, 22–3 on pure and practical ideology and Gill 2011, 2–3, incorporating Gill's concepts of ideology as well as metanarrative.

[51] Schurmann 1966, 9n108 refers to the Party's "self-perception," but regimes have identities to both insiders and outsiders.

[52] Geddes, Wright, and Frantz 2018, 5. On democracy: "In keeping with much of the literature, countries are coded as democratic if government leaders achieve power through direct, reasonably fair competitive election; indirect election by democratically elected assemblies; or constitutional succession to democratically elected executives."

[53] For electoral authoritarians, see Levitsky and Way 2010; Schedler 2013. I define reform as a choice to undergo a major change in direction for a political regime, in terms of policies, institutions, practices, and rhetoric. The reference to choice here connotes both some minimum of (1) intentionality and (2) ability to make other choices (i.e., voluntary).

dilemmas. The appearance of objectivity and universalism rather than particu-
laristic favoritism appeals to humanity's pro-fairness disposition. Number-based
discussions complicate issues, pushing deliberation into measurement questions
rather than values and framing debates as about concrete facts rather than more
ephemeral but significant reactions. Yet quantification is hardly a panacea, as the
gaming of evaluation systems eventually produces unreliable measures of their
original intent and performance inevitably wanes. These effects lead audiences
and authors to yearn for a different discourse.

The third chapter wades into the debates that undergirded the Mao to post-
Mao transition in China to show how revolutionary Communist ideology was
supplanted by quantified state capitalism as the regime's main argument for
staying in power. While Mao and his thought emphasized revolution as the
method to transform a backward country into a Communist utopia, by the
time of his passing in 1976 the population and many elites were ready for a new
message and course of action. The regime called for individuals to emancipate
themselves from ideological shackles and granted lower-level officials greater au-
tonomy to pursue development. While under Mao numbers had significant po-
litical import, they represented a means to an end rather than becoming the core
political end in themselves. Under Deng, a system of limited, quantified vision
was established intentionally, despite understanding that moving away from rad-
ical Maoism increased opportunities for corruption.

The fourth chapter showcases the political difficulties of leaving behind the
status quo for a new strategy of justification. China's reforms were not settled at
1978's Third Plenum, but aftershocks from that conference reverberated in the
decade that followed. After detailing personnel changes as revolutionaries were
retired and replaced by technocrats, the chapter presents examples showing
how numbers came to define Chinese politics, with emphasis on the deeply
quantified nature of the one-child policy. The political waves of loosening and
tightening that dominated the 1980s illustrate that mass politics and the macro-
economy shaped elite political debates and choices. The aftershocks settled in
a two-step of repression against the Tiananmen movement in 1989 and public
acknowledgment of the reform trajectory's developmental success with Deng's
Southern Tour in 1992.

The fifth chapter turns to the ways that the Reform Era's political economy
model of limited, quantified vision worked to generate development through
the 1990s and early 2000s. Inequalities deepened despite growth, and while
some efforts were made to aid left-behind regions and the poor, the chief rhetor-
ical switch was to embrace "advanced" forces of capitalism and capitalists. The
Hu-Wen leadership team rhetorically made alleviating poverty a priority and
tinkered at its edges through different programs, but, in the main, the Chinese
ship of state continued sailing in the same direction of seeking aggregate

economic growth. When the 2008 global financial crisis shook the world, the regime reverted to massive Keynesian stimulus to calm the waters.

The system of limited quantified vision's core institution is cadre evaluation, with its numerical performance targets. Original cadre evaluation forms and guidelines enrich existing understandings of the system, which are based mostly on observed promotion patterns. Even as the diversity of targets increased, aggregate economic targets remained central to the scoring. The direct politics of quantification is also seen in the contrasting tales of two environmental indicators, the failed Green GDP and the successful measurement of PM2.5, which worked rhetorically as a simple metric that captured public attention and galvanized government action.

The sixth chapter shows how debts, pollution, corruption, and falsification accumulated over time as externalities of the system of limited, quantified vision. The center's focus on a few statistical quantities left room for enterprising individuals to hide facts for their own benefit. Risky loans funded short-term investments to meet performance targets by leaders who left broken balance sheets in their wake. Corruption grew from merely pervasive to market-distorting. In China's cities, who and what was counted led to the striking presence of slums amid ghost cities. Officials falsified data, "juking the stats" by which Beijing judged them. Statistical analyses demonstrate that GDP jumped during politically significant moments more than other, less politically sensitive measures indicated. Citizens, too, took advantage of the regime's limited vision and manipulated data to their own benefit, as seen in examples of strategic divorces and "growing houses."

The seventh chapter describes China's neopolitical turn. China's leaders are reshaping the country's politics and economy through massive efforts of anticorruption, centralization, repression, and rhetoric focused on narratives of the Party as the champion of a strong Chinese nation. As with the beginnings of the Reform Era, significant debates about threats, priorities, and possibilities—regime identity—dominated discussions, as official consensus acknowledged the failures of limited, quantified vision. The early days of Xi's rule are then explored to demonstrate the incremental and tentative nature of such changes and interpretations of them. The turn takes the Chinese regime beyond its limited, quantified vision in two ways. First, rather than presenting political and economic problems as clean, technical issues to be counted and resolved, the regime under Xi presents a messy, conflictual picture with failures and enemies, but also depicts itself as a regime guided by a strong leader who can helm the ship of state amid the turbulence. Second, the regime is massively expanding the information that it collects and monitors about its own agents as well as society, notably through its social credit system.

The book concludes by moving beyond China to the ways its boom has re-made the world. First, it dives into the initially dangerous but ultimately trium-phant politics of the COVID-19 pandemic, affirming the fundamental nature of authoritarian information problems. China's limited quantified vision and censorship apparatus have extended past its borders, prompting concerns about the role of facts in politics and the power held by those shaping their presenta-tion. Finally, Chinese developmental successes have upended beliefs about ec-onomic governance, and China has played an underappreciated role in the rise, hegemony, and fall of neoliberalism.

Quantifying Like a Regime

Because the regime is captive to its own lies, it must falsify everything. It falsifies the past. It falsifies the present, and it falsifies the future. It falsifies statistics. It pretends not to possess an omnipotent and unprincipled police apparatus. It pretends to respect human rights. It pretends to persecute no one. It pretends to fear nothing. It pretends to pretend nothing.

—Vaclav Havel, *The Power of the Powerless*

Shortly after coming to lead the Chinese regime, Deng Xiaoping expressed regrets. He admitted, in February 1980, "I . . . made mistakes. We were among the activists in the anti-Rightist struggle of 1957, and I share the responsibility of the struggle—wasn't I General Secretary of the Central Committee then?"[1] The anti-Rightist campaign was not the only past event that troubled Deng: "Comrade Mao got carried away" with launching the Great Leap Forward in 1958, but "didn't the rest of us go along with him?" He continued, "[W]hen the Central Committee makes a mistake, it is the collective rather than a particular individual that bears the responsibility."[2]

Aiming to pass Great Britain's steel production, the Great Leap Forward attempted—without adequate capital or technology—to catapult China's economy into the future through the force of exuberant labor. It failed on a monumental scale. Local officials felt compelled to report success, but exaggerated production figures led the center to take all of the agricultural harvest and leave nothing for the farmers themselves to eat. Starvation stalked the land, killing between 30 million and 40 million Chinese.[3] In pursuit of utopia, officials faked data, and disaster decimated the people. Deng certainly had reasons to feel regret.

[1] During the fifth plenum of the 11th Central Committee. Quote from Pantsov and Levine 2015, 185.

[2] Pantsov and Levine 2015, 189, quoting Deng 1984, 281.

[3] For more details on the Great Leap Forward, see J. Yang 2012.

Seeking Truth and Hiding Facts. Jeremy L. Wallace, Oxford University Press. © Oxford University Press 2023.
DOI: 10.1093/oso/9780197627655.003.0002

To be fair, in 1958 Deng operated as an elite politician in a moment when Chairman Mao Zedong dominated Chinese politics. The extent of this domination is hard to fathom.[4] "Everyone was hurrying to jump on the utopian bandwagon. . . . [M]en who might once have reined the Chairman in, were speaking with a single voice and that voice was Mao's. . . . Everyone was caught in the grip of this utopian hysteria."[5] Mao was in command, and his commands pointed the Chinese regime and society to aim for a Communist paradise.[6] A few years later, as the scars the Great Leap had left became clear, Mao retreated to "the second line," and his colleagues in the Party's elite moved economic policy in more market-like directions.

The last two decades of Mao's life were full of turbulence for himself, the political leaders that made up the inner sanctum of the CCP, and the Chinese people. The Great Proletarian Cultural Revolution (1966–76) saw Mao calling on students and the common people to rise up against the Party itself, setting aflame institutions that his regime had used to govern and turning on fellow elites with whom he had worked for decades.[7] Upon Mao's death in September 1976, uncertainty reigned as individuals aligned into groups to compete for control of the regime and the regime's identity.[8] Who should lead the CCP, and for what purpose? Many—but not all—saw utopian Maoism as a colossal wreck. Mao's designated successor, Hua Guofeng, worked with more established leaders to oust some of the regime's most radical elements. However, Hua himself was sidelined shortly thereafter by Deng and, by 1982, was simply one of two hundred Central Committee members. Despite lacking the top Party and state titles, Deng was understood to be the most powerful figure in the regime's collective leadership, overseeing an overhaul of the country from a state-planned autarky justified by zealous Communism to a marketized, profit-oriented center of global production justified through quantification.[9]

Deng's regrets and the convoluted paths that both he and the Chinese political sphere more broadly followed over the past seventy years show that political regimes are not monolithic, static entities. Authoritarian regimes are made up of individuals who operate within institutions, hierarchies, networks, and factions. They exist in intellectual, ideological, and imagined communities at particular moments in time and govern societies and populations that retain

[4] Pantsov and Levine 2015, 190. "He [Deng] believed in the Great Helmsman as in God and blindly subordinated himself to Mao."

[5] Pantsov and Levine 2015, 190, quoting Li's *Private Life of Mao*.

[6] "Mao-in-command" is Nathan's 1973 term for these kind of arguments.

[7] Referred to as "Cultural Revolution" from here on.

[8] Such jockeying began long before 1976.

[9] Deng was the chairman of the Central Military Commission, the top position in the military hierarchy, for most of the 1980s, but was neither president of China nor general secretary of the CCP.

some degree of agency. Deng and others regretted that the regime became personalized by Mao, that it ruled through the Chairman's top-down diktat, and that it ceased aiming to improve people's lives in concrete fashion and instead worshipped Mao in a vain attempt to come closer to an abstract utopia. They sought to remake their regime, to hold power, and to keep the population acquiescent.

How do authoritarian regimes generate compliance? Regimes may co-opt and coerce their citizens, but few can rely on an endless supply of carrots and sticks to maintain their rule. Regimes must also attempt to convince their citizens of their *right* to rule. Convincing entails rhetorical, symbolic, and material efforts to keep people complying with the regime. But the work of convincing is not just about keeping citizens in line; it keeps the machinery of the regime churning. Regimes are complex entities full of individuals with their own ideas, histories, ambitions, and worldviews. They have contested identities over who rules, how that rule should be undertaken, and for what purpose. Believing in the regime or at least believing that others believe keeps the gears turning.

Quantification is a common rhetorical device central to the strategies that regimes use for persuasion. Quantification's utility has multiple sources, including its ability to imbue decisions with a sense of objective truth and scientific authority. Quantified discourse presents an image of transparency and is suggestive of accountability. Numbers simplify and organize a complex reality in systematic fashion. Inside regimes, quantified monitoring and evaluation evokes fairness and equal treatment. While not inimical to extremism—as seen in the impossible targets of the Great Leap Forward or incredible feats of Stakhanovite worker-heroes—quantification tends toward incrementalism associated with technocracy and neoliberalism.

The chapter proceeds as follows. First, the who, how, and why framework for understanding regime maintenance is developed, focusing on the role of ideas. The strategies that regimes use for convincing are then examined, and quantification's political utility and limitations are explored. The chapter concludes with a discussion of how regimes "see" reflecting on quantification's shaping of threats and threat perceptions under authoritarianism.

Framing Regime Maintenance: Who, How, and Why

Who am I? . . . I am the Chinese Communist Party, always together with you.
 —Chinese Communist Party ninety-fifth-anniversary television
 advertisement, 2016

The identities of regimes are constructed in the main by the individuals atop them.[10] This constructed and contested regime identity is close to Havel's panorama, a series of beliefs, understandings, worldviews, and institutions.[11] I propose a framework focusing on key questions of regime maintenance—who, how, and why—to better assess authoritarian politics.

Who? Individuals and Contested Identities

Dictators cannot rule a modern nation-state alone. Authoritarian regimes have three principal kinds of actors: dictators, elites, and agents. Dictators rule. Elites, also referred to as the "inner circle" or "ruling coalition," represent the core leadership team of the dictator, and hence the regime. While some elite actors, such as military officers, are affiliated with the regime, many others tend to have some independence from it, including religious leaders, powerful economic actors, and intellectuals. What separates the elite is some capacity to affect the regime's political economy with their own actions, not just as agents of the regime. Agents are individuals working for the regime, outside of the critical decision-making processes, who implement and oversee the regime's activities and engagement with the population on the day-to-day, grassroots levels.[12]

Dictators and elites have complex motivations about the ends of power that are shaped by worldviews and uncertainty as well as their own individually understood and collective regime interests. The primary dimension of divergent interests between the dictator and elites is the dictator's personalization of power. While elites share power, some scholars draw a critical distinction between two worlds: in the first, dictators have elites who retain a credible threat to remove the dictator—referred to as "contested autocrats." In the second, "established autocrats" have effectively "acquired enough power so they can no longer be credibly threatened by an allies' rebellion."[13] Machiavelli, similarly, wrote of "the King of France, who cannot take away the privileges of his barons 'without

[10] Of course, citizens, agents, and outside observers may come to contrasting assessments when they try to describe a regime's identity.

[11] Havel 1985.

[12] In a large polity like China's, the term "agent" could refer to a provincial governor or Party secretary of a large metropolis. As will be discussed more below, though these figures are referred to here as agents of the regime, they can retain substantial agency of their own, depending on political choices related to identity and monitoring.

[13] Svolik 2012, 55. While acknowledging that regimes could be placed at a variety of points on the personalism dimension, Marquez 2016b, 8 follows Svolik in treating the critical distinction here between "personal dictatorships" and "institutionalized regimes." For Marquez, the set of potential key organizations exercising power in nondemocracies is the same as in Cheibub, Gandhi, and Vreeland 2010, that is, "dynastic families," "political parties," and "military organizations."

endangering himself,' and the Turk, whose ministers are his 'slaves.'"[14] Geddes, Wright, and Frantz go further, arguing that

> the dictator and inner circle engage simultaneously in two kinds of strategic interaction: (1) a cooperative effort aimed at keeping all of them (the regime) in power and (2) noncooperative interactions in which different members/factions seek to enhance their own power and resources at the expense of others in the inner circle.[15]

Those members of the inner circle "consider how all policy, appointment, and institutional choices might affect their own standing, as well as regime maintenance."[16]

Taking the role of ideas seriously can help clarify elite contestation and authoritarian politics more broadly. Individuals in the regime's inner circle simultaneously possess worldviews, personal and regime preferences (or ambitions),[17] and policy ideas.[18] Worldviews, here referring to views on how the world works, arise from an individual's ideological vision or purpose, experiences, information, risk aversion, base political beliefs,[19] and self-interest.[20] Elites also tend to have ambitions for the regime itself, but here too multiple potential ambitions exist, such as survival, ideology,[21] the "national interest," status, and legacy.[22] Explicating these multifaceted components of elite decision-making only scratches the surface of the complexity of contestation at this level.[23]

Uncertainty pervades elite contestation. Elites have difficulty monitoring the dictator possibly usurping power and rely on imperfect signals to try to avoid

[14] Cited by Svolik 2012, 6; Machiavelli (1513) 2005, 16–7.

[15] Geddes, Wright, and Frantz 2018, 67.

[16] Geddes, Wright, and Frantz 2018, 66–7. But principally, Geddes, Wright, and Frantz's effort is to point out how differences in the groups that seize power in a dictatorship mediate these dynamics (93).

[17] Magaloni 2006 refers to her argument as "ambition theory."

[18] These build off of Rodrik 2014.

[19] Here I mean about human nature (à la Machiavelli's "feared" vs. "loved").

[20] Personal preferences arise from individuals' worldviews and their own identity choices, and ambitions can be broken down into those emphasizing the past (judgment/vengeance), the present (consumption, status), or the future (legacy, future consumption), where individuals have their own priorities. Legacies are often considered along financial, ideological, status, or power lines.

[21] Either ideological domination or ideological purity, among others.

[22] Differences in policy ideas can arise from variation in assessments of political economy problems or of potential solutions, assessments of the potential regime, and individual-level consequences of particular policy choices.

[23] This is true complexity rather than just a complicated system because of the large number of choices that can be taken simultaneously or concurrently by a large number of players (Ang 2016); further adding to the complexity is the uncertainty discussed in the following paragraph.

that path.[24] Actions are debated in terms beyond self-interest but as supporting broader public or regime interests. While individual members of the inner circle, including the dictator, often have clear interests that they attempt to pursue through their actions, these are usually explained rather than taken without words. Naked self-interest tends to be less compelling than justifications that suggest a broader public or regime interest in the actions being considered.[25] These broader interests arise from the ends of the regime; to put it another way, they answer the question: Why does the regime rule? These ends, however, are not fixed but are themselves subject to debate and contestation.

Tactical and policy exchanges can turn into fundamental questions of the leader's and regime's identities. For instance, a discussion about addressing the potential threat of extremists from a minority region with financial incentives for assimilation or massive involuntary internment can shift into a debate over whether this regime would detain millions of its own citizens? While likely most debates do not explicitly turn to the regime's identity, the possibility of such a turn suggests that multiple subtexts lie underneath discussions of an authoritarian regime's inner circle.[26] The first is that individuals propose actions that serve their own interests while also navigating those of the regime and other elites.[27] The second is that individuals proposing actions could push on the limits of the regime's ends in ways that might upset its identity as understood by those in the inner circle, and by doing so disturb its equilibrium.

Yet questions of who the regime is do not stop at the dictator. The size and makeup of the inner circle, succession, the role of other elites, and more all exist as well. Beyond the elite, important considerations include who can join the regime, who is removed from its ranks, how mass ideas and opinions are incorporated into who the regime empowers, and what types of connections the regime has with different kinds of people in its population.

To summarize, I assume that authoritarian regimes can be broken down into a dictator, an inner circle, other elites, regime agents, and the society that these individuals rule over and that simultaneously contains its future members. Dictators can pursue personal domination of politics, while inner circles oppose such pursuits. Crucially, however, the domain of these disputes is not simply in the realms of information, power, or resources, but also ideas. I argue that these disputes should be understood as reflecting contestation over the regime's identity along not just who rules, but also how and why it rules.

[24] Svolik 2012.
[25] Rodrik 2014, 194. In a truly personalized regime, the dictator desiring it is likely to suffice.
[26] Svolik 2012.
[27] As the quote above from Geddes, Wright, and Frantz 2018 lays out.

How

The methods of rule—the *how*—of dictatorship are the verbs that generate accept-ance, or at least acquiescence, on the part of the population and elites: "to co-opt," "to coerce," and "to convince."[28] In the end, co-optation and coercion—the prover-bial carrot and stick—are the main material methods used by regimes to convince citizens to comply. Compliance is often routine, habitual rather than considered, and regimes endeavor to create conditions to generate habitual compliance by shaping the information environment. After all, fewer carrots and sticks are needed when citizens are convinced by a regime's justification strategies. Nonmaterial con-vincing through rhetoric and symbolic power will be examined under the banner of *why* dictators rule, as that practice is more deeply enmeshed in self-understanding and presentation than co-optation and coercion.

Empirically, scholarship on co-optation and repression has principally investigated authoritarian institutions and treated these categories separately.[29] Parties, legislatures, and elections incorporate individuals into the power struc-ture, can neutralize potential opposition, and generate information for the re-gime about its own agents and varying levels of popular support for the regime itself and individual policies.[30] As coercive forces are the modal source of au-thoritarian regime turnover, numerous investigations of the organization of mil-itary and other repressive personnel inside dictatorships have shed light on these issues.[31]

Joint assessments of coercion and distribution are rare.[32] Lisa Blaydes's study of Saddam Hussein's Iraq incorporates mass beliefs and identities into an analysis of compliance and resistance and jointly assesses redistribution and repression. In her conception, regimes decide on the intensity and precision of distribution and repression, subject to budgetary and legibility constraints, the former more often associated with distribution and the latter with repression.[33] In particular,

[28] These are the methods of rule of democracy as well. And, in the end, co-optation and repres-sion are methods of convincing, just principally external as opposed to internal. Gerschewski 2013 calls "legitimation, repression, and co-optation" the "three pillars of stability" (14).

[29] I use "repression" and "coercion" interchangeably here.

[30] Fenner 2016 emphasizes that "co-optation" tends to conflate incorporation and neutralization. Like the dictator's identity, the formal institutional setup of authoritarian regimes is amenable to measurement. Elections and their level of competitiveness vary across dictatorships: some do not even have them at all, while others have truly contested, multiparty affairs where, to use Levitsky and Way's 2012 phrasing, the playing field is tilted in favor of the dictator to a greater or lesser extent.

[31] Greitens 2016; Policzer 2009; Quinlivan 1999.

[32] Pan 2020 provides an excellent exception in the context of Chinese neighborhoods with her analysis of the *dibao* system and its connection to unrest.

[33] Blaydes 2018, 39–43. In this context, I would argue that budgets are choices rather than true binding constraints. While I concur with Blaydes that legibility varies across the population and over

she emphasizes that individuals process rewards as material benefits that neu-
tralize potential opposition, and that such rewards induce individuals' invest-
ment in the regime.[34] Yet some regimes make choices beyond the scope of her
analysis, namely high-intensity collective goods provision, as I would argue
China was able to provide for much of the Reform Era.

My perspective differs from that of Blaydes in two ways. First, distributive
policy is often a component of development strategy. The PRC engaged in mas-
sive rural extraction in an effort to develop heavy industrial capacity.[35] Rural
extraction followed from the development plan, as the resources to construct
the factories had to come from somewhere. Rentier states, such as Iraq, on the
other hand, can use their resource wealth to operate, at least in the short run,
without such development plans.[36] Second, distributive policy can "encourage
individuals to present themselves to the state rather than hide from it, increasing
the legibility" of the population to the regime.[37] In a system with individualized
but broadly available rewards—such as food or housing subsidies tied to an ID
card—removal of such support can be very trying economically.[38]

Redistributive decisions are not just about levels of taxes or transfers but
about strategies. Capitalism is a choice. Indeed, it is an uncountable number of
choices. Regimes make choices about the extent of state ownership and control
of the means of production, the organization of labor, the regulation of produc-
tion in private hands, how capital and labor interact, how goods and services can
pass through national borders, and the delineation and prevention of undesir-
able economic activities. These choices about how regimes manage social and

space, the ability to "see" into places difficult to discern is mainly a question of choices related to
budgets and monitoring capacity. See below.

[34] Blaydes 2018, 40–1. "Investment," however, is not my preferred terminology, as Blaydes
provides no discussion of the returns to this "investment." It is "active cooperation" or support.
Investment in a regime is more akin to Svolik's 2012 discussion of individuals joining an authori-
tarian party and working hard early in their careers, followed by receiving their rewards after achieving
success.

[35] Following the Soviet Union.

[36] Here we must recognize dimensionality on the state/private economy side. Iraq is very state-
dominated; China is more market-oriented (at least in the contemporary period). This might affect
the extent to which the direction of co-optation/financial incentives/rewards matters compared with
broader ideas-based arguments about what actually shapes ideas about performance/competence/
legitimacy.

[37] Wallace 2014, 30. Albertus, Fenner, and Slater 2018 further explore this topic with a focus
on land reform, although they ignore the major role of development strategy, among other political
strategies, in the initiation of distributive policy.

[38] Blaydes 2018, 44. The text discusses subsidy cuts but considers them only at the level of the
community or the population rather than individuals (e.g., cheap fuel, but no ration cards to limit the
amount purchased or to punish misbehavior by ceasing to deliver such ration cards to a dissenter).

economic activity are not only strategic choices about how the regime generates compliance through material means but are also connected to its own identity and purpose.

Why

Co-optation and repression convince individuals crudely. Yet if regimes had to rely solely on transfers, payoffs, and violence to generate acquiescence from the population and cohesion from their regime partners, they would exhaust their resources quickly. As Jean-Jacques Rousseau wrote in *The Social Contract*, "The strongest is never strong enough to be always master, unless he transforms his strength into right, and obedience into duty."[39] Many regime actions, then, are meant to convince their populations—as well as the regime's agents themselves—to accept, or at least comply with, their rule.[40] After addressing the question of the potentially epiphenomenal character of symbolic power, these two audiences are discussed in turn.

Ideas and ideologies can provide sources of cohesion among the elites of a regime.[41] The regime's rhetoric and messaging serve as scripts for public officials. For those who come to believe in it, indoctrination imbues the work of Party-state functionaries with purpose and meaning. Even those with nonaligned preferences will repeat the words, contaminating them in the eyes of those opposed to the regime, and by doing so entrenching partisan identification.[42]

Do symbols have identifiable causal power? Consider authoritarian institutions. If institutions that ostensibly constrain regimes are subject to manipulation, then it is hard to see how they can operate as true constraints and thus have significant causal power.[43] Such a critique could appear to be even stronger against the import of symbolic power. After all, dictators dictate. If authoritarian legislatures—solid buildings with important people inside them—could be considered epiphenomenal to underlying political factors, then defending the study of the words of dictators by looking at expenditures seems unlikely to provide much cover. However, major institutional or rhetorical changes can

[39] Rousseau (1762) 1893, 7. See also Dukalskis 2017, 2.

[40] "Legitimacy" can be an analytical quagmire (Marquez 2016a; Wedeen 2019). Regimes use their power—material and symbolic—to seek to "guarantee active consent, compliance with the rules, passive obedience, or mere toleration within the population," which Gerschewski 2013, 18 uses as a definition for legitimation.

[41] Levitsky and Way 2013, 5.

[42] On contamination, see Schedler and Hoffman 2016, 108. On varying partisan identification inside of the Chinese regime, see Mertha 2017.

[43] Pepinsky 2014.

serve as focal points for both elites and citizens to help resolve the coordination problems that bedevil them.[44]

Regimes use rhetoric and symbols—positively and negatively—in their interactions with their populations for numerous purposes. As Alexander Dukalskis notes, the literature is "replete with theories" of what ideology can do: repress, motivate, legitimate, unify, rationalize, universalize, naturalize, reify, defend, incorporate, strengthen, constrain, and influence.[45] In shaping regime relations with the population, managing the information environment—promoting some messages and censoring others—serves three principal purposes: generating compliance, marginalizing opposition, and cultivating supporters to fill its ranks.[46]

The ubiquity of compliance makes isolating the ways in which state symbolism affects it difficult to uncover. State symbolic power generates compliance even absent indoctrination by signaling strength and encouraging coordination, as well as through indoctrination, as seen in changing worldviews and beliefs. Neither the regime nor Havel's greengrocer expects that the workers of the world will unite due to the slogan hanging in his shop window, but the sign slots into the broader panorama of other signs as evidence of general acquiescence to authority and the regime's strength on propaganda and general compliance with authority on the part of the populace. The censorship apparatus increases the take-up of the panorama by limiting alternative visions or arguments conflicting with the regime's agenda.[47] In similar fashion, Chinese high school seniors must provide correct answers to ideological questions as part of the high-stakes college entrance tests (*gaokao*).[48] Once in Chinese universities, those students must pass required ideological courses. Using surveys of college students, Haifeng Huang argues that what these courses teach is less the content of the texts themselves than their subtext: that the regime is strong.[49]

Whereas Huang claims that the propaganda apparatus signals strength via its burning through resources—that is, it changes beliefs of individuals about the strength of the regime—Andrew Little argues that propaganda can induce compliance without indoctrination as long as some people believe that others will

[44] Constitutional changes and shuttering a legislature certainly happen, but such actions can serve to focus attention on the regime and make it appear vulnerable. See Meng 2020.

[45] Dukalskis 2017, 59.

[46] Controlling the public sphere is about generating compliance through symbolic power as well as delimiting acceptable behavior, such as disallowing organizational activity.

[47] See Roberts 2018 on China's censorship apparatus.

[48] See Koesel 2020 for a fascinating study of the changing material on the test (the *gaokao*).

[49] Specifically, Huang 2015 argues that students do not accept the regime's rightness but do acknowledge it as providing order. Of course, maintaining order is a major theme of Chinese political rhetoric.

be indoctrinated.[50] Even in a world where most citizens are not credulous them-selves, given a strong enough coordination incentive they will act "as if" they believe propaganda; "propaganda can successfully influence mass *behavior* even without affecting most citizens' *beliefs*."[51] Symbolic power can affect change even without truly convincing individuals of its content.

From the regime's perspective, signaling strength has utility and makes it less likely that individuals will challenge its authority. But what is the utility of inducing citizens to act "as if" state symbolic power is believed? Even in the presence of biting cynicism and the absence of belief in the substance of the cult—viewing Assad as the "premier pharmacist" and other farcical examples—Lisa Wedeen shows that Syrians participated in the cult.[52] Indeed, going beyond simply rational actions given the beliefs of others, she makes the point that the cult itself helped generate compliance by "substantiating" the regime. Beyond one-off coordination with the credulous, she argues that by holding up a slogan at a sports gathering, compli-ance begets more compliance, creating habits and normalizing behavior. Citizens learn the regime's "vocabulary." Wedeen builds on the "vocabulary" metaphor: the "larger rhetoric shares . . . a prescriptive grammar, a coherent system of rules that regulates speech in ways that are comprehensible and facilitate communication."[53] Such habits of action and of mind substantiate the rhetoric of a regime, even in the absence of belief and in the presence of skepticism about its content. "The popu-larity of political satires and cartoons and the prevalence of jokes unfavorable to Assad," Wedeen explains, "tell us that although Syrians may not challenge power di-rectly, neither do they uncritically accept the regime's vision of reality."[54] Such satire can be the basis of collective resistance, but can also "operate to reassert dominant patterns of behavior by providing moments of release and exception."[55] Negative depictions of the government itself can be slotted into the panorama.[56]

Many may roll their eyes, but the panorama is persuasive. The empirical record suggests that skepticism about indoctrination may be unwarranted. As Little acknowledges, empirical analyses show that those exposed to propaganda tend to be credulous, in laboratory or real-world settings, "even if the sender has transparent incentives to misrepresent their information."[57] Propaganda can

[50] Little 2017.

[51] Little 2017, 225, emphasis in the original.

[52] Wedeen 1999.

[53] Wedeen 1999, 32.

[54] Wedeen 1999, 87.

[55] Wedeen 1999, 89.

[56] Holbig 2013 makes a similar case—even more explicitly—but it's about officials themselves participating rather than citizens.

[57] Little 2017, 225. On incentives to misrepresent, see Cai and Wang 2006; Patty and Weber 2007; Wang et al., 2010. On changing beliefs and behavior, Little 2017 continues, "Observational

induce compliance and change beliefs even without indoctrination, but it also indoctrinates many of those exposed to it, especially those inside worlds shaped by a regime's information management.[58]

Authoritarian regimes vary in the extent to which they control the information environment. The presence or absence of competitive elections divides the set into electoral authoritarian and nonelectoral regimes.[59] Having elections where an opposition exists—one that is allowed to speak, organize, and legitimately compete for power—represents a suite of information management choices that are off the table for electoral authoritarians compared with those who do not hold such elections.[60] Press freedoms also correlate with elections, although they do not stop propaganda from filling newspaper pages, TV broadcasts, and websites. Finally, regimes engage in censorship, not just through fear-based deletion but also through increasing friction to access disliked content and flooding the public sphere, making the act of finding such disliked perspectives more difficult.[61] The increased capacity to collect and share information, particularly connected to digital technology, the internet, and social media is double-edged, allowing information from below to reach massive audiences rapidly but simultaneously allowing the state incredible surveillance power.[62]

How do regimes use their domination of the public square? Based on the comparatively maximalist levels of such domination pursued in Burma, North Korea, and China, Dukalskis argues that authoritarian rhetoric contains six "legitimation elements": "concealment, framing, inevitability, blaming, mythological origins, and promised land."[63] Concealment refers to obscuring "undesirable elements of rule," such as coercion and internal divisions.[64] Framing packages "particular events or issues so that they are consistent with the regime's overarching legitimation," such as rightful resistance.[65] Inevitability elements build from Pierre Bourdieu's idea of "doxa," "the realm of thought that is taken for granted."[66] Blaming "deflect[s] the attribution of responsibility to the state" by directing attention to the role of outsiders or enemies.[67] Mythologized origin

empirical studies of propaganda and information manipulation also tend to find a large influence on the beliefs and behavior of the target audience (e.g., Enikolopov et al., 2011; Yanagizawa-Drott, 2014; Adena et al., 2015)."

[58] See Brady 2008, 2012; Stockmann 2010, 2013; Stockmann and Gallagher 2011.

[59] Schedler 2013.

[60] "Off the table" as doing so would mark them as nonelectoral.

[61] Roberts 2018; see Chapter 6.

[62] See Roberts 2018; Xu 2021.

[63] Dukalskis 2017, 61.

[64] For Dukalskis 2017, presenting a unified vision of the regime is also the work of "inevitability."

[65] Dukalskis 2017, 62.

[66] Dukalskis 2017, 64–5; Bourdieu 1977.

[67] Dukalskis 2017, 67.

elements utilize reservoirs of popular goodwill and positive associations with "founding figures, wars, or popular uprisings that either brought the regime to power or to which it traces its origins" and connect present circumstances with those heroic historical images.[68] By contrast, promised land elements connect today's situation with the future and "the prospect of progress under the regime's continued guidance."[69]

While these frames capture significant portions of the landscape of the rhetorical stylings of authoritarian regimes, control over the information environment affords those regimes other advantages and choices, but can also generate risks vis-à-vis society. Distraction is a primary mode of authoritarian communication, as is selective comparison. When negative stories arise, regime agents and their supporters attempt to draw attention to the individual heroism of public safety officers.[70] Indeed, the CCP's ninety-fifth-anniversary commercial in this chapter's epigraph explicitly links the Party to individual heroes: the one who shows up for work first, who stays the latest, and who works the hardest.[71]

Neoliberal hegemony following the end of the Cold War led many to depict twenty-first-century authoritarian regimes as interested only in demobilizing populations.[72] But depoliticization is not the only rhetorical strategy that authoritarians can choose when engaging with their citizens. As seen with Xi's neopolitical turn, aggressive politicization, particularly of nationalism, encourages emotional and intellectual engagement with politics in ways that seemed unlikely two decades ago, when ideological regimes were considered a failed experiment.[73]

Control of the public sphere can marginalize the opposition in other ways, obvious and subtle.[74] While most constraints on opposition activity are matters of policy rather than rhetoric, discursive opportunities tend to slant in favor of regimes. For instance, regimes produce official documents and fill them with their own vocabulary, beyond transmitting a given bit of information; that message slots into the broader panorama. Dissonant imagery from opposition candidates can have a hard time penetrating the panoramas that regimes build inside of censored information environments for their populations to observe, consume, and substantiate. When the discourse is quantified, those who create the numbers call the shots.

[68] Dukalskis 2017, 68.

[69] Dukalskis 2017, 69.

[70] King, Pan, and Roberts 2017.

[71] For more on heroic depictions of the Party in crises, see Christian Sorace 2017 on the 2008 Sichuan earthquake and Roberts 2018 on the 2015 explosions at the Port of Tianjin.

[72] Dukalskis 2017 is far from alone in holding this view; see, e.g., Robertson 2011, 30–1.

[73] Robinson 2006, 504.

[74] See Manion 2016 for a discussion of independent candidates for local people's congresses.

While the population at large is aware of the panorama of state rhetoric, this vocabulary saturates those inside the regime. These officials tend to know the ins and outs of messages as they work within their dictates and deliver them out of their own mouths. As it does with the population at large, indoctrination takes place here as well, but a higher dosage suggests stronger effects on those inside the regime. They generate a terrain for political discussion and the language used in those debates. They build points of interest as well as the ability to defend them.

The regime and its agents manage the information environment and make and disseminate the propaganda, refine the ideological lines, and devise and implement policies. They are enmeshed in it; for many, it is their principal work product. I have already argued that elite conflicts over who and how can cross over into existential questions about the regime's purpose—why—but such questions can also puzzle or affect agents who are tasked with putting decisions into practice in a messy reality. They can ably justify nonaction or apparent noncompliance with policy A because of precept B rather than mere laziness, corruption, or ideological defiance. Following David Beetham, Heike Holbig argues that ideology "provides the normative justification for the rightful source of political authority," defines "the proper ends and standards of regime performance," and "serve[s] as the main governance mechanism for mobilizing subordinates' consent."[75] Yet while ideology cast in these terms is about beliefs—and hence indoctrination—Holbig sees it principally is a "language game."[76] Cynicism, then, is ambiguous, because while it is a "measure of resistance," by "playing by the rules of the official language game, it stabilizes the symbolic arsenal of political discourse and subscribes to the social reality as constructed by ideology, thereby confirming the regime's hegemony in the ideological sphere."[77] Even inside the regime, ideology can do work absent belief.

Quantification

While understood as a part of the rhetorical arsenal of regimes, the political tool of quantification has been underexplored.[78] Christian Sorace's excellent analysis of the CCP regime's discourse in the wake of the 2008 Sichuan earthquake notes its dizzying use of numbers: "The vertiginous stream of statistics the Party publishes on urban-rural integration (or any topic, for that matter) is typically

[75] Holbig 2013, 64–5. See also Beetham 2013.
[76] Holbig 2013; Link 1993.
[77] Holbig 2013, 74.
[78] See, e.g., Scott 1998. Exceptions include Ghosh 2020.

more bewildering than clarifying. Reading statistic upon statistic and campaign slogan after campaign slogan produces a disorienting effect through which reality is negated by its statistical representation."[79] In its overwhelming nature, the regime's quantified rhetoric evokes Havel's panorama and demonstrates strength. These statistics, however, do more than disorient and negate reality; they shape perceptions and serve as core justifications of the regime, both to itself and to the world. Diving into quantification—the politics of numbers as numbers—is the principal task here.

As a political technique, quantification has significant strengths, perhaps especially for an authoritarian regime. Quantification imparts an aura of objective truth, transparency, and scientific authority to decisions. It digests reality's complexities into a few simple numbers. Quantification appears to aid accountability, without democracy, by generating commonly understood numerical benchmarks and facilitating comparisons, yet it simultaneously empowers the elites who create the metrics under evaluation.

Quantification can be defined as "the use of numbers to describe social phenomena in countable and commensurable terms."[80] Doing so necessitates the construction of categories to transform "different qualities into a common metric"[81] and building some infrastructure to count and calculate them. Such systems should be transportable and universal inside a polity or, if adhering to international standards, across the world. These categories inevitably fail to include parts of life, often in ways that reinforce existing power hierarchies, such as the noninclusion of female-dominated unpaid domestic labor in GDP statistics.[82]

Statistics, and so quantification, are ubiquitous in politics and economics. But their present ubiquity does not mean that they were not invented. The rise of the modern nation-state and colonization drove statistical developments.[83]

For instance, the brief history of the Bureau de Statistique in early nineteenth-century France shows how numerical capacities and desires can be at odds, as well as how the varying perspectives of those who want data and write down knowledge can come into conflict. In 1800–1, the French Republic's Bureau de Statistique "hoped that by gathering up and disseminating great masses of information about all the regions of France, they could promote national unity and an informed citizenry."[84] As such, they set off to conduct a census not just of

[79] Sorace 2017, 103–4.
[80] Merry 2016.
[81] Espeland and Stevens 1998, 314.
[82] For example, Merry 2016.
[83] Merry 2016, 35. See also Ward 2004 (esp. Box 0.1 and Box 0.2), who argues that antipoverty efforts were crucial to early quantification projects.
[84] Porter 1995, 35–6.

the population but covering a range of agricultural, economic, and cultural data and sent prefects of every *département* a quantitatively dominated questionnaire. Yet these officials did not have such information at hand, nor the manpower to collect it, and turned to local elites, who produced volumes full of knowledge but rarely focused on quantitative measures that the Bureau de Statistique could digest and summarize and use to compare *départments* across the country. Napoleon Bonaparte's desire for conquest pushed him to want a limited set of quantitative data related to war-fighting, counts of people, revenues, and economic production, and as the Bureau de Statistique did not have the ability to provide these simplified numbers, he shuttered it.[85]

Modern statistical systems were an innovation of the industrialized world of the late nineteenth and early twentieth century.[86] The creation of "the first real bureau of standards, the Physikalische-Technische Reichsanstalt in Berlin," occurred in 1871.[87] The Great Depression led the U.S. National Bureau of Economic Research to come up with national income statistics, work for which Simon Kuznets was later awarded the Nobel Prize.[88] Following World War II, the global System of National Accounts (SNA) was first formalized in 1953, eventually displacing the rival Material Product System (MPS) that was used by Communist countries for decades.[89] The SNA, including various updates, remains the global standard and "structures the content, categorization, definition, collection, and dissemination of information about the economy throughout most of the world."[90]

Quantification's utility for states in simplifying reality can associate it with broader strategies along lines that James C. Scott has described as "legibility."[91] An individual inside a large organization "'sees' the human activity that is of interest to him largely through the simplified approximations of documents and statistics," and these simplifications are "indispensable for statecraft."[92] Such simplifications tend to be facts that possess the following characteristics: "interested," "documentary," "static," "aggregate," and "standardized."[93] Yet these are far from noninterfering observations; Scott is clear that "society and the environment have been refashioned by state maps of legibility."[94] The British Indian

[85] Porter 1995, 35–6.
[86] Tooze 2001, 4.
[87] Porter 1995, 27.
[88] Coyle 2014, 12–3.
[89] Herrera 2010, 2–4. See also Ward 2004.
[90] Herrera 2010, 4.
[91] Scott 1998. See also Wallace 2014 and Blaydes 2018 on connecting legibility to authoritarian politics.
[92] Scott 1998, 76–7.
[93] Scott 1998, 80.
[94] Scott 1998, 3.

census, for instance, "not only stabilized caste but also homogenized it."[95] Scott's argument focuses on particular moments when efforts to make societies legible, powered by high modernism, failed in spectacular fashion, yet its unified state and state-society dichotomy ironically make it too simple a model to build on.

A chief political feature of quantification is that it is a "technology of distance."[96] Mathematics is "highly structured and rule-bound" and universalist in its public orientation[97] and can appear to possess objectivity.[98] Similar to Scott, Theodore M. Porter sees quantification as violent to local knowledge, as "[i]t aims to supplant local cultures with systematic and rational methods."[99] Transfiguring people into numbers separates the counter from the humanity of the counted. Porter argues that "the moral distance encouraged by a quantitative method of investigation made the work much easier," especially when counting the lower classes.[100] Collecting and assessing individual-level data furthers the distance between people, as they are encouraged to consider and treat themselves as individuals rather than as members of broader communities.[101]

Science, quantification, and distance are bound together as well. To convince other experimenters of their results, scientists relied on simple quantitative information that "minimizes the need for intimate knowledge and personal trust," which could be lacking in scientists across distances of geography and time.[102] Quantification became a "means" that aided in the construction of science as a "global network rather than merely a collection of local research communities" by producing "a more public form of knowing and communicating."[103] Porter summarizes it thus: "[S]trict quantification through measurement, counting, and calculation, is among the most credible strategies for rendering nature or society objective."[104] Statistics came from states but influenced the rhetoric and practice of science. In so doing, statistics became imbued with the credibility and authority of science's accomplishments at understanding and manipulating the natural world.[105]

[95] Merry 2016, 28.
[96] Porter 1995, ix.
[97] Porter 1995, ix.
[98] "A highly disciplined discourse helps to produce knowledge independent of the particular people who make it" (Porter 1995, ix).
[99] Porter 1995, 77.
[100] Porter 1995, 77. See Ward 2004 for a more positive perspective.
[101] Merry 2016, 34. See also Thornton 2011, 258–9.
[102] Porter 1995, ix.
[103] Porter 1995, ix.
[104] Porter 1995, 74.
[105] Porter 1995.

Quantification's perceived objectivity has not kept it from being seen as having political valence, namely as pro-democratic. An early line of thinking referred to as "political arithmetic" argued that "governance should be based strictly on numbers and measurements instead of theories and rhetoric."[106] John Dewey "considered science an ally of democracy, and argued that scientific method means nothing more than the subjection of beliefs to skeptical inquiry."[107] Karl Popper went further, holding science up as the "antidote to the century's totalitarianisms" as it "sets free the critical powers of man."[108] Quantification allows for democratic communication—"a man speaking to five hundred people, of all common and various capacities, idiots or lunatics excepted, should be understood by all in the same manner."[109] A different vantage point sees quantification not as universally understandable but as arcane, with true understanding requiring the capacity to deal with "complex, formalized (and ultimately repellent) language."[110] As Porter put it, "thinking about quantification from the broad perspective of social morality tends to turn contraries into obverses and to emphasize moral ambiguities."[111]

Knowledge and power are intimately connected.[112] While some may appeal to an idea of knowledge as nonpolitical, Michel Foucault critiques this notion, for "power produces knowledge (and not simply by encouraging it because it serves power or by applying it because it is useful)."[113] Quantification produces a particular kind of knowledge that is itself powerful and can be "purposive."[114] Scott asserts:

> A thoroughly legible society eliminates local monopolies of information and creates a kind of national transparency through the uniformity of codes, identities, statistics, regulations, and measures. At the same time it is likely to create new positional advantages for those at the apex

[106] Lam 2011, 23. Lam is referring to John Graunt and William Petty in particular.

[107] Porter 1995, 73.

[108] Porter 1995, 73, quoting Popper.

[109] Porter 1995, 74.

[110] Porter 1995, 74, 74n2.

[111] Porter 1995, 74.

[112] Merry 2016, 28, citing Foucault 1977, p. 27: "[P]ower and knowledge directly imply one another." This perspective seems to contrast with Kelley and Simmons 2015, 56, who make the point that "performance indicators *leverage* power via credibility; they do not create power out of thin air." Of course, the credibility of a given piece of information matters for its ability to affect power relations, but new knowledge can radically change political and power structures even if the source of the information or number was previously seen as inconsequential.

[113] Foucault 1977, 27.

[114] Kelley and Simmons 2015, 56.

who have the knowledge and access to easily decipher the new state-created format.[115]

Quantification is deeply associated with monitoring—in the political context, by citizens of the states and organizations that create and produce these numbers, as well as by the principals inside of political regimes, for their agents. Quantification fits squarely with monitoring, in that numbers are easily amenable to being systematized, repeated, and routinized.[116]

Quantification aids monitoring, but also transforms that which it counts. Monitoring is an act of control, as it can bring shame to those who fail to perform and in so doing induce efforts to meet monitoring standards.[117] But monitoring through quantification can do more than that. By quantifying an aspect of life, it can more easily become enmeshed in existing numbers and, in particular, yield "the expansion of the economic into areas previously deemed noneconomic."[118] The logic of markets and investments tends to infest numerical information. Quantification can push for "reconfiguring human beings, organizations, and states as market actors" or "in the image of the market" with its "competitive behavior, culture, and mindset."[119] Quantification can turn people into consumers, as "market-oriented quantifications involve the creation of new subjectivities" with "citizens, patients, students, prisoners . . . turned into (quantifiable) consumers, who are to be satisfied and fought over."[120] Quantification assists authorities even as it shapes how they function.

Yet this assistance does not signify that quantification implies a particular political organization. While quantification has utility for the autocrat—as it is symbolically transparent and accountable while still granting him substantial hidden power and control over the numbers—quantification is not destiny. The famed Toyota Production System is highly quantified but not as hierarchical as other managerial systems that are as number-dependent. Unlike most numbers-based "command-and-control management techniques," the Toyota Production System is governed by "collaborative, consensus-building discussions among shop-floor workers who engage in problem solving and focus on improvement

[115] Scott 1998, 78.

[116] Kelley and Simmons 2015, 57.

[117] Kelley and Simmons 2015, 57. Foucault 1977; Löwenheim 2008. "Monitoring standards" is significant here because if monitoring is ad hoc, then it is unlikely to be accepted as justified compared with a more systematic, "standardized" monitoring and evaluation protocol. Both Goodhart's Law and Campbell's Law capture this dynamic (Goodhart 1981; Chrystal 2003; Campbell 1979).

[118] Mennicken and Espeland 2019, 233.

[119] Mennicken and Espeland 2019, 233–4.

[120] Mennicken and Espeland 2019, 234.

rather than assigning blame," where a "key strategy is benchmarking" and indicators play an "important role."[121]

Whether in corporate governance or political rhetoric, the detailed practices of quantification deeply affect how such systems work and feel to those living inside or underneath them. While some saw the Nazi regime's extensive use of statistics as damning for quantification, Adam Tooze acknowledges relationships between statistical systems in many countries but forcefully responds:

> They shared certain common intellectual origins, certain technical preconditions and they were marked by their simultaneous appearance at a particular moment in time. But they were not identical. They were differentiated in technical terms. But, more fundamentally, they were distinguished by their relationship to politics. The most serious side-effect of technological determinism is that it makes it impossible to take politics seriously.[122]

Technological choices can predispose and shape subsequent patterns of behavior, but they do not obviate the need to understand politics in general, as well as in specific cases. The international statistical systems of the United Nations have shifted their objects and instruments numerous times since their initial development in the 1940s.[123]

Similarly, quantification's rise in China came in waves, with changing objectives and personnel. While imperial China was precociously bureaucratized beginning in the Han period, its empirical culture was not that of the modern social fact.[124] The early modern practice of "evidential research," or *kaozheng*, used "philological methods to determine which sections of the classics were verifiable and therefore authentic and true," while scholars at the end of the nineteenth century invoked the same expression—"seek truth from facts"— to describe their social surveys and other statistical enterprises.[125] However, like many quantified projects, their attempts to put numbers to aspects of life were not purely observations but had specific goals in mind. Like the French Republic's efforts a century earlier, the Chinese "social survey movement" was "interested in collecting empirical facts to affirm a set of emerging claims about

[121] Merry 2016, 34.

[122] Tooze 2001.

[123] Ward 2004, 15–7, Table 0.1.

[124] Fukuyama 2011, 128–38; Poovey 1998; Lam 2011, 22: "Charlotte Furth, for example, observed that empirical and specialist knowledge in imperial China was articulated in terms of 'cases' (an), as opposed to facts, in legal and medical discourses."

[125] Lam 2011, 3.

society, nation, culture, and history."[126] The very words to describe the people shifted with this epistemological transformation, from *qun*[127] or, "more pejoratively, *'yumin'* ('unenlightened and parochial foolish people')"[128] or even "a heap of loose sand" (*yipan sansha*) as Sun Yat-sen put it, to *shehui*, or society.[129]

Half a century later, after their triumph in the battle for control of the country, the CCP faced a "dual challenge" in the world of statistics: "a nearly nonexistent statistical infrastructure and the pressing need to escape the universalist claims of capitalist statistics."[130] Head of the Northeast Statistical Bureau, Wang Sihua, and others rejected random sampling for its connections to capitalist statistics and built a "complete enumeration periodical report system" that was supplemented in the agricultural sector with "typical sampling" surveys.[131] This system was said to possess "extensiveness," "completeness," and "objectivity," in contrast with capitalist, bourgeois statistics that could be distorted by profit motives.[132] These critiques negated the idea that statistics or economics was universal, following the ideological and institutional divides between market and planned economies.[133] As noted, even measures of the overall size of the economy differed across the Iron Curtain, with the Soviet Union, China, and other centrally planned economies using systems referred to as the MPS versus the Western-led UN-based effort of the SNA.[134]

The third wave of quantification followed from Deng's "Four Modernizations," when "emancipating the mind, seeking truth from facts" (*jiefang sixiang, shishi quishi*) became core to development. This "socialist modernization project" led to the emergence of "new social science academies" and the return of sociology and other disciplines that had been dismissed under Mao as "bourgeois pseudoscience."[135] Socialist statistics was pushed aside for a more universalistic discipline associated with the developed world and the West. Methods like the "typical cases" were attacked "as a vehicle of subjectivism that distorted researchers' attempts to capture and convey popular sentiment" and that "only capture[d] the views of a select minority of respondents."[136] But the

[126] Lam 2011, 3.

[127] Lam 2011.

[128] Lam 2011.

[129] Lam 2011.

[130] Ghosh 2018, 150.

[131] Ghosh 2018, 151–2.

[132] Ghosh 2018, 152–3.

[133] Ghosh 2018, 165, Table 1 summarizes the differences between "two approaches to statistics."

[134] In China, often Net Material Product. See Herrera 2010 and Rosen and Bao 2015 for more on MPS and SNA.

[135] Lam 2011, 171.

[136] Thornton 2011, 250–1.

reintroduction of randomized surveys and other statistical practices faced crit-
icism, both from defenders of the prior methods as well as those supportive of
reform who did not appreciate the negative feedback from some respondents
about what reforms had wrought in their lives.[137] In 1981, *People's Daily*
published a piece floating a proposal to "study our readers" using surveys to
"better our services to the broad masses" and posited that such work "should
be considered the rightful heir to the Maoist concept of the 'mass line' in prop-
aganda work."[138] Afterward, the Beijing News Study Association conducted
such surveys through their "audience research group," followed by Tianjin city's
"Thousand Household Investigation," and then Premier Zhao Ziyang's think
tank (the China Economic System Reform Research Institute) doing a series
of national surveys.[139] Susan Thornton argues that these acts of quantification
could be seen as transforming potential political actors and agents of the masses
into political subjects or audiences without direct ability to act politically.[140]

Beyond shifting the role of numbers in state-society relations in China, the
Reform Era's quantification push is seen inside the regime through the cadre
evaluation system. In 1979, Deng was already using the language of gross national
product (GNP), the language of the Western SNA, to measure the development
of the Chinese economy, despite the fact that it would be another fourteen years
before China officially switched its statistical systems to follow it completely.[141]
Despite this, the State Statistical Bureau began calculations of GNP, based on
connections with the World Bank and other organizations as early as 1980.[142]
GNP and its successor, GDP, would come to be core elements of cadre evalu-
ation, which I describe as a system of limited vision. That is, to encourage eco-
nomic development, the central government increased the functional autonomy
of local officials by giving them quantitative targets on a few elements, while
allowing officials on the ground to implement projects with some flexibility. For
the center, a limited number of quantified targets provides direction but also
space for local action; Yuen Yuen Ang refers to the broad Reform Era project
as one of "directed improvisation."[143] For local officials, quantification has the

[137] Thornton 2011, 239–40.
[138] Thornton 2011, 251.
[139] Thornton 2011, 251–2.
[140] Thornton 2011, 257.
[141] Deng 1984, from a speech on October 4, 1979. See Chander 2014; Herrera 2010 for more
details. The MPS/NMP legacy continues in part due to its differential accounting of the service
sector (Ramesh Chander, 2016, personal communication).
[142] Ramesh Chander, 2016, 2020, personal communication.
[143] Ang 2016.

benefit of commensurability and is suggestive of fairness in interjurisdictional competition.[144]

Quantification, then, has significant rhetorical benefits for the regime. Its association with science and mathematics provides authority through appearances of universality, objectivity, transparency, and fairness. Thus political rhetoric that relies heavily on statistics gives the framer the ability to present claims as about concrete facts instead of more airy visions or to substantiate the successful progress toward such visions with concrete facts.

At the same time, the reality of quantification or the production of indicators is that significant room is left for the crafter of the indicator to shape it for her own benefit; similar abilities to shape the narrative surrounding a given quantitative release also come in during the calculation and reporting of those indicators.[145] Debates tend toward measurement issues rather than underlying values or concepts, which in the main tends to engage the psychological processes of slow thinking rather than the more emotionally volatile fast thinking, taking some of the potential heat out of political disagreements framed by quantitatively oriented rhetoric.[146]

While these benefits exist in presentations both internal and external to the regime, internally the use of quantitative metrics as core to competition within a political system can help with prioritization for agents engaged in highly complex endeavors, suggests fairness and focus on efforts toward measured goals rather than purely network or factional investments. Yet quantification and high-leverage indicators also tend to degrade in value over time as their ability to be gamed by the agents increases. More broadly, quantitative discourse can become dispiriting as further refinements separate insiders from those outside. This dispiriting nature has demobilization effects for an authoritarian regime, especially as part of an overall symbolic and rhetorical effort to signal strength and competence. However, if the statistics being proffered seem to have drifted too far from the real concerns of the people they are supposedly describing, the system, or large chunks of it, can be set aside.

At any given moment in time, a regime's placement in political space will be some function of where it has been and where it believes it needs to be. Regimes make choices about their positions in part based on their perceptions of threats

[144] Of course, there are always differences. Should the competition be scored by maximum GDP growth? By increase from prior periods? What of too rapid growth that could lead to inflationary pressures?

[145] That being said, once a statistical system has become entrenched, it is difficult to dislodge. The Chinese NMP-to-SNA transition and its difficulty in measuring the service sector is one example; the *hukou*-based population statistics in Chinese cities provides another (Ramesh Chander, 2020, personal communication). See also Rosen and Bao 2015.

[146] Kahneman 2011. Also referred to as System 1 (fast thinking) and System 2 (slow thinking).

and opportunities that they face. To put it another way, regimes make decisions about how they *look* to themselves and others based on what they *see*. The next section addresses questions about threat perceptions and state vision before intertwining these two threads to produce a theory of reform.

Seeing Like a Dictator

This framework of authoritarian politics attempts to improve analyses of how regimes look but does little to specify the details of how they see. Dictators, after all, are just individuals and cannot personally inspect everything they may wish. Take, for instance, the second volume of Stephen Kotkin's biography of Stalin, which is set almost completely in a single room—Stalin's Kremlin office—and presents a slice of the massive amounts of information, much of it statistical, that flowed through that office, which itself was a small summary and sliver of the raw information that could possibly be useful for his decision-making on a given day.[147]

Despite their prominence in theories of authoritarian politics, as Sheena Greitens puts it, "much more research could be done to understand and theorize the origins of threat perceptions under dictatorship."[148] Threats to the regime itself means threats to its identity, including its purpose.[149] The most common way that dictators lose power is when their own elites seize it via coups or coup-like maneuvers and rule as new dictators.[150] Regimes make efforts to address these kinds of threats via "coup-proofing" and purging potential plotters.[151] These efforts principally entail choices in the design of their coercive institutions, fragmenting their forces to decrease the ability and likelihood of coordination against the dictator, but this fragmentation comes at the cost of hampering efforts to collect intelligence and repress threats arising from the population at large.[152]

While the threats to those in the top tiers of an authoritarian regime are documented, less analysis has gone to lower-level officials and the threats that they pose to regimes. Regime officials below the elite level have an ability to shape the implementation of decisions made by the top echelons. Intellectuals provide justifications for the policies that can affect their politics. Political

[147] Kotkin 2017.
[148] Greitens 2016, 305.
[149] See also Schedler's 2013 discussion of threats.
[150] For example, Geddes, Wright, and Frantz 2018.
[151] For example, Quinlivan 1999; Greitens 2016.
[152] Greitens 2016. The analysis in Blaydes 2018 is more iterative.

entrepreneurs can generate energy to address particular problems and ignore others, or to suggest specific solutions rather than alternatives that, again, affect politics and policy under authoritarianism.

Three kinds of analyses of threat perception should be considered. First are efforts to uncover proximate or direct threats to regimes. These are coup plots, foreign attacks, opposition protests, mass rebellion, elite splits, or other obvious acts that would threaten the regime's survival, and hence its ends.[153] Second are patterns in performance and perception of performance that are not directly threatening to the regime or its ends, but are principally about beliefs related to overall levels of implementation, attitudes, and support that undergird political regimes. Stories of pervasive corruption, government malfeasance, or systematic failure fit this bill. Third are meta-analyses of the ways in which other regimes are operating or have been brought down, that is, learning about comparative cases in order to improve the assessments of the regime's own situation. As the existing literature has focused on intelligence services looking at the first kinds of threats, my focus is on the other two.

With the caveat that this book does not examine elections, authoritarian regimes use many different information channels to collect and transmit information about grassroots-level political realities of both its agents and its citizens.[154] In authoritarian systems, legislatures are often information collectors and processors as much as legislators.[155] Alongside their information-dissemination role, news media are another institution inside nondemocracies that can be used for information collection by the regime, and the choice to limit media freedom is a trade-off between higher-quality information and greater control of the information environment.[156] Regimes can conduct polls or surveys of populations to try to assess public attitudes, although the data quality can be variable due to preference falsification.[157] Local informants can assist in keeping track of "targeted populations" that might be more likely to agitate.[158] Internet and social media provide rich sources of information about popular sentiment and attention for dictatorships.[159] With the exponential growth in computing power, the ability to vacuum up vast amounts of data and analyze it for potential threats or

[153] To the extent that the regime valued its continued survival.
[154] On information channels, see Chapter 6. Also see Jiang and Wallace n.d.
[155] Gandhi and Lust-Okar 2009; Little 2012; Manion 2016; Simpser 2013; Truex 2016.
[156] Distelhorst 2012; Egorov, Guriev, and Sonin 2009.
[157] See Dimitrov 2015; Kuran 1995. See Thornton 2011 and Chapter 4's discussion of sample surveys.
[158] Pan 2020.
[159] King, Pan, and Roberts 2013, 2017.

changes in attitudes can appear limitless.[160] Some dictators encourage citizens to register complaints—that is, to voluntarily disclose their grievances—as an information tool as well.[161] Dimitrov argues that a system of complaints needs to meet some minimum level of responsiveness to keep people working within the system and feeding it the information that will help the regime understand its position.[162]

If citizen discontent grows in a population skeptical of the benefits of using formal channels to address grievances, citizens can go outside those formal channels and take to the streets. Some scholars, like Peter Lorentzen, have argued that Beijing uses protests as yet another data point in their efforts to monitor local agent behavior at lower costs than auditing.[163] Overt discontent among the citizens in an authoritarian regime is rarely stabilizing, but the dangers in the Chinese case tend to be limited by the ways in which the regime directs citizen protest into what Kevin O'Brien and Li Lianjiang refer to as "rightful resistance," calling out local agents for harming citizens in contravention of the center's intent.[164]

The final kind of information gathering is comparative intelligence work. Such meta-analyses can be seen as more academic than truly monitoring and improving threat assessments, but threats can emerge suddenly from actions and results outside of a given regime. Take, for instance, Kurt Weyland's assessments of European dictatorships in 1848 and the "tsunami" following the February overthrow of Louis Philippe.[165] Even regimes that contain "experienced political operators" can find the emergence of new threats "paralyzing" in the moment, as Weyland describes a number of European regimes facing the 1848 revolutionary wave.[166] Such waves are not uncommon and are, in fact, a major source of authoritarian turnover. Yet soon afterward, "helped by long-established albeit informal procedures of discussion and deliberation . . . [they] learned from earlier mistakes, designed a fairly coherent plan for outmaneuvering their adversaries, and enacted this program in a savvy way, taking advantage of opportunities and avoiding risks."[167] In the wake of

[160] Yet this too does have constraints because of agency problems and technological interoperability. On the former, see Pan and Chen 2018. On the latter regarding China's social credit system, see Daum 2021; Horsley 2018a.

[161] Dimitrov 2015.

[162] Use of the legal system, such as China's Administrative Litigation Law, would also fall here.

[163] Lorentzen 2013, 2014. Dimitrov 2019 presents a strong critique of this perspective.

[164] O'Brien and Li 2006.

[165] Weyland 2016.

[166] Weyland 2016, 216–7.

[167] Weyland 2016, 216–7.

the collapse of European Communist regimes, the Chinese Party-state has investigated and reinvestigated the sources of their demise, as Mao drew instruction from classical Chinese political dilemmas.

The threats that regimes perceive are not necessarily the true set of threats that they face, nor even an unbiased subset of such threats. Rather, they are in large part the function of prior assessments of threats and the development and capacities of the monitoring agencies that attempt to observe and catalogue such threats. Having examined both how regimes look and how they see, we are finally ready to consider how they change, or to use the term of art, *reform*.

Applying the Argument to China

> The masses' eyes may be bright, but their hearts are deaf, dumb and blind. They believe that what they see is real. They don't know that the world is absurd, and that absurdity is the true essence of reality.
> —Wang Xiaofang, *The Civil Servant's Notebook*

The Chinese regime has a long and tortured history that is deeply intertwined with quantification. The chapters that follow attempt to test the argument and theoretical frameworks developed here. Ideological debates about why the regime ruled became connected to personnel issues in the wake of Mao's death, as the regime reconfigured itself without its guiding light. As part of its development strategy, the center limited its monitoring of localities to encourage officials to improvise methods to accomplish the center's goals of aggregate economic development. Gamesmanship emerged as always when ambition exists under hierarchy. Eventually, the center reversed course and expanded its vision and control in response to these emerging threats. That changing course is now not simply remaking China, but remaking the world.

The third chapter examines the origins of this system of limited quantified vision. Deng regretted the regime's actions under Mao and his own part in them. He attempted to create a political system wherein a singular individual would not have so much authority to act unilaterally to set the entire regime's course by both instilling collective leadership at the top and reserving some autonomy for officials below. The creation of this system was far from smooth and produced aftershocks as the old and new ideologies and information systems clashed in the 1980s, explored in the fourth chapter. The fifth and six chapters investigate the ways in which the system of limited quantified vision worked and how it failed, respectively. The seventh chapter again examines a period of ideological conflict as differing interpretations of the weaknesses of the old system fought

to shape what became Xi's neopolitical turn. Finally, in the eighth chapter, the continued problems of information quality under authoritarianism rear their head in China's COVID-19 response, while the differing internal and external lessons learned from China's developmental leap highlight the power of perspective when evaluating numbers.

3

Seeking Truth

Practice is the Sole Criterion of Truth
—*People's Daily*, May 12, 1978

This chapter assesses quantification in the shifting politics of China following Mao Zedong's death.[1] After a brief tour of the politics of statistics in Maoist China, it examines efforts to work within Mao's ideas—or at least his vocabulary—but pursue different ends by different means. Through turbulent resistance from elites, pragmatic ideas about how to achieve wealth and power for the Chinese people via essentially capitalistic methods replaced visions of utopia through command economies and constant revolution. Questions of who rules and how were also debated and integral to the origin story of China's Reform Era. Informationally, the regime's leaders intentionally limited and quantified their vision into the daily operations of local governments, firms, and people's lives to encourage initiative and signal transparency, pragmatism, and fairness.

The narratives and supporting evidence show how the regime's identity was contested in terms of personnel (who), policy as well as institutions (how), and purpose (why). These debates also highlight other features of authoritarian politics. First, individuals are multidimensional, with varied networks, experiences, expertise, talents, and beliefs that all can affect not only their own individual trajectories but also that of the regime. Second, as Guillermo O'Donnell and Philippe Schmitter have emphasized, moments of great political consequence can occur precipitously, with conflicts on different dimensions proceeding simultaneously and, indeed, merging.[2] Third, despite the fact that the moments

[1] Who should be credited with authorship of the chapter's epigraph—Hu Fuming or Sun Changjiang—is debated; see Schoenhals 1991. It was published in *Theory Trends* and *Guangming Daily* prior to its appearance in *People's Daily*, but it was this printing that generated the key political controversy.

[2] O'Donnell and Schmitter 1986.

Seeking Truth and Hiding Facts. Jeremy L. Wallace, Oxford University Press. © Oxford University Press 2023.
DOI: 10.1093/oso/9780197627655.003.0003

under examination here represent a significant departure from China's Mao-era policy and political status quo, there is a remarkable degree of continuity of personnel and rhetoric.

Counting on Mao

Numbers, like everything else, were radically politicized in the PRC under Mao's rule (1949–76). As discussed in Chapter 2, Mao expressed strong opinions on the correctness of different methods of collecting information, preferring censuses and typical cases to representative surveys, which he saw as tainted by capitalism.[3] Mao's revolutionary vision desired less to describe the world than to remake it, and he believed that people have difficulty breaking free from traditions and seeing the true range of the possible. While this radicalism enabled historic change, such as moving toward gender equality with concepts such as "Women Hold Up Half the Sky," it also occasioned tremendous violence and calamity.

By the time the CCP was victorious in the Civil War (1945–9) and controlled the bulk of the Han mainland, the country had been racked with instability, invasion, and war for decades.[4] Even before victory over the Nationalists (Guomindang), areas under CCP authority engaged in land reforms: dispossessing the landlord class and redistributing agricultural land to the tillers. This dispossession was public, with accusations flung at landlords in large gatherings that often ended in violence.[5] The means of production were also seized in urban areas as the state claimed ownership of land and businesses transitioned to state hands.[6]

As the CCP consolidated authority, the regime was pushed and pulled by contradictory impulses—between centralization and reliance on the grassroots, organized institutionalization and activist campaigns, radicalism and incrementalism, and economic and noneconomic goals. Planned economies, as China under Mao was attempting to construct, require coordination to allocate labor, material, capital, goods, expertise, and services in the absence of market mechanisms. As ever, the devil remained in the details. Should urbanization be encouraged or stymied?[7] How much surplus should be extracted

[3] See Chapter 2; Thornton 2011.

[4] Taking over Xinjiang and invading Tibet a decade later in 1959.

[5] See, e.g., Dikötter 2015; Walder 2015.

[6] Solinger 1999.

[7] Barnett 1974, 119 has a full page of such questions that bedeviled Party leaders, intellectuals, economists, officials, workers, and farmers for decades.

from agriculture to support industry? What share of production should go into consumption versus being saved and invested for the future? What sectors should be emphasized, and where should their facilities be located? How should enterprises be managed, and who should do the managing? While some potential answers to these and related economic questions could be ruled out, differences of opinion reigned. Perhaps most acute were issues where economic goals came into conflict with political goals; these became conflicts not simply about methods or policies but about the regime's purpose and priorities—its identity.

Mao understood that the country he ruled was impoverished. Simply nationalizing the means of production and distributing the resulting output equally across the populace would leave too many without enough to fill their bellies or fulfill his promises of a strong China that would stand up in the world. Land reform took property from the landlords and gave it to farmers. Harvests grew, but production was still individualized and oriented toward profit-seeking. A push toward collectivization of agriculture became an effort at communization, with nearly all elements of life organized by the state, from assigning work duties in the fields to requiring all food be eaten together in communal dining halls. Mao's utopian vision pushed the country and its numbers far past the breaking point with the Great Leap Forward. Zealous competition between communes to please Mao and demonstrate success prompted massive overreporting of harvests, which led to state extraction that cut to the bone and left tens of millions to starve in the countryside.[8] These gross exaggerations of agricultural production were the apex of what had been an ongoing conflict between the Ministry of Agriculture and the State Statistical Bureau and despite the warning that "to report fictitious or false statistical figures and materials would be under severe penalty as a dishonest act against the state."[9]

Radical political campaigns were not inconsistent with quantification. In multiple efforts, such as the anti-Rightist campaign, numbers remained essential, principally through quotas of "Rightists" persecuted. Such quotas were rarely central mandates, but instead were created by eager lower-level officials interpreting the utterances of Mao and other top leaders in literal fashion, as also happened in the Great Leap. The Socialist Education Campaign (1962–6) showed a similar quantitative streak, but in the antiradical direction, as Harry Harding puts it: "At the local level there was some effort to reduce the numbers of cadres purged in the campaign, even if that meant reversing the verdicts on

[8] See J. Yang 2012; Dikötter 2010; Kung and Chen 2011. Yang, Xu, and Tao 2014 present a compelling riposte to Kung and Chen's analysis.

[9] Li 1962a, 33–5, quoting Hsueh's November 1957 report. See also Ghosh 2018. State Statistical Bureau becomes the National Bureau of Statistics.

some of those who had been dismissed in late 1964. The goal was to conform to Mao's instruction that only 5 percent of cadres should be criticized and only 1 or 2 percent punished."[10] Governing at scale via edicts led to incongruities at lower levels.

Despite Mao's helming one of the world's largest bureaucracies, he always held some antipathy toward bureaucracy.[11] Avoiding bureaucratism meant ensuring that it was not overly stuffed with personnel in cozy positions in the middle of the hierarchy pushing paper and filling their days with make-work meetings while leaving the center bereft of detail on the true situation at the grassroots.[12] The staffing of the bureaucracy, in terms of prior political or class affiliations and age and technical capacities, was also often difficult to navigate.[13] While Mao perhaps leaned toward a Taoist vision of governance without government, where people would follow their "inherent virtue,"[14] in practice his dictates would call for radical decentralization to rural communes or urban collectives. Yet this decentralization was principally rhetorical, for officials ostensibly given freedom of action saw themselves in a game to hit targets, either those Mao explicitly gave them or those they distilled from his rhetorical flourishes.[15] Many of those flourishes were admonishments to moral performance. Often boiled down into slogans—"Serve the people," for example—such calls to perform were part of the Chinese practices of study and self-criticism, often instantiated through struggle sessions.[16]

To reflect on the broader strategies of the CCP during this period is to see their anticapitalist and anti-imperialist focus. Enemies were easier to agree upon than the nuances of balancing political and economic imperatives for positive development strategies. Asceticism was a long-running characteristic of the regime, dating from early hardships, especially the Long March and Yan'an periods. Resources were directed out of the hands of individuals to fulfill state projects, and the wages of urban workers were "virtually frozen from 1963 to 1976."[17] In its poverty, urban China was one of the world's most equal societies, with a Gini coefficient estimated at 0.16, as shortages of consumer goods, housing, and household durables (sewing machines, wristwatches, radios, and bicycles) were

[10] Harding 1981, 214.
[11] Harding 1981. Harding argues that the CCP had four traditions for shaping bureaucracies to better pursue the purposes of the regime that led it: internal and external remedialism, radicalism, and rationalization (19–30).
[12] Harding 1981, 198. He also discusses the failures of inspections here.
[13] Hinton 1980, 2469. Also see Harding 1981, 312.
[14] Harding 1981, 25.
[15] Chung 2016, 19 on Maoist decentralization.
[16] Such as in the Cultural Revolution, but Harding 1981, 21 points to Yenan.
[17] Walder 1986, 225. Walder adds the caveat "with only a small adjustment in 1972."

widespread.[18] But while its cities were egalitarian, China overall exhibited more inequality than any other major socialist state because of the deep destitution of the countryside.[19] Fully 30% of the rural population fell below the Chinese poverty line, and meager grain rations provided for nothing more than subsistence.[20] State extraction from farmers and workers and investment in heavy industry were justified through the "state promoted ethos of hard work and frugal living (*jianku pusu*艰苦朴素)," which pushed individuals to see their sacrifice as aiding the country.[21]

The numbers, words, and material reality of the PRC during Mao's final days and those same features of the country five years later diverge markedly. In that time, the regime's personnel, policies, and purpose were all refashioned, remaking governance of the world's largest country.

Practice

On September 9, 1976, Chinese around the country wept upon hearing the news that the Great Helmsman had "gone to meet Marx."[22] Mao had led the Party for forty-one years, from a conclave's decision in 1935 in Zunyi until his death. At its height, his cult of personality included daily loyalty dances and inspired flights of fancy as ludicrous as venerating a mango that he had purportedly touched, as well as a belief that as a seventy-two-year-old he had broken records while swimming across the Yangzi.[23] Mao's words were definitive for political elites, intellectuals, and the people. His successor as Communist Party chairman, Hua Guofeng, had been appointed vice-chairman in April 1976 and was said to be blessed by Mao with the following refrain: "[W]ith you in charge, my heart is at ease" (你办事，我放心). On October 8, 1976, Hua orchestrated the arrest of the radical Gang of Four from their high positions within the regime, consolidating his authority, albeit temporarily.[24]

[18] Walder 2015, 328, 331.

[19] Walder 2015, 331.

[20] Oi 1999, 3; Teiwes and Sun 2016, 54. See also the discussion of rural reforms in Chapter 4.

[21] Gerth 2020. To be clear, the Chinese state did not completely eliminate consumerism, as Gerth shows, but his claims go further than my own about the extent of capitalism in China under Mao.

[22] Tang 2011; Jones 2011. These refer to images and television broadcasts of people weeping, although the witness in Shanghai described citizens' faces as "subdued or dazed."

[23] Solomon 1999. On mango cult, see Leese 2011; Marquez 2012.

[24] It is beyond the scope of this analysis, but the Gang themselves represented a serious threat to the regime's stability as well, including potentially plotting an armed insurrection with the Shanghai militia.

Some of Mao's last official words vociferously attacked Deng Xiaoping.[25] Understandably, then, Deng was unhappy with an editorial jointly published in *People's Daily*, *Liberation Army Daily*, and *Red Flag* on February 7, 1977, stating that "the revolution triumphs when we implement Chairman Mao's revolutionary line" and "suffers setbacks when we depart from [it]," concluding with a call to "hold Chairman Mao's great banner high, implement Chairman Mao's revolutionary line even more consciously, resolutely defend *whatever* policy decisions Chairman Mao made, steadfastly abide by *whatever* instructions Chairman Mao gave."[26] Should Mao's decisions determine fates after his death? How could individual leaders or the regime operate solely by a dead man's statements, even if Mao's words were definitive on ideology for a Party-state that justified its rule ideologically?

Deng groused, but in April 1977 he suggested that, far from repudiating Mao, the Party should use "correct" and "comprehensive" Mao Zedong Thought as its political compass.[27] The subtle distinction and advantage to Deng between "correct and comprehensive" and "the Two Whatevers" came from an ability to take pieces of Mao's thought and use them to criticize Mao's individual words and decisions.[28] In order to be reinstated to his prior high-level positions, Deng accepted Hua's role as paramount leader but would not concede on the theoretical points, as he believed ultimately that these were more critical to moving the regime in his direction.[29]

[25] Central Committee Circular 4, 1976, cited in Schoenhals 1991, 249.

[26] Translation from Schoenhals 1991, 249, emphasis added; date from Vogel 2011. The piece came to be known as the "Two Whatevers." At the March 1977 Central Party Work Conference, Hua confirmed the connection: "Criticizing Deng and attacking the rightist reversal of verdicts were decided by our Great Leader Chairman Mao Zedong. It is necessary to carry out these criticisms" (quoted in Vogel 2011, 193 from Cheng, Wang, and Li 1998, 43). Not everyone accepts this interpretation. See, for instance, Teiwes and Sun 2016, 61n34, who argue against thinking of the Two Whatevers as critical of Deng, but the evidence presented for this contrarian take is thin. The Two Whatevers have their own political history. Hua had arrested the radical faction of elites known as the "Gang of Four" and was accused by other radicals of betraying Mao in so doing; the Two Whatevers was Hua planting the flag of his support for Maoism (Vogel 2011, 188).

[27] Vogel 2011, 195. Schoenhals 1991, 251 uses "accurate and comprehensive." Documentation on grousing is from May, although one assumes it was continuous (Schoenhals 1991, 251; Vogel 2011, 192–8). Vogel puts forward evidence of Hua's critics as immediately "galvanized" by the editorial and understanding it to be a way of blocking Deng's return to the top of the Party hierarchy. Deng was again given access to Party documents in December 1976, and in January 1977 a Politburo meeting discussed his return to "some position" (Vogel 2011, 192).

[28] Schoenhals 1991, 252.

[29] Ding 1994, 84–6 notes that Deng's emphasis on "seeking truth from facts" and "practice" was not solely intellectual or the only possible arrow in the quiver of using Mao against Maoism. Rather, it was likely selected because of its resonance with Deng's overall worldview and its connection with a number of specific priorities that he had at the time, namely reversing Tiananmen Incident verdicts,

By August 1977, Deng was calling on the Party to follow Mao's 1938 invocation of the classical saying "Seek truth from facts" (*shishi qiushi* 实事求是).[30] This pragmatic phrase contrasted in tone with much of Mao's ideas and words from the last decade of his life. However, it appealed to many Chinese elites and the broader population, who had grown frustrated by the political turmoil and economic stagnation of the Cultural Revolution and its ideological conflicts.[31]

People's Liberation Army Marshal Ye Jianying called for an official history on the past decade's conflicts to be written by the Central Party School.[32] As the school's effective director,[33] Hu Yaobang, an ally of Deng's and someone who—like Deng—had suffered during the Cultural Revolution, believed that this history represented an opportunity to reassess the Cultural Revolution. He called on his staff to "liberate their thinking."[34] Some staff members came up with the slogan "Practice is the sole criterion of truth." This theoretical claim became the title of an editorial published by *Theory Trends* on May 10, 1978, republished in *Guangming Daily* the following day, and—of ultimate importance—reprinted in the central Party's principal mouthpiece, the *People's Daily*, another day later.[35]

By calling for truth to be determined by practice, the article attacked the revered status of Mao's words and was said to "cut down the great banner" of Mao Zedong Thought that the Two Whatevers praised. Debate on the merits of the claim raged for nearly a month. Deng made a speech praising Mao's invocation of "Seek truth from facts," and this speech was emphasized in *People's Daily* (June 3, 1978) and connected to the fact-based empiricism of "practice."[36] After the military came out in support of practice with a piece in *Liberation Army Daily* (June 24, 1978), other political elites pronounced their support for the claim as well.[37]

bringing back officials pushed out during the Cultural Revolution, and demolishing the theoretical foundations of Cultural Revolution radicalism.

[30] Deng at the 11th CCP National Congress (quoted in Schoenhals 1991, 254).

[31] See Teiwes 1984 on the lack of popular support for Mao.

[32] In Party parlance, the 9th, 10th, and 11th line are struggles against Liu Shaoqi, Lin Biao, and Deng Xiaoping, respectively—the 11th is conflict between Mao and the Gang of Four (Yu 2004, 14).

[33] Technically Hu Yaobang was the third-rank official—second vice president—in the school, but the first and second were Hua Guofeng and Wang Dongxing, both of whom were already stretched thin by their more significant offices and responsibilities.

[34] Schoenhals 1991, 253.

[35] This publication strategy allowed the piece to escape the censoring hands of Wang Dongxing, who was a supporter of the Two Whatevers, as Schoenhals 1991, 258–60 explains.

[36] *Renmin Ribao* 1978; Schoenhals 1991, 264.

[37] Schoenhals 1991, 265.

These debates covered both means and ends. The triumph of "practice" suggested a pragmatic victory, an ends rather than means approach to achieving goals, but these debates were happening concurrently with discussions about the desired ends of the CCP. Rather than Mao's ends—Communist utopia through rebellion—China's post-Mao leaders converged on an older set of desires, namely "Wealth and Power," for the country, the people, and the Party itself.[38] The prominent Chinese economist and chronicler of the period, Yu Guangyuan, was explicit in October 1978 about the regime's ends: "The Communist Party of China seeks to maximize the material interests available to the proletariat and all working people."[39] He emphasized the idea of rewarding initiative and strong performance, at the level of not just individual workers but enterprises: "well-performing enterprises shall be distinguished from poorly performing ones and profitable enterprises from loss-making ones,"[40] with only strong performers keeping a share of profits. These shifts came about through a series of debates, discussions, speeches, and conferences associated with the purpose of social production and consumption, but quickly became connected to broader and deeper discussions about the nature of the CCP-led regime: who should have a voice and what were the acceptable limits of debate.

These theoretical transformations presaged changes in leadership, policy, politics, and economics in China. Rather than be guided in policymaking by beliefs about the nature of a given policy tool as either capitalist or socialist, the Party-state would emphasize the results that such policies produced in practice. New leaders would call on the Party-state and the people to liberate their minds and seek truth from facts. This fact-based approach, when paired with strong beliefs in rationalism and identification of statistics with the scientific and modern, would end up yielding a quantified governance that characterized much of the Reform Era. To be clear, I consider this a shift in ideology, not a retreat from ideology. Justification based on performance is an ideological choice.

By choosing to focus on practice and the concrete results of modernizing agriculture, industry, national defense, and science and technology—the "four modernizations"—as core to its justification, the regime's center regained its footing. But coming to a broad agreement on the regime's purpose did not end contestation over its identity. Indeed, conflicts raged over who should rule, how, and why.

[38] See Schell and Delury 2013.
[39] Yu 2014, 4.
[40] Yu 2014, 5.

Central Party Work Conference, November 10 to December 15, 1978

The CCP's official history views the Third Plenum of the 11th Central Committee (December 18–22, 1978) as the turning point in China's embarking on reform and opening. Yet that tidy history fails to convey the more convoluted and murkier realities of politics in the days and months beforehand, when Maoist pieties would not be eliminated, but performance targets and incentives would come to the fore.

As perhaps goes without saying for an organization that would name a major gathering "the Third Plenum of the 11th Central Committee," the CCP holds an impressive number of meetings. Two that preceded the Third Plenum have particular significance. The first, the Principles Forum, was a series of twenty-three morning sessions on "Principles to Guide the Four Modernizations," convened over July 6 to September 9, 1978. The Principles Forum focused on the policies of the future—particularly related to openness to international economic forces, including capital, technologies, and equipment—rather than the regime's past errors.[41] The meeting's chair, Li Xiannian, closed the forum and "announced the beginning of a new age of openness for China."[42] The Party elite agreed in broad terms on how it would reach its new purpose of modernization.[43]

Both Hua and Deng supported focusing on modernization. Working on other duties, Deng was not present at the Principles Forum, while Hua managed to attend thirteen of the morning sessions.[44] Yet Deng's call for financial rewards and penalties based on performance and a "system for the evaluation of work" that "must be strict, comprehensive, and regular ... in all trades and professions," resonated with the discussions at the Principles Forum.[45] Promotions, Deng argued, should also be based on such quantitative metrics of performance, and while "moral encouragement" could be placed first, "material incentives cannot be dispensed with," and he called for reinstating bonus systems.[46] Citing foreign experiences, Deng even recommended cadres have their promotions and pay

[41] Vogel 2011, 224–5.

[42] Vogel 2011, 225.

[43] "In broad terms" is necessary here because Chen Yun agreed that borrowing foreign capital was correct but was extremely concerned about the scale of borrowing that the forum suggested (Vogel 2011, 226). This policy disagreement does not differentiate Hua and Deng, who were both supportive of massive borrowing ("When told of the decision to borrow US$18 billion ... Deng casually said, 'Why not US$80 billion?'" [226]).

[44] Vogel 2011, 224–5.

[45] Deng 1984, 118.

[46] Deng 1984, 118.

linked to the performance of the factories they oversaw, with bonuses for good work and pay docked for those with poor work performance.[47]

The second and more significant meeting before the Third Plenum was the Central Party Work Conference (CPWC, November 10 to December 15, 1978).[48] For thirty-six days, over two hundred high-ranking officials and Party intellectuals met in Beijing's Jingxi Hotel. Unlike the Principles Forum that preceded it, the conference was a full-time affair. Hua had called the meeting and set out its agenda in his opening remarks: agriculture, the national development plan for 1979–80, and continued discussion from the Principles Forum.

Hua framed the meeting in policy terms to focus attention on questions of how to make clear and get all officials to accept that the four modernizations would now be the basic framework of the Party's purpose. He wanted to avoid discussing the errors of the past, particularly those that split the elite.[49] Those attending the CPWC had disparate experiences of the Cultural Revolution. Some suffered, while others climbed to power amid the tumult; still others were absent due to decisions made by the newly discredited Gang of Four.

Hua was surprised by his inability to keep the conference's attention on policy issues, and on its second day, Ye Jianying privately "advised Hua Guofeng either to accept the changed mood or prepare to be left behind."[50] This mood was not about dissent on policy issues, but focused almost solely on personnel issues and the official Party line. For instance, Vice Premier Ji Dengkui's presentation of two documents coming from the Party center on agriculture at the second plenary session was relatively well-regarded on *policy* terms.[51] He called for increased investments in agriculture and higher procurement prices for grain.[52] Yet the two documents and Ji himself were criticized for having ideological problems,

[47] Deng 1984, 118. In Romania.

[48] This account of the CPWC comes principally from Yu Guangyuan's recollections, in his own writings (principally, *Deng Xiaoping Shakes the World* [Yu 2004] and Vogel 2011), as well as Teiwes and Sun 2016 on details related to agricultural policy. See also Teiwes and Sun 2019.

[49] Namely the Two Whatevers, the status of the April 5, 1976 Tiananmen Incident, and the reversal of verdicts. Many officials were purged during the Cultural Revolution—some, such as Deng Xiaoping, multiple times. In the post-Mao regime, many sought to reverse these verdicts. Similarly, demonstrations that honored Zhou Enlai in April 1976 following his death were declared counterrevolutionary.

[50] This is Vogel 2011, 233 citing a reflection by Ye's nephew, Ye Xuanji (2008). While Vogel is the one who suggests that Hua was surprised, later in his chapter he notes that "many believe that with the decisive change of atmosphere that had been building up over the summer and fall and that had crystallized during the first three days of the work conference, Hua had no real option" (Vogel 2011, 237).

[51] Teiwes and Sun 2016, 51–8.

[52] Yu 2004, 40. See also Teiwes and Sun 2016. The shorthand for the agricultural reforms that most of rural China will implement by 1982, decollectivization, especially in the form of household contracting, was seen as too radical at the time (Yu 2004, 49). Yu writes that the "prevailing mood"

principally related to the questions of learning from "the Dazhai model" of com-
mune agriculture and, for Ji, connections to the Gang of Four.[53] The documents
rhetorically praised Dazhai even as they broke from using it as a policy model, yet
that remaining praise was out of step with the shift in thinking toward assessing
policies by practice rather than ideology. Chinese agriculture was seen as a mess
by 1978, and part of that policy failure was attributable to the Dazhai model
being imposed on localities from on high without considering local characteris-
tics.[54] Beyond the ideological failings of the documents themselves, their mes-
senger was also seen as suspect by many who had suffered during the Cultural
Revolution. Ji had risen quickly during those years, and for some of that time
played a role in the special case groups that handled charges against high-ranking
cadres, leading many to blame him for their fate and those of others inside their
networks.[55]

How did historical experiences of the Cultural Revolution split an elite that
broadly concurred on issues of specific policies and overall direction? The case
of Ji Dengkui is but one example. Dozens of high-level officials who had run afoul
of Mao and the Gang of Four during the Cultural Revolution remained sidelined
at the time of the CPWC in 1978, over two years since Mao's death and the ar-
rest of the Gang. On November 11, three officials spoke out on the need to re-
verse the verdicts against them. By the end of the next day, a dozen speakers had
come forward contesting the judgments. Chen Yun, a former Politburo Standing
Committee member, listed six items—all fundamentally related to personnel
issues—to be reconsidered ahead of the meeting's prior agenda.[56] As Ezra Vogel
put it, "a torrent of previously suppressed anger was released by speakers in all
of the groups against officials like Hua Guofeng and Wang Dongxing [Mao's
former bodyguard] who had blocked the return of good officials unjustly ac-
cused."[57] This rising tide of reconsideration that was taking over the conference
quickly escaped the halls of the Jingxi Hotel.

of the conference was against household contracting (50). Mao's commitment to communes made
household contracting politically difficult in 1978. That is, it couldn't be tossed aside as a mistake in
his last years. Teiwes and Sun believe that Ji's documents did not mention household contracting and
that the decision to ban household contracting actually came after they were taken out of his hands.

[53] Teiwes and Sun 2016, 55–7.

[54] Eisenman 2018 has a contrarian perspective, arguing that Chinese agriculture was in a less
disastrous situation than is generally acknowledged. However, even if the facts line up as Eisenman
claims, the arguments that won the day among the Chinese elites were based on very different
perceptions.

[55] Teiwes and Sun 2016, 58n25. Teiwes and Sun see this blame as unfair—Ji was just following
orders—which is true but also beside the point. Yes, the Cossacks work for the czar, but the Cossacks
who burn the village also deserve the villagers' ire.

[56] Chen 1994.

[57] Vogel 2011, 234.

The Beijing Party Committee had just come under new leadership in October, transitioning from Wu De, who had a major role in the April 5, 1976, Tiananmen Incident,[58] to Lin Hujia, who began planning to change the official position on the incident as soon as he took office. On November 13, the Beijing Party Committee met and officially declared the Tiananmen Incident a "revolutionary action."[59] Word of this decision quickly made it into the city Party Committee–controlled *Beijing Daily* without fanfare, buried inside a long article. On November 16, the *People's Daily* published this news with a headline blaring, "Beijing Municipal Party Committee Announces Tiananmen Is an Entirely Revolutionary Action."[60] This position went further than Hua, who had maintained that while many of the individuals participating in the incident were acting in a revolutionary manner—honoring Zhou Enlai—a counterrevolutionary element had taken advantage of this opportunity. Declaring the event "entirely revolutionary" was a major change. On November 19, *People's Daily* published definitive evidence of Hua showing his support for this new status for the Tiananmen Incident: the title page of a book of poems valorizing participants in the Incident was written in his own hand.[61]

Elites were not alone in calling for change. Over the same weekend of November 17–19, on what came to be known as "Democracy Wall" in Beijing's Xidan neighborhood, a poster appeared that criticized Mao, by name.[62] This poster, and many others, discussed, debated, and dissented from the current policy and political status quo. The official press had signaled the acceptability of such public comment earlier that week, when the *People's Daily* published an article stating, "It is imperative to develop democracy and strengthen the legal system."[63] Democracy Wall made apparent that public support for the status quo, and even for the venerated former Chairman, was weak.[64] Yet the leaders of the CCP could and would do only so much to disassociate themselves and the Party from its Chairman. What was undertaken were moves that attempted to

[58] See Teiwes and Sun 2007, 484–5 for a view of the incident that suggests Wu De had little agency at the time in broadcasting a message to clear the square, as the radicals of the Gang of Four pressured him to do so. Wu De seems to not have been reappointed to a different position in October; he remained a Politburo member, but someone closely associated with Hua and the Two Whatevers losing his main position before the conference should have clued Hua in on the prevailing mood.

[59] Vogel 2011, 234; Yu 2004, 70.

[60] 人民日报 1978b.

[61] Xinhua News Agency 1978. See Vogel 2011, 236.

[62] Garside 1981, 212.

[63] Lin and Li 1978. See Goldman 1991, 223. The *People's Daily* headline is "要大大发扬民主和加强法制." The original *China Youth* headline is translated as "It is necessary to bring democracy into full play" (Goldman 1991). A few months hence, those posters would be seen as a danger to the regime, and Democracy Wall would be shut down. See Chapter 4.

[64] Teiwes 1984.

bracket Mao's life as head of the Party into decades of success, followed by a late fall into error with the promotion of Marshal Lin Biao, the Gang of Four, and the Cultural Revolution. The regime's leaders would come to dismiss, demote, or sideline those who were seen as beneficiaries of the chaos of the Cultural Revolution as a way to separate the Party's image from the public frustration with those years.

On November 25, Hua stated that he accepted the majority view among the Party elite on the Tiananmen Incident and the other issues brought up by Chen Yun almost two weeks before. Hua's speech was well-received by the "vast majority of the participants"[65] at the CPWC, and Yu praised him: "Hua Guofeng's attitude also deserves our praise. I had attended many meetings. But I had seen almost no top Party leaders who could solicit others' opinions in such a way and I had seen almost no problem solved so thoroughly and explicitly."[66] Later on November 25, the Politburo Standing Committee heard a report on the "opinions of the masses after the reevaluation of the Tiananmen Incident,"[67] and then collectively published a speech by Deng that supported practice as the sole criterion of truth and acknowledged Mao's mistakes.[68] The philosophical turn was definitively decided by the top leaders. Hua encouraged participants to continue "discussing questions with open minds,"[69] which only led to more direct criticisms of political opponents in the following days.

Deng's closing speech to the CPWC on December 13 is seen in retrospect as the launch of China's Reform and Opening, yet the content of his speech was politics, not policy.[70] He discussed one question, "namely, how to emancipate our minds, use our heads, seek truth from facts and unite as one in looking to the future."[71] He clearly laid out the Party's purpose at this time: "Our drive for the four modernizations will get nowhere unless rigid thinking is broken down and the minds of cadres and of the masses are completely emancipated."[72] The "vital political task" of emancipating the mind entailed moving beyond the "ideological taboos" of the past, deconcentrating power, and reviving "democracy."[73]

Deng was most direct about the need to move away from the Maoist period's concentration of power, not just in the top individual but freeing those in local

[65] Yu 2004, 75.
[66] Yu 2004, 75.
[67] Yu 2004, 76.
[68] Yu 2004, 77.
[69] Yu 2004, 74.
[70] Yu 2004, 58–60.
[71] Deng 1984, 152.
[72] Deng 1984, 154.
[73] Deng 1984, 152. Deng's antidemocratic practices eclipsed his pro-democracy rhetoric; see below.

offices and factories to have the autonomy to make decisions that considered their own circumstances. For that freedom to be effective in practice, it needed to be accompanied by responsibility systems that would reward and punish individuals for the outcomes that resulted from their actions. That is, the higher levels needed to watch lower levels closely on measures of key performance but overlook the means by which those outcomes arose—a limited vision.[74]

Deng called for democracy not just inside the Party but with the masses and for supporting that democracy with the rule of law, stating, "In political life within the Party and among the people we must use democratic means and not resort to coercion or attack."[75] Citizen rights stipulated in the state and Party constitutions "must be resolutely defended and no infringement of them must be allowed," even if "a few malcontents take advantage of democracy to make trouble."[76] He argued that laws were needed to guarantee democracy: "Democracy has to be institutionalized and written into law, so as to make sure that institutions and laws do not change whenever the leadership changes, or whenever the leaders change their views or shift the focus of their attention."[77] These statements were both comments on past practices—critiquing the Cultural Revolution for its radical mob justice—as well as a marker for the future direction of politics. Deng's portrayal of a strong, popular Party that could withstand sharp criticism and let "one hundred flowers bloom, a hundred schools of thought contend" may have appealed to himself and those in the room, but would essentially fail its first test, the Democracy Wall movement of 1978–79.[78]

These vignettes highlight several aspects of this book's framework. First, regimes are staffed by distinct individuals. Hua was helicoptered to the top of the Party hierarchy by Mao during a time when other decisions by Mao were angering other elite politicians, as well as much of the public. The April 5, 1976, Tiananmen Incident was the moment when Deng was pushed aside by Mao for the final time, and it was at that moment that Hua was granted the full set of titles that marked him as Mao's chosen successor. Despite Hua's relatively sophisticated navigation of the system, the fact that his rise to official positions of power came in part from attacks on Deng was seen as unfair by the majority of those non-Gang Party elites and made his hold on power precarious. There is no way to know whether slightly different tactical choices by Hua throughout the 1977–8 period, or specifically at the CPWC itself, would have changed anyone's thinking. There is no counterfactual to assess whether a more conciliatory or

[74] See more on decentralization in the section "Limited Vision."
[75] Deng 1984, 155.
[76] Deng 1984, 155–6.
[77] Deng 1984, 157–8.
[78] Deng 1984, 156.

more aggressive opening plenary address would have changed the conference's prevailing mood.[79]

Second, politics moves with pace. Hua opened the CPWC on November 10 with an address that was generally well-received by the elites in attendance. After the following day's sessions, however, he was being counseled by Ye Jianying to change course or get out of the way. Vogel refers to the shadow of the coup of Khrushchev, ousted by his own Central Committee a little over a decade before, as at the forefront of the minds of Hua and other Chinese elites.[80] Preparations and debates about the delicate issues of agricultural reform devolved into fights over ideology and the history of the messengers chosen to participate in those debates.

Third, mass politics shapes elite politics. While personal grudges and jealousies served as proximate factors pushing change, the seeds of those grudges largely grew out of top-down decisions that went against popular sentiments.[81] The Tiananmen Incident protestors who rallied to respect Zhou Enlai attest to that resentment, as did the quick purge of the regime's most radical elements in the immediate aftermath of Mao's death. Yet many individuals who had benefited from the chaos of the Cultural Revolution remained reluctant to recognize that in the post-Mao period, their prior decisions and actions were political liabilities, especially in the eyes of the masses.

Why Reform?

Following Mao's death, the Chinese Communist Party–led regime reformed for many reasons. The passing of Mao necessitated a transition, and no one who replaced him would have the same stature among the Party elite or the population. As to the question of *when* reform would occur, Mao's death holds the primary explanatory power. The Tiananmen Incident demonstrated that at least some segment of the country's population mourned the loss of Zhou, and the antiradical positions that he had come to represent, enough to defy radicals even while Mao still breathed. The immediate punishment of the protestors and elites associated with their positions (i.e., Deng) pointed to the danger of perceived attacks on even the infirm Mao while he remained alive.

Hua crossed terrain treacherous for both himself and the regime, ousting the radical Gang of Four while attempting to protect Mao's own quite radical

[79] Although Yu's praise suggests that these tactical choices were well done, the die was already cast against Hua Guofeng by that time.

[80] Vogel 2011, 233.

[81] A large swath of people were obviously frustrated with the regime's radicalism in Mao's last days.

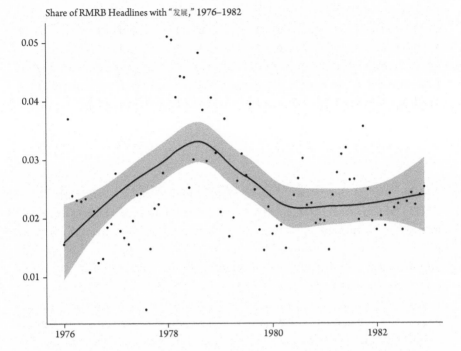

Share of RMRB Headlines with "发展," 1976–1982

Figure 3.1 Development Discourse on the Rise. Source: data.people.com.cn, 3515 instances in 146,566 headlines

legacy, as it was Mao's anointing that granted Hua the top official positions of power. As an individual, he was situated at a middle ground between the radical past and the revisionist future; he served as a compromise candidate between radicals and the reformers-to-be. His personal history and ideological positioning constrained his political options. Hua and his allies had benefited from the Cultural Revolution, and while they attempted to lay the blame of its excesses at the feet of the Gang of Four, they were reluctant to criticize their own actions or accept culpability in its wake. Aesthetically, Hua modeled himself on Mao, even crafting propaganda that emphasized their physical resemblance.[82] In policy terms, he emphasized development and growth rather than class struggle. This turn to development can be seen in the changing headlines of the Party's mouthpiece, *People's Daily*, as depicted in Figure 3.1.

In more abstract terms, China's late 1970s turn toward reform occurred because of personnel changes at the top of the dictatorship. Elite competition between potential successors with distinct power bases, ideological and policy visions, and histories shaped the strategies and tactics of individuals navigating

[82] Chinese Posters 2018; Jenne 2018.

these waters. General recognition of the economic plan's failure to develop the country pushed the regime toward change, as did the population's frustrations with the omnipresence of a radical political climate. Such failures were seen not just in the Chinese case but in the difference in economic performance between Eastern and Western Europe, suggesting that the failures were systemic and ideological rather than resulting from narrow issues of implementation.[83]

Limited Vision

A core claim of this book's analysis of the initial decisions and methods of China's reform is that the regime's political center intentionally limited its vision into localities. This limited vision arose for multiple reasons; two chief ones are presented here. First, it allowed for what Yuen Yuen Ang has termed "directed improvisation": the center would direct local officials, but they would also have room to maneuver in response to local conditions.[84] This directed improvisation was allowed to take place despite a clear understanding at the center that increasing local autonomy also increased the potential for corruption and other self-dealing that might be both economically and politically harmful for the center. Second, vision into localities was limited as a way to (1) decrease the need to specify policies that could be construed (often correctly) as capitalistic in their orientation, (2) allow such pro-development but capitalistic moves to be less precisely observed by those in the center who held ideological or policy objections to such moves, and (3) allow those local officials willing to take such steps to move forward without forcing those more recalcitrant into doing so before sufficient evidence of their success was apparent from the practice of other localities.[85]

There are two potential objections to this claim. The first accepts its truth but argues that it is already well-documented by prior research, while the second rejects it altogether. While the literature strongly demonstrates local entrepreneurship, my account departs from each of these in more or less significant ways.[86] First, my focus is more in understanding the decisions of central leaders constructing the system than the experience of those officials at lower levels

[83] See Gewirtz 2017 for an examination of how foreign perspectives, especially those of economists, affected reform trajectories.

[84] See Ang 2016, especially Figure 2.1 on p. 67. As seen in the text, I differ somewhat from Ang on the interpretation of *why* the center engaged in this directed improvisation. Arguably, the "guerrilla-style" policymaking argument prefigures directed improvisation (Heilmann and Perry 2011).

[85] Close to Teiwes's claim.

[86] Especially Lieberthal and Oksenberg 1988; Oi 1999; Ang 2016; Huang 1996; Chung 2016.

enmeshed in it. Second, my perspective synthesizes political and ideological accounts of the early Reform Era into this economics-focused scholarship on local bureaucracies to improve analysis of the period's political and economic foundations.

On the other hand, Vivienne Shue, among others, would likely reject the claim that the center intentionally limited its vision into localities.[87] These objections would argue either that the center's vision was not limited or, if it were, that these limits were not the result of conscious decisions but rather a Maoist legacy, particularly a result of the Cultural Revolution's tumult.[88] It is true both that the center's *authority* was not limited and that it received an immense amount of information about the situations in localities. However, the ability to truly see what was occurring in China's more than thirty thousand townships, twenty-five hundred counties, and two hundred cities quickly enough to comprehend and respond was beyond the capacity of the center at the time. Even if individuals at the center did see decisions that they objected to at an early stage, the center as a whole often allowed these to proceed in the short term as if they were neither seen nor important, until sufficient evidence had accrued to make a determination about the future course of policy.[89] Individual farmers and families acted on their own initiative in ways that went against the status quo.

Another distinct reading points to the provincial domination of the Central Committee in 1970 as presaging successful decentralization.[90] However, as seen in the complexities of timing and ideological debates over practice, the regime's identity, and rural reform, the political disputes of the time were more multidimensional and precise than the gloss of centralization versus decentralization presents.[91] The political efforts to remove radicals and rehabilitate victims while simultaneously attempting to reinvigorate the Party-state with new, more formally educated and technically inclined personnel were substantial. However, the conflicts that produced these efforts are precisely the work of those attempting to shift the regime's identity away from economic planning and ideological dogmatism toward marketization and pragmatism. Finally, while there is

[87] Shue 1988.

[88] Lieberthal and Oksenberg 1988 argue that fragmented authoritarianism occurred under Mao as well. Indeed, they might argue that all hierarchical organizations exhibit fragmented authority, which is at some level true. Liu, Shih, and Zhang 2018 argue that Central Committee composition dating from 1970 accounts for decentralization.

[89] Here I'm specifically referring to the emergence of household farming that became the Household Responsibility System, the explosion of Township and Village Enterprises, and Hu Yaobang downplaying the significance of economic crimes in Special Economic Zones as less significant than their growth.

[90] Liu, Shih, and Zhang 2018.

[91] Cf. Liu, Shih, and Zhang 2018.

some possibility that leaders were simply attempting to spin a difficult situation, the many discussions of central leaders lauding efforts to decentralize authority and give others freedom of action point toward intentionality.

Deng advocated decentralization from the earliest moments of his return to preeminence within the Party.[92] From November 10 to December 23, 1978— the five days of the Third Plenum of the 11th Central Committee and the thirty-six days of the Central Work Conference that preceded it—have been called the "41 days that changed the fate of China" and serve as the most common start date for the Reform Era.[93] At the closing session of the Work Conference on December 13, after calling for "emancipating the mind," Deng repeatedly emphasized, "Under our present system of economic management, power is over-concentrated, so it is necessary to devolve some of it to the lower levels without hesitation but in a planned way."[94] He continued, "The various localities, enterprises and production teams should be given greater powers of decision regarding both operation and management."[95]

Why did Deng support decentralization? He stated his reasoning plainly: "Otherwise it will be difficult to give full scope to the initiative of local as well as national authorities and to the enterprises and workers, and difficult to practice modern economic management and raise the productivity of labour."[96] Decentralization, Deng argued, was a way to emancipate minds and increase production. Once empowered, team members "will lie awake at night" until all resources are utilized and opportunities are exhausted.

Deng was not naïve. Simply granting local authorities more autonomy would not be enough to spark this new bounty. Decentralization must be paired with an effort to "manage the economy by economic means" rather than "empty political talk."[97] The economic means he had in mind were quantitative measurement with leadership quality judged by technical innovations, productivity, profits, workers' income, and collective benefits.[98] He scolded the individuals of the Party for their unwillingness to bear responsibility for their actions:

> Right now a big problem in enterprises and institutions across the country and in Party and government organs at various levels is that nobody takes responsibility. In theory, there is collective responsibility.

[92] On Maoist decentralization, see Chung 2016, 19.
[93] Yu Guangyuan et al. 1998. 《改变中国命运的41天》.
[94] Deng 1984, 156–7.
[95] Deng 1984, 156–7.
[96] Deng 1984, 156–7.
[97] Deng 1984, 161.
[98] Deng 1984, 162.

In fact, this means that no one is responsible. When a task is assigned, nobody sees that it is properly fulfilled or cares whether the result is satisfactory. So there is an urgent need to establish a strict responsibility system.[99]

To justify this attack on collective responsibility, which could be heard as anti-communist, he immediately turned to the ideological authority of Lenin, whom he quoted as saying that "to refer to collegiate methods as an excuse for irresponsibility is a most dangerous evil" which "must be halted at all costs."[100] Otherwise, Deng stressed, "our modernization programme and social cause will be doomed."[101]

In sum, at the moment of his ascension, Deng called for central authorities to measure the performance of individual local officials through a quantified responsibility system. Giving local officials responsibility without actually empowering them to make decisions would not achieve their objectives, he warned: "The responsibility system is bound to fail if there is only responsibility without authority."[102] To hold individuals responsible required a system of evaluation:

[W]e must have a strict system of evaluation and distinguish clearly between a performance that should be rewarded and one that should be penalized. . . . Rewards and penalties, promotions and demotions should be based on work performance. And they should be linked to increases or reductions in material benefits.[103]

Deng believed that such a system would likely spur individuals to action, not simply because they had emancipated their minds to see possibilities but because it included material benefits and because individuals would compete for these rewards and promotions.[104] Indeed, he anticipated that learning would take place, as areas that succeeded first showcased new methods of development, providing "an impressive example to their 'neighbors,' and people in other regions and units [who] will want to learn from them."[105] Deng viewed this inequality—allowing some "to earn more and enjoy more benefits sooner

[99] Deng 1984, 162.
[100] Deng 1984, 162.
[101] Deng 1984, 161.
[102] Deng 1984, 163.
[103] Deng 1984, 163.
[104] Deng 1984, 163.
[105] Deng 1984, 164.

than others, in accordance with their hard work and greater contributions to society"[106]—as a way to help "the whole national economy to advance" and "become prosperous in a comparatively short period of time."[107]

He acknowledged that contradictions and difficulties would arise yet called the Party to this new course of action. His defense of economic inequality as a method of development was immediately followed by recognition that some parts of the country had "difficulties in production," meaning that "the life of the people there is hard," and as such he called on the state to give "strong material support" to these places.[108] Making the bureaucracy more efficient entailed "deciding who will stay on and who will leave."[109] Reforms were needed because the energies of the party were misdirected, with its "main efforts on political campaigns" causing it to "not master the skills needed to build [the] country." He insisted that "the whole Party must start learning again," and while he rhetorically mentions Marxism-Leninism and Mao Zedong Thought, his emphasis is elsewhere: "[A]t present most of our cadres need to apply themselves to three subjects: economics, science and technology, and management."[110]

Deng called for new methods to achieve the regime's newly accepted purpose of modernization. Emancipating the mind entailed reduced consideration of the politics of different tactics—as capitalist or socialist—and increased consideration of their efficacy in producing some desired outcome, whether that be increased steel production or increased incomes for farmers' households. If, as Peter Dutton put it, Maoist politics was always quintessentially about "Who are our enemies, who are our friends?," then the Reform Era's politics replaced that question with: What produces good outcomes? [111] Yet while the shift in rhetoric came from the top of the regime, the content of that rhetoric required the center to cede autonomy to individuals for much of its implementation.

Integrating Practice

Mao's revolutionary campaigns used numbers in ways that almost literally decimated the population of China. The regime at Mao's death was riven with ideological divisions and animosities governing a desperately poor society

[106] Deng 1984, 163.

[107] Deng 1984, 164.

[108] Deng 1984, 164.

[109] Deng 1984, 164.

[110] Deng 1984, 165.

[111] Dutton 2005, 3, quoting Mao from 1926. On depoliticization, see Walder 1986, especially 229–35.

suffering from economic and political exhaustion. "Practice Is the Sole Criterion of Truth" and "Seeking truth from facts" are claims and slogans that prioritize quantifiable outcomes over philosophical pieties. But far from being minor rhetorical choices in a knife-fighting leadership succession confrontation, they provided the intellectual edifice for evaluating the regime's justification strategy, to both itself and the citizens it ruled over. The narrative demonstrates the intentional creation of the system of limited, quantified vision that this book uses as the lens to focus China's political economy over the ensuing four decades. Establishing the new system—growing pains, warts, and all—is the focus of the next chapter.

4

Aftershocks

> One thing a revolutionary party does need to worry about is its ability
> to hear the voice of the people. The thing to be feared most is silence.
> —Deng Xiaoping, December 13, 1978, reprinted in Deng 1984

In late 1978, the new captains of the Chinese state leaned heavily on the helm to change their vessel's trajectory. These choices came to shake and remake the world, the lives of China's citizens, and the Party-led regime that made them, and would continue to reverberate for years. This chapter is bookended by popular protests demanding to be heard about the steering of the state, its directions, and priorities. It begins with the Democracy Wall movement that filled the streets of Chinese cities as the key Party meetings of 1978 were taking place behind walls and curtains. It ends with the tearful, raucous, joyful, and ultimately tragic 1989 Tiananmen movement, its violent denouement, and the aftermath.

In between, the chapter examines intra-Party debates over policymaking and conflicts in implementation. The countryside was the site of many key initial economic reforms, the resistance to them, and the difficulty of designing metrics and incentive systems. Encouragement of entrepreneurialism at the local level waxed and waned with cyclical political concerns about the extent and consequences of reforms.[1] The regime's identity continued to be contested, with ongoing debates along the three dimensions of who, how, and why, and the dangers that arose around these debates. Specifically, revolutionaries were replaced by technocratic experts through forced retirements and exams in the early 1980s, yielding a distinct change in the kinds of individuals that served in the Party. The impact of these new perspectives can be seen, for example, in the domain of family planning, where simplistic quantification created a perception of demographic threat that motivated China's "one-child policy," its implementation forcibly

[1] Ang 2016 is the best recent account on the economic side, principally from a bottom-up perspective.

Seeking Truth and Hiding Facts. Jeremy L. Wallace, Oxford University Press. © Oxford University Press 2023.
DOI: 10.1093/oso/9780197627655.003.0004

remaking lives and plans of millions of families. Theoretical debates about political reforms, including decentralization and neo-authoritarianism, raged, culminating in the ousting of multiple general secretaries amid mass protests, including the 1989 protests and subsequent Tiananmen Massacre.

The quantified governance lens-based interpretation presented here complements rather than replaces alternative perspectives of the first decades of China's Reform Era.[2] Richard Baum zooms in on elite and ideological domains highlighting the regime's uncertainty about holding and wielding power in the moment. While success can now seem inevitable from the vantage point of history, Chinese leaders in the 1980s experienced simmering conflicts that boiled over into dismissals and protests, and they feared for the very survival of the regime as they saw similar forces claim many of China's Communist compatriots elsewhere.[3] With a similar lens, Joseph Fewsmith looks at the regime in the wake of the Tiananmen crisis. Susan Shirk's work illuminates internal divides and preferences within a complicated bureaucratic system, with its analysis of the selectorate serving as the theoretical basis for a significant chunk of the subsequent authoritarianism literature.[4] Jean Oi and Yuen Yuen Ang emphasize the institutional foundations of economic reform and the ways in which states and markets coevolved.[5] Focusing on investment and the possibilities of runaway inflation, Yasheng Huang and Victor Shih present contrasting visions of the ways in which the center loosened and tightened the reins of local officials to promote growth without losing control, the former more institutionally focused and the latter stressing factional conflicts. The chapter integrates these analyses with the book's theoretical framework to show how the limited, quantified vision of the Chinese Reform Era came into its own.

Democracy Wall

As described in Chapter 3, the Chinese regime turned over during the final months of 1978. Ideology had not vanished, but its content had changed. Rather than following Mao's thought and actions whatever the consequences, the Party became fixated on the outputs of particular political practices and the extent to which those outputs contributed toward China's modernization of agriculture,

[2] For example, Naughton 1995; Baum 1994; Shirk 1993; Oi 1999; Fewsmith 2001; Ang 2016; Shih 2009.

[3] Weber 2021 details the economic debates about how China avoided shock therapy of wholesale price liberalization.

[4] Baum 1994 considers the Politburo to be more relevant.

[5] Xu (2011) presents a version of the institutional argument as well.

industry, national defense, and science and technology: the four modernizations, the Party's new purpose. Now clearly at the helm, Deng Xiaoping had declared that all Chinese—inside the Party and out—must emancipate their minds. He argued that "democracy is a major condition for emancipating the mind," yet within months he would put an end to a popular movement that demanded it.[6] Democracy Wall may have been unlikely to bring an end to the regime, but it crystallizes the threats that can arise during focal points of reform. When a re-gime admits mistakes and calls for change, those calls can explode and rever-berate back, endangering the regime.

Near the beginning of the CPWC, on November 13, *People's Daily* devoted its entire third page to an article with the headline "Greatly Develop Democracy and Strengthen Law."[7] The piece profoundly criticized the current political order, blaming the Cultural Revolution not simply on feudal legacies and bad elite actors but on "the absence of reliable organizations and systems to safe-guard socialist democracy."[8] It righteously declared that "it is now imperative to implement firmly measures to call for the electing of the people's representatives through secret ballot" as "the Chinese people have lived too long under an auto-cratic system."[9] These demands quickly became part of mass action.

Students on campuses and people on the streets of Beijing felt emboldened to participate in politics and make their views known. Large signs and posters covered walls throughout the city. These citizen voices were lent symbolic sup-port by Deng and Hu Yaobang, effective head of the Central Party School, vis-iting Beijing and Tsinghua universities on November 16, 1978, and calling for all Party members to support such postings.[10] The posters at the main protest site in Beijing's Xidan district became more and more strident. On November 19, a poster exclaimed, "In 1976 after the Tiananmen incident, the Gang of Four made use of the prestige and power of *Chairman Mao Zedong's mistaken judg-ment on class struggle* and launched an all-out attack on the cause of revolution in China."[11] The author of the poster, self-identified as a mechanic with Worker Permit 0538, went on to say that "the broad masses of people experienced a great contradiction between the current political theory and harsh reality."[12] Ordinary

[6] To be clear, the democracy referenced by Deng and many of the movement's activists was likely limited, not a demand of free and fair elections but instead a call for a more open political system, freedom of speech, and freedom to labor as they wished.

[7] Lin and Li 1978, author's translation.

[8] Goldman 1991, 224, Goldman's translation.

[9] Goldman 1991, 224, Section 4 of the original.

[10] Goldman 1991, 226. This visit occurs during the Central Work Conference preceding the Third Plenum, so perhaps the depiction of dissent was part of a tactic in a complicated elite struggle between Deng and Hua Guofeng.

[11] Garside 1981, 212, emphasis in original.

[12] Garside 1981, 213.

individuals were coming to believe that they wielded power, such as claiming credit for reversing the verdicts on the Tiananmen Incident in mid-November. "Under great pressure from the people, the Tiananmen Incident has been cleared up," claimed a pseudonymous poster.[13] Another declared, "Democracy Must Judge Despotism" and that those who "crushed" the 1976 demonstrations should be "handed over to the judgment of a people's court."[14]

The fever went far beyond the confines of a two-hundred-foot-long wall in west-central Beijing. The distant cities of Guiyang, Guangzhou, and Changchun all saw posters in November.[15] Manifestos and opinions began circulating in unofficial journals, including Guiyang's *Enlightenment* (*Qimeng*) and Shanghai's *Voice of Democracy* (*Minzhu Zhi Sheng*). These publications proliferated; one compilation counted 140 journals from twenty-five cities and an additional forty-five journals based on college campuses around the country.[16] The movement quickly added other restive populations to their number. More than two dozen farmers from Yunnan marched in Beijing, claiming to represent fifty thousand similarly destitute from the intolerable situation on communal farms.[17] On December 10, Shanghai's waterfront hosted a gathering of ten thousand people demanding "more democratic government and the full panoply of human rights, including the right to choose work assignments."[18] Extreme tactics emerged. Shaanxi saw a hunger strike of thirty-one youths. One hundred protestors, holding banners with such slogans as "Down with oppression" and "We want democracy and human rights," even tried to enter the Zhongnanhai leadership compound.[19]

The movement grew as official media continued to express support. On November 26, Xinhua reported Deng saying, "[This] is a normal phenomenon . . . permitted by our constitution."[20] The next day, thousands marched in the streets of Beijing from the wall in Xidan to Tiananmen. In late December, the *People's Daily* reported the existence of elite debate, stating that some officials dismissed the posters as inappropriate and detrimental to stability before saying that such thinking was "entirely wrong."[21] On January 3, 1979, *People's Daily* blared, "Let the people say what they wish."[22] On January 5, Deng told the foreign

[13] Garside 1981, 214.
[14] Garside 1981, 216.
[15] Chen 1982, 11.
[16] Chen 1982, appendix.
[17] Butterfield 1979b; Chen 1982.
[18] Garside 1981, 249.
[19] Agence France-Presse 1979.
[20] Garside 1981, 241–2.
[21] Garside 1981, 247.
[22] *New York Times* 1979a; Garside 1981, 247, Garside's translation.

press there was no problem with the posters, which could last for generations.[23] On January 8, the largest protest in Beijing occurred. Organized by a 32-year old female construction worker named Fu Yuehua, several thousand farmers from every corner of China, including Tibet, marched for hours in Tiananmen Square and along Chang'an Avenue.[24] Fu's protest filled the symbolic home of the regime with visual proof of the dismal economic realities its farmers faced, the disheveled masses huddling homeless in the city's streets and train stations.

By the end of January, about thirty thousand farmers had made the trek to Beijing, but by then Fu was not there to organize them; she had been arrested on January 18. Her arrest shocked the movement. One unofficial journal, *Exploration (Tansuo)*, edited by Wei Jingsheng, who was working as an electrician at the Beijing Zoo, lambasted the officials who had arrested her and exposed the brutality of Chinese prisons.[25]

The complex simultaneity of Chinese politics at this time reared its head. On the same day as Fu's arrest, a new Principles conference began in Beijing. Additionally, Deng visited to the United States and Japan from January 27 to February 5 and launched a costly attack on Vietnam on February 17. While Fu's arrest showed that some local officials were already becoming wary of the extent of the growing protests, critiques of Maoism, and their democratic messages, the Principles conference began with theoretical discussions of similar topics.

Following the CPWC and the Third Plenum, there was agreement that the Party should meet to formulate the justification for its new direction. Many intellectuals associated with Hu Yaobang's network and the Practice debate—most notably economist Yu Guangyuan—presented thoughts on how to remake the ideology of the Party and "lay the theoretical foundation for the forthcoming economic and political reforms."[26] The first part of the conference, from January 18 to February 15, was very open about the possibilities of political reforms to accompany the changing economic systems that had been and were being unleashed around China. Even Deng himself on January 20 "called for discussion of democratic and legal institutions."[27] Other intellectuals went much further with withering criticism for the Mao era. On February 13, journalist Wang

[23] Chen 1982.

[24] Chen 1982, 16; *New York Times* 1979b.

[25] Chen 1982, 17; Goldman 1991, 227–8. Thanks to Martin Dimitrov for clarifying that despite his blue collar employment at the time, Wei Jingsheng was from a prominent Beijing family.

[26] Goldman 1994, 230–1.

[27] Goldman 1991, 235. On January 27 Deng apparently further specified his thoughts on these matters, but that's also the day that he took off for a U.S. and Japan trip. Vogel 2011 notes that Deng was likely aware that a crackdown of the activists before the U.S. trip would imperil it. Deng's January speeches are omitted from his *Selected Works*.

Ruoshui called the Cultural Revolution "a gigantic catastrophe for our Party and the people."[28]

Outside the conference, the escalation went much further. On February 5, thousands of youths sent to the countryside at the height of the Cultural Revolution besieged the Shanghai Party Committee headquarters and disrupted trains coming into and departing the city.[29] Others crossed a line in criticizing the decision to launch an attack on Vietnam.[30]

A backlash ensued. While Deng was distracted with foreign relations, Chen Yun and other senior leaders such as Li Xiannian grew concerned about the level of criticism that the Party's prior policies and the Party itself were generating, both on the streets and in the conference halls of power.[31] Led by Hu Qiaomu, the conference's tone and content turned on a dime, attacking the Hu Yaobang network that had dominated its first half.[32] By February 28, Hu Yaobang, whose network had also presented the most radical critiques during the Principles conference, was backtracking and defending Mao, telling a journalists' conference, "[W]e must objectively acknowledge the great contributions of Chairman Mao."[33] The turn at the conference reverberated beyond its walls. Party newspapers attacked the movement's activists, labeling them "anarchists" who were harming both the economy and social stability.[34] On March 6, Shanghai's government issued a circular halting public demonstrations that "disturbed public order."[35]

Deng's attention returned to domestic affairs by March 16, and he addressed a group of Party leaders, making clear his position that there were limits to acceptable criticism of the Party and the regime. He had come to this view by reading reports of the Principles conference crafted by Deng Liqun and Hu Qiaomu, whom liberals believed exaggerated the criticism expressed at the conference and on Democracy Wall to provoke Deng's attack.[36] Nonetheless, even

[28] Goldman 1991, 233.

[29] Brødsgaard 1981, 764.

[30] Which Deng used to justify his attack on the Democracy Wall posters and journals (Chen 1982, 18).

[31] Vogel 2011, 260.

[32] Vogel 2011; Goldman 1991.

[33] Vogel 2011, 260-1. See Goldman 1991 on Hu's network on the critiques. Individuals highlighted by Goldman include Yu Guangyuan calling to study Yugoslavia's marketized economy (232); Zhang Xianyang's three-thousand-character critique of Mao (232).

[34] Goldman 1991, 228.

[35] Brødsgaard 1981, 770.

[36] Vogel 2011, 261. Ming 1994, 56. A great example—if true—of distraction and complexity increasing the space for handlers to shape the information consumption and decision-making of leaders.

if the internal assessments at the conference shifted away from stridency, the Democracy Wall movement continued to build momentum.

Wei Jingsheng demanded democracy, which he saw as a necessary step to achieve the modernizations that the Party claimed as its justifying purpose. On March 25, his rallying cry "The Fifth Modernization—Democracy" exploded on the political scene. A passionate condemnation of the regime's failings in its own grammar, Wei's poster expressed the "need to refute the Maoist-type of dictatorship" and claimed that Marxist systems "without exception neither acknowledge nor protect the equal human rights of the individual members of society."[37] He lambasted Deng by name: "The people must be aware of Deng Xiaoping's metamorphosis to a dictator. . . . [H]e is no longer worthy of the people's trust and support."[38] These words likely sealed the fate of the movement and its authors. Four days later, Wei was arrested by the Public Security Bureau.

In the wake of the Democracy Wall movement and the Party's internal theoretical debates, Deng and his compatriots felt a need to draw lines that could not be crossed. On March 30, Deng issued the Four Cardinal Principles, setting the limits of the acceptable in post-Mao China: uphold the Party, Marxism-Leninism and Mao Zedong Thought, Socialism, and People's Dictatorship.[39] With this, Deng established a framework that continues to this day. The Party's purpose may be to modernize China, but behind that is a starker reality: the Party believes that it must be in power and ignores or rejects the possibility that its continued reign and modernization could come into conflict. The Party asserts that China's modernization requires the leadership of the CCP.

The end of Democracy Wall represented an initial effort at delineating acceptable from unacceptable speech in this new era of reform. Some of the movement's most successful slogans—"Democracy is the 5th Modernization" and "Without democracy the four modernizations would not be achievable"— came from the zoo electrician Wei Jingsheng, showing that those outside the selectorate do have political power inside nondemocracies.[40] But the Four Cardinal Principles show that Deng held a deep belief beyond China's pursuit of wealth and power: that the CCP would rule China. He was confident that better incentives would produce measurably better outcomes, that good policy would prove good politics. His new efforts to sustain that rule would start where the solid majority of China's people lived and worked and where the deepest suffering from Maoist excesses had taken place: the countryside.

[37] Brødsgaard 1981, 769, Brødsgaard's translation.
[38] Brødsgaard 1981, 770–1.
[39] Goldman 1991, 232.
[40] Goldman 1991, 227. Cf. selectorate theory, Bueno de Mesquita et al. 2003.

Rural Reforms

> The [PRC] has been in existence for nearly 30 years, but we still have
> [peasant] beggars.... If this problem remains unsolved, the peasants
> are likely to rise in rebellion, [with local Party leaders] leading them
> into towns to beg for food.
> —Chen Yun, December 10, 1978 at the Central Party Work Conference

Although Ji Dengkui was condemned personally during the CPWC, the sub-
stance of the agricultural policy documents he presented had support. The
documents admitted that the Chinese agricultural system was failing, yet, like
Deng and others in different domains, Ji walked a line between trying to main-
tain some continuity with the status quo and calling for change.

What was failing? Mao's strong belief in the benefits of commune-based ag-
riculture, exemplified by the Dazhai model, had not produced more food for
the country's people. While total production of some crops, such as cereals, had
been on a fluctuating but generally upward trajectory since 1970, in 1978 the
figures did not look good for commune supporters for two reasons.[41] First, total
grain production stagnated over the precise period (1975–7) when Hua was
pushing the Dazhai model and agricultural policy toward radical collectiviza-
tion. Total grain production was 284.50 million metric tons in 1975, rose slightly
to 286.30 in 1976, and then dropped to 282.75 in 1977. Second, and more seri-
ously, while total production numbers were trending upward, per capita figures
were not. China struggled to feed a rapidly growing population throughout the
1960s and 1970s.[42] Per capita grain production in 1977 was 2.5 kilograms less
than it had been in 1957, and grain rations had actually declined in size from
1956 to 1976 to bare subsistence levels.[43] In total, the agriculture and forestry
ministries estimated that 100 million people were left without enough to eat.[44]
Farmers protested en masse during Democracy Wall, substantiating Chen Yun's
worries.[45]

As happened with the "practice is the sole criterion of truth" debate, separate
perspectives on agricultural policy clashed in the pages of the country's propa-
ganda outlets, including *People's Daily*, in 1978.[46] The Dazhai model's advocates

[41] Eisenman 2018.

[42] Cf. Eisenman 2018, who focuses on total production, which did increase, rather than per capita
levels, which seemed more relevant to the leaders and farmers of China.

[43] Teiwes and Sun 2016, 54: 5 *jin* at 500g in China.

[44] Teiwes and Sun 2016, 54.

[45] Chen 1994, 237.

[46] Yang 1996, 128. *Renmin Ribao* 1978b; Dazhai Joint Reporting Group 1978; Wang and
Chen 1978.

were dealt a major blow when Anxiang County (Hunan), a Dazhai-style exemplar, was outed as having falsified its output figures in the pages of *People's Daily*.[47] By July 1978, the agricultural policy team under Hua had shifted to favor less radical policies.[48]

Ji Dengkui's policy recommendations included increased investment in agriculture, improvements to seed and fertilizer supplies, and a massive extension of credit available to farmers. Additionally, and perhaps most significant, the state purchasing price for grain would be increased by 30%.[49] These moves would represent a sea-change in agricultural policy. Instead of attempting to extract as much as possible from farmers, thereby diminishing their incentives for effort, the state would "give farmers a chance to catch their breath."[50] These policy initiatives entailed real trade-offs, such as reduced investment in other sectors, doubling grain imports, and cutting back on the importation of foreign technology.[51] Yet such tactical trade-offs were required. Chinese collectivized agriculture was not doing enough to feed the people and fuel industrial development, so to cement the former the latter would be paused.

These major policy shifts tend to be overlooked, with most discussions of rural reforms being boiled down to decollectivization, the ending of compulsory collectives and a return to households controlling their own harvests. Decollectivization was not included in the documents presented to the CPWC. Yet within just a few years, "work points, grain rationing, and state-set limits on consumption," as well as communal agriculture itself, would be "relics of the past."[52] The process by which decollectivization came about is convoluted and still debated to the present day.[53] In some accounts, peasant farmers are treated as the principal actors, while others suggest that leaders within the regime drove the changes. The goal of this section is not to settle these debates, but to (1) demonstrate that mass politics affects elite politics through bottom-up pressures for decollectivization, (2) show how reform's complex nature defies the simplicity of most models of authoritarian politics, and (3) illustrate in particular how ideology and information play a role in its implementation and resistance.

[47] Yang 1996, 129; Shi and Liu 1978.

[48] Teiwes and Sun 2016.

[49] This list come from Vogel 2011, 233, citing Yu 2004, 39–42.

[50] Naughton 2007, 89.

[51] Naughton 2007, 89.

[52] Oi 1989b, 155.

[53] Teiwes and Sun 2016; their entire book-length project on post-Mao rural reform from 1976 to 1981 attempts to correct what they see as misperceptions in the literature. Eisenman 2018 offers yet another perspective.

Rural land was owned by the collective, and farmers worked as part of production teams.[54] The state emphasized grain over cash crops or sidelines. Farmers did not own the grain that they produced as part of the production team; the collective and the state did. Instead, farmers were compensated with work points for their collective labor, which paid for grain rations.[55] Potential changes to this system required answering fraught questions: Should farmers labor and be compensated as members of a collective or as individual households? Should income be connected to labor contribution or output? Who should hold farmers responsible for agricultural work, and how would they do so?

David Zweig details six "popular responsibility systems" operating in various regions of China in the late 1970s and early 1980s.[56] The most anticapitalist was *Dazhai work points* (*Dazhai gong fen*), whereby labor contributions and political attitude were collectively evaluated during Maoist indoctrination sessions. Two task-based mechanisms, *short-term task rates* (*xiao duan bao gong*) and *specialized fixed tasks* (*zhuanye chengbao*), involved compensation based on job completion with a chance for bonuses. In the fourth responsibility system, *linking output to the group or to the individual* (*lian chan dao zu, dao lao*), "the team divided its fields into strips, and individuals or groups contracted to meet fixed production quotas," with compensation coming in work points and bonuses (or fines for underproduction). The final two systems are those that came to be associated with the term "household responsibility system." Under *household production quota* (*baochan daohu*) and *household contracts with fixed levies* (*baogan daohu* or *da baogan*), households contracted to meet a particular quota on land that had been divided up by the production team.[57] Under some versions of *baochan daohu*, households agreed to fixed levels of investment, work points, and output in addition to a bonus for additional production (thus "three fixes and one bonus," *san bao yi jiang*). Under *baogan daohu*, households fulfilled the obligations that had been the work of the production team, such as paying the agricultural tax, compulsory sales to the state, contribution to villagers in need, and on occasion funding the development of collective enterprises. "Otherwise," Zweig explains, "all produce was theirs to sell or consume, and the household became the primary unit of account and accumulation. The only socialist aspect of this system was that land remained collective property."[58] Farmers had use rights for a given allocation of land, but not the right to sell that allocated land.[59]

[54] From Oi 1989b, 31. As seen below, different localities had different specific practices that complicate the narrative even further.

[55] Oi 1989b, 31.

[56] Zweig 1997, 55–6.

[57] The translation of the terms is from Chung 2016, 103. The explanation is from Zweig 1997, 57.

[58] Zweig 1997, 56.

[59] Use rights, not dislocation rights. Oi 1989b, 1999.

Decollectivization, or the household responsibility reform, can be helpfully considered as occurring in three stages.[60] Before 1980, the Party center "strongly opposed" and provincial authorities "forbade" household contracting, except for "special cases." Over the next year, Beijing became more permissive, explicitly allowing household responsibility in "designated 'poor and backward regions' and 'production units dependent on state subsidies'" with Central Document 75, issued on September 25, 1980.[61] On August 4, 1981, *People's Daily* ran an article describing household farming as a method to relieve rural poverty and increase productivity in agriculture, "without tainting the collective nature of the socialist economy."[62] The third stage began when Beijing "formally endorsed both *baochan daohu* and *baogan daohu* as systems of the socialist economy" in Central Document 1, released on January 1, 1982, and culminating with national adoption by the end of 1983.[63]

Proposing decollectivization was ideologically dicey, and putting it into practice raised the stakes further. Fears of polarization and of undermining the state plan or the successes of more developed areas were combined with frustrations from the military and local officials, who lost significant control over the villages and villagers they governed. Many peasants, rural officials, and intellectuals saw household farming as a return to a past that they wished to leave behind; after all, a polarized rural situation with landlords dominating communities had been the tinder that lit the fire of the Communist Revolution in China. Some saw household farming as a step back, away from "Chairman Mao's road."[64] Leaders like Chen Yun also expressed concerns about the extent to which household farming might undermine the state's economic plan.[65] Chen seized on news that farmers did not reach their grain quota in 1981 and "reasserted the importance of following the plan." With households' incomes dependent on what they could harvest, families with children who had left the farm were at a disadvantage. Of particular note and political significance is the case of soldiers, since "having a son in the army places a peasant family at a distinct economic disadvantage vis-a-vis its neighbors."[66] The People's Liberation Army had to deal with desertions and morale difficulties.

Provinces that had thrived under the prior system, such as Jiangsu, evinced concerns about changes to the status quo undermining their success.[67] But the

[60] See Chung 2016, 103–4 for this breakdown.
[61] Chung 2016, 104. Permissive (*yunxu*).
[62] Zhang 1981; Chung 2016, 104.
[63] Chung 2016, 104.
[64] Zweig 1983.
[65] Zweig 1983, 889. At a 1982 Chinese New Year's Party.
[66] Zweig 1983, 889.
[67] Zweig 1983, 889.

most notorious resister of the household responsibility system at the provin-
cial level was the Manchurian locale of Heilongjiang.[68] In August 1982, Hu
Yaobang visited the province and delivered a speech criticizing Heilongjiang
for slow compliance with the new regulations.[69] Even as late as November and
December 1982, when most provinces had surpassed 90% implementation,
Heilongjiang remained at 12% adoption of household responsibility. Provincial
Party Secretary Yang Yichen remained defiant, even stating in a speech, "In
determining which responsibility system to implement, we have to value the
opinions of the masses that will eventually choose a system on the basis of their
local conditions."[70] Beijing then transferred him to the capital as the "supreme
people's procurator-general" and replaced him with someone more amenable to
decollectivization, Li Li'an.[71]

The reforms aimed to invigorate the Chinese countryside, and economic ac-
tivity blossomed and diversified. For local officials, decollectivization cut off sig-
nificant revenue streams and circumscribed their authority, but many seized the
new opportunity and fostered an explosion of rural industry.[72] To assess these
local initiatives, the regime constructed a system of monitoring that focused
on certain quantifiable indicators, with the cadre evaluation system, which
will be discussed in Chapter 5, at its core. Allowing profit-making and accumu-
lation generated a wide spectrum of governance issues, and while the regime
maintained other information channels, they remained limited, allowing local
initiatives to thrive.

Information Channels

Dictators desire data. Yet CCP leaders, like other dictators, had to balance
expending scarce resources to watch for dangers with other priorities. While

[68] For more on Heilongjiang's resistance, and to a lesser extent that of Jilin and Liaoning, see
Chung 2016, 103–7 and Table 6.5.

[69] Chung 2016, 106.

[70] Chung 2016, 107, emphasis in original.

[71] Chung 2016, 107.

[72] Nee 1989. Nee argued that the power of local officials would ebb as market incentives shifted
power to producers but was sanguine on officials' acquiescence to this eventuality. A serious debate
has emerged on the nature of the Township and Village Enterprises (TVEs) that were critical to
rural industrial growth in China during the 1980s. Oi 1999 and Naughton 2007 present the standard
view—particularly Oi's "local state corporatism"—contrasting with Huang's 2008 view of TVEs as
overwhelmingly private rather than owned and operated by local states. While Huang is correct in
noting that private TVEs account for most of the increase in their number, the change in TVE em-
ployment comes from both private and local state-owned firms.

some citizens and officials called for elections up to the county level at the height of openness during the Democracy Wall movement, that technology of information gathering and processing was not used until the introduction of village elections later in the 1980s.[73] Even without elections, numerous channels that enabled the center to learn about lower levels of government and society existed, were created, re-created, or repurposed in the late 1970s and early 1980s. These included the complaints system (*xinfang*), the state security apparatus (police, spies, military), investigations, media (public and *neibu* [internal]), informal networks, surveys, People's Congresses, ministries, and work units as well as auditing, inspection, and statistical bureaus.[74]

The Chinese regime had an unusual complaint system that allowed individual citizens to register formal complaints to different government bureaus, as well as to a separate complaints bureau.[75] Complaints were to be delivered to the bureaus that were their cause or at the same level, but individuals who failed to have their issues resolved at that level would skip up a level to deliver complaints to higher bodies, including to the central government in Beijing. Cadre evaluation scores incorporated such petitions.[76] The Chinese dictatorship considered public satisfaction in making decisions and believed that the system of complaints was a significant channel to address some of them.[77]

The state security apparatus was in a precarious position as leadership of the regime transitioned from Hua to Deng. Several of its chief leaders had been attacked during the CPWC and Third Plenum for their earlier actions, sowing distrust with the new leadership and leaving the organizations weak.[78] This weakness was poorly timed: police faced a rising wave of crime as the country turned its attention to economic matters.[79] In 1976, nearly 489,000 criminal cases were opened, but in 1981 that number stood at over 890,000, a jump in the crime rate per 100,000 people from 52 to 89.[80]

[73] Goldman 1991, 241. The whole front page of the July 5, 1979, *People's Daily* featured discussions of elections and democracy, focusing on People's Congresses. China's levels of government are the country, the province, the prefecture, the county, and the township. Rural townships are broken down further, into villages that serve as a level of administration.

[74] See, e.g., Dimitrov 2019.

[75] See Cai 2004; Minzner 2006; Dimitrov 2015 on petitions (*xinfang*).

[76] See the discussion in Chapter 5 on cadre evaluation.

[77] Fang 2013, 119.

[78] Guo 2012, 362. "Deng did not trust the [Central Investigation Department] to be his vanguards against Hua Guofeng, and he deemed the CID a 'severe disaster area'; many CID officials were accused of being Kang Sheng's followers and were either dismissed or exiled to small cities. When Deng finally took over party leadership in the late 1970s, he conducted a large-scale screening of all personnel and officials."

[79] Dutton 2005, 256.

[80] Dutton 2005, 257.

Beyond citizens and security officials, the Party-state also had its own institutions to watch local behavior. The Party reconstituted the Central Commission on Discipline Inspection (CCDI) in 1979 as an investigatory and monitoring agency looking at the political performance of cadres.[81] Multiple economic agencies were also tasked with overseeing the activities of the Party-state's local agents: the State Planning Commission, the State Statistical Bureau, and the General Accounting Administration.[82] At the founding of the General Accounting Administration in 1983, Tian Jiyun, then vice premier, explicitly acknowledged that the increased economic freedom of localities would generate divergences between national and local interests.[83]

These monitoring institutions failed to serve as strong checks on local malfeasance because of their bureaucratic weakness and lack of capacity. One crucial factor was their subordinate relationship to local Party committees. That is, these agencies were tasked with monitoring and reporting to higher authorities the actions of their immediate political superiors, who often controlled their budgets and personnel appointments. Second, they were given staffs inadequate to the work of observing local actions closely. In 1988, Qiao Shi, a Politburo Standing Committee member and leader of the CCDI at the time, told auditors that since they were responsible for overseeing 800,000 organizations, even a staff of 500,000 would be inadequate, yet rather than suggesting funding a staff up to the task, he emphasized the importance of aiding "internal auditing bureaus" inside those organizations.[84] State leaders acknowledged this problem yet fashioned these institutions in this short-handed manner, indicating a deliberate decision to create a monitoring apparatus with limited vision.

The 1983 Statistics Law criminalized data falsification, an acknowledgment that the center understood the trade-offs involved in the design and spending levels of its monitoring. To attempt to avoid such manipulations, in 1984 the National Bureau of Statistics (NBS) created an urban and rural survey team that would report directly to the central NBS, bypassing local officials. However, those teams were also devolved to local control just two years later, constraining their ability to capture and report numbers without local intermediation.[85] Observing localities while giving them freedom of action remained a difficult needle to thread. A separate tactic to improve local performance was

[81] Guo 2014; Huang 1996. The state-side equivalent institution of the CCDI is the Ministry of Supervision (监察部) that was formed in 1987 (Huang 1996).

[82] Huang 1996. These organizations are now the National Development and Reform Commission (中央法改委), the National Bureau of Statistics, and the National Audit Office.

[83] Tian 1983; Cui and Shao 1990.

[84] Qiao 1988; Cui and Shao 1990.

[85] NBS 2010a; Gao 2016.

to change officialdom itself, replacing the old guard with a new generation of Communists.

Revolutionaries to Experts

Expertise does not equal Redness, but Reds must be experts.
—Deng Xiaoping, January 16, 1980

The convoluted maneuverings of Cultural Revolution radicals, beneficiaries, and victims at the top of the regime were matched in their complexity by the ways that personnel issues cascaded throughout the entire system. The Chinese regime felt a need to address two kinds of difficult questions about who rules simultaneously in the early 1980s: staffing the regime after a political purge, and shifting personnel from the revolutionary generation that had seized power thirty years before to a new, younger cohort. These moves were further complicated by the regime's shift in purpose away from revolution toward economic develop- ment.[86] The regime steered around these obstacles; in half a decade, 2.5 million government officials and workers from the revolutionary generation would re- tire, replaced by a new class of cadres with greater levels of formal education and an acceptance of the regime's quantified pro-development orientation.

One could imagine that an expedient solution to these dual problems would be to limit removals and hire new talent as needed to fill the positions. Indeed, Hua Guofeng "originally envisioned very limited personnel changes both in the purge of the Gang of Four's followers and in the rehabilitation of the victims of past political purges."[87] The initiation of the long process of ending lifelong tenure for officials also began in mid-1978 amid the elite debates.[88] Some officials who had been labeled counterrevolutionaries for attacking the Gang of Four while they remained in power called for their verdicts to be reversed by August 1978, as the Gang had been arrested nearly two years earlier, yet the regime at that time balked: "The Gang of Four were members of the Politburo, and your opposition to them was a direct attack on Chairman Mao. . . . Your revolt against the Gang of Four was a little too early, and it undermined the strategic plan of Chairman Mao."[89] With politics, as with humor, timing is everything.

However, once Deng had ascended to leadership, the regime restored veteran cadres to positions of power while at the same time implementing a retirement

[86] Manion 1993, 11.
[87] Lee 1991, 228.
[88] Manion 1993, 3.
[89] Lee 1991, 173.

system for those very same veterans. These seemingly contradictory policies coexisted because "veteran cadres with pre–Cultural Revolution political loyalties were needed to help implement a massive elite transformation," as they were to "discover and cultivate a new generation of successors."[90]

After the Third Plenum's call for reversing elite verdicts, the Central Organization Department instructed that others should value the "historical contribution made by old cadres," and as long as they could do "regular work," those old cadres should be "quickly reassigned."[91] The rehabilitation was massive. In Yunnan province alone, about 100,000 individuals had their political records cleared.[92] Rehabilitation extended beyond the scope of the Cultural Revolution as well, with some reinstated who had been purged during the Socialist Education Movement (1963–5) or even earlier.[93] Hu Yaobang believed that, absent a thorough rehabilitation, both the Party and the people "will not be at ease."[94]

Cadres purged during the Cultural Revolution were brought back, but the circumstances and the regime to which they returned differed from the one they had left a decade before. Not only had the cohort of revolutionary veterans continued to age, but the revolutionary regime to which they had demonstrated decades of loyalty was shifting beneath their feet. As Melanie Manion explains, "A poorly educated and increasingly feeble corps of leaders with skills best-suited for making revolution jarred with the post-Mao regime's commitment to economic modernization."[95] Assessing the loyalty of leaders in the aftermath of the purge and chaos of the Cultural Revolution to staff the regime would be a difficult enough task, but it was made even more complicated by the additional needs of shifting generations and shifting purposes. Once the modernizers secured their dominant position through mass rehabilitation, they more earnestly began moving toward instituting a norm of retirement, which entailed pushing out the very individuals who had just returned to office.

Creating a norm of retirement was a delicate process taking place over nearly a decade.[96] The first inklings of age-based retirement policy and the end of lifetime tenure emerged from Deng's and others' critiques of the follies of Mao's final years. Only one article on the subject appeared in *People's Daily* in 1978, whereas it soon became such a common refrain that it appeared as a topic listing

[90] Manion 1993, 46.
[91] Lee 1991, 171.
[92] Lee 1991, 178.
[93] Lee 1991, 176.
[94] Lee 1991, 170.
[95] Manion 1993, 11.
[96] Manion 1993. Xi Jinping's removal of term limits makes this a live issue once again. See Chapter 7.

in the paper's 1982 index.[97] A set of inducements was engineered to make retirement more attractive. Moving out of office to advisory and other honorary positions as a "semi-retirement" or "retirement to the 'second line' " emerged in 1978.[98] These positions gave potential retirees at least a modicum of power and status. Financial rewards were also used to entice veterans to move on. The language of retirement transitioned from inability to work to a simple age-based standard of when retirement was expected—at age fifty-five for women and sixty for men—with some positions allowing postponement of retirement to sixty or sixty-five.[99]

Hypocrisy at the top—the nonretirement of elderly elite leaders attempting to push their contemporaries out of office—further complicated these efforts. Citing the need for "continuity and stability," a March 1982 edition of *Red Flag* (*Hongqi*) made public a February decision by the Central Committee that several dozen core leaders would remain in their posts.[100] In September 1982, the Central Advisory Commission was filled with 171 veteran leaders who stepped down from their offices, yet fourteen veterans beyond seventy joined the Politburo at the same time. Indeed, fully half the Central Committee and Politburo were over seventy.[101] Even provincial leaders were able to evade the rules requiring retirement at sixty-five, until the final overage leader (Chen Huanyou) left his leadership position in Jiangsu in 2000 at the age of sixty-six.[102]

Changing the face of officialdom was not simply about youth but also about the Party's future direction. Existing and rehabilitated cadres had been shaped by their experiences in office and had "learned that the best way to preserve their positions in the bureaucracy was to play it safe by refusing to take clear-cut positions."[103] The Central Committee's Organization Department held a month-long conference in the fall of 1979, where "Hu Yaobang transmitted Deng's instruction that the aim of organizational work should be changed to fit the task of modernization."[104] But with the goal changed from revolution to growth and the center relying on local initiative, Deng and other leaders "changed the criteria for personnel management from political loyalty to the ability to further economic development."[105]

[97] Manion 1993, 73.
[98] Manion 1993, 52.
[99] Manion 1993, 65
[100] Manion 1993, 54.
[101] Manion 1993, 71–2.
[102] Liu 2018, 3. Again, Wang Qishan in 2019, and potentially Xi Jinping down the line, have torn open these old scars.
[103] Lee 1991, 193.
[104] Lee 1991, 230.
[105] Lee 1991, 228.

Recruitment going forward would favor youth and formal education, as Ye Jianying emphasized in his speech celebrating the thirtieth anniversary of the PRC.[106]

The treacherous political terrain of near simultaneous rehabilitation, retirement, and renewal was not traversed without some missteps. Veterans who were supportive of economic reforms in theory quickly reversed when they and their jobs were the ones targeted in practice. Deng, in an August 15, 1980, Politburo session, pushed for making the population of cadres "better educated, professionally more competent, and younger," which many existing officials reasonably viewed as a threat to their positions.[107] This push was ill-received, and by December the Party and Deng specifically were walking back these changes. Four months after that push for a new population of cadres, Deng made "revolutionization" a goal of reform, watered down age and education requirements, and assured incumbents, "If we depart from our present cadre corps, we will not be able to complete any of our tasks."[108]

In the end, the revolutionary generation was eased out of office and replaced by a younger cohort of cadres, who had more formal education and were seen as more closely connected to the goals and methods of economic development through reform.[109] This new generation were labeled technocrats, presented as interested in solving problems rather than messy politics.[110] Lee summarized the key difference between generations: "[U]nlike the old revolutionaries who split over the fundamental goals of the regime, the technocrats agree on basic goals but disagree on the method to achieve them."[111] While the Party's renewal did not extend to elites at its very top, the regime's dual post-Mao staffing crises were resolved through these maneuvers.

This new set of technocratic leaders pursued economic development through many different policies, including some in nontraditional issue domains. For instance, increasing wealth on per capita terms attracted attention both to the numerator (the size of the economy) and the denominator (the size of the population). Officials sought to control population growth through family planning, in particular with what became known as China's "one-child policy."

[106] Ye 1979; Lee 1991, 230–1.
[107] Lee 1991, 231.
[108] Lee 1991, 232–3.
[109] Lee 1991, 254.
[110] Li and White 1990; Andreas 2009.
[111] Lee 1991, 287.

One-Child Policy

China's infamous 1979 one-child policy illustrates that the regime's political calculations took place in a numbers-based grammar. Simple and powerful statistics could and did swing policy debates and generate action inside the Chinese system, but family planning policy serves as a stark reminder of how technocratic language and a limited, quantified vision can create blinders, yielding violence and barbarism.[112]

Quantification suffused the project, from its authorship by number-crunching military scientists to its implementation on the ground. Those who constituted the regime and whom policymakers trusted affected the policy course: the technocrats who pushed it emerged from military science fields, as the Cultural Revolution had eviscerated the rosters of intellectuals in other disciplines. These scientists delivered ominous warnings. Extrapolated fertility statistics foretold total environmental and economic collapse under population pressure, pushing policymakers to adopt more stringent regulations on child-bearing. Additionally, family planning reinforces that the regime's pursuit of its new purpose—economic development and modernization—was dogged enough to alter the trajectories not just of the economy but of the population to improve metrics such as GDP per capita. Finally, it provides further evidence that local officials took quantitative targets set by higher levels seriously and acted to implement them.

While the term "one-child policy" may sound self-explanatory, myths and confusion surround its convoluted history. Most notably, the one-child policy was born amid falling, not rising, fertility. In 1970, just a decade after the utter calamity of the Great Leap famine, concerns about the country's ability to feed its people led to directives to control population growth.[113] Increasing calories per capita required either more production, which the country had difficulty achieving, or fewer people.[114] A campaign was launched in 1971 with the slogan "One child isn't too few, two are just fine, and three are too many."[115] A 1973 conference put forward "Later, longer, and fewer" as another rhetorical shorthand directing couples to delay children until later in life, wait longer between them, and choose to have fewer of them.[116] Slogans alone, however, were insufficient

[112] Thanks to Thomas Bernstein for emphasizing this in a personal communication.

[113] White 2006, 58: "This was the third time an incipient grain crisis gave new urgency to the need for population control." See Chapter 3 discussion on food insecurity.

[114] White 2006, 58: "If the numerator in the economic equation—the grain supply—could not be made to rise with sufficient speed, the denominator—the population base—would have to be squeezed."

[115] J. Zhang 2017, 143.

[116] J. Zhang 2017, 143.

to change social behavior radically. Many scholars have demonstrated evidence of significant coercion of women and couples during these periods.[117] Statistics have shown jumps in sterilizations, intra-uterine device insertions, and abortions; these statistics mesh with numerous anecdotes indicating that many such actions were involuntary or forced after detentions.[118] The "Later, longer, fewer" campaign achieved its goals: the country's total fertility rate moved from 5.8 in 1970 (i.e., almost six children per woman) to 2.75 by 1979.[119] Despite such "success" in curtailing population growth, the government did not stop inserting itself into reproductive decisions; instead, 1979 marked the beginning of the even more intrusive one-child policy.

In April 1979, Chen Yun publicly called for "a widespread one-child policy, urging the adoption of a law demanding that each couple have one child."[120] This disconnect between the already reduced fertility rates and the push for even more stringent laws on family planning came from an unexpected source. Song Jian, a prominent rocket scientist, applied techniques from missile control technology to demography and became a major policy force at this time.[121] The mathematics of partial differential equations was not too different when the parameter labels switched from "missile velocity, position, and thrust" to "population density, death rate, and migration rate."[122] He and others took over technocratic debates about population policy by attacking social science in China as lacking quantitative skills. As Susan Greenhalgh writes:

> The systems engineer Wang Huanchen put the point forcefully, arguing that Chinese social science, "because it lacks quantitative things" (*dingliang de dongxi*), was not up to the task required of the population field, but that quantitative research, especially along the lines of population systems engineering, could provide the answers to China's critical problems of population policy.[123]

[117] Whyte, Feng, and Cai 2015; Zhang Junsen 2017; Greenhalgh 2003, 2005, 2008. *One Child Nation* 2019 is an emotionally powerful documentary film on the phenomenon.

[118] Whyte, Feng, and Cai 2015.

[119] Banister 1987, 230; Whyte, Feng, and Cai 2015. Note, however, some tension in claiming that economic development deserves the most credit for reducing births in China and the idea that the true successes of the family planning policy occurred during the coercive policies of the 1970s, when economic development was modest, at best.

[120] Greenhalgh 2005, 9. The policy proceeded from a heteronormative baseline belief that all adult couples should be in male-female pairs and produce one child.

[121] Greenhalgh 2005.

[122] Greenhalgh 2005, 14. She continues, "Song himself stressed the relative ease of the conversion."

[123] Greenhalgh 2003, 169–70.

These would-be demographers extrapolated out the population's size decades later, suggesting that the four modernizations would fall prey to a Malthusian disaster.[124] Their solution was "rapid one-childization (*yitaihua*) country-wide."[125] Without such a policy, these scientists imagined an apocalyptic future, with "national security and even survival" at risk.[126] There was pushback against their projections at a conference in Chengdu from a group of demographers with more traditional grounding in social science and Marxism. Yet even for those who did not agree with the worst-case scenario, the broader vision of reducing China's dependency ratio and slowing population growth to increase per capita economic production statistics had purchase.

The quantitative-heavy cadre responsibility system produced initiative and efforts on the part of local officials, albeit often in horrifying directions. In addition to the obvious numerical focus of the policy itself, higher levels assigned targets for those working beneath them in the hierarchy. Tyrene White describes Donghu commune's five targets for 1981: (1) births at 13.5 per 1,000, (2) having 85% of couples with one child to foreswear having another, (3) reaching a 90% "late marriage" rate, (4) 90% of births inside the plan, and (5) universal usage of birth control.[127] Those officials whose localities met their targets received cash bonuses and political credits, while those officials who failed faced political difficulties. In Liaoning, cadre compensation depended on three statistics: grain, money, and people (*liang, qian, ren*).[128] The combination of directives and incentives prompted action by officials, even if those actions did not necessarily yield dramatic results. After all, having a child is a life-altering decision, making fines and fees of questionable utility to stop it. The dual reality that some people will do anything to have a child while others will accidentally get pregnant makes "policing" fertility a challenging task. The horrors that the system inflicted—dreams deferred, limited life possibilities, forced abortions, coerced sterilizations, and hidden births—were an order of magnitude more common in the early 1980s than in the 1970s; this violence is discussed in Chapter 6.

The one-child policy thus illustrates and complicates this chapter's claims. Simple quantitative metrics produced by technocratically inclined scientists won the policy and political debates against more nuanced depictions of reality,

[124] Greenhalgh 2003, 172. "By mid-1979, however, around the time the natural scientists joined the debate, China suddenly faced a virtual population crisis, one that was ruining the country's chance of achieving the four modernizations by century's end."

[125] Greenhalgh 2005, 14.

[126] Greenhalgh 2005, 13. The thinking among Song and his colleagues followed the Club of Rome's terrified vision of an overpopulated world, but was not informed by any of the critiques of that work that had come out in the years since.

[127] White 2006, 101.

[128] White 2006, 102.

leading policymakers to push simple numeric regulations on their local agents. Seeing that these statistics were being closely monitored, local agents then went forward and enforced the policy with brutality. The population growth rate did continue to decline during this period, although there remains significant debate about the extent to which economic development, rather than the family planning policies, explains that result.[129] The family planning policies were implemented with differential ferocity over time and space, but it would be nearly forty years until China's leadership reversed course with various relaxations of the restrictions, culminating in a 2015 abolition, and a subsequent shift to pro-natalist messaging. Family planning is atypical in this regard, as the 1980s saw China's political economy tossed back and forth from open to closed in numerous waves.

Political Waves

Describing the regime's personnel transformation and the effects of its quantitative focus through the one-child policy captures only some of the turbulence at the top of Chinese politics during this time. Reform, like revolution, turned out not to be a dinner party. Pro- and anti-reform sentiments ebbed and flowed throughout the 1980s; openness spurred successes for a time, but then concerns would arise about the presence or potential of disarray to such an extent that the system would retreat and close in on itself. These political cycles were "loosely correlated" with economic cycles, especially jumps in inflation.[130] This ebb and flow demonstrates reform's tenuousness amid contestation from within the regime and the population, and further illustrates the ways that mass politics shapes elite politics.

Opening begat success by releasing pent-up social demand but would often be seen as going too far into disorder before being clamped down.[131] But each wave of openness and retrenchment had its peculiarities. From 1978 to 1989, Baum extracted six such cycles. Looking back, the waves themselves could be flattened by post-hoc bias, suggesting that because the regime endured, these convulsions were immaterial. However, this impulse is doubly wrong. First, in the moment, the whipping back and forth of political and economic policies and practices was profoundly unsettling to those experiencing them, and other paths were entirely plausible or even likely. A second mistake is to treat the waves themselves as tidy phenomena with regular beats rather than massive tides threatening to

[129] See, for example, Whyte, Feng, and Cai 2015; J. Zhang 2017.
[130] Shih 2009, 12.
[131] Baum 1994.

sink the ship of state with changing pressures. The waves' turbulence had some general patterns, but uncertainty dominated regularity.[132] Individuals—elites inside the regime and on its periphery, as well as common citizens—surfed these waves, dodging dangers from different directions, and attempted to live their lives without succumbing to the tumult.

The point here is to show not just that mass politics shaped elite politics but to give more definition to how that shaping took place. When leaders enact policies that produce strong results, they are emboldened, and when their policies are seen as failures, those elites are weakened and can even be removed. Those initially skeptical of reform efforts gathered every bit of ammunition throughout the 1980s to try to force them to retreat. Political choices on all three aspects— who, how, and why—often remain open even after they may appear settled. The major turning point in the 1980s was the nationwide mass movement that essentially ended with the Tiananmen Massacre on the morning of June 4, 1989.

Surveys, Authority, and Tiananmen

The masses support reform, demand further reforms.
—*People's Daily*, August 26, 1986

How did Chinese leaders see themselves as succeeding or failing? While quantitative measures of output and prices dominated discussions, statistical surveys were increasingly used in the 1980s to gauge public attitudes about key policy issues. Surveys provided ammunition for debates within the elite, but favorable results were publicized through the media as well. Having justified action through public opinion, public validation came to be seen as critical.[133] By the end of the decade, pressure mounted as students and workers rallied in the streets around the country. Clearly something and someone had failed. Convincing and co-optation failed to control a restive population. Despite splits at the highest levels, the regime's coercion beat back the protest movement and conveyed the deadly seriousness of its intent to hold onto power.

The most influential survey house was the System Reform Institute (CESRRI), due to its association with Premier Zhao Ziyang. The institute's young staff were clearly pro-reform in their inclination but endeavored to allow the data to speak, to seek truth from facts, collecting millions of data points, many of popular attitudes.[134] The rise of the sample survey in Chinese public

[132] Baum 1994, 7.

[133] Rosen 1989.

[134] Chen Yizi's opening essay in the *Reform in China* (改革:我们面临的挑战与选择) volume is titled "Social Scientific Research Serves Reform" (CESRRI 1986a; CESRRI and Reynolds 1987).

People's Daily mentions of '抽样调查,' 1983–1992

Figure 4.1 The 1980s Survey Wave. Source: data.people.com.cn, 819 instances

discourse can be seen in Figure 4.1, which shows mentions of the term in *People's Daily* from 1983 to 1992.[135]

By October 1984, the urban populace had seen fawning media attention given to framing the rural reforms as successful, building expectations for urban reforms.[136] In surveys conducted by CESRRI respondents overwhelmingly expressed beliefs that reforms were necessary.[137] But those beliefs were not uncomplicated. Some 77.3% of urban residents expressed a preference for stability over increased income, and 65.6% of young people supported the idea that the country should take care of all aspects of people's lives.[138] Citizens wanted the increased income associated with reform but seemed either unaware or unwilling to trade the stability of the old system for potential higher income. Rising prices also complicated the picture, when in 1985 the consumer price index hit levels not seen in decades.[139] When the reality of reforms failed to live up to the hype, those with high expectations were frustrated. A CESRRI survey from November 1986 found a negative correlation between reform expectations and reform evaluation ($r = -0.31$, $n = 2{,}451$).[140]

[135] The pattern in the figure holds if the term "人口" (population) is excluded, which is a potential concern as the 1987 1% Sample Census could have served as a confounder.

[136] Bai 1987; Rosen 1989, 160.

[137] CESRRI 1986b. Yang Guansan reports a figure of 92.6%.

[138] Bai and Yang 1986.

[139] NBS 2010b; Weber 2021, 230–1.

[140] Bai 1987, 58.

To try to parse these and related sentiments, Wan Li called for openness and "letting a hundred flowers bloom and a hundred schools of thought contend."[141] He argued that emancipating the mind requires an atmosphere of "academic freedom" where people can "speak without taboos."[142] As prices continued to rise, much of the blame fell on local governments and debates proliferated.[143] While Isabella Weber focuses on the crucial economic discussions of price reform between proponents of package reform (shock therapy) and dual-track supporters, a related political debate on the proper level of centralization was also occurring.

The contours of this debate show, first, how prior theoretical constraints from Marxism had become loosened over time as China's economy evolved toward acceptance of private wealth and profit.[144] The debate's participants considered different kinds of models for China's current and future political economy, including capitalist economies, on issues of centralization and the "toughness" of governments and economies.[145] Wang Huning, later to rise to the very top of the Party-state hierarchy and take a seat on the 19th Politburo Standing Committee, argued in 1986 that "reform of the government structure" was required to keep pace with the changing economic and social systems of the country.[146] He called for centralization, concerned that provinces and counties had become "30 dukedoms, with some 2,000 rival principalities."[147] The limited, quantified vision was having minor success at producing strong national-level movement toward desired outcomes.

While intellectuals debated, students and workers in state-owned firms observed with deep concern growing corruption, rising inflation, and the deterioration of their relative position in society.[148] CESRRI surveys showed dissatisfaction over growing inflation, from 74% in November 1986 to 92% in May 1988.[149] Beyond inflation, city dwellers' support eroded under the weight of significant equity, housing, and job security issues.[150] Reform's and the regime's legitimacy decayed rapidly, culminating in a massive deluge of collective action in April–June 1989. With the death of the recently deposed Hu Yaobang, a leader

[141] Wan 1986. The speech was delivered on July 31, 1986, and published in *People's Daily* two weeks later.

[142] Wan 1986.

[143] Sautman 1992; Perry 1993. Weber 2021 focuses on the debates about price reforms.

[144] Sautman 1992, 73.

[145] FBIS 1988; Sautman 1992.

[146] See FBIS 1986; Sautman 1992.

[147] FBIS 1986; Sautman 1992, 75.

[148] The relative position here is critical. See Walder 1991.

[149] Rosen 1989, 161.

[150] Walder 1991.

viewed as more connected to the desires of the masses, serving as a catalyst, what began as individuals attempting to mourn coalesced into demonstrations across the country, usually in the symbolic centers of the city. The movement took its name from its occupation of Beijing's Tiananmen Square, the symbolic heart of the regime.[151] As Dingxin Zhao argues, the protestors and the regime itself had different ideas about the ways the regime justified its rule.[152] In this way, it looks like the academics who had moved beyond Marxism in the neo-authoritarianism debate were far ahead of the country's politicians, who remained more dogmatic.

The tactical, strategic, and rhetorical decisions of the movement and the regime's responses to it contain multitudes, beyond the scope of this project. One telling moment during the height of the crisis and a number of debates in its aftermath are my emphasis here. The first highlights the difficulty of repression, the second sheds light on threat perceptions, and the third points to the significance of ideology in the post-Tiananmen period.

Protests in Tiananmen Square began following Hu's death on April 15, 1989. By May 17, hundreds of thousands of protesters continued to occupy the space, and Zhao Ziyang, Hu's successor as general secretary, called to set up a personal discussion with Deng regarding the situation.[153] Zhao was told to come by in the afternoon. By the time he arrived, the regime's top leadership—the Politburo Standing Committee plus Deng and President Yang Shangkun—were all there, and Zhao understood that "things had already taken a bad turn."[154] On April 26, *People's Daily* had published a front-page editorial denouncing the student protests, signaling the top leadership's unwillingness to hear their demands. In the May 17 meeting, Zhao wanted the leadership to "relax the judgment" from that editorial line,[155] arguing that without doing so, the demonstrators would not peacefully return to their homes. In response, he was criticized by Li Peng and Yao Yilin for undermining the threat posed in that editorial in a speech that he had delivered to the Asian Development Bank on May 4.[156] Deng and the other

[151] There is a truly vast literature on the 1989 protest movement and the Tiananmen Massacre. I do not seek to relitigate the causes, processes, and consequences of the movement here. On symbolic locations in capital cities, see Wallace 2014, 101–3.

[152] Zhao 2001 uses the analogy of chess and Chinese chess to signify that the two sides understood themselves to be playing different games.

[153] Narrative principally from Zhao Ziyang's 2009 memoir. Also see Vogel 2011. To be clear, Zhao was far from alone in holding this position. Xu Qinxian, commander of the 38th Army, refused a verbal order to mobilize his troops to clear the Square once martial law was declared (O'Neill 2011; Jacobs and Buckley 2014).

[154] Zhao 2009, 27–8. Wan Li was not present.

[155] Zhao 2009, 28.

[156] Zhao 2009, 28. Here again, perceptions of threats are intertwined with tactical and personnel decisions.

leaders decided[157] that the regime needed to be "firm" and that the "solution" to "turmoil" had to begin in the capital.[158] Zhao's career was over.

Martial law was next. Soviet leader Mikhail Gorbachev had been in Beijing for a May 15–18 summit and departed the city on the morning of May 19. Some fifty thousand troops converged on Tiananmen Square that evening. Yet when Li Peng publicly declared martial law at 10:00 the following morning, the soldiers had failed to seize the Square; Li wrote in his diary, "[W]e had not expected great resistance."[159] Soldiers, mostly unarmed, were pushed back by the power of the people—who were blockading subway stations, lying across train tracks, and barricading streets—and stuck in place for fifty hours.[160] The protestors took the opportunity to educate the soldiers of the justness of their cause: fighting corruption and expanding freedom.[161] Li quoted Deng on the key point: "Deng worried that the 'soldiers' hearts may not be steady' (junxin buwen)."[162] The soldiers were ordered to withdraw and regroup. Protestors celebrated their victory and even unveiled a statue, the Goddess of Democracy, in Tiananmen Square on May 29.[163] Regime leaders put into place more elaborate plans to seize control, with three times as many troops involved and even more reinforcements on standby, and dozens of soldiers secretly infiltrating the city center starting on May 26.[164] The leaders worried about the soldiers being identified, so all manner of civilian disguises and alternative paths were used to gather intelligence as well as to prepare for the actual clearing of the Square. Deng commanded General Chi Haotian to "do whatever was necessary (yong yiqie de shouduan) to restore order" at 2:50 p.m. on June 3.[165] As Anne-Marie Brady and Juntao Wang explain, "political work successfully mobilized units to action."[166] Melanie Manion argues that "the force used on June 4 promised to end the movement immediately, certainly, and once and for all."[167]

Repression is usually an implicit, off-the-path threat. When collective action occurs despite this potential danger to the demonstrators, then the threat is made

[157] Deng's decision came in the face of opposition from Hu Quli and equivocation from Qiao Shi. (Zhao 2009, 28).

[158] Vogel 2011, 617.

[159] Vogel 2011, 620.

[160] Vogel 2011, 620–1.

[161] Vogel 2011, 620. The documentary film Gate of Heavenly Peace shows soldiers sympathetic to the protestors.

[162] Vogel 2011, 621.

[163] Vogel 2011, 625.

[164] See Vogel 2011, 625–32.

[165] Vogel 2011, 625.

[166] Wang and Brady 2011, 127.

[167] Vogel 2011, 625–6.

explicit and, if that too fails, the threat is realized. From the regime's perspective, the botched initial threat of force (the April 26 editorial) and implementation attempt with martial law (May 19) represented deep cuts at central pillars of regime stability. Elites fractured, and the population successfully resisted. Only actual shooting in the streets dispersed the movement. Such actions required soldiers to be willing to and actually pull the triggers on their guns, sending bullets into the bodies of their own countrymen, and politicians and officers to be willing to give the orders to do so. While Chinese leaders and soldiers took that step and the regime endured, the Eastern European Communist regimes did not.[168]

Following the crackdown and the movement's dissolution, different assessments of the nature of the threat and its origins raged among the regime's elite. In particular, a set of leaders, most notably Chen Yun and Li Peng, viewed inflation as the source of grievances that led to the mass mobilization, and they saw marketization underlying that inflation. As such, their proposed solution was to undo some of the marketizing reforms, showing a willingness to trade some growth for price stability. This position was not simply something that these leaders came to after the Tiananmen crisis, but rather fit into their existing ideas about the likely consequences of the liberalizing reform agenda. As Joseph Fewsmith wrote, "Among Party conservatives there was a deep sense of 'we told you so.'"[169]

Deng and others, on the other hand, viewed reform as a critical component of the regime's remaining in power. Without the growth and improved economic circumstances that reform had provided, the Party-state would likely already be in the dustbin of history. Debates about the extent of reforms, whether they should be rolled back or pressed forward, whether they were capitalist or socialist, continued to play out in the back rooms and pages of Party propaganda newspapers.[170] The sensitivity of the debate pushed it off the front pages for some time, but by September 1989 multiple pieces in the *People's Daily* insisted that reform must continue, that the country could not "stop eating for fear of choking" (因噎廢食).[171]

Even if the conservatives had pushed to pause the reform program, they were cognizant that Marxist and Maoist ideological messaging lacked power to justify the regime to the population. Yet they and the rest of the regime's leadership believed that something must more strongly tether the population to the Party;

[168] See Dimitrov 2019 for an account of this difference using an argument based on information; See also Thompson 2001 for an alternative position.
[169] Fewsmith 2001, 33.
[170] Fewsmith 2001, 30–57.
[171] Ren 1989; *Renmin Ribao* 1989; Fewsmith 2001, 35.

only by binding the two more closely would the regime be able to endure performance shocks such as those that occurred in 1989. The regime turned to nationalism, and while Suisheng Zhao's construction "rediscovering nationalism" goes too far—the regime never lost or forgot about nationalism—his assertion that the regime began to use nationalism as a "spiritual crutch" is compelling.[172]

Utilizing nationalism could seem like an obvious decision, but even retreating to the least common denominator involves choices; in this case, there are two to stress. First, leaders had to decide to what extent the nationalism that would be imparted to the country's children through a campaign of patriotic education should be focused on the grievances that China had suffered in its past—the Century of Humiliation—or on pride in prior accomplishments. An additional consideration here is that focusing on foreign enemies would likely entail being less antagonistic to historical Chinese figures that had been shunted aside as class enemies. Second, how anti-West, and consequently anticapitalist, should such messaging be? Underlying much of this debate were tensions about the depth and direction of reform, but also threat perceptions about "peaceful evolution," or the role of international actors during the Tiananmen movement and more broadly the collapse of the Communist states in Eastern Europe. The pages of the *People's Daily* in October and November 1991 were filled with distinct perspectives on this debate.[173]

In the end, Deng's triumphant final significant act of leadership—the 1992 Southern Tour—won the day and returned the country to a marketizing path. Deng traveled to the country's South to promote his vision for the future; especially significant was an eleven-day inspection tour of the Shenzhen and Zhuhai Special Economic Zones, where he sounded a call to action for reform.[174] He urged the government to be bolder and for his colleagues not to behave like "women with bound feet."[175] Slashing through arguments about whether specific policies were socialist or capitalist, Deng argued that socialism should be thought of in terms of "advantages": whether it was "advantageous to the development of socialist productive forces, advantageous to increasing the comprehensive strength of a socialist nation, and advantageous to raising the people's standard of living."[176] The tremendous development of Shenzhen was emblematic of the practice criterion and his pragmatism: "Shenzhen's development and experience prove that our policy of establishing the Special Economic Zones

[172] Zhao 2004, 212–4.

[173] Although, to be clear, different articles across different days came to different conclusions— *People's Daily* was not directly pitting the arguments against each other on the front page.

[174] Vogel 2011, 669–78.

[175] Fewsmith 2001, 56.

[176] Fewsmith 2001, 56.

was correct."[177] Far from being concerned about foreign ventures approximating colonial concessions with Western actors buying China, Deng was confident that the government "had political control over all foreign-owned firms."[178]

Adding Complexity

How did Chinese politics and economic growth intertwine in the first three decades of reform? The decisions made by the regime's elites to shift its purpose away from ideologically rigid radical egalitarianism toward pragmatic growth-oriented development in the late 1970s and early 1980s succeeded for a number of reasons. Compared with other reform scenarios, the regime was able to redirect policies in ways that generated years of "reform without losers." China's desperate poverty and poor economic organization at the beginning of the Reform Era gave it significant space for progress.[179] At the same time, the beneficiaries of initial reforms—mainly farmers and rural industry—remained politically weak and could not halt the reform process at an early stage.[180] The policy process underlying this growth entailed significant back-and-forth between local and central governments, as detailed by Yuen Yuen Ang.[181]

Further, the chapter highlights the messy realities of reform. Once unmoored from the status quo, some activists inside and outside the regime called for more radical change, including popular mobilization and demands for democracy. Yet opposing forces also exhibited serious recalcitrance to any such shifts against prior policies and purpose. That such political dangers emerged in a circumstance without an economic crisis alongside it further confirms the risky nature of reforms.

The political system absorbed challenges throughout this process. Questions of who, how, and why churned throughout the 1980s. Formally educated cadres were brought onto the ship of state to operate as political technicians, replacing a generation of revolutionaries. These technicians brutally followed the simplistic one-child policy, imposing immeasurable harms on Chinese society to meet quantitative targets out of statistical fears. Continued oscillations over the depth of reform reached their height with 1989's Tiananmen movement, which repression rebuffed. The regime's ideological campaign of patriotic education followed that crackdown and attempted to inoculate the Party from weak performance by tying its identity to the nation.

[177] Vogel 2011, 671.
[178] Vogel 2011, 673.
[179] Malesky and London 2014.
[180] Oi 1999; cf. Hellman 1998.
[181] Ang 2016.

‖ 5 ‖

Quantified Governance

> Reform and opening up bring many new things. At first, we won't be
> familiar with or understand them, so problems of one sort or another,
> perhaps even very serious problems, are bound to occur. These are hard
> to avoid, but after paying "tuition," we must absorb the lessons, deal
> with things correctly, and straighten out our thinking.
> —Zhu Rongji, October 24, 1998, in Zhu 2015

After a couple slow-going years,[1] the Chinese economy took off under reforms. GDP grew from 364 billion RMB in 1978 to 30.3 trillion RMB in 2008 in current prices; after controlling for inflation, the economy was sixteen times larger in 2008 than it had been thirty years before.[2] In the main, the new policy directions and adjustments of the Reform Era achieved their central author's goals, often to such an extent that they surprised leaders in Beijing. Starting from the peripheries of the planned economy, markets disciplined production and expanded consumption. Decentralization spurred initiative, and focus on key indicators like GDP yielded returns on them. Yet these successes were neither simple nor painless. Two decades into reform, Premier Zhu Rongji still presented himself and the regime as learning—and "paying tuition" for—its lessons.

Overall, and for decades, the system of limited, quantified vision worked, producing the economic development that the regime framed as its core purpose and that ensured the regime's durability and survival. This chapter explores how China successfully navigated the waters of the comparatively ordinary times of the 1990s and early 2000s, leaving for the next chapter the deficiencies that would become increasingly hard to ignore by the end of the new millennium's first decade.

[1] The year 1981 only saw 3.9% growth in GDP per capita (NBS 2010b).
[2] Current prices (NBS 2010b).

Seeking Truth and Hiding Facts. Jeremy L. Wallace, Oxford University Press. © Oxford University Press 2023.
DOI: 10.1093/oso/9780197627655.003.0005

The system and its machinery was buffeted by waves, some of which were continued reverberations from Maoist legacies or earlier reforms. Continuing the narrative from the previous chapter, after stabilizing in the wake of the regime's violent suppression of the Tiananmen movement and the global censure that accompanied it, the system faced an internal crisis related to a disjuncture between the central government's political strength and its budgetary weakness. This disconnect was ameliorated by the centralizing fiscal reforms in 1994. As the economy began to run out of easily captured gains from transitioning inefficient agricultural labor into more productive industrial and service positions around the turn of the millennium, the regime embarked upon industrial consolidations that saw tens of millions of urban state-owned enterprise (SOE) workers lose their jobs and status—the cracking of the iron rice bowl. A new leadership generation, headed by Hu Jintao and Wen Jiabao, took over from the post-Tiananmen leadership of Jiang Zemin and Zhu Rongji in 2002, emphasizing the need to construct a harmonious society. While such efforts included expanding the range of quantitative measures that cadres pursued to include people-centered inequality, the core technocratic presentation of the regime rarely wavered. Even in anticorruption efforts, this leadership transition kept its political cards out of view compared with what would follow it a decade later under the helm of Xi Jinping.[3]

The chapter then dives into a central piece of the machinery of China's limited quantitative vision: cadre evaluation. The cadre evaluation system was created, intentionally, as a limited, quantitative system following Deng Xiaoping's call for local initiative and throwing off ideological shackles. While a few quantitative indicators were closely monitored, the details of cadres' work and decision-making authority on how to go about achieving these numbers was effectively decentralized. Officials understood these numbers to be significant, seeking to improve them in fact or through manipulation of data, and such efforts appear connected to promotion outcomes, especially at lower levels.

That numbers dominated the actions of Chinese officials is an argument put forward by the regime itself and its defenders, who describe it as meritocratic. But this obsession with numbers is also brought up by some of the regime's deepest critics, who observe numbers that feel disconnected from the lives of individuals and even reality itself.[4] Yet while citizen input has some role in the quantitative metrics of the cadre evaluation system, it is fundamentally a within-regime instrument for creating incentives and monitoring rather than presented

[3] Ang 2020 credits the 1997 civil service reforms for pushing corruption into "access money" and away from theft.

[4] See Bell 2016 for a meritocratic defense, and Wang 2012 for a sharp critique.

to the population as public opinion data, as happened in the 1980s sample survey moment.

Local officials competed with their rivals stationed in other localities to produce superlative outcomes on the measured sets of indicators. After reviewing the system's origins and secondary literature on promotions, this chapter discusses an original cache of cadre evaluation documents from different regions, levels, and times to establish its quantification and pervasiveness.

The chapter concludes with the contrasting tales of two environmental indicators that highlight the ways in which numbers ruled. Green GDP, an attempt to factor environmental considerations into economic growth metrics, was scuttled due to officials' concerns about how it might harm their reputations. On the other hand, air pollution statistics like PM2.5, which measures particulate matter smaller than 2.5 microns in diameter, became public and have led to substantial changes in the way that citizens and the regime consider smog, allocating tens of billions of dollars to combat those problematic numbers. If the cadre evaluation system is the institutional heart of the regime's limited, quantified vision, the environmental indicator comparison shows the political salience of numbers and shifts the focus to the system's negative externalities, which are taken up in more depth in Chapter 6.

The Center Grasping and Letting Go, 1994–2001

While inflation saw an additional spike and significant policy changes were made in the 1990s, the political waves that had roiled Chinese society in the 1980s faded. Turbulence was still felt inside the regime and throughout society, but internal strife felt bounded rather than existential, and social grievances tended to be isolated, either regionally or demographically, amid relatively broad-based prosperity.[5] Two incidents of note are the 1994 fiscal reforms and the SOE reforms of the late 1990s that left tens of millions unemployed (xiagang). The former recalibrated the regime's decentralization amid concerns of centrifugal forces pulling the country apart. The latter drove the regime to acknowledge its capitalist reality and pushed aside the formerly favored urban proletariat from their status as inheritors of the Revolution.

Decentralization and limited quantified vision encouraged growth but left Beijing's coffers empty. Under Mao, China's fiscal system had been tightly integrated with the overall economic plan; in the 1980s, it moved to limited and ad

[5] See O'Brien and Li 2006 on rightful resistance as structuring expressions of discontent.

hoc contracts with different entities as the plan's share of the economy declined.[6] The plan's price system controlled the location of profits and thus the sources of government revenues. Reform's marketization threw a wrench into the fiscal system as firms increasingly came to buy and sell items outside the plan, and profits emerged in places where central taxation was nonexistent.[7] The central government's share of total government revenue dropped from over 40% in 1984 to just 22% in 1993—and that statistic understates the weakness of Beijing's budgetary position, as it fails to include significant locally controlled extrabudgetary revenues.[8]

The end of Communist rule across Eastern Europe, especially the dissolution of Yugoslavia, led many scholars to express concerns that Beijing might have difficulty "holding China together."[9] A "disintegrationist" literature became prominent.[10] "Letting some get rich first" generated growth but also regional inequality, with a rich industrial coast leaving behind a poor agricultural interior. Even those less prone to hyperbole saw real power flowing to the localities, and China's "fiscal federalism" became an explanation offered for its economic success.[11]

However, the center largely wrested back control of the country's purse strings with its 1994 fiscal reforms. Rather than becoming beholden to provinces, the rules of the budgetary game flipped to favor the center. Following the 1994 changes in the fiscal system, the center grabbed over 55% of such revenues and maintained control of at least 50% of revenues for the next decade and a half.[12]

To ensure that richer coastal areas would accept the reforms, local leaders who opposed losing power over their revenue streams were compensated with side payments from the newly filled central coffers. As a result, for the rest of the decade China's fiscal system skewed even more strongly regressive, exacerbating the centrifugal forces that ostensibly justified the 1994 reforms in

[6] On the introduction and economic failures of the contracting system, see Wong 2005, 5; 1991; Wong, Heady, and Woo 1995; Naughton 1995.

[7] See Chapter 6 on price distortions and local protectionism.

[8] For example, NBS, *China Statistical Yearbook* 2012, Table 8-2. See also Figure 5.1 from Wallace 2014.

[9] This is the title of a 2004 volume (Naughton and Yang 2004).

[10] Naughton and Yang (2004, ch. 1) coined the "disintegrationist" term. Examples of such works include *China Deconstructs* (Goodman and Segal 1995); Goldstone's 1995 "The Coming Collapse of China"; and Gordon Chang's 2001 book with the same title. While surely some of this analysis was wishful thinking, the underlying trends of exploding disparity were real and significant.

[11] For example, Shirk 1993; Montinola, Qian, and Weingast 1995.

[12] Rithmire 2015 has a nice discussion of the ways in which authority over land use and revenue was a principal component of this rearrangement.

the first place.[13] In 1990, for example, China's five poorest provinces accounted for 14% of government expenditures; by 1998, that share had declined to 8.6%.[14] General Secretary Jiang Zemin himself acknowledged the political problems that disparities could cause in a 1996 speech, saying, "[W]hen income disparities between members of society and between regions become too great, clashes break out between ethnic groups, between regions, between classes and between central and local authorities. This can lead to a country on the brink of chaos."[15] To gain access to the resources that the center would need to address regional disparities, the center accepted policy kludges that stretched these rich-poor gaps even wider.

By the end of the 1990s, the reconstructed fiscal system had replenished the center sufficiently to spur redistributive actions. The final years of the growth-focused Jiang and Zhu leadership saw them launch the Develop the West program. While measuring the program's size is difficult because existing projects were folded into it, real resources were expended: 400 billion yuan (~5% of national GDP) was spread across nearly two dozen large-scale investments in 2000–1.[16] Yet even this redistributive program was regional in scale and attempted to reduce inequality by promoting growth through infrastructure development funded by the state and state-owned financial institutions, rather than directly aiding impoverished people in those poor regions. Aggregate growth through state capitalism had invigorated a moribund regime and enriched a depleted society over just two decades; China's leaders would continue down this path, despite accumulating concerns.

Jiang and Zhu's Communist apostasy reached its zenith in the late 1990s, when they pushed through a massive surge of layoffs of the previously favored class of urban workers in SOEs, cracking the hallowed "iron rice bowl" of permanent employment.[17] As marketization had continued to deepen in the years following Deng's Southern Tour, numerous SOEs that had prospered under the economic plan never came to thrive in the new environment. Collectively, SOE

[13] "The tax rebates operated essentially as transfers to provinces based on a share of the growth of VAT and excise taxes. These tax rebates dominated the center-to-province fiscal transfers in the mid-1990s, at around 75% of them, whereas transfers to equalize the fiscal position of the provinces 'were only 1–2 percent'" (Wallace 2014, citing Wong 2002, 19; 2005, 9n11). Wong 2002 specifically refers to "Transition Transfers"; other transfers from the center are tax rebates, quota subsidies, specific purpose grants, and final account subsidies. As the growth rates differed by province, the flat rebate rate was effectively regressive: provinces with more rapid growth received larger rebates on their tax revenue growth. See also Park et al. 1996, 771–5.

[14] Wong 2002, Table 2.6; 2005, Table 3.

[15] See Wallace 2014.

[16] Wallace 2014, 129.

[17] Solinger 2003; Hurst 2009; Naughton 2007; Hsieh and Song 2015; Lee 2007.

losses became a massive burden on local, provincial, and central authorities. While the regime was deeply worried about breaking the social contract with these workers,[18] ultimately it pressed forward, laying off approximately 20 million workers over half a decade, from 1996 to 2001.[19]

China's northeast and central coast regions saw state employment shrink by 2001 to half its 1993 level.[20] In a policy referred to as "Grasping the large, letting go of the medium and small," the state-owned sector was consolidated, and the set of firms emerged stronger financially in its wake.[21] The regime claimed that three in four laid-off workers (*xiagang*) found other employment, but such estimates are seen as optimistic and perhaps gamed by such techniques as not including individuals as young as forty if they took "early retirement."[22] Such positive outcomes are also difficult to square with the extensive protests that dominated urban life in many cities, especially in the northeastern Rust Belt, during and after the reforms.[23]

While in economic terms the policies represented an aggregate success, they also created real losers. The disruption improved profitability and productivity, but the gains from reducing the scope of the inefficient state sector were not distributed broadly. The displaced workers were given meager compensation, while insiders were able to acquire controlling stakes in firms at cut-rate deals and instances of managerial corruption were far from rare.[24] Workers' grievances went beyond the purely economic, as they were also unceremoniously shunted out of their exalted status as core to the regime's purpose.

The regime shaped its policies to reduce the likelihood of laid-off workers' grievances giving rise to significant resistance to the regime, with the potential for fallout. Rather than simple privatization, SOEs were encouraged to restructure to slow down firm-level decisions about laying off workers that would potentially generate unrest. When layoffs happened, policies were designed to the fragment workforce—through staggered layoffs and restrictive subsidies—in ways that reduced solidarity and increased the difficulty of collective action.[25] Rural migrants remained distinct from the urban population due to the household registration, or *hukou*, system, which in the Reform Era allowed those born

[18] Lee 2007, 38. While such rhetoric had been used previously (see Weisskopf 1982), the scale of the layoffs matched the rhetoric only here.
[19] NBS 2010b; see Hurst 2009 for distinctions between registered unemployment and *xiagang* (laid off).
[20] Hurst 2009, 20.
[21] Hsieh and Song 2015.
[22] Naughton 2007, 187.
[23] Lee 2007; Hurst 2009.
[24] Wedeman 2012.
[25] Wallace 2014.

in the countryside to come to cities but treated them as second-class citizens, without equal access to social services.

Compared with the earlier rural reforms, that urban industrial reforms were delayed until this point was overdetermined. SOEs were entrenched in the regime's political institutions and served as the backbone of its urban and international political economy. Concrete concerns about the urban unemployed rising up in large-scale protests obviously worried the regime, but harming the interests of this group was particularly dicey because of their status as the ultimate inheritors of the Communist Revolution. The CCP's identity and moral authority had come as much from its claim to serve as the vanguard of the proletariat as anything else.

Abandoning so much of the urban workforce represented a change in the regime's identity, and justifying it required an ideological heavy lift. Efficiency would be favored over fairness, as Jiang's report at the 2002 16th Party Congress made explicit.[26] Jiang's principal slogan, the "Three Represents," summarized his solution.[27] Shifting the basis of the regime's support from an urban proletariat to a broader set of economically successful and productive agents fit with the Reform Era's move from Marxist ideology to performance legitimacy. Yet the idea that capitalist entrepreneurs should be encouraged to join the CCP shocked participants and observers into noticing how much the regime had changed.

While one could perceive the Three Represents as expanding the Party's social base to include capitalists,[28] the CCP, especially at local levels, had already had strong working relationships with private-sector entrepreneurs for a decade or more by 2000.[29] Yet even at this late date, ideological conflicts existed between those more and less favorably inclined to the inclusion of capitalists into the Party.[30] The Party enacted its ban on entrepreneurs joining its ranks in August 1989, following the Tiananmen crisis, as some had supported the movement.[31] Especially when paired with the concurrent laying-off of tens of millions of SOE workers, the Three Represents is as much a reorganization of the Party's social priorities as it is an expansion or restriction of the political community.[32] Welcoming capitalists to the Party incorporated and neutralized them, preventing opposition but also adding their skills to the Party's set of assets.[33]

[26] Solinger 2003, 953.

[27] Solinger 2003; Dickson 2003. Also Zeng 2014.

[28] As in ideas of "inclusion," à la Jowitt 1975.

[29] Solinger 2003, 954.

[30] Dickson 2003, 2.

[31] Dickson 2003, 14.

[32] Cf. Solinger 2003, 954 on restriction.

[33] Fenner 2016. To be clear, being a capitalist was alone insufficient to join the Party, which claimed that only "outstanding elements" would be allowed to become members (Dickson 2003, 18).

As part of its reorientation toward the economically successful, the regime also radically expanded higher education in the late 1990s.[34] Growth in the sector throughout the 1990s was steady and rapid by any measure as new student enrollment grew from 610,000 in 1990 to 1.08 million in 1998. But with the Asian financial crisis roiling exports and the number of laid-off workers mounting, the top leadership overruled the Ministry of Education, drastically scaling up this sector in an effort to increase domestic consumption and delay more youths from entering the oversupplied labor market.[35] In 1999, new enrollments grew nearly 50% from the year before to 1.59 million, and the torrid pace continued, with 2.20 million recruited in 2000 and over 5 million new enrollees by 2005.[36] Such social convulsions helped goose growth statistics but wrenched society uncomfortably.

Harmonious Society

> First is to incentivize cadres to be truthful and practical, we must establish and perfect a whole system of institutions, standards, and methods that are scientifically reasonable . . . [and] we must both look at the overall economic growth and the tangible benefits people receive.
> —Hu Jintao 2016

After over a decade of Jiang's single-minded focus on growth, the PRC's fourth generation of political leadership, with Hu Jintao as general secretary and Wen Jiabao as premier, emphasized their desire to construct a "harmonious society" (*hexie shehui*). Harmony was widely seen as a balm for the inequalities that had entrenched deep divisions across Chinese society. Yet despite their tinkering to dial back growth promotion as the Party's lodestar, in favor of projects to alleviate poverty, regional inequality, rural hardship, and anti-migrant discrimination, their efforts only slowed down the expansion of the yawing gaps dividing Chinese society and the accumulating costs from the system of limited, quantified vision.

Hu Jintao was rarely seen as a charismatic politician—his compatriot Wen Jiabao was always more natural posing with the destitute—but his political biography, particularly his work in poor western provinces, associated him with the plights of the hundreds of millions of Chinese still waiting in line to become rich. Writing that poverty is "the main challenge facing the Party" and participating in inspections highlighting the marginalized, his rise to power was presented as a

[34] Q. Wang 2014.
[35] Q. Wang 2014.
[36] NBS 2010a.

shift away from the more hard-nosed laissez-faire capitalism practiced under the Shanghai-based team of Jiang and Zhu.[37] Under Hu and Wen, the central state would play a more active role in managing large enterprises and supporting the people's welfare.[38]

Fiscal and investment data also show this progressive shift. In 1999, richer and more urbanized locales received greater per capita transfers from the center, but by 2004 transfers were no longer regressive, if not actually reaching progressivity either.[39] The size of transfers also increased dramatically over this period, cementing their import for local budgets and representing a key lever that the center held over localities.[40] The Hu-Wen leadership team also prioritized domestic investment in interior provinces. Industrial operations seeking access to low-cost labor and priced out of the increasingly expensive coastal manufacturing zones relocated to interior regions. These moves were incentivized by policies, such as 2004's Rise of the Central Regions (中部崛起), which paired with Develop the West (西部开发) and 2003's Revitalize the Northeast (振兴东北).[41]

As China's inequality combined regional disparities with a steep urban-rural divide, any efforts at poverty alleviation required attempts to improve the situation of the countryside, farmers, and agriculture.[42] Li Changping, a scholar of rural China, wrote an open letter to Zhu describing the situation in rural areas: "[P]easants' lives are truly bitter, villages are truly poor, and agriculture is truly in danger."[43] In the 2004 Government Work Report, Wen announced an ambitious plan to eliminate the agricultural tax in five years.[44] By 2006, fiscal extraction from the Chinese countryside had been replaced with a subsidy program under the slogan "Industry feeding agriculture in turn."[45] Yet while the amount of extraction that farmers faced decreased with these changes, they also gutted rural government finances and public goods provision. Chinese leaders,

[37] Hu (2016) took a tour of poverty alleviation and the Develop the West program before the 16th Party Congress. "Poverty is the major challenge facing the party" (quoted in Solinger 2003, 958).

[38] On attempted centralization under Hu-Wen in the arena of SOEs, see Leutert 2018a. She sees the establishment of the State-owned Assets Supervision and Administration Commission (SASAC) in 2003 as core here, but that it "faltered on state firms' recalcitrance" (27).

[39] See Wallace 2014 for more.

[40] Wallace 2014, Figure 5.3.

[41] See Ang 2016, 217–9. For more on Revitalize the Northeast, see Chung, Lai, and Joo 2009; NDRC 2007. Even after all of the SOE reforms and job losses, in 2003, Dongbei remained problematically attached to the SOE model; see Chung, Lai, and Joo 2009, 111.

[42] *San nong wen ti* (三农问题).

[43] Wallace 2014.

[44] Wallace 2014, n70. The 1990s "tax-for-fee" (*feigaishui*) reforms simplified and reduced peasant burdens but also curbed illegible extraction by local officials.

[45] Wallace 2014, 122.

always cognizant of the effects on growth, ensured that even these progressively minded redistributive policies included provisions to prevent communities that had already developed some industrial capacities from being "punished," to "avoid whipping the fast ox" (避免鞭打快牛).[46]

Improving the income situation of farmers also aided the circumstances of those who had migrated from the countryside to find work in more urban locales. On the margins, some potential migrants decided to remain on the farm, and those who did depart knew they would have a higher shadow income if they returned, putting upward pressure on migrant wages. Beyond the agricultural tax abolition, migrants' lives in cities were simplified by the removal of requirements regarding the detention and expulsion of migrants not carrying temporary residence permits following the infamous 2003 death of Sun Zhigang, aHubei native and Wuhan Technical Institute graduate working in Guangzhou.[47] To be sure, migrants continued to suffer discrimination in Chinese cities, with limited access to safety net programs and local schools.

The Hu-Wen leadership team pushed back against the portrayal of the CCP regime as uncaring toward those among its own people who were not succeeding under reforms. Far from ignoring the urban unemployed and other impoverished Chinese citizens, which had been "relegated outside Jiang's idea of 'the people,' " as Dorothy Solinger put it, the new leadership team emphasized its attempts at poverty alleviation and reducing inequality.[48] Yet these rhetorical flourishes and policy adjustments remained at the edges of Chinese politics. As discussed below, additional metrics were added to cadre evaluation forms, but they had little effect on practices. GDP supremacy reigned, with stability preservation providing support, and the squeaky wheels of the aggrieved might be given some side payments to quiet them.[49]

While beginning to address the inequality issue, many within the leadership understood the political economy of the system of limited, quantified vision as increasingly precarious. After delivering the 2007 Government Work Report, Wen held a press conference in which he described a series of "major problems" that were making the Chinese economy "unstable, unbalanced, uncoordinated, and unsustainable."[50] Yet before much progress could be made on transforming the economy's structure, two earthquakes hit. First, a literal lurching of the earth killed tens of thousands in Wenchuan, Sichuan.[51] Then a metaphorical earthquake shook the economy of not only China but also the rest of the world.

[46] Wallace 2014, n82.
[47] See Wallace 2014, 140.
[48] Solinger 2003, 952.
[49] On stability maintenance, see Lee and Zhang 2013.
[50] Xinhua News Agency 2007.
[51] See, for instance, Sorace 2017.

The 2008 Global Financial Crisis

Retrospectively, it can be difficult to discern the political threats that the global financial crisis began to manifest in China.[52] The country's overall macroeconomic situation was resolved quickly, and the regime's practices were singularly successful compared with the situations that racked the world's other major economies (Europe, the United States, and Japan). Yet convulsions undermined social stability, with dire portents for economic development and the regime itself before they were held in check.

Coming into the crisis, Chinese economic leaders worried that excessively rapid growth could cause inflation and had begun allowing the yuan to appreciate.[53] This revaluation had already harmed the export sector, with firms by the tens of thousands closing their doors.[54] As the American financial sector imploded, especially with the collapse of Lehman Brothers on September 15, 2008, global demand for goods and services evaporated.[55] In China, the trickle of firms shutting down under the weight of revaluation became a flood amid the deep global recession. Over 1.5 million new college graduates could not find employment, and tens of millions of migrants lost their jobs. Many factory owners who had employed migrant workers absconded without paying their laborers.

Disgruntled workers responded, occasionally with fury, and collective labor disputes nearly doubled from 2007 to 2008.[56] Attacks on capitalists easily extended to their benefactors in the local state, and, perhaps as worrying for the regime, discontent erupted along other social cleavages as well. In November 2008, hundreds of workers at a Hong Kong–owned toy factory rampaged, smashing property and police vehicles.[57] At a Guangdong toy factory, rumors spread that Han women were raped by Uyghur workers. In late June 2009, a group of Han laborers attacked Uyghurs in their dormitory, the violence spilling into the streets and leaving 118 injured and two Uyghurs dead.[58] One week later, over twenty-five hundred miles away in Xinjiang, a thousand people marched in Urumqi's People's Square demanding further investigation of the dormitory

[52] Cf. Shih 2020.

[53] For more, see the series of pieces by Barry Naughton in the *China Leadership Monitor* from 2008 to 2009 as well as his chapter in *The Global Recession and China's Political Economy* (Naughton 2008, 2009a, 2009b, 2009c, 2009d, 2012). Also Ang 2020; Tooze 2018; Shih 2019; Wallace 2014.

[54] *Changjiang Commercial Daily* 2008; Sina 2013.

[55] Mamudi 2008.

[56] There were 271,704 cases in 2007, compared to 502,569 in 2008. NBS, *China Labour Statistical Yearbook*, various years.

[57] Friedman 2012, 466.

[58] Millward 2009. For more information on the Shaoguan incident in Guangdong that sparked the Urumqi riots, see Pomfret 2009; Xinhua News Agency 2009a.

attack.[59] Carnage then exploded around the city, mainly in Han-dominated areas, with nearly two hundred killed, according to a State Council white paper.[60]

Still, such explosions were the exception rather than the rule, as discontent was structured, dispersed, and reduced.[61] *Hukou* restrictions kept solidarity between migrants and locals from coalescing into a more unified voice demanding change. The regime had inculcated beliefs about particularistic protests as acceptable and efficacious compared with generalized demonstrations.[62] Migrant workers left their coastal cities for communities closer to their official residences, and Chen Xiwen, deputy director of the Central Rural Work Leading Group, estimated that 20 million migrants stayed at home in their villages after Spring Festival 2009; unofficial figures exceeded even that number.[63] To these existing anti-crisis features of the political system, the government added a double-barreled stimulus, using fiscal and monetary channels to keep the economy's heart pumping. These infusions of money put people in jobs, kept firms in operation, and prevented localities from shuttering.

The stimulus was rapid in its appearance and gargantuan in its scale. After substantial weakening of the economy became apparent in October 2008, Wen announced the 4 trillion yuan ($586 billion) fiscal stimulus plan in early November, and by November 10 provinces were already proposing projects. The central government pledged to spend 100 billion yuan by the end of the year. The fiscal stimulus funded substantial investments in rural health infrastructure and the high-speed rail network.[64] While most funds were directed at investments, some subsidies also supported household appliance purchases for people in the countryside.[65]

The state-dominated financial sector leaped into action as well. In the first quarter of 2009, banks made loans of 4.6 trillion yuan, hitting the lending target for the whole year before that target was then doubled to 10 trillion yuan.[66] Credit likely grew by over 13.5 trillion in 2009 and predominantly flowed to state-owned firms.[67] These funds offered a lifeline, and those unable to access them—disproportionately private firms—crumbled.[68] Orders for local

[59] Millward 2009.

[60] July 7 saw Han counterprotests and riots. In addition to hundreds of shops and motor vehicles destroyed, by July 17, 2009, according to an official account, 197 people had died and over 1,700 were injured (Millward 2009).

[61] See Wallace 2014, ch. 6 for more.

[62] O'Brien and Li 2006; Lorentzen 2013.

[63] People's Daily 2009. For unofficial estimates, see Huang et al. 2011.

[64] Fardoust, Lin, and Luo 2012.

[65] Fardoust, Lin, and Luo 2012.

[66] Tooze 2018, 249.

[67] Shih 2019, 152.

[68] For example, the East Star Airlines bankruptcy (Xinhua News Agency 2009a).

governments and their entities to spend fit neatly into the system of limited, quantified vision and were happily complied with.[69] By 2011, the National Audit Office estimated local government debts, including those of various investment companies or financing vehicles, to be 11 trillion yuan, up from only 1 trillion in 2008.[70] An extreme example is seen in Hubei, which had projects worth 2.5 trillion RMB under construction in 2010, fully twice the province's 2009 GDP; by 2012, those provincial officials had planned 8.3 trillion RMB in construction, nearly 650% of 2009 GDP.[71]

The domestic political implications of the crisis were substantial, even if nipped in the bud before they could rise to the level of regime menacing. With state-owned banks preferring to lend to other SOEs, the overall tilt of the economy shifted away from the private sector; "state advance, private retreat" (*guojin mintui*) became a watchword. While the global financial crisis did lead to a shift away from export dependence for the Chinese economy, the rebalancing was far from what Wen had described as needed in 2007. As many of the stimulus-supported infrastructure and real estate investments were barely economical in their own terms, they made the need to rebalance away from such investments and toward other areas—such as technology or innovation—even more acute and obvious. With so much money sloshing around so quickly, the sticky hands of the corrupt inevitably grabbed a piece. The stimulus succeeded by cranking up the system of limited, quantified vision to eleven. GDP grew through the storm, but the accumulated costs were apparent and the need to rethink clear.

While there was recognition that the system of limited, quantified vision was nearing the end of its run domestically, China's comparative success became a major point of pride and changed both the reality and the narratives about China's place in the world. Japan, the United States, and Europe all suffered deep recessions due to the global financial crisis, dragging down global GDP, leaving only China's economy humming along. As a major creditor of the United States and, in particular, owner of significant amounts of debt of the U.S. government-sponsored entities Fannie Mae and Freddie Mac, China demanded, and received, assurances that its assets would not be devalued.[72] Gao Xiqing, the American-educated head of the China Investment Corporation sovereign wealth fund, lectured Americans to "be nice to the people that lend you money" and recommended needed reforms, such as restricting the derivatives market and compensation in the financial sector.[73] The wreckage of the Washington

[69] See Shih 2019, 154 on locals being happy with Hu and Wen.
[70] Ang 2020, 62–4. Tooze 2018 provides the 1 trillion estimate.
[71] Naughton 2010.
[72] Tooze 2018.
[73] Fallows 2008; Tooze 2018.

Consensus led to a spike in use of the term "China model," and although there was little agreement between thinkers about the components of such a model, the yearning for a new method of governing for the twenty-first century was palpable.[74]

Seeing the existing system as nearing its end contradicted beliefs that China's governance could serve as a model globally. Having explored the overall narratives and experiences of China under the system of limited, quantified vision, the next sections dive into the bureaucratic and statistical operations of the system to probe its practices.

The Cadre Evaluation System and Promotions

> Whether by persuasion or coercion, cats who can meet their quotas are good cats.
> —Local Hebei officials, 1993, quoted in O'Brien and Li 1999

The cadre evaluation system is the core of the system of limited, quantified vision. It has been a focus of study over the past four decades, and its significance for China's political economy is difficult to overstate. Chenggang Xu describes it as one of the "fundamental institutions of China's reforms and development."[75] This section establishes that the system was intentionally created, intentionally limited, deeply quantitative, and understood as significant by relevant actors in their positions at the time, and that the outcomes of the political system tend to follow the expectations of incentives that define it. This final point can be summarized as performance on statistical indicators being associated with promotions for local cadres.

Following Deng's calls for decentralization and evaluation based on production at the end of 1978, in November the next year the Organization Department of the CCP "called for the establishment of a new system of evaluation for cadres."[76] Constructing national civil service and cadre responsibility systems was a "critical precondition for economic development and modernization."[77] In the first half of the 1980s, the generational replacement and political rectification described in the previous chapter were main considerations.[78] However,

[74] See *China Media Project* 2010.

[75] Xu 2011.

[76] Whiting 2000, 101.

[77] Edin 2003b, 37.

[78] Manion 1985, 227–8 emphasizes "investigation" (*shencha*) as "the most critical basis for deciding on changes of Party and state leaders"; these investigations are political and nonquantitative but focus on "bad elements," "rebels," "factionalist," opponents of the Reform Era line, and reversing verdicts.

even in 1983, organization documents "placed greater weight on the assessment of concrete achievements rather than political attitudes or work style," with these concrete achievements directly "determining material rewards and penalties as well as promotions."[79] The quantitative nature of this system was discussed and promoted as a virtue by Chinese commentators, who were dismissive of the prior practice of "subjective evaluations of political attitudes."[80]

This quantitative system of evaluation was limited to a few indicators. Performance targets varied in priority, as ranked by "soft targets, hard targets, and priority targets with veto power," where failing to meet a veto target alone could derail a career even if performance in other domains was successful. National veto targets were related to family planning and social order, while hard targets were overwhelmingly economic and soft targets related to ancillary concerns such as environmental protection and Party building.[81] Evaluations covered all ten ranks of leading cadres, from state leader to deputy section head, managed at four different levels: the center, provinces, cities, and counties.[82] In 1988, the national performance criteria guidelines for local officials included gross national product, agricultural and industrial output, fiscal income, infrastructure investment, national population growth rate, local budgetary income and expenditures, and ten other measures.[83] While eighteen indicators may stretch the concept of "limited," consider what was not included. As Yuen Yuen Ang notes, "conspicuously absent from leadership evaluation were targets for environmental protection, energy conservation, cultural preservation, and other soft goals that were nonessential for—and even antithetical to—achieving rapid economic growth."[84] Even those who argue that decentralization increased the state's capacity to monitor acknowledge that it "govern[ed] less" and left "large discretion to local agents over implementation of non-priority policies, and little control over areas which are strategically less important."[85] The goals were transparently laid out in numerical form; the ways to reach them were left to the imaginations and resources of the local officials in question.

While particulars of the cadre evaluation system maybe have been omnipresent to those inside it, the external scholarly study of this system has been hampered by the regime's opacity, manifested by limited interview information

[79] Central Personnel Office 1991; Whiting 2000, 101. Here we are talking about evaluation of "leading cadres" by organization departments (*zuzhibu*) rather than ordinary cadres, who are under the purview of personnel departments (*renshibu*) and civil service regulations (Edin 2003a).

[80] Whiting 2000, 102.

[81] Edin 2003b, 39.

[82] From Kou and Tsai 2014, 156–7. "Nonleading cadres" are below the department deputy level.

[83] Whiting 2000, 103; Central Personnel Office 1991.

[84] Ang 2016, 111.

[85] Edin 2003b, 52.

or documentation of actual evaluation forms and score sheets. Works by Susan Whiting and Ang are two excellent exceptions, each adding an evaluation document for township-level leaders in prosperous areas—Whiting's from 1989 Shanghai and Ang's from 2009 Zhejiang—to the stream of scholarship on this topic. While the 1989 evaluation had only six categories covering sixteen targets, the 2009 document had sprawled to sixty-six categories.[86] These targets ranged from economic performance—still first and the greatest contribution to the overall evaluation score—to Party building and political work, including addressing petitioners' complaints and the root causes of corruption.[87]

While the evaluation criteria remained quantitative, they shifted from more easily countable quantities to more abstract and value-laden assessments. However, Ang concludes that, in practice, these sprawling documents did not represent a departure from an economic-focused class of local leaders. Economic and revenue growth were still both the first and largest assessment items; they were "more measurable and visible" than softer targets, and they came associated with "personal benefits to local leaders," such as opportunities to "exert power, command prestige, distribute patronage, and collect personal rents."[88] However, the sprawling set of targets and mandates shows that by the end of the first decade of the twenty-first century, the leadership was already chafing at the restrictions of its limited vision into localities, even if it was ineffectual in generating actions to deal with the costs accumulating in its blind spots. Indeed, Graeme Smith's study of a county government led him to conclude that county officials would implement initiatives "wholeheartedly" only when three conditions were in place: the initiative would aid annual assessment, raise revenue, and benefit cadres financially.[89] Cadre evaluations expanded beyond a few limited quantities, but the overall practices of GDPism were relatively unaffected by these subtle moves.[90]

The system of limited quantified vision with cadre evaluation at its core is a centrally developed project. However, like other policies and projects, it followed the logic of political hierarchy, being dominantly top-down but with lower-level officials possessing some ability to negotiate the terms of their assessment.[91] Leng and Zuo show that evaluation criteria for city-level officials

[86] Ang 2016, 116–22.

[87] Ang 2016, 116–20.

[88] Ang 2016, 122–3.

[89] Smith 2009, 30.

[90] To be fair, absent the global financial crisis, perhaps these incremental changes in incentives could have precipitated greater shifts in behavior.

[91] Margaret Pearson and Ciqi Mei analyze such dynamics in a number of works. See Mei and Pearson 2014 on local defiance and Mei and Pearson 2017 on the "hold-to-account" system.

take three main factors into consideration: central initiatives, provincial leaders' preferences, and the previous year's targets.[92]

To expand the evidentiary base of this line of inquiry, I collected seventeen different score sheets and other documents related to cadre evaluation. Summary information about the documents is presented in Appendix 1. While these documents demonstrate the basic claim of the ubiquity of quantitative metrics in the evaluation system and that system's pervasiveness across different levels and institutions inside the country, there are interesting nuances worthy of note. In particular, shifting economic indicators, individualized incentives, and discussions of democracy are significant. The earliest form, a 1989 Jiading County evaluation guideline with score sheet, measures the economy based on direct output measures—agricultural and industrial production—rather than on the more abstract GDP metric that would come to dominate later economic discussions.[93] Xiaoshan's 1990 forms are similarly output-centric in their economic sections but also lean heavily on family planning.

A 1995 guideline from Jiading mentions specific monetary incentives for civil servants for hitting particular targets, and disincentives also are present, as seen in a 1999 Wuhua County guideline stating that civil servants who violated the one-child policy would be ineligible for meritorious promotion for five years. Finally, the language of "democracy" was present in the documents, such as a 1990 guideline from a special economic zone in Shantou that mentions "democratic evaluation, democratic examination, and democratic reference." A 1999 county guideline from Heze strikes a similar tone, describing three "innovations" in their cadre evaluation: more democracy, more emphasis on the economy, and more quantifiable scores.

Incorporating public assessments into cadre evaluations evokes democracy, or at least a shifting balance of accountability to the masses rather than only to leaders at higher levels of the Party-state hierarchy. The advantages, to the center, of such a shift are related to monitoring costs. A Shenyang official in 2004 contrasted "the organization [that] evaluates me once a year" with the masses who watch him every day, emphasizing that "the eyes of the people are sharp."[94]

Public opinion and GDPism were juxtaposed in a 2006 *People's Daily* description of cadre evaluation in Zhejiang. A "civil appraiser" (民平官) has been introduced and the headline calls to "eliminate the singular standard of economic growth."[95] Economic items beyond growth were also included, such as environmental quality, energy intensity, and debt. Those surveyed scored

[92] Leng and Zuo 2022, 120.

[93] Originally used by Whiting 2000.

[94] Zhang and Jiang 2005.

[95] Chen and Bao 2006. Original: 破除单纯以经济增长论英雄.

officials on ten individual dimensions, including honesty, cultural construction, and anticorruption. To be clear, this public opinion survey differs from the sample survey methodology discussed in the previous chapter as it seeks to gather input from grassroots representatives of the Party-state, local representatives from the people's congress and people's political consultative conference, rather than from the population at large via random sampling.[96] Chen Xiaoheng, an Organization Department official in Lishui city, claimed that including data from over 150 such representatives in cadre evaluations improved the "democratic nature" of their work.[97]

Skepticism pervaded discussions of public opinion's importance in the evaluation process. For example, a 2009 *People's Daily* commentary by Wu Yan (吴焰) laid out four concerns. The public opinion component of the annual evaluation was almost always negligible in quantitative terms. Absent transparency and disclosure of the questions and public responses, the public would have little faith that the reported assessments reflected their opinions. A more basic concern is whether the people truly have the freedom to know and express their opinions given the power dynamics and information controls in place. Unless their willingness to speak out has tangible results, "the masses will lose their motivation to express their opinions."[98] With such democratic resonances, though, come concerns that public validation would become required for government action rather than an extra prop supporting regime durability.

While the significance of public opinion in the cadre evaluation system was debated, the dominance of GDP can be seen not only in the score sheets themselves but in public discussion of these evaluations, including repeated promises to remove it from assessment scores. In 2007, a headline blared, "If Not GDP, Then What Will Be Assessed?"[99] In the remote region in Qinghai that holds the headwaters of the great Yellow, Yangzi, and Mekong rivers, evaluations were flipped from favoring economic indicators to social and environmental ones, from "6:4" to "3:7" afterward. Environmental protection in such an area has obvious global significance, but the justification offered was not about downstream beneficiaries of Sanjiangyuan's sacrifice but the economic nature of herding animals in that place and time. Increasing numbers of livestock made GDP and incomes increase in the short run but could collapse the local ecology by straining its resources too deeply. Separately, much of the variance in productivity came down to atmospheric conditions, and officials argued that "many economic indicators are determined by God." The rhetoric was far from

[96] This is also distinct from "intraparty democracy" (党内民主). See Li 2009.
[97] Chen and Bao 2006.
[98] This aligns with Dimitrov 2019.
[99] Liu 2007.

antidevelopment in its orientation; it merely attempted to separate development from its most well-known proxy, GDP.

While some similar rhetoric in this vein exists, such as from Beijing in 2005, the larger wave follows the global financial crisis and attendant stimulus.[100] Provinces like Sichuan and Zhejiang proudly proclaimed in 2010 that their officials would no longer engage in GDP competition.[101] The "people's livelihood" was the new focus of such remade indicators, suggesting again that GDP growth's detachment from the well-being of the people had become well-known if not fully common knowledge. But while canceling GDP from a list of indicators was easy, it did not resolve the overall issue of the cadre evaluation system's disconnect with popular sentiments and the growing unease with the problems accumulating in the blind spots of the system's limited, quantified vision.[102]

A score sheet from Wuhan (Table 5.1) shows the system's quantitative nature and its expansion beyond the purely concrete and economic into environmental, cultural, and political—Party-building—sectors. Economic development is the largest category, and many other ostensibly noneconomic sections are fundamentally economic.

The blinders narrowing the state's vision were not completely opaque. First, topics and policy priorities shift in significance and the closeness of monitoring over time would change. In particular, campaigns launched by higher-ups would induce a whole-of-government effort on a specific target.[103] Second, the regime's central leadership retained other channels that allowed it to be informed of official misbehavior, corruption, or harms that cadres inflicted while attempting to maximize the quantitative indicators on their performance contracts. These channels acted as alarm systems when particularly egregious situations arose, but the normal process prioritized outcomes, with less monitoring of the mechanisms that officials took to achieve these numbers.[104]

To be sure, when various new indicators were added to performance contracts and evaluations, outcomes shifted in the incentivized direction. For example, Samantha Vortherms describes how different kinds of expenditures varied over time. As welfare targets were added, traditional economic priorities in evaluations and the timing of political cycles helped account for politicians' choices. Namely, large, visible projects were timed to coincide with periods

[100] Wang 2005.

[101] For Zhejiang, see Wang 2010. For Sichuan, see Liang and Zhu 2010.

[102] For instance, Tu 2011. This article called for greater democratic participation and monitoring to resolve the issue.

[103] Zhou and Lian 2020.

[104] O'Brien and Li 1999; McCubbins and Schwartz 1984.

Table 5.1 **Example Cadre Evaluation Score Sheet, Wuhan 2012**

Wuhan City Party-State Leadership Annual Evaluation Score Sheet

Categories	Main indicators
Economic Development (30 points)	Gross regional product & growth rate (4 points)
	Local revenue & growth rate (2 points)
	Industrial value-added and growth rate (for firms above a given size) (2 points)
	Fixed asset investment and growth rate (2 points)
	Total export volume and growth rate (4 points)
	Tertiary sector added value as share of GDP (3 points)
	Proportion of industrial value-added from high-tech firms (4 points)
	Proportion of tax revenue to general local budget revenue (3 points)
	Proportion of scientific and technical expenditures to total local budget expenditures (3 points)
	Fatality rate per GDP and decline (3 points)
Social Progress (15 points)	Fertility policy compliance (2 points)
	Sex ratio at birth (1 point)
	High school graduation and college admission rate (1 point)
	Societal security and mass satisfaction rate (4 points)
	Letter and visit completion rate (3 points)
	Hospital beds and doctor-to-population ratio (2 points)
	Urbanization rate (2 points)
Citizens' Lives (20 points)	Food safety index (2 points)
	Drug safety index (2 points)
	Per capita disposable income and growth rate of urban residents (4 points)
	Urban registered unemployment rate (2 points)
	Urban social insurance coverage (2 points)
	Housing security subsidy coverage (2 points)
	Per capita net income and growth rate of rural residents (4 points)
	Rural new cooperative medical participation rate (2 points)

(*continued*)

Table 5.1 **Continued**

Wuhan City Party-State Leadership Annual Evaluation Score Sheet	
Resources and Environment (10 points)	Energy-GDP ratio reduction rate and carbon emission rate (3 points)
	Major pollutant statistics (2 points)
	Cultivated land protection (2 points)
	Reforestation rate (1 point)
	Urban water quality statistics (2 points)
Cultural Construction (10 points)	Mass spiritual civilization construction (4 points)
	Public cultural services construction (3 points)
	Cultural sector value-added and share of GDP
Party Construction (15 points)	Leading ideological and political construction (3 points)
	Grassroots Party organization (3 points)
	Clean Party and government construction (4 points)
	Cadre work satisfaction (3 points)
	Team talent construction (2 points)

when promotion decisions were likely being made, while longer-term welfare investments were shunted to the beginning and end of terms, as they were seen as less directly connected to the overall promotion narrative.[105]

These patterns of improved performance on a given indicator when it is included in the evaluation system also support the claim that the system of limited, quantified vision was understood as significant by the actors within that system, not just theoretically by its creators. Whiting describes local cadres as being "aware at all times of where they stood in terms of fulfilling their key performance targets," as well as their relative position compared with their rivals in other townships and villages.[106] Ang points out that it is common knowledge that these numbers are so significant, and further that they are able to be manipulated, that falsifying statistics can be a joke.[107] Documented instances of falsification are discussed in detail in the next chapter.

The final step in this logical chain is that the results of the system are consistent with the incentives it purportedly holds. In this case, performance in the various quantitative metrics is associated with the benefits, including promotion, that the system itself describes and officials act as if they understand and

[105] Vortherms 2019.
[106] Whiting 2000, 101.
[107] Ang 2016, 111.

believe. At a basic level, this is obviously the case. Officials who meet quantitative targets receive bonuses and avoid punishments.[108] A stronger claim is that those with the best performance are more likely to be promoted than those with lower levels of performance. Given that performance contracts are private and rarely accessible, studies usually compare promotion rates of different officials ostensibly in competition with each other and see if their statistics on GDP growth or fiscal revenue have significant explanatory power. Hongbin Li and Li-an Zhou saw competition along these lines as a tournament, where the best performers went on to the next level to compete again.

This tournament hypothesis is often placed against a factional explanation of promotions, where connections drive career advancement in the hierarchy, and is often described as the loyalty-competence trade-off.[109] A third, more nuanced scenario connects these two strands of argumentation. In particular, Pierre Landry, Xiaobo Lü, and Haiyan Duan find evidence of *both* connections *and* performance accounting for promotion inside the system:

> Specifically, we show that the regime is quite successful at fostering meritocracy at the lower levels of the administrative hierarchy, where local leaders are several steps removed from the selectorate that is relevant to central leaders. However, the imperative of protection against potential competitors results in a weaker propensity to promote high-performing officials as they climb the political ladder.[110]

They argue that this pattern generates strong performance by lower-level officials, but at the highest levels of the regime, where there are greater threats to the dictator and the regime arising from individuals, they see an attenuation of performance-based promotion compared with loyalty- and connection-based advancement.[111] This pattern is also consistent with Milan Svolik's analysis of the political utility of Party organizations for authoritarian regimes—namely, that they can incentivize and lock in efforts at regime maintenance early in an official's career, with payoffs accruing to those successful inside the system reaping rewards at higher levels.[112] A set of similar findings comes from Ruixue Jia et al., who emphasize the complementary nature of connections and performance on promotion probability rather than pitting the two against each other.

[108] Whiting 2000; Edin 2003b; O'Brien and Li 1999.
[109] For example, Dittmer and Wu 1995; Shih, Adolph, and Liu 2012. On the trade-off, see Egorov and Sonin 2011; Berliner 1957, 245.
[110] Landry, Lü, and Duan 2018, 1076.
[111] Landry, Lü, and Duan 2018, 1081.
[112] Svolik 2012.

The stakes of this debate are some of the Chinese regime's strongest claims to justify its rule or further its political model. If statistical production yields promotions and one believes that this reflects "merit," then one could argue that the tournament-style interjurisdictional competition system is a modern Confucian exam system, a quantitative meritocracy, the performance of which could rival democracy for legitimacy.[113] Yet, as compelling as such a system might be on its face, Michael Dunlop Young's *The Rise of Meritocracy* was a satire, and contemporary American meritocracy is seen by some as failing everyone, even those who succeed within it because of the ways it distorts values and perceptions.[114] Political leadership is complex, with diverse styles, perspectives, and personalities being appreciated by different people and succeeding in disparate circumstances. Further, diverse teams tend to produce better outcomes.[115] Merit may not be fully in the eye of the beholder, but neither can it be distilled into a single statistic. The next chapter details ways in which pursuit of promotion produces social costs.

Relatedly, there appears to be a parallel promotion path for star political recruits that is distinct from the standard system, even at lower levels. Rather than toil for close to a full term in a given job at a given rank in the regime's political hierarchy and be promoted based on quantitatively measured performance in that position, officials who make it to the top of the hierarchy tend to experience rapid jumps in their career trajectories. These quick elevations— promotion after a single year rather than three to five years in a given position, or "leap-frog promotions" that skip over a particular rank—have been referred to as "sprinting with small steps."[116]

The cadre evaluation system was a core cog in the machinery of China's system of limited, quantified vision and underlies much of the successful economic development of the past three decades. After the upheaval of initial reforms in the late 1970s and the political waves of the 1980s, the quantified governance of the 1990s and early 2000s sought to calm the situation, putting more and more distance between the utopian Communist visions of the PRC under Mao and a deepening developmental capitalist practice. Government finances were recrafted by the centralizing 1994 fiscal reforms and the state-owned sector jettisoned tens of millions of workers as the regime pursued efficiency in political control and production. The new regime's fourth leadership generation,

[113] Bell 2016.

[114] Young 1959. For contemporary critiques of American meritocracy, see Markovits 2019; Sandel 2020.

[115] Herring 2009; male dominance remains near total at and above the Central Committee level throughout this period (90%+). See also Rosen 1995.

[116] Kou and Tsai 2014; Pang, Keng, and Zhong 2018.

headed by Hu and Wen, came into power and attempted to reorient the ship of state, expounding on inequality and expanding the set of indicators to reduce the system's excesses.

Comparing Green GDP and PM2.5

The Chinese central government was not unaware that the system of limited vision encouraged behaviors that maximized counted quantities while ignoring negative externalities. Yu Guangyuan, for one, noted in the early 1980s that environmental concerns would likely be underexamined with the pro-development biases of the cadre evaluation system.[117] These costs and their undermining of the system are discussed extensively in the next chapter. However, for the first two decades of the system, such concerns remained secondary in the minds of the regime's highest officials and its local agents. The primary concern was the economy's underdevelopment.[118] The tales of two quantitative environmental indicators further establish the claim that numbers ruled, and their divergent outcomes offer more nuance as to how numbers worked their magic.

Green GDP

If the four modernizations were the core of the Chinese regime's purpose after Deng's ascension, then GDP became the quintessential statistic that measured modernization's progress. To be clear, there is nothing inherent or natural about GDP; it is simply the ubiquitous summary statistic developed by the System of National Accounts out of the United Nations.[119] Other metrics could have been used, such as median or mean incomes, consumption patterns, or other survey-based measures of subjective happiness or quality of life.[120]

GDP summarizes the economic activities of a locality in one number. Its power derives from its ubiquity and its claim to encapsulate the performance of an economy singularly. While there are international standards, methods to calculate GDP shift over time and space. The best known omission is household work, which tends to be excluded from GDP, but debates persist over the inclusion of research and financing expenses, depreciation, and intermediate good classification, among many others. GDP figures also fail to account for the

[117] Yu 2014, 64. This 1981 speech was titled "The Environment Should Be Quantitatively Measured."

[118] Or, to use the CCP's language, "the principal contradiction."

[119] Emerging out of World War II planning and prior work by S. Kuznets (Coyle 2014).

[120] Soviet statistical systems are studied in Herrera 2010. See also Rothman 2018.

environmental costs of economic activity. In China, the tremendous economic development of the Reform Era has been accompanied by environmental destruction on a similarly epic scale.[121]

Acknowledging this weakness, economists and bureaucrats have attempted to incorporate environmental realities into GDP and other economic summary statistics. However, a universally accepted set of standard practices to create such a measure, usually referred to as an "environmentally adjusted domestic product" or "eco domestic product," or most notably a "Green GDP," has not arisen over the decades since the UN Conference on Environment and Development endorsed the idea in 1993 as part of the Agenda 21 initiative.[122] The immediate difficulty is treated as technical, as Jane Qiu notes, citing the head of the "environmental-economic accounting department" of Germany's statistical office: "[T]he main obstacle of such systems is the difficulty in calculating the market value of environmental impact—be it the extinction of a species, the cost of soil erosion due to deforestation, or the health damage from pollution."[123] Assigning such costs is possible, but the difficulties come in at the level of ideas and ideology—defending arbitrary values with radical implications for economic activity in ways that challenge hegemonic worldviews.[124] The inability to give particular market values for most environmental costs of economic activity in the absence of actual markets has paralyzed most actors.

Despite these technical and ideological difficulties, in the early 2000s China's State Environmental Protection Administration (SEPA) believed that creating a Green GDP metric would do enough to protect the environment that it would be worth it.[125] A provincial study conducted by the Shanxi Academy of Social Sciences showed that after environmental considerations were included, the province's 2002 GDP was a mere 66% of its officially reported statistics.[126] In 2004, SEPA worked with the National Bureau of Statistics (NBS) to launch a "Green GDP." In October of that year, it put out a call for local governments interested in participating in pilot studies as they developed a national system.[127] The pilot began in ten provincial-level units: Beijing, Tianjin, Chongqing, Liaoning,

[121] Economy 2004.

[122] Li and Lang 2010, 47.

[123] Qiu 2007, 519.

[124] Jameson 2003: "Someone once said it is easier to imagine the end of the world than to imagine the end of capitalism."

[125] In 2008, it became the Ministry of Environmental Protection and as of 2018, the Ministry of Ecological Environment.

[126] Fifield 2004.

[127] SEPA 2004.

Hebei, Zhejiang, Anhui, Guangdong, Hainan, and Sichuan.[128] SEPA and NBS built a team of experts from their own staffs, as well as the Chinese Academy for Environmental Planning, the Policy Research Center of Environment and Economy (both part of SEPA), Renmin University, and the China National Environmental Monitoring Center.[129]

The green accounting and pilot studies were explicitly limited in scope and not universal. The 2004 pilots were in part based on prior studies that NBS and SEPA had completed with partners at Statistics Norway and the London Group of Environmental Accounting.[130] The 2004 pilots' estimates of environmental costs focused on collecting information on air, soil, and solid waste pollution; estimating the costs to ameliorate these pollutants; and then subtracting these costs from the size of the GDP or growth. There was also some attempt to incorporate the depletion of resources, which "were appraised through estimating the hypothetical amount of investment needed to recover the resources exploited, such as fisheries, forestry, minerals and farmlands."[131] The study itself acknowledged the limitations of its work, as it was unable to find sufficient evidence to estimate a wide range of issues, such as the "number of patients suffering from infectious and digestive diseases caused by water pollution and costs for outpatient services, medical treatment in hospitals and loss of working time," among many others.[132] The report that was released was conspicuously labeled "public version," leading some to wonder what a complete version might have contained. Yet when the pilots' results were released in 2006, even these limited assessments were startling. The study estimated that the costs for "containing and managing the environmental impacts" of economic growth were over 4.8% of GDP, with 1.8% of GDP in abatement costs and 3.05% of GDP in degradation costs.[133] Rather than a world-leading 10% growth rate, with some environmental considerations incorporated into its metrics, China's development would look pedestrian.

After expanding from ten to all thirty-one provinces and provincial-level cities the following year, the conclusions of the 2005 study were not released to the public.[134] Differences of opinion between NBS and SEPA joined concerns from local governments about the release of this information.[135] In July 2007,

[128] Rauch and Chi 2010. Xi Jinping was Party secretary of Zhejiang at this time.

[129] Wang et al. 2006.

[130] See Li and Lang 2010, 50.

[131] Li and Lang 2010, 48.

[132] Wang et al. 2006, 3. The U.S. Clean Air Act has a built-in updating of the air pollution science to assess its costs to society, but no economic valuation, aside from the statistical value of a human life.

[133] Li and Lang 2010, 51. Wang et al. 2006.

[134] That is, excluding Taiwan, Hong Kong, and Macau.

[135] Li and Lang (2010, 54) reference Wang Jinnan on this point. See also Ansfield 2007.

NBS director Xie Fuzhan[136] downplayed the Green GDP effort.[137] Yet NBS was aware of the difficulties of the task heading into it, suggesting that pressures arising from others inside the Party-state hierarchy changed the NBS's opinion on its public release. There is some evidence that leaders who publicly praised the report did their best to scuttle it behind the scenes. While Xinhua published a piece in which Yang Jing (杨晶), the Party secretary of Inner Mongolia at the time, said that he "thirsted" for the release of Green GDP because of the province's environmental efforts, such as shuttering coal mines, other sources suggest that Inner Mongolia joined other mining-dependent provinces, such as Shanxi and Ningxia, in private opposition.[138]

What information has leaked from the study suggests that the results were even more damning than those of the previous year. Peking University's Lei Ming, a professor at the Guanghua School of Management and an advisor to the Green GDP team, stated that some provinces had environmental costs of 10% or greater, suggesting that once these limited environmental concerns were considered, the economies were not developing at all.[139]

The failure of Green GDP was total but did not come from the public. An online survey of over twenty-five hundred participants by *China Youth Daily* showed 96.4% support for Green GDP, and 79.6% thought that it might be a way to constrain officials' weighting of the economy over the environment.[140] Having a quantitative metric with environmental content was understood by the population as a way to fit this priority into the calculations of local officials, yet this particular statistic required too much—too much effort and technical capacity to create, too much cooperation with local officials whose careers it might destroy to evaluate, too much honesty about the country's environmental degradation to share, and too much change for the system of limited vision to incorporate. A simpler statistic made headway where Green GDP did not.

[136] Xie was new to the position as his predecessor, Qu Xiuhua, had just been removed for corruption. Xie is described by Ansfield (2007) as more "bureaucratic" than "technocratic" and scared to offend the provincial bosses that outranked him.

[137] Li and Lang 2010, 53.

[138] See Xinhuanet 2007 for Yang Jing's public call for release. See Ansfield 2007 and Li and Lang 2010, 52 for anonymous remarks that this claim was belied by his private behavior.

[139] Shanghai Stocks News 2007; Li and Lang 2010, 51.

[140] *China Youth Daily* 2007a, 2007b. Online surveys, of course, are not reliable metrics of public opinion at large, but they do demonstrate the existence of a population willing to rebuke the government on its decision to not move forward with Green GDP.

PM2.5

In April 2008, the U.S. Embassy in Beijing began collecting samples of PM2.5, small particulate matter (under 2.5 micrometers in diameter) in the city's air, and in July it started publishing the results hourly under the @BeijingAir account on Twitter, despite complaints from Chinese authorities.[141] In October 2010, the account tweeted that Beijing's air was "crazy bad" as its reading exceeded 500—twenty times the World Health Organization's guideline—after programmers had jokingly coded in that label for absurdly high scores that fell beyond the index, not expecting it to ever be triggered.[142]

In the fall of 2011, Beijing's air quality was again, by international standards, dangerous. As it had the previous fall, the U.S. Embassy's monitoring equipment registered scores so polluted that they were "beyond index," while the Beijing city government officially reported that the air was merely "slightly polluted."[143] Yet this episode cut a deeper impression. Pan Shiyi, a noted real estate developer, sent multiple messages to his over 16 million followers on the social-media platform Sina Weibo in early November 2011, calling for the Chinese government to monitor PM2.5 rather than just PM10 (larger particles). Pan's Weibo post included a poll, in which over 90% of forty thousand respondents agreed with his recommendation. Just a few days later, Premier Wen acceded to these requests, saying that the government needed to improve its environmental monitoring and bring its results closer to people's perceptions.[144] New standards on air pollution further restricting sulfur dioxide and nitrous oxides and adding PM2.5 were put into place in February 2012, with monitoring stations in dozens of cities by the end of that year.[145] PM2.5 is now incorporated into a broader air quality index featured in weather reports on state media and available on phones through a variety of apps. PM2.5 levels have dropped significantly in urban areas since being thrust into the public and governmental consciousness, and a system of environmental inspections has been established.

Green GDP and PM2.5 both highlight quantification's role in post-Mao governance. The different outcomes for these environmental indicators—the failure of Green GDP and the success of PM2.5—can add more light as well. First, Green GDP built on GDP itself, the beating heart at the core of the regime's development justification. The green audits of GDP show that the process cut down Chinese growth statistics, pillars upon which the regime's performance

[141] U.S. State Department 2017.
[142] Demick 2011.
[143] Demick 2011.
[144] China Council for International Cooperation on Environment and Development 2012; Oliver 2014.
[145] Oliver 2014, 61.

legitimacy stood. This proximity to GDP made it potentially powerful, but that very potential ultimately led to its being sidelined.

On the other hand, PM2.5 is quantitatively disconnected to the overall development narrative. A city's PM2.5 level on a given day is simply a number that reflects the amount of small particulates in the air, but there's no direct connection between GDP growth and PM2.5 akin to the Green GDP discounting. Second, PM2.5 succeeds in part precisely because it is a simple, concrete number depicting a real problem that individuals can often see with their own eyes.[146] Green GDP is both complicated and abstract. The technical difficulties of building the measure and the choices entailed therein could be endlessly debated by experts, whereas PM2.5 measurement is settled science. Green GDP is invisible and arguably even more difficult to visualize than GDP itself, as more and more economic activity always increases GDP, while more extractive economic production might not increase Green GDP.

Multiplying Gains and Losses

The system of limited, quantified vision structured the economic development of China as it moved from below the world's top-ten economies by GDP in 1990 to behind only the United States in 2010. Capitalistic development, guided by local officials competing on particular metrics and extolled by central leadership justifying itself through growing national wealth and power, deepened its now entrenched position as to how allocation happened within Chinese society. The shift in the Party's base from the urban proletariat to the more economically successful "advanced" forces was demonstrated in practice by the willingness to endure SOE job losses and given rhetorical cover by the ideological jump to the Three Represents.

As the system continued to produce the desired GDP growth numbers, much government effort—strained as it was—in retrospect appears little more than tinkering around the edges of a vast machine sailing ahead. The regime's 1994 reversal of its deep fiscal decentralization initially expanded regional divisions, as rich provinces kept their pieces of silver for being willing to accept a deal, before eventually giving way to regional redistribution. These anti-inequality and antipoverty initiatives became the calling card of the Hu-Wen leadership team, which inserted additional metrics for local officials to pursue. However, as shown by promotions and the environmental indicators narratives, the regime's

[146] Once improvements in air quality became sustained, global indices of "most polluted cities"— either just measured by PM2.5 itself or a mix of different particular figures—shifted from China to other major developing country cities, such as Delhi.

focus on a few quantitative indicators led to contestation about which indicators mattered and who did the measuring rather than questioning the trajectory of the system or the system itself. The system's blinders remained in place, and as the country's development trajectory led it to run out of obvious investment opportunities and approach global production frontiers, the downsides of having such a large number of unmeasured aspects of Chinese governance accumulated over time.

Hiding Facts

GDP figures are "man-made" and therefore unreliable, [Executive Vice Premier] Li [Keqiang] said. When evaluating Liaoning's economy, he focuses on three figures:

1) electricity consumption, which was up 10% in Liaoning last year;
2) volume of rail cargo, which is fairly accurate because fees are charged for each unit of weight; and
3) amount of loans disbursed, which also tends to be accurate given the interest fees charged.

By looking at these three figures, Li said he can measure with relative accuracy the speed of economic growth. All other figures, especially GDP statistics, are "for reference only," he said smiling.
—Li Keqiang via Wikileaks, Cable 07BEIJING1760, March 15, 2007

China's system of limited, quantified vision produced extraordinary economic results, but it was not a panacea. Organizational design has its limits. Hierarchies, like the Chinese Party-state, face what Gary Miller refers to as "the fundamental problem of hidden information"; that is, "superiors require information from subordinates in order to set goals and expectations for those subordinates."[1] This chapter focuses on the system's downsides.

Behind the system of limited, quantified vision were information controls. An open media environment or political landscape with organized opposition would likely have exposed the system's weaknesses earlier and demanded government responses. Constraints on discourse themselves have costs—economic, political, and social. Economically, opportunities are missed and technologies are separated from global ecosystems.[2] Politically, leaders come to believe their own

[1] Miller 1992, 138.

[2] Although protectionism in the tech space may provide economic advantages for some Chinese domestic firms.

Seeking Truth and Hiding Facts. Jeremy L. Wallace, Oxford University Press. © Oxford University Press 2023.
DOI: 10.1093/oso/9780197627655.003.0006

propaganda, and controlling behavior becomes harder as yes men abound and reality is harder to pin down. Socially, distrust reigns.[3]

Beyond necessitating a closed information environment, the system's main downsides are seen in the harms and hidden things that local officials generated in their attempts to produce excellent numbers. Ignoring waste and risks, officials raced for growth, and many grabbed as much as they could take for themselves. Pollution devastated the air, soil, and water. Safety was sacrificed for production, perhaps most obviously with industrial accidents. Officials overbuilt in their own territories, gaming the reforming price system and unconcerned about inefficiency. The growth engine of urbanization under Chinese quantification yielded slums in ghost cities. Economies grew, but debts grew faster. Citizens' autonomy was abandoned to meet targets, as seen with the one-child policy's repressive implementation. A tactic existed for those officials willing to deceive at a deeper level—falsifying statistics—which, while less destructive in physical terms, hammered at the faith, trust, and goodwill upon which contemporary economies rest. Finally, citizens were not simply subjects under this system of limited, quantified vision but retained some agency.

Underlying Ideas

China's system of limited, quantified vision focused, in the main, on a small number of statistics to assess the performance of localities, the governments that ruled over them, and the officials who staffed those governments. Paying attention to a few critical outputs was consistent with the pragmatic call to seek truth from facts, where the material presence of outputs demonstrated their factual nature. But it was also consistent with the general socialist pattern of focusing on production measures rather than the efficiency of production, which connected to concerns about the capitalist notion of profit.[4]

Measuring a particular set of quantifiable outputs to ensure their emphasis also furthered the society's wealth and power.[5] As shown in Chapter 3, China's leaders often referred both to increasing the strength and to improving the economic circumstances of the country and the people. Yet measuring performance

[3] Cf. Tang 2016. Tang's surveys document comparatively high levels of both trust and regime support in China. The coercive underpinnings of authoritarianism are hard to escape, and the regime's push to establish a social credit system (see Chapters 7 and 8) is often justified by perceptions of a lack of trust.

[4] Whiting 2004, 113 describes the experience of two townships adjusting indicators to include profits in 1989 after dealing with wasteful overinvestment.

[5] Schell and Delury 2013.

at the aggregate level—GDP, investment, and fiscal revenue—more heavily than at the individual level, with income, unemployment, health, wellness, or other measures, turned out to be consequential.[6] While initial efforts in rural reforms were explicitly tied to increasing the incomes and consumption of farmers as an end in itself, as well as a strategy to increase overall production, over time the growth of aggregate statistics came to dominate politics and override "the people's interests."

The quantification and tangible nature of output measures were attempts to avoid problems of feet-dragging and noncompliance by making expectations explicit rather than remaining abstract. These targets specified goals, but at the same time suffered from moral hazard and "gaming the system" problems that proliferate when high-powered incentives connect with performance-based measures.[7] Variants of this gaming involved some forms of deception, a complicated concept worthy of some parsing. John Mearsheimer's *Why Leaders Lie* divides deception into concealing truth, spin, and lying, where concealing is hiding true facts rather than making untrue statements, while lying is the knowing presentation of false statements. Spin exists in the middle.[8] Chinese officials at all levels have engaged in such deceptive acts. The regime's messaging extolling its successes and its control of the broader information environment also could be placed on this spectrum, as does the "preference falsification" that it has induced in its citizens, who can feel forced into "living a lie."[9]

Information Environment

> Publicity, we've often said, should "primarily report positively and primarily publicize achievements." Although this policy is correct, it also constrains us. What does it mean to report positively? Does it mean 99% of reports should be positive? Won't 98% or 80% be acceptable? I wonder if 51% would also be acceptable.
> —Zhu Rongji, October 7, 1998, reprinted in Zhu 2015

Premier Zhu Rongji's rhetorical questions about the optimal propaganda ratio highlight the multiple contradictory goals of information control for the Chinese regime. Positive reporting dominated, attempting to communicate to both the regime's agents and its population what endeavors the regime was embarking

[6] See Whiting 2000, 2004. Also see Shirk 1993, 189–90.

[7] Whiting 2004, 112.

[8] Mearsheimer 2011, 16.

[9] Kuran 1995, 2: "[P]reference falsification aims specifically at manipulating the perceptions others hold about one's motivations or dispositions." Of note, Kuran suggests that "self-censorship" is narrower than preference falsification.

on, that those endeavors were correct, and that it was successful in its efforts. Throughout the Reform Era, most state-sponsored media content for public consumption fit into Vaclav Havel's conception of the panorama, projecting positivity, consistency, and agreement. As Zhu himself put it in 2001, "[W]e mustn't cause the people to lose confidence."[10]

In addition to the public-facing media, China's information ecosystem included journalists reporting through internal media channels, where concerns about the effects of "bad news" on the public were attenuated while ensuring information could flow up to higher levels.[11] All manner of internal police, spies, and informal reporting channeled information to the top of the regime. Two caveats are in order. First, such nonpublic information flows kept the regime's center aware of circumstances beyond the limited nature of the public information environment. Second, the system of limited, quantified vision for local officials is an intentional filtering of the state's ability to observe, to focus, and to prioritize a few quantitative indicators.

Yet Zhu's questions about the ideal proportion of news coverage likely arose from a belief that pure positivity would lead some viewers to reject the panorama as overly simplistic, compared with a presentation that included negative stories. Zhu also saw utility in media reporting to control official behavior,[12] stating his thoughts on this point by referencing a report about corruption in the granary system in Hebei from the TV show *Focus*.[13] When the episode, titled "[State-]Purchased Grain Shouldn't Wind Up in Private Granaries," was broadcast in 1998, relevant officials sprang into action, including the "provincial Party secretary and governor," who "couldn't sit still." Indeed, "the next day, they sent a telegram," which Zhu shared with other Politburo Standing Committee members, about the meeting that the Hebei leadership had held that night, which attempted to establish both "how much work they had done in the past" and also "how they were going to strengthen and improve" their efforts in the future. Zhu concluded that the episode "had a greater impact than anything I said, and it made a major contribution to reform of the grain purchase-and-sale system."[14] This reflection points to the strengths of public information compared with internal reporting and orders based on private communications. Common

[10] Zhu 2015, 318: "for public consumption" here is in contrast to the internal media systems referred to elsewhere in the section and analyzed by Dimitrov 2017, 2019.

[11] Dimitrov 2017, 2019.

[12] Akin to Agent Smith in the 1999 film *The Matrix*: "Did you know that the first Matrix was designed to be a perfect human world? Where none suffered, where everyone would be happy. It was a disaster. No one would accept the program."

[13] Dimitrov 2019, citing Bandurski and Hala 2010 that investigative journalism in China signals responsiveness rather than illuminating unresolved issues.

[14] Zhu 2015.

knowledge has power. The information environment and the regime's efforts to control it during the Reform Era contained tensions.

In her 2008 analysis of Chinese propaganda and thought work, Anne-Marie Brady writes that *Focus* "represents a new trend in propaganda work, whereby instead of education, criticism and debate are now used to guide audiences' thinking."[15] Media organizations navigate between the strictures of the government on one side and commercial demands on the other, as the early 1990s saw "the end of direct State subsidies to the Chinese media."[16] The commercialization of media itself is another example of the double-edged nature of reforms, as they resulted in a tremendous amount of economic activity in new content and consumption, but less control for the regime.[17]

Differences in approaches and the seriousness with which these debates were taken can be seen in personnel conflicts atop the Central Propaganda Department hierarchy. Deng Liqun, who had drafted the anti–Democracy Wall report that turned Deng Xiaoping against the movement in 1979, headed the department from 1981 to 1985, but his conservative leanings and connection to the Anti-Bourgeois Liberalization Campaign led to his replacement by the more liberal Zhu Houze.[18] Just two years later, Zhu himself lost the position, and the department was again helmed by a more conservative leader, Wang Renzhi.[19]

These tensions can be seen in action beyond bureaucratic reshufflings, such as in the shutting down of publications like *Freezing Point* (冰点周刊), a weekly supplement to *China Youth Daily*, an official newspaper controlled by the Communist Youth League, which suspended publication of *Freezing Point* in January 2006. Preceding the suspension, a new editor-in-chief—appointed by the CCP—"announced a plan to tie employees' compensation to how favorably senior officials viewed their articles."[20] While based on his statements Zhu Rongji, for one, might have appreciated hard-hitting criticism of corruption inside the Party-state, that perspective was not how this plan was viewed by those inside the newspaper. Li Datong, a senior editor with *China Youth Daily* and *Freezing Point*, responded in August 2005 with a "long and scathing letter" that the plan and the new editor "will enslave and emasculate and vulgarize the *China Youth Daily*."[21] This response was leaked to outsiders by other members of

[15] Brady 2008 also mentions cognitive dissonance.
[16] Brady 2008, 82.
[17] On commercialization of media, see Lynch 1999.
[18] Brady 2008, 40–1.
[19] Brady 2008, 41.
[20] Hassid 2008, 54.
[21] Hassid 2008, 54.

the editorial staff, where it received some notoriety, but no punishment came to Li immediately.

Li's fate changed following the publication of an article by Zhongshan University professor Yuan Weishi on how official middle school textbooks distorted history, emphasizing the humiliations inflicted on China by imperial powers.[22] Anti-imperialist nationalism had been a critical component of official CCP discourse, and indeed has been invoked consistently throughout the tumult of PRC history. Questioning official rhetoric on this touchstone proved dangerous, as the Communist Youth League decided to halt publication of *Freezing Point*. Li and his colleagues railed in public against the decision against them, calling for protests and giving some a sense that room for debate inside China's public sphere was expanding.[23] However, when *Freezing Point* returned in March 2006, Li and another top editor were gone.[24]

The information environment in China's Reform Era would also tighten in moments of political import. Some of these moments were regularly scheduled high-level meetings, such as the annual dual sessions of the National People's Congress and Chinese People's Political Consultative Congress in early March and the Party Congress every five years. Events would sometimes burst onto the scene in a flash that some insiders feared could spark a prairie fire.[25] For instance, a massive earthquake struck Wenchuan, Sichuan on May 12, 2008, killing more than eighty-five thousand people. The Chinese government fought to define this unbelievable tragedy in the public eye as a "natural disaster" rather than a "manmade catastrophe," despite in its own private analyses concluding the opposite.[26]

A disproportionate share of the earthquake's dead were schoolchildren. Echoing a 1998 phrase from Zhu Rongji about construction of low enough quality to be "a crime against the people," many saw collapsed school buildings lacking steel structural supports and called them "tofu dregs projects."[27] Two days after the earthquake, the official *China Daily* published a commentary explicitly questioning the quality of school construction.[28] Despite initial statements about transparency and a notably more open set of reports coming out of the earthquake-affected regions, including graphic imagery of buried

[22] Kahn 2006.

[23] Yardley 2006a.

[24] Yardley 2006b.

[25] To use the Maoist phrase. Many observers say even small adjustments in the scheduling of "regular" meetings are suggestive of either divisiveness of a given time or topic or its import.

[26] Sorace 2017, 5.

[27] "'Tofu Dreg Projects' are a Crime against the People" (Zhu 2015, 98). See also Sorace 2017, 1–7. Ang 2009 refers to a Tsinghua study that substantiates these impressions.

[28] *China Daily* 2008.

bodies and wounded victims, real constraints on who could say what persisted to guide the information environment.[29] In particular, those seen by the Chinese state as activists or provocateurs were targeted and held. Tan Zuoren, a schoolteacher, was arrested for "inciting the subversion of state power" in his efforts to collect information about tofu-dregs schoolhouses.[30] On August 12, 2009, the internationally famous artist Ai Weiwei was beaten with such ferocity for supporting Tan that he sought treatment abroad. Ai had put together a team to conduct a citizen investigation assembling information about the schoolchildren who died. Members of this team were arrested.[31] Rights advocate Huang Qi was also jailed, ostensibly for having what were nebulously defined as "state secrets," although the statements of his captors left little doubt that his organizing with the parents of deceased children was at the heart of his detention.[32] Most horrifying, dozens of these suffering parents were detained, and some were paraded through the city while bound, to send a message to others.[33] While "Grandpa Wen" (Wen Jiabao, so dubbed for his kindly public demeanor) and the central leadership cultivated a caring image over technocratic competence, repression and fear were never absent from the political system, especially at the local level.

The use of legal threats or intimidation are the classic hallmarks of censorship, defined by Margaret Roberts as "the *restriction* of the public expression of or public access to information by *authority* when the information is thought to have the capacity to undermine the authority by making it accountable to the public."[34] The Chinese information environment in the Reform Era has hardly been one note. While the Chinese government has instituted a "Great Firewall" to constrain the inflow of unwanted information from external online sources, it is a porous wall, able to be overcome by simple technologies such as virtual private networks (VPNs).[35] Similarly, while the work of crusading journalists and activist investigations are often quashed, the Chinese information environment is overflowing with an immense number of stories, data, social media posts, memes, and so on, many of which are far from what an official in the Propaganda Department might wish to see. Suppressing information, after all, is costly, with monitoring and enforcement costs, the potential for backlash, missed connections, and lost opportunities. Censorship can also be *too* overt: if

[29] CECC 2008.
[30] Sorace 2017, 5.
[31] Ai 2018.
[32] Sorace 2017, 5.
[33] Sorace 2017, 5.
[34] Roberts 2018, 37, emphasis in original.
[35] Roberts 2018.

a "too perfect" Potemkin village were presented, then the perception of the "free flow of information" would disintegrate.[36]

Beyond fear, the Chinese government censors use techniques that Roberts refers to as friction and flooding. Using a VPN to "jump" the Great Firewall is an example of an individual paying the "tax" for government-imposed friction.[37] There is no punishment for the individual accessing the information, nor for the creator disseminating it; instead, friction makes finding or acquiring information more costly in terms of time and money. A key advantage to the authority of friction compared with fear is that "it does not need to be observable to be effective."[38] Its plausible deniability lowers the probability of friction inducing backlash, as "international websites load too slowly or perhaps have been blocked" is a weak rallying cry. Friction occurs at both the distribution and the collection of information stages, although in authoritarian contexts like China's, restrictions on the collection of information tend to be paired with fear-adjacent potential sanctions.[39]

Along with deletion, censorship can also take the form of distraction. Flooding is "the coordinated production of information by an authority with the intent of competing with or distracting from information the authority would rather consumers not access."[40] Contrary to the notion that more information is always better, in an information-saturated age flooding taxes the consumption of good information by burying it amid low-quality, distorted, or irrelevant data.[41] *Xinwen Lianbo*, CCTV's daily evening news program, is a quintessential example of flooding; during its thirty-minute broadcasts, Chinese leaders are always depicted as governing triumphantly and the statistics are always above average.[42] A "fifty-cent party" has also emerged, a derisive name for Chinese on social media who post regime-supporting information.[43]

Citizens, even in democratic societies where they are called upon to select their rulers who act at their behest, exhibit "rational ignorance."[44] The Reform

[36] Roberts 2018.

[37] Roberts 2018, 58–9.

[38] Roberts 2018, 59. To be sure, different individuals may experience the same website-loading failure or delay in disparate ways, one being oblivious to potential repression while the other might legitimately fear that their action has been flagged by the authority.

[39] That being said, many corporations seem to flout official regulations about the collection and dissemination of information in China. The statistics law makes independent collection extremely knotty.

[40] Roberts 2018, 80.

[41] Roberts 2018, 80.

[42] Roberts 2018, 83.

[43] At the behest of the government directly or as if so directed. See, e.g., King, Pan, and Roberts 2017 for more on the bureaucratic fifty-centers.

[44] Roberts 2018, 30.

Era's information environment was open compared to what had preceded it under Mao. Ignoring high politics was increasingly an acceptable option rather than being antirevolutionary. Yet events often arose that would have commanded citizen attention, had relevant information not been prevented from being either collected or disseminated.

For example, the Chinese media system suppressed news about the severe acute respiratory syndrome (SARS) outbreak. In November 2002, a deadly new respiratory illness seemed to be emerging out of Guangdong at the same time as critical moments in the generational change in national leadership from Jiang Zemin to Hu Jintao. The 16th Party Congress took place that November, and directives had been circulated to the media that "in order to create a good atmosphere during the leadership transition, editors were instructed to focus on positive news from the congress and up until Chinese New Year 2003" in early February.[45] Despite the disease's rapid spread around the country and internationally, where it received coverage starting in February 2003, the domestic media suppressed reporting on SARS until April.[46] China was lambasted for its secrecy and received "massive international censure" for its lack of transparency. Yet while some senior and midlevel officials from both the propaganda and health bureaucracies were demoted, the episode "only resulted in small, but not systemic change" in the propaganda sector.[47]

The information environment's general shape is set by the regime's center. Commercial media exist but are watched. Social media companies hire their own censors to delete posts that they either proactively assume the center wishes to see deleted or as proscribed in directives by the authorities.[48] Most such posts are never written, or even contemplated, by a populace aware of the overall nature of their political system or unwilling to tread too close to the line of unacceptable action.[49] The regime has spent considerable resources shaping the language that it and others use to describe events, although disputes remain at the level of language as well as the purposes that such language suggests.[50]

[45] Brady 2008, 57.

[46] Brady 2008, 57.

[47] Brady 2008, 57. Of note, China's political prioritization of marginalizing Taiwan also had real consequences during the SARS outbreak when Taiwanese scientists faced difficulty accessing World Health Organization information because they were not members of the organization (Cyranoski 2003). Taiwan received observer status at the World Health Assembly in 2009 (deLisle 2009).

[48] See King, Pan, and Roberts 2014.

[49] On the benefits of such fuzziness, see Link 2002; Stern and Hassid 2012.

[50] See Brady 2008, 2012; Sorace 2017.

Local Harms and Hidden Things

> Some cheat and lie to their superiors and subordinates, only report the
> good news but not the bad, cover up conflicts and problems, fool the
> people and their superiors.
> —Hu Jintao, January 12, 2004, reprinted in Hu 2016

Beyond the national-level information environment, the system of limited,
quantified vision led to local officials acting in ways that produced numbers but
hid other realities. The harms and hidden things that locals attempted to keep
from the center are legion. This section focuses on some of these that festered
in the system's blind spots: the one-child policy, pollution, industrial accidents,
protectionism, overcapacity, corruption, and falsification by local officials.

One-Child Policy

The quantification of the one-child policy is obvious from its name, and its
convoluted, quantified origins are described in Chapter 4. Family planning
often served as a veto target for officials, making it a high-priority item, often
implemented in draconian fashion. Women pregnant outside of the plan were
coerced into having abortions, and sterilizations proliferated.[51] Knowing how
tightly enforced the policy was and following cultural preferences for male heirs,
many Chinese terminated pregnancies, committed infanticide, or abandoned or
hid their children, especially girls, from the state.[52] The increase in China's male-
biased sex ratio in the population from 108:100 in 1982 to 119:100 in 2000 is
largely attributable to the one-child policy.[53] China's fertility rate declined sig-
nificantly, both before the one-child policy in the 1970s and then continuing
through the 1980s and early 1990s, when it stabilized at about 1.6 children
per woman, far below the replacement rate of 2.1.[54] Yet for decades, the system
continued to forcibly control women's bodies. In 2012, authorities took Feng
Jianmei, a twenty-three-year-old expectant mother in Shaanxi, to a hospital,
where she was blindfolded and forced to sign a document without being able

[51] See Whyte, Feng, and Cai 2015, 151.

[52] For a historical perspective on China's "missing females" issue, see Coale and Banister 1994.
See also Kennedy and Shi 2019. The 2019 documentary *One-Child Nation* explores in wrenching
fashion the toll that the implementation of family planning policy placed on Chinese.

[53] Li, Yi, and Zhang 2011.

[54] As mentioned in Chapter 4 and as Whyte, Feng, and Cai 2015 emphasize, the one-child policy
is only one part of this shift. Obviously it cannot account for decreased fertility in the 1970s, prior
to its enactment, and economic development is likely as responsible for subsequent changes as the
family planning policy.

to read it.[55] She was seven months pregnant and knew she was in violation of the one-child policy, but she could not afford the 40,000 yuan "excess birth" fee quoted to her by local officials. Images of the grim aftermath of her forced abortion went viral, and fury over the cruelty and inequity of the system raged.[56] Numbers took precedence over people, even children.

Pollution and Mining Accidents

At present some comrades have a short-term perspective—they care only about results in the near term and often blindly give orders when dealing with the relationship between developing the economy and protecting the environment. They rush to start projects and don't even care if these destroy the environment and create pollution.
—Zhu Rongji, October 25, 1993, reprinted in Zhu 2013

The scale of harm produced by China's pollution, including soil and water as well as air pollution, is staggering, as seen in a World Bank estimate from 2007 that pollution killed 750,000 Chinese every year.[57] While air pollution issues have captured the attention of both citizens and the regime in the past decade, it is critical to remember that they are comparatively visible and easily quantified.[58]

Elizabeth Economy's chronicle of Chinese environmental issues during the Reform Era, *The River Runs Black*, uses the Huai River to exemplify the challenges the regime faced and the twists and turns it took to alternately address and ignore them. In the summer of 2001, 38 billion gallons of highly polluted water flowed down the Huai, devastating fish, plants, and water supplies for 150 million people. Word of the disaster struck deeply because the river had been pronounced clean just a half-year before. That bill of health followed campaign-style efforts to clean the river, although some cast doubt on the proclamation and said that it was based on "false figures."[59] Beyond air and water pollution, desertification, diminishing forests, and the redistribution of water increasing both flooding and scarcity confronted China in 2004. While acknowledging variation over space and continuities from traditional attitudes lacking an "ethos of conservation,"[60] Economy argues that "China's environmental practices are overwhelmingly shaped by the dramatic process of economic and political reform,"

[55] Osnos 2012.
[56] Langfitt 2012.
[57] Barboza 2007. The World Bank's report includes water pollution as well.
[58] The previous chapter discussed air pollution issues that China faced by the mid-2000s in comparing the failed Green GDP initiative and the successful takeoff of PM2.5.
[59] Economy 2004, 1, 7–8.
[60] Economy 2004, 17.

highlighting the "devolution of authority to local officials" and "weak and underfunded" environmental protection bureaus.[61] Prioritizing growth over the environment followed not just from the institutional apparatus described above but also the personal economic interests of officials themselves, who tended to have strong connections with—indeed, even ownership of—polluting indus-trial enterprises.[62] Environmental bureaus were often overwhelmed not just by higher-ranking government officials with conflicting priorities but by the struc-tural reality that the enterprises they were mandated to regulate often outranked them as well.[63] Downwind and downstream pollution imposed costs beyond the local jurisdictions of the officials overseeing their point sources, a classic externality.

Many of the air pollution problems plaguing the country arose because China's growth during the Reform Era was largely fueled by coal, which peaked as a share of electricity production in 2007 at almost 81%.[64] But Chinese coal killed citizens more directly than through air pollution. Despite accounting for "less than 4 per cent of the broadly defined industrial workforce," the coal sector produced "over 45 per cent of industrial fatalities" and saw death rates over ten times those experienced in Russia or India.[65]

Dismal statistics like these can be paired with individual stories that detailed corruption and malfeasance, as in a tin mine accident that Zhu Rongji described as a tragedy. He claimed he learned about it from an intrepid *People's Daily* reporter:

> The owner of that mine had bought off the leading cadres, including the Nandan County Party Secretary and magistrate. He operated this mine on his own without any safety measures. The workers he hired were all poor people from Hunan and Guizhou, with no one to care about them when they died. Once the waters rushed in, those 70 to 80 people were inundated, yet the county covered it up and said there had not been a single fatality.[66]

Such cases of corruption were "a serious embarrassment to the leadership." During Chinese New Year celebrations in 2003, "Vice-Premier Wen Jiabao

[61] Economy 2004, 20.

[62] Economy 2004, 20.

[63] Lorentzen, Landry, and Yasuda 2014; Economy 2004, 109.

[64] Only after the centrality of air pollution increased with the public outcry about the airpocalypse did coal's share start to plummet, by 2016 dropping below 70% for the first time in a quarter-century (World Bank 2017).

[65] Wright 2004, 629–30.

[66] Zhu 2015, 317.

shared dumplings with coal miners 500 meters underground and urged officials to give priority to improving coal safety."[67] Unlike general pollution figures, which steadily climbed with development in the 1980s, the statistics for mining safety had been improving before reversing course in the mid-1990s.[68]

Yet, like other numbers produced by the system of limited vision, many observers saw statistics on mining accidents as distorted by strong incentives to underreport harms.[69] Tim Wright argues that dependence on the resources themselves or the funds they generated led to local governments being captured by the mining industry and willing to look the other way when safety protocols fell by the wayside; this happened in "Jiawang township in Xuzhou, where 92 miners were killed in an explosion in 2001, [and which] received 30 per cent of its revenue from small coal pits."[70] At other times, local businesses like Maotian, Hebei's tobacco-drying industry, could not afford legally mined resources that came from a distance and so pressured local officials to allow illegal local mines to remain open.[71] When safety campaigns did come through, they were often treated—rightly—with skepticism; workers felt that such campaigns were about favoring some firms over others instead of actually putting the safety of workers first, so they tended to prioritize their income over their own safety.[72]

A 2004 policy from the State Administration of Work Safety exemplifies the reliance of the system on quantitative targets and its limitations.[73] The measure laid out a series of provincial-level targets aimed at reducing accidental deaths by 2.5% that year. While apparently successful, as seen in the provincial results published in People's Daily, Raymond Fisman and Yongxiang Wang present overwhelming evidence that these statistics were manipulated. In particular, their research focuses on the "death ceiling," or the maximum number of accidental deaths that a province was allowed in a given period of time. These statistics were tied to officials moving up in the political hierarchy, with the slogan "No safety, no promotion."[74] While one might expect something like a normal distribution given this kind of data, and the official statistics appear to have a reasonable shape below the ceiling, manipulation is clearly seen by the almost

[67] Wright 2004, 629–30.

[68] Wright 2004, 631–2.

[69] Wright 2004, 631–2. "As with other Chinese statistics, those for coal mining fatalities are unreliable. Mine owners and local governments have many incentives to conceal accidents, and this has become a major concern in China's press. Actual numbers of fatalities are almost certainly much higher than those reported."

[70] Wright 2004, 642.

[71] Wright 2004, 642.

[72] Wright 2004, 643–4.

[73] Jiang 2004; Fisman and Wang 2017.

[74] Fisman and Wang 2017, 203.

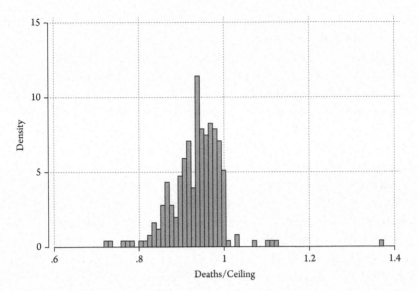

Figure 6.1 "No Safety, No Promotion" Leads to Data Manipulation. The figure provides a histogram of the ratio of overall reported accidental deaths to the government-mandated ceiling for provinces from 2005 to 2012, replicating Fisman & Wang 2017, Figure 1.

total drop-off of reports at or above the ceiling. Figure 6.1 shows this pattern and indicates falsification of data.

To be clear, even as it induced falsification the campaign-style action was successful, and coal-mining safety did improve during this period of higher scrutiny. Official death numbers plummeted from nearly 6,000 in 2005 to 2,000 in 2011 and only 375 in 2017.[75] That is, echoing the broader theme, targeting and quantification simultaneously led to both improved outcomes and distorted data.

Local Protectionism

China's gradual transition away from a planned economy induced many distortions over the decades. Particularly nettlesome were transitions related to prices and taxes.[76] Dual-track pricing—that is, the economy simultaneously possessing market and planned prices for the same items—led to feverish competition for producers and consumers to get goods at the much cheaper (usually planned) price rather than the higher (usually market) price. The tax system distorted investment decisions, as the profitability of a firm depended less on how it was run than on "pricing and their tax rate."[77] Yet these

[75] Wright 2021.
[76] See Weber 2021 on 1980s price reform debates.
[77] Xue 2011, 83.

problems were exacerbated by the system of limited vision, with its emphasis on interjurisdictional competition.

In the 1980s local officials were judged on the economic performance of their jurisdictions, many of which contained systematically underpriced but valuable commodities. That some officials acted to capture that value lest it be "lost" to others outside of the jurisdiction is hardly surprising. Yunnan's 1981 economic plan bluntly directed that "purchasers should not look to producers outside the province to purchase products."[78] In 1983, "the central government complained" that cement, rolled steel, iron, coal, lumber, and more goods that had been intended for various local state-owned enterprises had been "diverted" by local governments.[79] Placing restrictions on the import or export of goods at the subnational level, referred to as local protectionism, ran rampant.[80]

Andrew Wedeman highlights cotton, tobacco, and wool as commodities that experienced these kinds of "wars." Cotton production more than doubled from 1981 to 1984, from 3 million to 6.2 million tons, with only a modest 7.5% increase in state procurement prices.[81] Unlike with most goods, the surge of production actually led to a period when planned prices temporarily exceeded market prices, and procurement stations took advantage, pushing for concessions from farmers rather than paying the official planned price, for instance paying the low-quality price for high-quality cotton.[82] The next year, farmers drastically cut back on production, sowing only 75% of the land that they had in 1984, and by 1986 production levels were back to 3.5 million tons.[83] In the interim, however, domestic demand for cotton had only increased, as major investments in processing had been made. The subsequent shortage led to hoarding behavior by local governments, "coercive" measures being used by purchasers of different stripes, and top-level governments "dispatched 'cotton purchase inspection groups' to patrol 'hot spots' along provincial borders."[84] At the level of regions, "the cotton war pitted cotton-growing regions against manufacturing regions as the former embargoed exports and starved mills in the latter, prompting buyers from manufacturing regions to 'attack' cotton-growing regions in search of supplies."[85]

Other conflicts had their own peculiarities but echoed the overall patterns. Compared to the cotton conflict, the wool war more deeply involved speculators

[78] Wedeman 2003, 83.
[79] Wedeman 2003, 83–4.
[80] Wedeman 2003, 84–5 separates export protectionism and import protectionism in his analyses
[81] Wedeman 2003, 91–2.
[82] Wedeman 2003, 92.
[83] Wedeman 2003, 92.
[84] Wedeman 2003, 95.
[85] Wedeman 2003, 107.

rather than different direct producers or users, and additional complications arose because of an alternative path to economic value for sheep (meat production as mutton).[86] A tobacco war followed the same battle lines as the cotton war, as agricultural and industrial production of cigarettes was spatially distinct.[87] Tax policies encouraged overinvestment in cigarette manufacturing facilities; as a Guizhou official put it, "[When] taxes on the sale of cured tobacco are 36%, taxes on cigarettes are 60%, who doesn't want to set up a tobacco factory?"[88] The waste from interjurisdictional competition, then, was twofold: significant efforts went into local protectionism to guard rents from price system distortions, and uneconomical overinvestment in factories was made to capture such rents and taxes. However, local protectionism was only part of China's overcapacity problem.

Overcapacity, Slums, and Ghost Cities

> The overall economy performed really well last year despite many hidden problems that may gradually come to light this year. At present, many sectors—especially urban construction—show a tendency for overkill, extravagance, and disregard for realities. The "Happy Homes" project hasn't been resolved, and ordinary people still find a great deal of housing unaffordable at over RMB 10,000 per square meter. For whom is this being built?
> —Zhu Rongji, "Halt the Tendency to Blindly Seek Increases in Urban Size," January 9, 2002, reprinted in Zhu 2015

While less dramatic than the instances of local protectionism in the 1980s highlighted above, local officials continued to push for overinvestment in enterprises, infrastructure, and real estate to generate the numbers that the cadre evaluation system craved. The rise and fall of TVEs from the early 1980s to the mid-1990s presents a separate lens on this issue. China's rural industrialization was critical to the economy, but the forces supporting rapid growth in TVEs nosedived as the marketplace went from underdeveloped to saturated to inundated with small-scale rural producers.[89] These small firms along with mining concerns are telling examples, but the massive economic risk from overcapacity emerged as the construction and real estate sectors took a more central role in China's growth trajectory.

China's rapid urban development has generated "urban sickness" (*chengshi bing*), two elements of which are a picture of contrasts: empty swaths of newly constructed apartment complexes next to dilapidated structures teeming with

[86] See Watson, Findlay, and Yintang 1989 on mutton; Wedeman 2003.

[87] Wedeman 2003, 113–4.

[88] Wedeman 2003, 116.

[89] Naughton 2007, 275–82.

people.[90] The system of limited, quantified vision interacted with remnants of China's planned economy— particularly the household registration (*hukou*) system and state ownership of land—in ways that produced these outcomes.

Since the Household Registration Law's passage in 1958, people have been registered in particular places and classified as agricultural or nonagricultural.[91] City governments separated their populations into urban (nonagricultural) locals, rural agricultural locals, and nonlocal *hukou*-holding migrants. Under the planned economy, the *hukou* system was the main way the regime limited freedom of movement within the country and into cities.[92] With Reform Era relaxations, migration became more common, yet firms, the state, and locals discriminated against migrants, treating them as second-class citizens.[93] Citizens' *hukou* status has been determinative of the social services they can utilize, with urban locals receiving services and nonlocals unable to access them. Further, city leaders counted their populations based solely on household registration, with migrants (nonlocal *hukou*) left out of the population (but not GDP) statistics.[94]

Land in China is classified as urban and rural, and subclassifications carry their own restrictions; importantly, local governments have significant control over the usage of land in their jurisdictions and often have the ability to convert the designation of land from rural to urban.[95] Chinese cities have operated under severe fiscal pressures, budget constraints, and restrictions on revenue generation that push them to convert land into urban construction to capture some of its value through leases.[96] Building high-rises generated GDP and the appearance of successful modernity, while those working on construction sites and residing in slum-like conditions went unseen and even uncounted. This set of blinders on state vision encouraged planning that did not focus on the full urban population but only the subset of those registered as locals.[97]

[90] Sorace and Hurst 2016; Woodworth and Wallace 2017; Baik and Wallace 2021.

[91] For more on the history of the *hukou* system in China, see Brown 2012; Chan 1994; Solinger 1999; Wallace 2014.

[92] Cheng and Selden 1994, 644–5. See also Solinger 1999; Wallace 2014.

[93] Solinger 1999.

[94] One effect on the statistical system of this lack of vision is the invalidity of almost all per capita figures in urban areas, since the denominator for much of the past three decades was hukou population. This issue has been mostly resolved since 2010, although the actual date of changing from registered population to total resident population varies across Chinese cities and provinces. See Gibson and Li 2017.

[95] See Hsing 2010; Rithmire 2015.

[96] See Hsing 2010. The 1994 fiscal reforms that recentralized revenues led localities to rely on land conversions and leases to generate funds.

[97] The very legal context that separates rural from urban and underlies the discriminatory practices against migrants in cities has long been thought of as likely to change. Indeed, in 2008, headlines had been proclaiming the demise of the *hukou* system for so long and so often that one

At the same time, the evaluation system has not prioritized the transition of rural migrants into full urban citizens. While low-wage migrant labor helped power China's industrial rise and the development of cities, urban leaders demurred from treating these workers as full citizens for political and budgetary reasons.[98] Urban locals have taken to the streets when their privileged access to social services has been compromised.[99] From a budgetary perspective, such expanded access would be dear, requiring massive education, healthcare, and pension investments. In 2011, Chongqing estimated the cost for turning a migrant into a full city resident at 67,000 RMB, even without accounting for pensions.[100] Granting access to regular urban benefits, including pension programs, to the country's nearly 300 million migrants would entail costs measured in the trillions of RMB.[101]

Debt

China has seen an explosion of debt during the Reform Era. The first wave of debt expansion came from collapsing SOE profitability due to dual-track pricing.[102] Firms that had relied on retained profits or direct state spending to fund investment were forced to switch to loan financing through the state-dominated banking system.[103] Waves of debt crashed into nonperforming status, and the central government bailed out the banks that had loaned the money multiple times through various measures, such as the creation of asset management companies that took the loans off the banks' balance sheets.

The debt explosion reached another order of magnitude with the global financial crisis. The central government funded only 1.18 trillion yuan of the 4 trillion fiscal stimulus, leaving local authorities to raise the remainder. As discussed in the previous chapter, the financial stimulus was far larger, with credit expanding by 13.5 trillion yuan in 2009.[104] Prior to the crisis, the nonfinancial sector's

set of authors felt the need to clarify that the system was actually still up and running despite the headlines, which have continued (Chan and Buckingham 2008).

[98] See Solinger 1999; Wallace 2014. On the more contemporary period, see Friedman 2018.

[99] In December 2012, for instance, a group calling itself the Shanghai Defense Alliance took to the streets to protest migrant workers and their children taking advantage of the Shanghai school system (Cohen 2012).

[100] See Miller 2012, 56–7.

[101] Miller 2012. If one takes that 67,000 RMB figure seriously, then estimates approach 20 trillion RMB.

[102] See Xu 2019 for more detail on connections between local government financial platforms and urban development.

[103] Naughton 2007, 304–5.

[104] Shih 2020.

credit-to-GDP ratio had been holding relatively steady around 140%, but by the end of 2009 it had jumped to 180%.[105]

Moving from the national to the provincial, because China's Budget Law (Article 28) explicitly prohibited local governments from resorting to market borrowing by issuing municipal bonds, local governments wanting to access financial markets created companies most commonly referred to as local government finance vehicles (LGFVs). To meet capital requirements for bank loans and bond purchasers, public assets, such as use rights to land, budget revenues, and existing infrastructural assets such as roads, bridges, subways, and so on, have been injected into LGFVs.[106] LGFVs thus have become the main financing agents for local governments.[107]

The mushrooming number of LGFVs has been accompanied by rapidly increasing local debt. In May 2009, statistics from the China Banking Regulatory Commission showed there were 8,221 LGFVs that had been formed at the provincial, prefectural, and county levels. According to a 2011 report by the National Audit Office, local government debt had already reached 5.57 trillion RMB prior to the global financial crisis, mainly in the form of bank loans.[108] Encouraged by the central stimulus package and the proliferation of LGFVs, by the end of 2010 local government debt had almost doubled, reaching 10.7 trillion RMB, with 4.97 trillion RMB debt held by LGFVs. The total local government debt equaled 27% of GDP in 2010.[109] Data on urban investment bonds from Wind's Financial Information Database shows the stunning increase in LGFV activity following the global financial crisis. Total issuance in the three years prior to the crisis (2006–8) was only 32.3 billion RMB, while from 2009 to 2011 that same figure was almost ten times as much—314.8 billion RMB—and 2012 saw another leap, to 574.6 billion RMB.[110]

LGFVs and governmental debts are far from the only area of concern. The property sector, principally construction and real estate developers, has expanded beyond actual demand for housing, as described above, and done so fueled by copious amounts of debt. A 2015 McKinsey study estimated that 40% to 45% of Chinese debt was connected to the property sector, including household mortgages, real estate firms, firms with deep ties to real estate development

[105] BIS 2021. An IMF research paper sees just a 35% jump by 2011 (Chen and Kang 2018, 5).

[106] Lu and Sun 2013; World Bank 2009.

[107] The first such company was established in July 1992 by Shanghai's municipal government to raise money for Pudong's development, and the relevant official, Huang Qifan, took this innovation with him to Chongqing in the early 2000s.

[108] National Audit Office 2011.

[109] National Audit Office 2011.

[110] Data from Wind. See Xu 2019.

such as materials and metals, and governments.[111] Overall, that study estimated a nonfinancial sector debt-to-GDP ratio of 282% by the middle of 2014.[112]

Corruption

Corruption was both the genius and the comeuppance of the system of limited, quantified vision. Decentralization inspired initiative by lower-level officials, in part by allowing them and theirs to profit personally from the new development agenda rather than resisting their more complete authority over the territories eroded at the beginning of the Reform Era. However, in the years leading up to and after the global financial crisis, corruption's pervasive stench threatened the regime deeply. Yet the corruption narrative in the Reform Era was not a straight line; instead, it morphed in response to various efforts to curtail it, until it grew to massive proportions. While never descending to the growth-destroying ends of full kleptocracy, the political viability of the regime came into question, as both insiders and outsiders increasingly came to view its social purpose as enriching officials and those connected to them.[113]

Greasing the wheels of reform, officials engaged in all manner of corrupt dealings throughout the 1980s. The price wars discussed above were but one of the many opportunities that officials used to take advantage of the dual-track price system for their own personal gain. The incidence of corruption was roughly constant during the 1990s, but that statistic masks an important shift, as corruption "intensified" during the decade.[114] Lower-level officials demanding small-scale payments from individuals were replaced by large-scale cronyism by higher-level officials.[115] Privatization of state- or collective-owned firms, including many of the TVEs that were critical to China's economy taking off under reform, was an opportunity for corrupt officials or their confidants to purchase assets at fire sale rates, transferring significant wealth from public to private hands.[116]

In the late 1990s, and in the wake of the Asian financial crisis, Zhu Rongji initiated a "modern rationalization drive" to improve governance and cut down on corruption, including "standardizing budget planning and implementation,

[111] Dobbs et al. 2015.

[112] By contrast, the BIS data show a debt:GDP ratio of "only" 218% (BIS 2021).

[113] Wedeman 2012; Ang 2020.

[114] Wedeman 2004.

[115] Wedeman 2004, 2012; Ang 2020.

[116] Ang 2020, 59. Ang notes that this privatization's limited scale differed from those in the Soviet Union, where shock treatment created oligarchic power by transferring so much state wealth into the hands of so few, while China's efforts in the early 1990s created a broad class of private entrepreneurs.

establishing a single treasury account system, adopting procurement rules ... and promulgating a new Civil Service Law."[117] These efforts cut down on petty corruption—misappropriation of funds and demands for bribes—but did little to "restrain [officials] from collecting grand transactional rents."[118] To be sure, such mundane bribery demands continued to exist throughout this period; especially difficult to eliminate were the "peasant burdens" that central efforts tried to rein in by remaking rural state finance and ultimately abolishing agricultural taxes.[119] The existence of bulk markets in fraudulent tax invoices used to circumvent tax authorities and by officials to supplement their salaries with reimbursements for nonexistent purchases belied the system's limitations in dealing with corruption.[120] What these reforms were unable to curtail was cronyism and intensification of corruption in land deals, reflecting the 1994 fiscal reforms shift that gave local government authorities more control over land use.[121]

Yet giving favored players access to underutilized state-controlled assets at low costs was pro-growth corruption, consistent with the overall system of limited, quantified vision.[122] Such transactions contributed to local government numbers twice: first, the revenue from the initial land sale; second, the subsequent development occurring on that land. Both were quantified elements core to the cadre evaluation system. Left uncounted was the value of the resource that was transacted. The theft occurring was notional rather than tangible; the funds coming to the state were not what they could have been—money left on the table rather than collected for the public purse. While the cronyism provided windfalls for developers with connections, who purchased land at deep discounts compared to normal prices, more immediately the firm in question would have significantly more funds after acquiring the land than if it had paid the full price to procure and transform it in ways that would subsequently boost GDP.[123]

The scale of such discounted pricing can be enormous. Firms connected with Politburo elites or other princelings often paid less than half the going rate for a given parcel, as shown in Ting Chen and James Kung's large-scale 2019 study of land transactions.[124] Along with his family, Zhou Yongkang, a Politburo

[117] "[M]odern rationalization drive" is Yang 2004, cited in Ang 2020. List is from Ang 2020, 60.
[118] Ang 2020, 60.
[119] See Oi 1999; Bernstein and Lü 2002; Wallace 2014.
[120] Barboza 2013.
[121] On land use and the 1994 fiscal reform, see Rithmire 2015.
[122] Ang 2020 refers to these kinds of grand graft cases as "access money."
[123] For more on the pro-growth features of "access money," see Ang 2020.
[124] Chen and Kung 2019. In a study of over one million land transactions, Chen and Kung find that politically connected firms receive discounts for land of 55% to 59% compared with unconnected firms. Anecdotes along these lines are legion (e.g., Barboza and LaFraniere 2012).

Standing Committee member under the Hu and Wen leadership team, was said to have acquired over 100 billion yuan worth of land and coal assets while paying only 150 million yuan.[125] Given that land revenue supplied upwards of 30% of total government revenue in 2011, such discounts significantly undercut the public purse.

More broadly, the estimates of corruption's scale—and particularly the wealth flowing to political elites, their families, and connections by 2012—were incredible. Shanghai Party Secretary Chen Liangyu was deposed in part due to misallocation of investments from the city's 10 billion yuan Social Security Fund.[126] Journalist Mike Forsythe found documentary evidence that Xi Jinping's family (although not the future leader or his wife) had accrued a fortune estimated in the hundreds of millions of dollars.[127] Similarly, *New York Times* reporter David Barboza exposed Wen Jiabao's family for amassing $2.7 billion in assets, largely through shares of the insurance giant Ping An.[128] Desmond Shum's memoir of his own travails among these superelite players provides color and names in Chinese corruption in this period. Overall, Yuen Yuen Ang estimates that China's level of corruption in this era came close to matching that of the United States during its first gilded age at the turn of the twentieth century.[129]

The first gilded age in the United States was overthrown by mass actions— wildcat and union-organized strikes, protests, and votes—and elite defections seizing on the frustrations of those not benefiting from the tremendous wealth being generated. Similarly, Chinese corruption was becoming a life-threatening ailment for the regime. While Chinese corruption practices were neither directly growth-inhibiting nor infuriating to the masses, as getting hit up for bribes on a daily or monthly basis might be, they siphoned immense wealth to insiders. This preference for insiders undermined belief in the system's meritocratic nature and in the fairness of the market mechanism as a system of allocation, but also directly implicated governance outcomes and undermined symbolic successes of the regime. Deadly food and drug safety scandals made the execution for corruption of Zheng Xiaoyu, the head of the Chinese Food and Drug Association, feel proportionate. The July 2011 crash of two high-speed trains on the outskirts

[125] Chen and Kung 2019, 194n11.

[126] Although his final conviction found only $340,000 directly for him. The head of NBS, Qiu Xiaohua, was also caught up in this scandal and removed from office (Barboza 2008).

[127] Forsythe 2012. In a report for *Bloomberg News* that led Bloomberg Inc. to fire him to protect its China business interests (terminals). See Forsythe 2014 for scale.

[128] Barboza 2012. Akin to the early dual-track pricing situation, opening new markets, like life insurance, can create massive opportunities for profit, and hence for graft. See also Shum 2021.

[129] Ang 2020. "First" gilded age, as many have come to see the post-2000 United States as in a second gilded age.

of Wenzhou killed dozens, and subsequent investigations depicted the minister of railways as a gilded-age boss.[130]

Corruption also abetted substantial growth in inequality. While official measures present estimates of income inequality that put China in 2012 on par with the United States at that time (GINI coefficients of 0.474 vs. 0.45, respectively), survey-based estimates suggest that the official number understated the true level of inequality by 10% or more.[131] Wealth inequality is even greater, with the top 1% owning more than 33% of household wealth in China.[132] Even if individuals' financial situations were improving objectively, for many people the subjective experiences of that improvement were diluted by feelings of relative decline amid a growing sense of a hyperelite with resources and connections locking itself into an oligarchic grasp of power.[133] The disconnect between one's own experiences and the aggregate economic trends as published by state sources was further exacerbated by distrust of official statistics.

Falsification

> I once said that when you do economic work in China, you should not put too much trust in figures.
> —Zhu Rongji, "Put 'Accuracy' Foremost in Statistical Work," October 28, 2002, reprinted in Zhu 2015

In the chapter's epigraph, Li Keqiang's dismissive "smiling" when queried about the quality of GDP statistics suggested that the system of limited vision could provoke not just urgent action to meet targets but, on occasion, actions that falsified the data to suggest a target had been hit when it was actually missed. But despite general belief in falsification's prevalence, documentation is relatively scant.[134] Lily Tsai used survey data to show falsification of income statistics at the village level in China.[135] Some court cases and self-criticisms have also referred to falsification. As in the example of deaths from mining accidents, the distribution of many raw Chinese statistics appears skewed, often to fit above rather than below some symbolic statistic. Figure 6.2 provides an example using

[130] Osnos 2012.

[131] See Xie and Zhou 2014. See also Piketty, Yang, and Zucman 2019. A Southwestern University of Finance and Economics study using the China Household Financial Survey had an eye-wateringly high level of 0.61 that received a lot of attention, but that seems to be an outlier.

[132] Xie and Jin 2015. Wealth inequality GINI was estimated at 0.73 in 2012. Piketty, Yang, and Zucman's 2019 number is not as high.

[133] The Hurun Rich List debuted in 1999. There were no dollar billionaires in 2003, 101 in 2008, 130 in 2009, and 251 in 2012 (Hu 2009; GlobalPost 2012).

[134] Some examples include Li and Cheng 2012; Ang 2016.

[135] Tsai 2008.

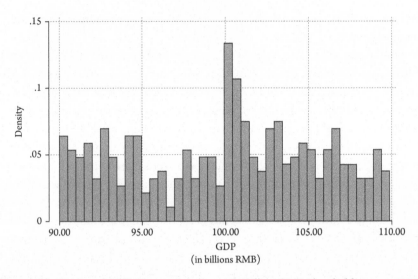

Figure 6.2 City-Level GDP Clusters Just Over 100 Billion RMB Threshold. Source: CEIC 2019, city-level data from 1994 to 2018. See Lei and Zhou 2022, Appendix Figure A6.

city-level GDP data, showing cities as much more likely to cluster slightly above 100 billion RMB than just below, likely connected to a policy that cities above this threshold were made eligible for subway funding.[136]

Wallace provided evidence of GDP falsification timed with political change, using provincial-level data.[137] Consider the dilemma of falsifying data. The principal constraint on the manipulation of economic data is the expected cost of such fraud being exposed. This expected cost has two components: the *cost* and the *likelihood* of exposure. While at any given moment there might be a political or economic upside to juking the stats to send a positive signal, if exposed, this fraud could destroy the regime's credibility and carry with it substantial downside risks. For a regime, investment levels would fall due to heightened uncertainty, and future statistics could be dismissed as cheap talk. For a subnational official, likely consequences include official reprimands, reduced promotion trajectory, termination of employment, or arrest.

Subnational leaders may be rewarded on the basis of manipulated data since monitoring costs make it difficult for central authorities to know the real situation on the ground. Questioning the veracity of economic statistics quickly leaves the social scientist without sure footing. Once one entertains the possibility that economic data are manipulated, how can one devise a research design that can show this to be the case? The difficulty becomes finding data that should

[136] Lei and Zhou 2022.
[137] Wallace 2016.

be relatively free from such influence and thus useful for evaluating the extent of manipulation.

One way to address this issue is to leverage variation in the likelihood of data manipulation over two dimensions. First, some *types* of data are more politically sensitive and hence likely to be manipulated than others. Second, some *times* are more politically sensitive than others, so data reported at these times should show more evidence of tampering than at other, less sensitive moments. GDP, which is both an abstract concept and the star measure among national statistics series, is more likely to be manipulated than its close correlates, electricity production and consumption. When electricity data and GDP data diverge, controlling for real sources of such divergence, manipulation of the GDP series is a possible culprit.[138] Second, incentives to manipulate are likely to vary over political cycles. With promotions on the line, subnational leaders might engage in overestimation of GDP growth at moments of political turnover as a signal of competence and success. A newly installed leader might initially tamp down growth numbers to later show improvement over time during their tenure in a locality. Separately or together, these data manipulations are artifacts of the political incentives of leaders and exist in the statistics rather than the real economy; that is, they represent a *reported* political business cycle.[139]

The *juking-the-stats hypothesis* holds that in years with elite political turnover, the difference between GDP and electricity growth rates should increase. These moments are highly politically sensitive and so should exhibit particular pressures to report GDP data in excess of actual growth rates.

The data to test the juking-the-stats hypothesis come from a number of different sources and timescales. The units of analysis are the province-year from 2000 to 2009 and the province-quarter from 2001 to 2008. The dependent variable for the annual analysis is the reported real GDP growth figure minus the electricity consumption growth estimate. For the quarterly analysis, the dependent variable is the difference between the economic growth series and the electricity production growth series.[140] The independent variable for both the

[138] Economists looking for the size of the "unofficial" economy in different countries have similarly compared electricity and GDP series. Taking the electricity consumption value as given, the difference in the official and the GDP level estimated from electricity consumption is declared the size of the unofficial economy (Johnson, Kaufmann, and Shleifer 1997).

[139] Contrasted with, of course, a *real* political business cycle, where the economy itself and not the statistics purporting to measure the economy are manipulated (e.g., Nordhaus 1975); see discussion below.

[140] Sub-annual data on electricity consumption at the provincial level is not available. For more details on the construction of the dependent variable, see the second appendix of Wallace 2016. The differences between GDP growth and electricity production growth for the provinces are depicted in Wallace 2016, appendix figure 4.

annual and the quarterly analyses is elite political *Turnover*, which is a dummy variable coded as a 1 in a year in which there was a change at the top of the Party or government leadership of that province. Factors in the real economy that might affect the *GDP–Electricity* growth rate differential are treated as control variables, including the following: industrial value-added growth, the level of GDP per capita in the province, the service sector's share of the provincial economy, and the net exports of electricity into or out of a province.

The results, shown in Table 6.1, support the juking-the-stats hypothesis. Model 6.1.1 finds that there is a positive relationship between *Turnover* and the difference between reported GDP and electricity consumption growth.

If, following Li Keqiang, one assumes that it is the economic growth series that is being moved due to political forces, then an increase in the difference between these series represents an increase in the reported GDP growth rate. The negative and statistically significant estimate of the industrial value-added coefficient in all of the models in Table 6.1 accords with the notion that as the industrial sector in a province grows, so too should the electric intensity of the province. The annual analysis, in sum, demonstrates that GDP growth estimates are systematically higher in key moments during the political cycle.

The quarterly results exhibit almost precisely the same patterns as those described in the annual analysis. Political turnover is again associated with a positive bump in the *GDP–Electricity* growth rate, ranging from slightly more than 1% to over 1.5%. Even in the context of the rapid growth of the Chinese economy, a 1.5% boost could turn a middling 10% growth rate for a province into a top performer at 11.5%. In the more slowly growing context of the United States, where the average change from the same quarter one year before is 2.1%, a 1.5% difference is dramatic.[141]

The results demonstrate a clear pattern of growth rate differentials aligning with political cycles. Of course, other explanations could account for what has been captured here. I argue that politicians facing cyclical pressures on performance metrics manipulate economic data in their regions at key moments. Yet it is plausible that a real political business cycle could account for some or all of the variance I attribute to data manipulation. A relative gain in GDP growth over electricity consumption growth, as happens in years with turnover, could be associated with an increase in real development that does not use electricity intensively. However, sectors linked with political business or budget cycles in China—services and construction—have little effect on the statistical significance of the *Turnover* variable. Significant gains in the service sector would be reflected in the GDP series more than the electricity series. Loans or government

[141] U.S. Bureau of Economic Analysis 2021.

Table 6.1 **Chinese Provinces Juking the Stats**

	Model 6.1.1	Model 6.1.2	Model 6.1.3	Model 6.1.4
Turnover	1.02*	0.95*	0.90*	1.02**
	(0.52)	(0.51)	(0.50)	(0.52)
Industrial Growth		−0.15**	−0.23***	−0.18***
		(0.07)	(0.08)	(0.07)
GDP per capita			11.15***	2.04**
(logged)			(3.01)	(0.83)
Service Sector				−5.86
(% of GDP)				(5.06)
Constant	−0.79	16.17**	−74.94**	3.26
	(0.96)	(7.56)	(28.83)	(10.69)
Province FE	YES	YES	YES	NO
Year FE	YES	YES	YES	YES
Observations	299	299	299	299
R-squared	0.27	0.28	0.30	0.29
# of Provinces	30	30	30	30

Notes: $*p < 0.1, **p < 0.05, ***p < 0.01$. Dependent variable is Provincial GDP Growth–Electricity Consumption Growth, annual data from 2000 to 2009. Robust standard errors in parentheses. Only thirty provinces are included; Tibet is omitted due to missing electricity consumption data. See Wallace 2016 for more details.

expenditures geared toward immediate spending at the end of the political cycle would be reflected through growth in services or construction channels.[142] Yet the turnover effect survives the inclusion of the service sector share of GDP, as shown in Model 6.1.4, and is resilient to the inclusion of construction growth as well.[143] Neither result diminishes confidence in support of juking the stats during the height of the political cycle.

A critique from the opposite point of view, which is skeptical not only of Chinese provincial-level GDP growth rates but also of the entire Chinese

[142] Blaydes 2010; Guo 2009.

[143] Unlike the service sector, with its low electricity intensity, construction is a more complex activity that has more or less intense electricity use at different points in the economic chain. Perhaps for this reason, construction growth has little explanatory power, and its inclusion does not affect the ability of turnover to account for variation in the GDP growth estimate.

statistical apparatus, is faced with similar difficulties in explaining these patterns. If the numbers are all a fiction, it is unclear what purpose there would be in incrementally increasing the GDP growth rate beyond the electricity growth rate in turnover years other than to report success in that province. That is, if the numbers are all theater, then the audience seems to favor reporting high GDP growth numbers in years with political turnover.

Why use these data if they are manipulated? Performance targets set for lower levels will be evaluated by monitors either under the control of the lower-level official being judged or from outside the territory. The former may possess the information but lack the will to report it. The latter possesses the will but faces difficulties in acquiring independent information.

Performance evaluations using data that is subject to manipulation may also be part of a regime-strengthening ritual. The inflation of GDP figures could, of course, simply be fooling officials at the center who reward apparent star performers based on reported figures. However, that high-level party officials seem to be aware of this kabuki theater discourages a purely naïve interpretation. Local officials might instead be signaling to the center their ability to accomplish goals despite bureaucratic obstacles or that they understand the Party-state's political game. Alternatively, bureaucrats might juke the stats as a signal of respect to an outgoing leader or, more intriguingly, as a positive signal about the locality. A province with fast growth might attract a stronger leader or dissuade the center from dispatching a reforming crusader to disrupt the status quo. Finally, connections between officials at higher levels and those at lower levels are shaped by these limited numbers of statistics but can extend far beyond them.

Informal Ties and Information

> A good general must have close confidants to extend his knowledge, sight, and influence. Without such people, one will be like acting in darkness, walking into danger without knowing it.
> —Zhuge Liang (诸葛亮), regent of Shu Kingdom, AD 181–234

To be sure, the claim here is that the system of limited, quantified vision represented a choice to narrow the focus of cadre evaluation to a few key indicators.[144] The regime's center had the capacity to see more deeply or broadly when it chose to do so. Campaigns represented such activations of officialdom to

[144] Epigraph original: 夫为将者，必有腹心、耳目、爪牙。无腹心者，如人夜行，无所措手足；无耳目者，如冥然而居，不知运动；无爪牙者，如饥人食毒物，无不死矣。Yan 2008, 86.

pursue some particular policy with zeal, but campaigns were time-delimited.[145] Other formal channels of information transmission, such as the public-facing and internal media systems and the letters and visits to bureaucrats, operated inside the regime, as Martin Dimitrov has discussed.[146]

Informal linkages, such as political connections, can also affect information flows and influence falsification rates, as I explored in joint work with Junyan Jiang.[147] Authoritarian information systems also contain important *informal* channels, which arise from connections with family members, personal acquaintances, political loyalists, and various types of networks. Informal networks have been found to matter in numerous domains of authoritarian politics, such as political promotions and policymaking, but the existing literature's emphasis has often been on their corrosive consequences.[148] In the case of information transmission in particular, research has shown that factions may encourage local collusion that obstructs the flow of information to higher-level authorities.[149] While recognizing the possibility of obscuring collusion, these networks can also induce improvements in the quality of the data flowing through formal channels. By *aligning incentives* of lower-level officials with that of higher authorities and *lowering the pressure* to meet quantified targets, informal networks can complement a regime's formal information collection efforts and offset information distortions created by the very government institutions designed to generate systematic data.

The falsification measure in this analysis includes the following key variables as input: *Electricity Consumption, Railway Freight*, and *Nighttime Brightness*, all measured in Log-difference from the previous year.[150] Electricity consumption and railway freight are both inputs to the Li Keqiang Index, a well-known measure that proxies the performance of the Chinese economy using changes in key productive factors and economic byproducts.[151] Recent economics research has also shown that they are among the best alternative measures of economic activities in the Chinese context.[152] *Nighttime Brightness* data, moreover, are produced by the U.S. Defense Meteorological Satellite Program and have

[145] And often have geographic bounds as well. See Zhou and Lian 2020.

[146] Dimitrov 2019.

[147] Jiang and Wallace n.d.; Jiang 2018.

[148] Geddes 2003; Grindle 1977; Shih, Adolph, and Liu 2012; Willerton 1992.

[149] Berliner 1957.

[150] Formally, a principal components analysis model

[151] The Li Keqiang Index has become widely adopted by financial institutions to estimate the actual performance of the Chinese economy (e.g., Bloomberg 2016a).

[152] Fernald, Hsu, and Spiegel 2015, 4. Other good predictors include import data from trading partners, retail spending, and usage of raw materials, none of which is available at the prefecture level.

been widely used by policy practitioners and recent academic research to gauge actual economic performance of countries and regions when systematic data are absent or unreliable.[153]

Does this measure accurately capture variations in economic falsification over time and space? Given the hidden nature of falsification, direct verification can be difficult, but several validation checks make us confident in the measure. First, an extensive internet search found news reports from seven provinces and four specific prefectures that exposed growth falsification in China. If this falsification index is valid, it should have a more positive value in those exposed cities than in those where such activities have not yet been exposed.

Table 6.2 displays the average falsification indices for three types of city-year spells: (1) those that were directly reported as falsifying growth statistics; (2) those located in provinces where falsification activities have been reported but are not directly tied to any specific cases; and (3) those located in provinces without any exposed falsification cases. The gradation of falsification indices across these three groups is largely consistent with expectations. Cities whose names are directly mentioned in falsification reports indeed have the highest average falsification index—about 60% of a standard deviation above the mean. The average falsification index for not publicly implicated cities in provinces with exposed falsification is somewhat lower, but still positive and much higher than provinces where stories about growth falsification have never been reported.

Informal channels are, almost by definition, hard to measure. Fortunately, in China résumés of senior government officials, which contain extensive information about their biographical and professional backgrounds, are published regularly. We focus specifically on whether a city's Party secretary belongs to the patronage network of the incumbent provincial Party secretary. To capture this type of network, we follow the promotion-based measure developed by Jiang.[154] Specifically, we define a city leader as having *Informal Ties* with a senior leader *P* if the city leader was first promoted to a city leadership position when *P* was serving as the provincial secretary. The rationale behind this measure is that since city leadership posts are highly valuable in the Chinese context, they are often disproportionately allocated to those who have close personal ties to senior provincial leaders, and, of course, such a promotion itself can generate a bond and network tie. The *informal ties hypothesis* expects less falsification by officials with informal ties because of aligned incentives and reduced pressure to hit targets.

[153] For example, Henderson, Storeygard, and Weil 2012.
[154] Jiang 2018.

Table 6.2 **Validation against Exposed Falsification Cases**

Locality	Average Falsification Index [95% confidence interval]
Exposed cities ($n = 4$)	0.63 [−0.57, 1.83]
Non-exposed city-year spells in exposed provinces ($n = 91$)	0.13 [0.08, 0.18]
Other provinces ($n = 207$)	−0.05 [−0.08, −0.02]

Notes: This table shows the average level of falsification across three different types of cities: those with exposed falsification cases, those located in provinces where other cities' falsification was exposed, and those located in provinces where no falsification was reported. n denotes the number of cities affected. See Jiang and Wallace n.d. for more details.

As seen in all models of Table 6.3, *Informal Ties* is consistently and negatively associated with economic falsification.[155] The discrepancy between reported and predicted growth is about 10% of a standard deviation lower in cities where the leading political figures are connected to senior provincial or national leaders.

Several coefficients from the control variables are also worth noting. First of all, the level of falsification from same-province neighbors has a strong and positive association with a city's own falsification, but the same association is much weaker for falsification from out-of-province neighbors. To the extent that promotion competition for city leaders mostly happens as a tournament within a given province, this coefficient pattern reinforces the general impression that career concerns drive falsification. Second, controlling for population, the size of the local economy is strongly negatively associated with overreporting of GDP growth statistics. Similarly, controlling for the level of own-source fiscal revenue, overreporting appears to be more severe in localities that have a relatively large government expenditure. These patterns suggest that falsification is more intense in poorer and more fiscally dependent cities. The weak economies of such regions often impede their ability to meet evaluation targets from above, so seeing them overreport at higher rates should not be too surprising.

Falsified data is part of the political game rather than representing the inability of the center to understand the true facts on the ground in their territory. As Dimitrov and others have demonstrated, the Chinese regime has access to incredible investigatory powers that vacuum up information. This analysis

[155] The baseline model uses the following specification:

$$Falsification\, x_{it} = \alpha + X_{it}\beta + \eta_i + \theta_t + \varepsilon_{it}$$

where i indexes the city and t the year. X is a vector of controls. We also include city fixed effects and year fixed effects to capture both time-invariant heterogeneity across cities and common time trends.

connects falsification arising from the system of limited vision with other information channels that the regime possesses, showing how these domains can fruitfully be analyzed jointly.

Deriving Distortions

While the Chinese state retained the ability to collect a vast amount of information when it urgently needed to do so, citizens existed almost exclusively in the normal political world of the system of limited, quantified vision with local government officials trying to get ahead. Despite the distorted information environment and the regime's efforts to push people in some directions rather than others, citizens kept their agency. Even amid the repressive enforcement of family planning policy, for example, many Chinese had multiple children despite the threat of punishment from planning officials. Indeed, the scale of this issue has knock-on effects for other ostensible problems that Chinese society is facing. If millions of Chinese girls have been born but remain hidden from official statistics out of fear, then China's gender imbalance problem may be less severe than generally believed.[156] In other domains, citizens game policy decisions to their benefit.

As China's economy turned ever more on real estate, housing policies and the incentives to extract more from policy became extremely lucrative. Numerous media stories have discussed the propensity of married couples to "strategically divorce" in order to receive greater compensation from a state policy or state-owned enterprise. Usually such policies granted one apartment per relevant household, so a married couple would receive one, but a divorced couple could receive two. Others' local *hukou* status gave them access to housing markets that they otherwise could not afford to purchase, and so some arranged an "economic marriage," whereby an outsider essentially used the local spouse's identity status to make a real estate purchase.[157]

Land and real estate compensation also factor into citizens' strategic actions of "growing houses"—expanding or upgrading houses slated for demolition into increased compensation for them, determined by size, which is part of a broader set of behaviors that Rongbin Han, Juan Du, and Li Shao describe as "unlawful bargaining."[158] For example, November 2010 saw a particularly dramatic scene unfold in Wuhan.[159] Over two thousand local city management (*chengguan*) officials destroyed some eighty illegally constructed buildings totaling over

[156] Kennedy and Shi 2019.
[157] F. Zhang 2017.
[158] Han, Du, and Shao 2019.
[159] J. Hu 2010.

Table 6.3 **Informal Ties Reduce Falsification**

	6.3.1	6.3.2	6.3.3	6.3.4	6.3.5
Informal ties	−0.119***	−0.102***	−0.100***	−0.099***	−0.224***
	(0.030)	(0.028)	(0.029)	(0.036)	(0.074)
Neighbor's falsification		0.399***	0.396***		
(same province)		(0.044)	(0.044)		
Neighbor's falsification		0.049	0.043		
(different province)		(0.049)	(0.050)		
Log GDP		−0.389**	−0.368**	−0.404**	−0.167
		(0.159)	(0.160)	(0.204)	(0.309)
Log population		−0.384*	−0.390*	−0.433*	−0.308
		(0.229)	(0.218)	(0.243)	(0.223)
Log fiscal expenditure		0.616***	0.630***	0.409**	0.231
		(0.133)	(0.141)	(0.177)	(0.339)
Log fiscal revenue		−0.247***	−0.272***	−0.136	−0.060
		(0.087)	(0.089)	(0.126)	(0.260)
City secretary: tenure			0.020**	0.020**	
			(0.010)	(0.009)	
City secretary: college			−0.083***	−0.081***	
			(0.032)	(0.031)	
City secretary: age			−0.001	−0.001	
			(0.005)	(0.005)	
City secretary: minority			0.050	0.030	
			(0.110)	(0.109)	
City secretary: female			0.054	0.058	
			(0.092)	(0.085)	
Year and city FE	Yes	Yes	Yes	Yes	Yes
Province-year FE				Yes	Yes
Leader FE					Yes
Adjusted R-squared	0.15	0.20	0.19	0.27	0.22
Number of cities	284	276	276	283	283
Observations	3,747	3,613	3,556	3,647	3,412

Notes: $^*p < 0.1$, $^{**}p < 0.05$, $^{***}p < 0.01$. This table reports regression results from the baseline models. Standard errors clustered at city level are reported in parentheses. FE stands for fixed effects. See Jiang and Wallace n.d. for more details.

ninety thousand square feet in Houhu Village (后湖村).[160] Residents protesting the demolitions attacked the *chengguan*; one villager drove his car into a cluster of eleven officials and critically injured one.[161] The phenomenon of farmers "growing houses" is less about providing space for farmers or migrants than about compensation agreements between local governments for demolishing housing, which is based on the covered square meter, ignoring quality.[162]

What these snippets suggest is that while the limited, quantified vision has been framed principally as the institutional framework of Beijing over local officials, that framework and its worldviews replicated themselves throughout the society. Attempting to maximize metrics, citizens became savvy enough to engage in the same kinds of game-playing with local officials that they themselves would engage in with higher-ups.

For over thirty years, the system of limited, quantified vision was key to China's transition from a poor, insular country riven by a decade of ideological warfare to the world's second-largest economy and beacon of calm amid the storm of the global financial crisis. Yet this chapter highlights the system's increasing failures.

While different actors might quibble with the characterization of one aspect or another, by the early 2010s there was general agreement inside China that the engine that had generated so much growth and change was in need of an overhaul. That consensus call for change did not extend to the form that change should take. Debates raged before they were silenced with the triumph of Xi Jinping and his neopolitical turn.

[160] Y. Hu 2010.
[161] Yan 2010.
[162] *ChinaHush* 2009.

A Neopolitical Turn

Why did the Soviet Union disintegrate? Why did the Soviet Communist
Party collapse? An important reason was that their ideals and convictions
wavered. . . . Finally, all it took was one quiet word from Gorbachev to
declare the dissolution of the Soviet Communist Party, and a great party
was gone. . . . In the end nobody was a real man, nobody came out to resist.
—Xi Jinping, December 2012, quoted in Buckley 2013c

Zhou Benshun's turtle lived in luxury. A full-time caretaker and ample space
in the Hebei Party secretary's 8,600-square-foot mansion ensured its com-
fort until its traditional Buddhist burial.[1] We know how Zhou could afford
such extravagances on his meager official salary because after anticorruption
investigators detained him in July 2015, he confessed to bribe-taking on a CCTV
series, *Always on the Road* (永远在路上).[2] He was sentenced to fifteen years in
prison in February 2017. As discussed in Chapter 1, Zhou had prostrated him-
self before Xi Jinping in 2013 for caring about "development speed and eco-
nomic volumes" over the "people's own interests." This performance, however,
did not save him.[3] With grotesque and pervasive corruption only the most ob-
vious of the failures of the system of limited, quantified vision, China under Xi
has taken a neopolitical turn.

This neopolitical turn is both an attempt to fix the economic and political
pathologies of the prior technocratic era as well as a new justification strategy
for the regime, serving as a hedge against the end of China's rapid economic
development.[4] While the accumulated detritus hiding in the system of limited,

[1] See Gan 2017 for the basic details. Technically the caretaker working full time looking after all
of his pets, not just the turtle. See also the anticorruption series *Always on the Road* (永远在路上)
2016; Liu 2016.

[2] On low official salaries such as Xi Jinping's roughly $22,000 in 2015, see Luo 2015. To be clear,
Zhou Benshun's confession was coerced (Steger and Huang 2016).

[3] Li, Zhang, and Qi 2013. See also *The Economist* 2013b; Huang 2013a; Zhang 2013.

[4] Thanks to Ben Lessing for this clarifying language.

Seeking Truth and Hiding Facts. Jeremy L. Wallace, Oxford University Press. © Oxford University Press 2023.
DOI: 10.1093/oso/9780197627655.003.0007

quantified vision's blind spots urged the need for change, the direction and shape of such a turn was much debated both before and after Xi's reign began. From nostalgic neo-Maoists to liberal constitutionalists, supporters of competing political economy models waged pitched battles in a place of real, if bounded, intellectual ferment. The neopolitical turn includes moves to centralize political authority, increase standards of behavior for local officials, extend the institutional capacities of extant inspection units, and promulgate new norms of behavior. But it is far from simply a realignment of the regime's institutions to address the old system's failures along neoliberal capitalistic lines. Xi's personalization of power and the in-your-face presentation of the regime's authority, its exploding surveillance capabilities, quasi-mandated participatory requirements, and brutal repressiveness portend a distinctively aggressive mode of governing.[5]

This chapter proceeds as follows. First, I show examples of elites acknowledging the failures of the system of limited, quantified vision. Next, I describe some of the competing conceptions of the regime's circumstances and possibilities, highlighting arguments surrounding what came to be referred to as the "cake debate" between models from Guangdong and Chongqing. The regime's first year under Xi is scrutinized, as the Third Plenum of 2013 provided something of an inflection point for its trajectory. Then I move from theoretical debates to different facets of the neopolitical turn in practice, both internal to the regime (Xi's personalization of power, centralization, and Partyfication) and external (its shifting rhetoric, confrontational style, and repression). Finally, alternative interpretations of these changes are presented, which can be connected to assessments of the degree of personalism inside the regime.

The fraught and complex changes demonstrate the framework's utility as contestation over the regime's identity occurred across the *who, how,* and *why* dimensions. Their timing and interpretation emphasized continuities even as they represented significant overall differences from prior governance practices. Finally, the liabilities of governance based on a few key numbers came to the fore and were replaced by a more emotional and deeply surveilled politics.

Seeing Limited Vision's Limits

> Growth must be concrete and without exaggeration; growth should be
> effective, quality, and sustainable.
> —Xi Jinping, November 30, 2012, reprinted in Xi 2015

[5] COVID-19, the post-COVID crackdowns, and the common prosperity drive are discussed in the conclusion.

By the time he emerged as the regime's preeminent leader, Xi Jinping was far from alone in observing the cracks of the system of limited, quantified vision. Under Hu Jintao and Wen Jiabao, efforts were made to nudge the system onto a more economically, politically, and environmentally sustainable path. But whether out of political weakness or the economic calamity of the global financial crisis, most observers saw the Hu-Wen period as a "lost decade," full of missed opportunity.[6] In a widely circulated essay from September 2012, Deng Yuwen, a scholar at the Central Party School, discussed the "ten grave problems facing China" in a pamphlet titled *The Political Legacy of Hu-Wen*.[7] These problems included "no breakthroughs in economic restructuring and constructing a consumer-driven economy," "failure to grow a middle class," a rural-urban gap that had increased, a suspect and demographically backward population policy that lagged reality, "environmental pollution ... worsen[ing]," "moral lapses and the collapse of ideology," and "insufficient efforts in pushing political reform and promoting democracy."[8]

The previous chapter detailed such accumulating concerns. Information problems baked into the system of limited, quantified vision allowed for suffocating pollution, pervasive corruption, stark inequality, rising debt, persistent poverty, inefficient investment, deliberate falsification, and slowing growth. What mattered was not counted, and what was counted did not measure up.

The outgoing Hu acknowledged the seriousness of the corruption problem. In his address to the 18th Party Congress, he said that "[c]ombating corruption and promoting political integrity" is a "major political issue of great concern to the people" and that "[i]f we fail to handle this issue well, it could prove fatal to the party."[9] Less than two weeks later, Xi, the newly installed general secretary, admonished officials and saw similar stakes: that failing to deal with corruption could "lead to the downfall of the Party and the state."[10]

Writing on the environment in his final Government Work Report, Wen mostly focused on successes but called for "effective measures to prevent and control pollution in response to people's expectations of having a good living environment."[11] That statement came after months of unprecedented reporting on the air pollution problem, including a *People's Daily* front-page piece, "Beautiful China Starts with Healthy Breathing."[12] Acknowledging the issue, the article

[6] See Greene 2012.

[7] See Davies 2013; Barmé and Goldkorn 2013. Echoing Mao's famous speech "On the Ten Great Relationships" from April 1956, Deng Yuwen's title is "胡温的政治遗产," originally in Caijing but deleted (Barmé and Deng 2012).

[8] Davies 2013; Barmé and Goldkorn 2013.

[9] Wee and Blanchard 2012; Hu 2012.

[10] "亡党亡国." Yuen 2014 says "inevitably lead to." See also Wong 2012b; Beach 2012.

[11] Xinhua News Agency 2013b.

[12] Wong 2013; Wu 2013 (original is "美丽中国，从健康呼吸开始").

stated, "The seemingly never-ending haze and fog may blur our vision . . . but makes us see extra clearly the urgency of pollution control and the urgency of the theory of building a socialist ecological civilization, revealed at the 18th Party Congress."[13] At a Politburo meeting on May 24, 2013, Xi asserted that "the people are highly concerned with environmental issues" and that, if poorly resolved, they "easily can generate mass incidents."[14]

As China moved from being severely underinvested to having ever greater capital stocks, the expected returns from new investments fell precipitously.[15] Even economists sanguine about China's growth prospects acknowledged the overinvestment.[16] Doomsayers, on the other hand, pointed to ghost cities and uneconomical airports built years ahead of anticipated demand, as shown by the rising amount of investment needed to generate an additional unit of GDP.[17] In 2008, every 2 yuan of capital produced an extra unit of GDP, and by 2015 that number had skyrocketed to nearly 9.[18] The financial system's accumulated debts and distortions figured among the major concerns.

On issue after issue, top Chinese government officials and intellectuals acknowledged that the regime's footing was precarious. While departing Hu-Wen officials presented information in rosier tones, they too—sometimes bluntly—noted imperfections and called for resolving situations. The convoluted origins of the Reform Era show how nettlesome attributing actions to one individual rather than another, or attempting to establish a causal chain, can be. Nonetheless, the next section attempts to examine points on the path to the neopolitical turn.

The Hu-Wen years were the best of times and the worst of times. They saw China's economy more than double in size and overtake Japan's in rank, but they were "lost" because, despite some efforts to tinker with the system, its known shortcomings were allowed to fester, beginning a rot that threatened the regime. Yet though the years of the CCP under Xi could be called many things—invigorating, repressive, sinister, bull-headed—they are not seen as lost, because they represent a real reconfiguration of the country's political economy, even

[13] Wong 2013; Wu 2013 (original is "延绵不散的雾霾遮蔽了视线，却让我们格外清晰地看到环境污染治理的紧迫感，格外真切地认识到十八大提出的加强生态文明建设的必要性").

[14] Xi 2013, 2018. "弄得不好也往往最容易引发群体性事件."

[15] Similarly with state planning, expectations of the economic viability of different concerns decrease over time as China's labor costs increase.

[16] For example, Lardy 2014.

[17] Kennedy and Johnson 2016. On ghost cities, see Woodworth and Wallace 2017; Baik and Wallace 2021.

[18] Kennedy and Johnson's 2016 estimate is on the high side, but the general pattern of rapid increase in the ratio is seen in other estimates (e.g., Wolf 2018).

though they may not succeed as a solution to the regime's troubles, or in trying to do so may succumb to other threats.

Model Debates

> Yes, China is in the midst of a fierce clash between different ideas, and this state of affairs has directly impacted political trends in China. These political trends concern the direction of economic development. At its most basic, this clash of ideas concerns the major question of what course the Chinese people should take. . . . This fierce clash of ideas exposes the crisis facing socialism with Chinese characteristics.
> —Wan Jun, May 10, 2011, quoted in Bandurski 2011

Agreement that the system of limited, quantified vision produced problems does not imply consensus about their relative priority or the politics and policies to address them.[19] The "cake debate" caricatured these disagreements, pitting Guangdong's growth orientation against Chongqing's pro-equity stance as inequality and poverty, both underemphasized within GDPism, became increasingly salient. These discussions simultaneously blended issues across the framework's three dimensions of the regime's contested identities.[20] Key protagonists included potential rivals for the PRC's fifth-generation leadership; how the regime would operate in institutional and policy terms were central to these discussions, and ultimately they proceeded from different answers as to why the regime ruled, with different purposes, justifications, and threats implicated.

Guangdong's environment was comparatively open, in both economic and political terms, so it tended to be associated with economists, liberals, or the "New Right." Guangdong is home to the Pearl River Delta, which over the past four decades has become the world's factory. Its impressive development was core to the Reform Era's national narrative: Guangdong and other places got rich first, through their market orientation and international connections. Then the global financial crisis saw tens of millions of migrant workers leave Guangdong and other coastal provinces' factory towns to return to the cities, towns, and villages of the countryside. Following the depths of the crisis, Guangdong's political economic model was caricatured as pro-market neoliberalism, but the province's governance under Party Secretary Wang Yang was more complicated than that.[21]

[19] The original title of Wan Jun's essay is "各路人马纷纷亮剑，中国社会何去何从."
[20] See also Ferchen 2013.
[21] For example, Lim 2011.

Guangdong's advantages go beyond its coastline, geographic proximity to Hong Kong, and deep diasporic linkages abroad. The migrant labor force that filled the factories of the Pearl River Delta came to work. Guangdong's economy benefited from their production without having to support much of their social reproduction, as education for migrant children was restricted, and, as seen during the global financial crisis, when migrants no longer wanted to or were able to find labor, they returned to their homes in the country's interior.[22] Guangdong's private insurance market is the country's most successful, but its government-based social security and minimum income (*dibao*) payments have been far below national averages.[23]

While markets have been critical to the province's success, especially in its export-oriented centers, Xiao Bin's analysis of Guangdong's governance argues that it is still best seen as a "government-led market economy."[24] He believes much of the province's ongoing success relies on a stability that could only be secured by the rule of law, which is needed to restrain the grabbing hands of corrupt officials, as "there is no way to supervise or restrain political power" in its absence.[25] To this end, the province has experimented with consultative democracy and made public budgets transparent.[26] The relationship with civil society is relatively cordial, which Xiao sees as making "the government more attentive to the public's views and concerns," as atomized individuals are less effective at communicating with the state given the power disparity.[27] If Guangdong's example shaped the national-level political turn, China could have grown into a more law-based society, willing to accept independent organizing and civic participation in governance.

Contrasted with Guangdong and its associations with China's liberals is Chongqing, which tended to be connected to various leftists, from nostalgic Maoists to the New Left.[28] An interior municipality but provincial in size and scope, Chongqing housed substantial numbers of state-owned factories from

[22] Wallace 2014; Friedman 2022.

[23] Xiao 2011.

[24] Xiao 2011, 2012.

[25] Xiao 2011, 2012.

[26] Zheng 2010.

[27] Xiao seems to lean into this need to constrain political power in ways that point against the monopoly power of the CCP: "At a deeper level, there are fundamental structural challenges arising from the inherent problems of the system—the tension between the monopoly logic of an integrated system and the competition logic of a market economy system. The future of the Guangdong model depends on further reform and opening up" (Xiao 2012, 37).

[28] While typically coded as a leftist state capitalist model, some defenders dispute this labeling, arguing that it "transcended left and right distinctions" with its combination of party, state, and market plans. For more on intra-left distinctions from this period, see Downie 2014.

the Maoist period as a legacy of the Third Front. However, rather than see these industrial operations as dinosaurs, their assets, particularly land, were used by former mayor Huang Qifan as key to Chongqing's development strategy. Taking state-owned enterprise profits as a third stream of revenue, alongside taxes and fees, but holding onto land as it accrued in value, the Chongqing budgetary model used expectations of future appreciation of its massive landholdings (some 200 km²) to fund infrastructure investments that increased the value of those holdings.[29] These funds, paired with an opportunely timed and highly discounted purchase of SOE nonperforming debts that the city was able to turn around, kept city finances flush and suggested a possible path forward of "state and private sector advanc[ing] together," in contrast to the more rivalrous patterns of state advance, private retreat (*guojinmintui*) or state retreat, and private advance (*guotuiminjin*).

State-directed investments were also key to the industrial policy efforts of Chongqing, such as deals with HP, Foxconn, BASF, Chang'an Automobile, and other major enterprises.[30] The pair of tech companies were mutually attracting, but making both leaps required significant investment. Statements from Mayor Huang suggested that the municipality spent $50 billion to draw in $5 billion in investment from HP.[31] Another massive land deal of over 6.6 square kilometers attracted a 35 billion yuan investment from Chang'an and similarly involved discounting the land leases from around 500,000 yuan per mu to 50,000 yuan per mu.[32]

But more than its state-led land-based development efforts, the Chongqing model is associated with overtly political and even confrontational efforts of state action in social life. A mass line revival was launched under the slogan "Three task system" (*san xiang zhidu*) in 2008, shortly after Bo Xilai arrived to serve as the municipality's Party secretary. Like its Maoist forebears, this version of a mass line campaign centered on intimate interactions between cadres and citizens inside their jurisdiction, mandating weekly meetings with public airing of comments and concerns as well as twice-yearly visits to the homes of residents.[33] These connections were seen as information-transmission mechanisms—letting cadres better know the people's interests—but also constrained cadre behavior, as nonaction became costlier when such interests became common knowledge. At the same time, mass attitudes about cadres were expected to improve through

[29] P. Huang 2011.

[30] P. Huang 2011 refers to these as "Chongqing's dragon head enterprises."

[31] To be clear, Philip C. C. Huang is quoting Huang Qifan, then mayor of Chongqing. P. Huang 2011.

[32] P. Huang 2011.

[33] S. Wang 2012.

both the direct effects of exposure and the enhanced governance that such meetings were expected to generate.[34]

Shifting mass sentiment and inculcating Party loyalty were also the justification for a program of "red culture." A core component of its content was learning and performing the range of the traditional Mao-era "red songs," which began with schoolchildren in 2008 before growing to include other populations, such as soldiers, cadres, university students, and retired people.[35] By 2011, the red culture program had moved to television, where Chongqing Satellite TV remade its offerings by removing commercial advertising, reducing fictional dramas and nonlocal programming, and adding more news, public service announcements, and local "cultural programs."[36] Examples of these cultural offerings included the *Daily Red Song Club* (天天红歌会), fifteen minutes of red anthems sung by local groups, and *Chongqing Good People* (重庆好人), which showed ordinary local people doing extraordinary deeds and "promoting socialism's core values."[37] The advertising cuts reduced the channel's revenue by 300 million yuan, but Huang argued that "public welfare" television was an international practice and Red TV was good.[38]

Another mobilizing effort was the "Strike black" campaign, launched in June 2009 following a notorious shooting and targeting crime and corruption.[39] Over the course of nine months (it ended in March 2010), the campaign produced over β,300 arrests and claimed to have cracked sixty-three criminal gangs.[40] Major figures in the local political economy were targeted, including Wen Qiang, the vice-chair of the Public Security Bureau under Wang Lijun, superior court officials, and property developers.[41]

Beyond conflicting purposes and methods, rivals for super-elite positions atop the regime helmed these two models. Wang Yang and Bo Xilai were both seen as potential members of the fifth generation of leadership. While Wang did ascend to the Politburo Standing Committee in 2017 with the 19th Party Congress, Bo was kicked out of the Party in 2012 following a scandal involving massive corruption and the murder of a British national, Neil Heywood, by Bo's wife, Gu Kailai.[42] Yet despite its progenitor's downfall, some of the aggressively

[34] Cui 2011.
[35] Mei 2013. Downie 2014.
[36] Bandurski 2011; *Chongqing Daily* 2011.
[37] H. Huang 2011.
[38] Liu and Li 2011.
[39] See Huang 2009; Downie 2014.
[40] Fewsmith 2010.
[41] Fewsmith 2010; Downie 2014.
[42] See, for instance, Garnaut 2012.

political aspects of the Chongqing model—if not its focus on economic equality—became core to Xi's neopolitical turn.

These contrasting practices and visions were just two prominent contestants in a competition to set the country's and the regime's future direction. China's very success in the economic realm has produced a new problem: an "affluence trap."[43] Affluence produced a middle class that held significant assets and might rebel should they lose value—along the lines of "environmental" NIMBY protests that are as much about real estate valuations as about pollution harming human health. But the country still had an impoverished underclass that saw skyrocketing home prices undermining their dreams of climbing economically.

While some, like economist Justin Lin, argued that continued rapid GDP growth was possible without significant changes to the country's political economy, this was likely the most sanguine perspective.[44] Market-oriented (rightist) analysts said that while they agreed with the continued pursuit of aggregate growth, the economics of the system required state retrenchment, with the telling exception of dealing with "vested interests" such as those state-owned firms that had come to dominate key assets and sectors of the economy. Leftists, on the other hand, focused less on aggregate growth and more on problems of poverty that persisted despite decades of development.

These deep differences over economic priorities bled into policy solutions as well as assessments of the regime's politics. Peking University's Qian Liqun grouped the array of perspectives into six clusters:

1. Mao-nostalgia, supported by certain old cadres, intellectuals and laid-off workers
2. "New Democracy," based on absolute preservation of the power of the Party but more flexible [than nostalgic Maoists] on policy matters
3. Social democracy, allying constitutionalism and social protection
4. Liberal constitutionalism (Charter 08)
5. New Confucianism, which supports a return of the state with a strong anti-Western streak
6. The "China Model," based on nationalism, statism and populism.[45]

These clusters could be placed on a one-dimensional Left-Right political spectrum of comfort with state intervention in the economy, from the left-most end

[43] Leonard 2012.

[44] Lin 2012 argues that China's backwardness is sufficient for its growth trajectory to remain at around 8% for another decade, a view more optimistic than official government projections (World Bank 2013).

[45] Veg 2013.

of the spectrum, represented by the Maoists, to the rightist New Confucians.[46] The "China model" seemed to operate as an opportunistic collage selecting elements from the more coherent perspectives. But flattening each of these perspectives into a single dimension erases much of their political differentiation.[47] Nostalgics focused on the past and returning to its putative simplicity and, for Maoists, its unity of vision through radical equality and anticapitalism.[48] Constitutionalists, whether more socially democratic or liberal, were more amenable to Xiao Bin's ideas about the necessity of the rule of law to control corruption, drive investment, and propel society forward. Others saw a greater mass-cadre connection or central monitoring inside Party institutions as sufficient to stanch the flow of corruption.

Democracy's role in Chinese governance was debated as well. While most discussions of democracy were circumscribed by the "intraparty" modifier, in 2011 elections resolved an acrimonious dispute between villagers and officials deemed corrupt in the Guangdong village of Wukan. The officials were ousted and replaced by protest leaders through a popular vote, suggesting to some that this political technology's time might have come. Yet even potential advocates of elections were cautious about what could be learned from Wukan. Tsinghua's Sun Liping argued that Guangdong's comparatively nondominated society, strong sense of rights, "tightly knit social groups," and migrant workforce made it an outlier compared with the rest of China.[49] While resolving one issue was difficult but possible, he saw a "correction predicament," whereby solving some problems would only expose more, a Pandora's box that could undermine the system's stability.[50] But while calling for determined and courageous leadership, Sun also requested "tolerance" and "understanding" from the people, whom he acknowledged had faced incessant challenges, including illegal land seizures, invalid labor contracts, and problematic family-planning practices. In a political system without decisive elections and with a new leader unwilling to show his cards completely, analysts from these and other perspectives debated their interpretations of Xi's moves in leadership at the November 2013 Third Plenum.

[46] Liberal constitutionalists and New Confucians as groups could be flipped, and individuals falling into various camps may differ from the group's mean.

[47] See, e.g., Huang 2010.

[48] Cf. Gerth 2020 on the persistence of capitalism under Mao.

[49] Sun 2012a.

[50] Sun 2012a.

The Neopolitical Turn's First Steps

> Since 2013, the whole world has looked at China with anxiety, some-
> times surprise, sometimes astonishment, and sometimes suspiciously.
> We inside the huge iron curtain are even more confused about the
> future.
>
> —Li Weidong, October 19, 2013

Xi was invested with power to help address problems that the Hu-Wen leader-
ship was unable to resolve. This was apparent immediately. When the traditional
lineup of the Politburo Standing Committee emerged following the conclave in
November 2012, only seven men in black suits were on stage rather than nine.
Many moves that would be core to the neopolitical turn came very early in Xi's
tenure.[51] Yet the regime's overall trajectory under Xi remained uncertain, as
observers predicting deeper marketization saw centralizing moves as serving
to push through neoliberal-esque economic reforms, while others interpreted
them as increasingly reminiscent of pre–Reform Era politics.[52] Similarly, while
the early institutional changes suggested that regime elites accepted some per-
sonalization and centralization of authority, it was unclear how they assessed the
risk of shifting from collective to individualized leadership.[53]

As the son of Xi Zhongxun, a major CCP figure, history had its eyes on Xi
Jinping. One can find through lines from his life, works, and rhetorical corpus
that fit various characterizations, for like most politicians his positions flexed
as his offices and their interests changed, so that "where you sit is where you
stand."[54] Some said that Xi was selected because, as a consummate careerist, he
could be molded or controlled. Others saw a basketball-loving reformer who
had charmed Iowans during a visit in the 1980s, whose father was heralded as
the progenitor of Guangdong's Special Economic Zones, and whose surviving
sister had become fabulously wealthy.[55] Another perspective placed his identity

[51] McGregor 2019, 21–2. McGregor lists the following of Xi's neopolitical moves: China
Dream, newspaper crackdown, strict new rules governing officials, locking up critics, Belt and Road,
Asian Infrastructure Investment Bank, poverty eradication, ratcheted up conflict with Taiwan, and
executing plan South China Sea bases, and anticorruption.

[52] Li 2013. "2013年以来，全世界都忧心忡忡地有时惊喜有时惊诧有时狐疑地注视着
中国，巨大铁幕内部的我们，更是对未来充满着迷茫。"

[53] Svolik 2012.

[54] For example, Economy 2018 sees continuity between Xi's record before and after ascen-
sion. She quotes a 2000 interview of Xi making a baton analogy (9). Wikileaks published a cable
by Ambassador Jon Huntsman 2009 that described Xi as "redder than red" during the Cultural
Revolution and "entitled" and "elitist" about Communist Party domination in later years. Xi's
232 "Zhijiang Xinyu" columns, authored under the pseudonym "Zhe Xin" while he was Party secre-
tary of Zhejiang, remain an interesting resource. Carbon Brief 2021; Sina 2015; Xi 2006.

[55] Nathan 2016.

with a red second generation that venerated Mao and saw themselves as the inheritors of a new empire they were determined not to lose.[56]

In his first public speech after taking power, Xi pushed the optimistic, forward-looking "China Dream" slogan "To achieve the great rejuvenation of the Chinese nation."[57] In Xi's China Dream, "each person's future and destiny [are] closely linked with the future and destiny of the country and the nation."[58] However, the positive vision of the China Dream clashed with aggressive actions to rein in "problematic" behaviors in the here and now.

In his first meeting with the Politburo as Party leader, Xi denounced corruption among the Party's ranks, warning that it could "doom the Party and the state."[59] This ominous conclusion, Xi said, was based on "a mass of facts," and the underlying mechanism—political rot—was identified by his use of one of the favorite aphorisms of his former rival, Bo Xilai: "worms only come after matter decays."[60] To strengthen the body politic, Xi stressed that "ideals and convictions are the spiritual calcium of Communists" as "a belief in socialism and communism is the political soul of a Communist and the spiritual pillar that allows a Communist to withstand any test."[61] Upon coming to power, both of Xi's most recent predecessors had initiated anticorruption campaigns, even removing relatively high-level leaders, so those inclined to see Xi as continuing with Reform Era patterns were not swayed by his visceral language or actions.[62] His anticorruption crusade began collecting scalps immediately, when Li Chuncheng, a deputy Party secretary in Sichuan and alternate Central Committee member, was dismissed in December 2012. Li was but the first of thousands of toppled officials and hundreds of thousands of punishments that the crusade would impose on officialdom.[63]

That same month, Xi took a pilgrimage to Shenzhen and Guangzhou, a transparent symbolic venture to replicate Deng's reform-reviving, post-Tiananmen Southern Tour. Thirty years before the Xi *fils* visit, Xi *père* had overseen the creation of the Special Economic Zones and led the trailblazing rise of Guangdong to its status as the world's factory. Many observers, such as former National People's Congress deputy Ng Hong-man, believed Xi's 2012 visit indicated the

[56] Li 2013; Nathan 2016.

[57] Callahan 2013, 21.

[58] Callahan 2013, 21, 21n3.

[59] Wong 2012a.

[60] Wong 2012a; Lam 2016, 411 suggests Hu initiated a study of other long-lived parties that perhaps served as the basis of Xi's "mass of facts." See Kalyvas 1999 on political decay and breakdown.

[61] Wong 2012a.

[62] Chen Xitong and Chen Liangyu for Jiang Zemin and Hu Jintao, respectively.

[63] That it happened in Sichuan foretold that Zhou Yongkang was likely to end up on the block as well.

leadership's economic priorities, and because economics was seen as the regime's bedrock, other pieces of the political puzzle were assembled around it.[64] Further marketization was acknowledged to be difficult for the regime politically, but paired with anticorruption actions and the nationalism of the China Dream, Xi's governance resembled the Self-Strengthening movement of the late nineteenth-century Qing reformers.[65]

While Xi basked in the economic successes of Guangdong, his allies seemed to find its comparatively open information environment anathema to their designs. In January 2013, the Guangdong newspaper *Southern Weekend* had its New Year's editorial censored, portending a tightened information environment. The editorial was titled "The China Dream, the Dream of Constitutionalism," a provocative play on Xi's slogan given the political apparatus had been lurching away from constitutionalist views.[66] The anticorruption crusade was operating through an empowered Central Commission for Discipline and Inspection rather than through more transparent legal channels.[67] A revised, softer title failed to keep the provincial propaganda chief, Tuo Zhen, from cutting sensitive sections and revamping the editorial's title to the obsequious "We Are Closer Than Ever Before to Our Dreams."[68] The censorship enraged the newsroom: staff went on a four-day strike and there were demonstrations outside the Southern Media Group's offices and viral posts on Weibo.

Li Chengpeng, a blogger from Sichuan with millions of followers, called the censorship an "insult toward freedom of speech."[69] The actress Yao Chen quoted Aleksandr Solzhenitsyn saying that "one word of truth outweighs the whole world."[70] After two of his Weibo posts were deleted, the blogger Han Han wrote a tribute to *Southern Weekly*, noting the contradictions of good governance, dreaming, and censorship: "They grab you by your collar, clamp you by the neck, yet at the same time encourage you to run faster, sing better, and win them more honour."[71] The denouement was simple, not a bang but a whimper: certain staff

[64] Tam and He 2012. Only Li Weidong puts up a discordant note here, both at the time and in his later piece (Wong 2012c; Li 2013). But this seems to be more a serious liberal wanting to push the regime even further than it seemed to go.

[65] Wong 2012c.

[66] Economy 2018, 20–1.

[67] An approach criticized by Chen Youxi as a "dead end[.] The more powerful the Discipline Inspection Commission has become, the more serious corruption has become, because if you depend on secretively fighting corruption, you only encourage more corruption" (quoted in Wong 2012a).

[68] Economy 2018, 20–1.

[69] Freedom House 2013.

[70] Osnos 2013; Freedom House 2013.

[71] Han 2013; Economy 2018, 21. Tuo Zhen was promoted in 2015 to the national Propaganda Department and, as of April 2018, was chief editor of *People's Daily*.

were fired and their social media accounts deleted. A similar drama unfolded at the Beijing-based *Yanhuang Chunqiu*, which had its website shut down for a period following its own constitutionalist editorial.[72] Authority had yanked hard on the reins of control, restricting the space for officials and the media that covered them. Even activists ostensibly pursuing goals close to the regime's—such as fighting corruption—found themselves discordantly attacked in the restricted political space, where the Party wanted to orchestrate all of the notes. Members of the New Citizens Movement (新公民运动) were arrested in Beijing on March 31, 2013, for unfurling small banners that called for officials to disclose their assets and connecting the fight against corruption to the China Dream.[73]

The regime's messaging continued to be ignored or stepped on by its own agents, as Xi officially took the title of president in March. Lei Feng, Mao's favorite patriotic and self-sacrificing soldier-martyr, had died fifty years before, on March 5, but 2012's "Learn from Lei Feng Day" flopped.[74] A "Micro Lei Feng" app was produced to "inspire good deeds."[75] A troika of propaganda films were pulled from theaters after dismal ticket sales.[76] The system of limited, quantified vision's messaging to society (apolitical, technocratic consumerism) and about the government and business elites (financially successful developers) made the ardent passion and selflessness of Lei ring false. Public cynicism turned Lei lame, and the media reveled in this example of the Party misunderstanding society, running stories questioning and cartoons lampooning the martyr's myths.[77]

By April, the information environment was tightened further with the circulation of "A Communiqué on the Current State of the Ideological Sphere," referred to as Document 9. The communiqué described a struggle between Western values and the CCP and listed seven ideas to be avoided (Seven Nos): "universal values, press freedom, civil society, citizens' rights, the party's historical aberrations, the 'privileged capitalistic class,' and the independence of the judiciary."[78]

Despite the tightening, the Party endeavored to improve the relationship between officials and the people with a "mass line campaign," similar to what Bo had orchestrated in Chongqing. Xi wanted the campaign, officially begun on June 18, 2013, to make cadres more accessible to the public and to eliminate formalism, bureaucracy, hedonism, and extravagance, the "four [bad] work styles."[79]

[72] Economy 2018, 21.

[73] Jacobs 2013.

[74] Jacobs 2012. Thanks to James Palmer for highlighting this moment.

[75] Levin 2013.

[76] Levin 2013.

[77] Levin 2013.

[78] Economy 2018, 38. In September 2011, Wu Bangguo made a speech that had "five nos."

[79] Doyon 2014. The announcement for the campaign was in May, but it did not officially launch until June 18 (Mass Line Leading Small Group 2013).

Reviving the Maoist practice of democratic life meetings and self-criticism, the campaign went beyond what previous leaders had initiated when coming into office to cement their leadership, but the practices rhymed.

Two days later, on June 20, Chinese banks trying to settle their daily books found themselves facing a massive cash crunch, as spot interbank interest rates that usually hovered under 3% shot up suddenly to 25%.[80] The Shanghai Composite Index lost over 5% of its value on June 24 before the Central Bank moved to calm markets the following day. The Chinese financial authorities' actions were interpreted as reflecting the regime's rhetoric that lending needed to be constrained and that credit would not flow as it had in the previous decade. While ultimately the crunch was a shot across the bow rather than a direct hit on the economy, the incident served as a costly signal to investors, speculators, and the banks themselves that the status quo was changing.[81]

While economic policy was shifting, the information environment continued to tighten into the summer. On July 17, it became known that the rights lawyer and New Citizens movement transparency activist Xu Zhiyong had been placed under house arrest.[82] Despite being seen as a moderate voice calling for change inside the existing political system, Xu's advocacy was inconsonant with the top leadership's ideas.

On August 19, Xi again addressed a crowd of officials and expounded on the significance of ideology.[83] Initially, commentaries about the speech suggested that the tone and content were relatively moderate. Xinhua's report had the following stultifying headline: "Xi Jinping Emphasizes at the National Propaganda Work Conference: [We Must] Grasp the General Situation and Focus on Major Events with a View of the Big Picture, Working Hard to Do Propaganda and Ideological Work Properly."[84] Though he emphasized ideology's significance, Xi stated that "economic construction is the Party's central work."[85] Yet in the days and weeks that followed, the impression of normalcy faded as more combative language, specifically the phrase "public opinion struggle," came to the fore, despite its connotations.[86] "Struggle" evokes violent episodes in the Cultural Revolution, and "public opinion struggle" was a rarely used term connected to the anti–spiritual pollution campaign of the early 1980s. The language also

[80] *The Economist* 2013a.

[81] On the credit crunch, see *The Economist* 2013a, 2013c.

[82] Buckley 2013a.

[83] August also saw the Bo Xilai trial.

[84] China Media Project 2013c.

[85] Lam 2016, 412.

[86] Specifically, China Media Project 2013c notes that a *Global Times* editorial in favor of "public opinion struggle" from August 24 was rebutted by Cao Lin in *China Youth Daily* on August 27 in a piece called "Public Opinion Struggle Makes People Uneasy."

makes prominent antagonists against which the Party and its ideology need to fight. As Hubei's propaganda minister put it in a September issue of *Seeking Truth (Qiushi)*, "[C]onstitutionalism and universal values were just 'beautiful lies.'"[87] Compared with Jiang's "public opinion guidance" and Hu's "public opinion channeling," Xi's "public opinion struggle" was emphatically confronta-tional and raised the stakes of political difference.

The following month saw Xi's visit to the democratic life meetings in Hebei that upended Zhou Benshun as well as the detention of outspoken venture cap-italist Wang Gongquan, a supporter of Xu Zhiyong and the New Citizens move-ment.[88] Xiao Shu, a friend of Wang's and one of the *Southern Weekly* journalists fired earlier in the year, wrote that it was "obvious" that "civil society is under attack" and that indeed the regime may see it as part of the "hostile forces."[89] Anticorruption investigations penetrated into the depths of Zhou Yongkang's political network, focusing on Sichuan and the oil sector.

Tensions continued to rise throughout the month of October as televised confessions expanded, Xi called for learning from Maoist practices in the "Fengqiao Experience," and violence rocked the symbolic heart of Chinese power, Tiananmen Square. A journalist at Guangzhou's *News Express*, Chen Yongzhou, was detained in Changsha for damaging the business interests of Zoomlion following critical reporting on the firm.[90] Initially his paper defended Chen, publishing a front-page editorial titled "Release Him," but it relented after a confession by Chen aired on national television, despite such forced confessions being in direct violation of the country's criminal procedure law.[91] Xi's reference to the Fengqiao experience suggested a willingness to embrace Maoist mobilizing practices after decades of Reform Era Chinese political and legal developments that distanced the regime from such energies.[92] October ended with ethnic Uyghurs driving an SUV through barriers and across a crowded Tiananmen Square; the car erupted into flames, injuring thirty-eight and killing five, including the vehicle's occupants.[93]

The Third Plenum sailed into this storm, and after an initial, difficult-to-parse communiqué confounded observers, a full Decision text emerged that solidified

[87] China Media Project 2013c.

[88] Bandurski 2013a.

[89] Bandurski 2013a.

[90] China Media Project 2013b.

[91] China Media Project 2013a. Wei Yongzheng, "China's most prominent media law expert," said that "allowing a detained suspect to face the television camera and confess before the whole country . . . directly violates *Criminal Procedure Law*, which states that 'no person may be forced to confess their own crimes.'"

[92] Bandurski 2013b.

[93] Wan 2013.

the perception of a regime prioritizing market reforms. The initial communiqué's language seemed to indicate that China would "unswervingly uphold the importance of the state sector."[94] This reading deflated pro-market expectations and was followed by steep drops in Chinese stock indices.[95] However, the reception of the Decision text was decidedly different. Economist Barry Naughton called it "a huge, sprawling, impressive document," while Arthur Kroeber said that it "encompasses an ambitious agenda to restructure the roles of the government and the market."[96] Kroeber saw in it a message about how to "get the government out of resource allocation": markets would shift from a "basic" to a "decisive" role. Beyond that change in language, analyst Christopher Johnson emphasized sweeping changes in removing "many of the regime's most noxious—and longstanding—practices," namely the labor camp system, the expansive use of the death penalty, and the stringencies of the one-child policy.[97] Assistant office director of the Party's Financial Leading Small Group, Yang Weimin, compared the resolution's agenda to Deng's Southern Tour in 1992.[98]

The Decision presented a sixty-point reform scheme, including opening the financial sector, reducing subsidies for energy, increasing space for foreign investment and ownership, expanding land use rights for rural dwellers, and prioritizing the environment.[99] Keeping state-owned firms as part of the economic mix was emphasized, but details were provided about reforms even in that hard-to-discuss sector.[100] The Decision document and the positive commentary around it reversed the market drops that had followed the communiqué's release. Yet despite its rapturous reception, notes of caution remained in place. Naughton explicitly avoided the term "blueprint" in his analysis, preferring "vision statement." Authoritative documents with extensive details shared publicly imply consensus on the goals and mechanisms to achieve them. While this "to do list" was impressively annotated and ticked off numerous issues and "policy clusters" for reform, it in itself was not the solution.[101] Further, some alternative readings of the decision pointed against connecting greater market-based economic activity with a more liberal governance structure: in particular, Xi being personally tied closely to the document and the creation at the conference of a Party-based "leading small group on comprehensively deepening reform."[102]

[94] Kazer 2013.
[95] Johnson 2013.
[96] Naughton 2014; Kroeber 2013.
[97] Johnson 2013.
[98] Kroeber 2013.
[99] Salidjanova and Koch-Weser 2013.
[100] Naughton 2014, 2: "does not evade difficult areas."
[101] Naughton 2014.
[102] Naughton 2014.

These two items suggested another scenario: a Party-led effort to enhance the economy's competitiveness without allowing markets to control outcomes.

The uncertainty and narrative swings over Xi's first year in power conform to a Bayesian learning model of new authoritarian leadership with weak priors and a vast, multidimensional political space. Savvy politicians build support and avoid lighting too many fires at once. Xi's politics are highly autocratic, but they are not nihilistic. His rhetoric is not that of ubiquitous lying that destroys the idea of belief, and while skillful rhetoricians and theorists have little compunction about twisting his words *then* to fit his current line *now*, there is some sense in which what has come to be called "Xi Jinping Thought on Socialism with Chinese Characteristics for the New Era" is coherent. His past words and deeds have some friction that holds up the future trajectory or slows it down. That is, these early actions are not presented as feints to deceive and acknowledged as such, but rather as correct steps toward the current line, if a bit convoluted in its path. The current line, as a moving target, is impossible to capture in a book, but the range of uncertainty has narrowed considerably as Xi's tenure has lengthened. The next section describes the neopolitical turn's direction and overall shape.

The Neopolitical Turn, Inside and Outside

To capture its contours, I examine facets of the neopolitical turn that focus on changes internal to the regime before moving to those facing society. Internal changes fall into the categories of personalization, centralization, and Partyfication of power. External changes in the regime's presentation of itself include rhetorical shifts, in-your-face stylistic moves, and repression.

Despite Deng's insistence on collective leadership and avoiding the dangers of one man holding all the levers of power, in China "personalistic rule is back."[103] Xi leads the Party, itself radically empowered under his rule. Authorities of all kinds have genuflected at Xi's altar. Military and security officials have sworn personal loyalty oaths. His ideas have been enshrined in the Party's constitution under his sobriquet. His visage fills state media to an extent comparable only to Mao's. He chairs so many commissions, committees, and especially "leading small groups" that Sinologist Geremie R. Barmé in 2014 coined the title "Chairman of Everything" for him. By assigning his close ally Wang Qishan to run the anticorruption crusade, Xi indicated his close ties to the campaign. He personally visited leading state media producers in 2016, demanding and

[103] Shirk 2018.

receiving loyalty pledges.[104] While often still referred to as the "core" of Party leadership, as Jiang and Hu were before him, the more exalted title of "leader" (*lingxiu*) has become common in state media. Xi's personality cult has extended literally into the hands of the people, as multiple smartphone apps aid in its construction and substantiate it.[105]

Most directly, Xi pushed through elimination of the two-term limit for president in China's Constitution, allowing him to continue to hold that position indefinitely. While the Party constitution has not contained an official term or age limit for the general secretary, the age threshold norms discussed in previous chapters had held for more than two decades. Changing the Constitution to keep the leader in office is precisely the kind of change that scholars use to gauge rising or falling personalism.[106]

Analyzing Malaysian prime minister Mahathir Mohamad's personalization of power, Dan Slater wrote that prospective personalists had three mechanisms at their disposal: "packing, rigging, and circumventing."[107] Xi packed key government positions with his supporters while purging rivals. He also created significant new organizations, such as small leadership groups, that he controls to circumvent rival power centers. With these latest constitutional changes, he has rigged the game in his favor. The CCP remains a massive and powerful organization, but increasingly it is an institution ruled by just one man.

Personalization is dangerous, for a regime and for the world. Personalism makes calamitous mistakes more likely, as policy follows the whims of an individual.[108] Policy errors and flip-flops abound under Xi's leadership. In 2015, officials encouraged stock purchases and blamed foreigners when the inevitable sell-off occurred.[109] In 2016, a poorly constructed "circuit breaker" designed to halt stock market crashes instead caused them—before being quickly removed.[110] Foreign policy tends to be more conflictual when leaders are strongmen rather than the head of political machines.[111] Since Xi came to power in 2013, China's military has acted with increased boldness in contested territorial claims in the East China Sea and South China Sea, as well as along China's border with India.

[104] Shirk 2018, 26.

[105] Wedeen 1999; on "substantiate," see ch. 2. On smartphone apps and clapping, see Davies 2018, 240–3.

[106] See Geddes, Wright, and Frantz 2018; Gandhi and Sumner 2020.

[107] Slater 2003.

[108] Svolik 2012. Think Nicolae Ceaușescu's demographic policies in Romania, Saddam Hussein ignoring diplomatic efforts to avoid the first Gulf War, or the famine from Mao's Great Leap Forward.

[109] Wallace 2015.

[110] O'Brien 2016. Tooze 2018, ch. 25 focuses on these episodes.

[111] Weeks 2012.

Personalization is a special subset of a broader trend of substantial centralization of power.[112] Beyond Xi, perhaps centralization's most important component is the increased activity and prominence of the Party's Central Commission on Discipline Inspection. While the CCDI operated prior to this period, its efforts were not as pervasive, feared, or commented upon as under Wang Qishan during the anticorruption "campaign," which has also targeted more and higher-level officials than previous efforts in the Reform Era.[113] An assumed red line protecting those who had served on the Politburo Standing Committee was shattered when Zhou Yongkang, a former Standing Committee member, was detained for corruption.[114] These anticorruption activities represent centralization of power because they expand the monitoring of local governments, officials, bureaucrats, and firms by central authorities to a greater extent and with more independence than before.

Xi's anticorruption crusade far outstrips his predecessors' and has revamped and empowered the CCDI. While local discipline inspection offices nominally have a reporting structure that is horizontal and vertical—for example, a city's discipline inspection commission is under both that city's Party committee and its provincial-level discipline inspection commission. Reforms empowered the vertical at the expense of the horizontal line of authority. Most notably, corruption investigations came to require only the approval of the discipline inspection committee above them and did not need the imprimatur of the local Party bosses. Personnel decisions for discipline inspection commissions also shifted vertically, with nominations of heads of discipline inspection occurring at one level above.[115] The CCDI also sends out its own teams to assist local discipline inspection offices and to conduct their own investigations that are reported through the system. These investigations have been conducted in local governments, ministries, the military, and state-owned enterprises.[116]

Interestingly, the anticorruption campaign explicitly referenced the idea that such changes are not singular or temporary. Xi told officials that they "should not have the wrong idea that they have passed the test just because the sessions are over."[117] Indeed, in August 2014, fourteen months after the launch of the

[112] Although the extent to which outsiders will ever know the "truth" of such dynamics is limited at best. On difficulties of assessing elite politics in China, see Teiwes 2015.

[113] "Campaign" is placed in quotes as it seems to be something of more permanence—something institutionalized—rather than a temporary campaign; the term "crusade" is also used. Higher-level targets include Zhou Yongkang, former Politburo Standing Committee member and Xu Caihou, former Politburo member and vice chairman of the Central Military Commission (Barreda and Yan 2014; Veg 2014).

[114] Veg 2014.

[115] Zhou 2014.

[116] For SOEs, see Leutert 2018a.

[117] Xinhua Insight 2013.

campaign, the regime promulgated further details about reinvigorating the implementation of anticorruption measures.[118] Years later, new cases of officials—high and low—continue to dominate the headlines.[119] Officials concerned about being perceived as corrupt have slow-walked policy moves and adjusted their patronage networks.[120]

Regardless of the impossibility of knowing the breadth of corruption perfectly, some cases show its massive scale in mid-2010s China. Lt. Gen. Gu Junshan's Puyang (Henan) mansion took twenty police officers two nights to empty, filling four trucks with gold, high-end liquors, and other valuables.[121] In a separate real estate deal in Shanghai, Gu reportedly took a 6% cut of a 2 billion yuan land sale.[122] News stories put the size of fortunes of some of China's "tigers," or high-level officials, at staggering values. Gen. Xu Caihou was said to have a "ton of cash," as in a literal ton of paper money, and Zhou Yongkang's fortune was assessed north of $14 billion.[123] Even low-level officials amassed astounding amounts of wealth, such as Ma Chaoqun, an official working in the water-supply bureaucracy in Beidaihe, who "allegedly used his position to stack up a prodigious fortune: $19.3 million in cash, 81 pounds of gold (worth about $1.4 million), and 68 properties totaling $163 million."[124]

Where did early anticorruption investigations take place? If Xi's personal anticorruption beliefs motivated the actions, then they would likely focus on the locales with the greatest corruption. An alternative perspective relates to the risks emanating from local economic mismanagement, which would point to investigations being targeted in locales with more accumulated economic and political risks, with relevant measures such as overinvestment.[125] The investigations under examination here come from the early waves of the anticorruption campaign, in particular 726 news releases publicized by the CCDI on its website in 2013 and 2014. Figure 7.1 shows the number of investigations divided by provincial GDP to account for this variation.

Residential construction completed during the three years from 2010 to 2012 divided by its value a decade prior (2000–2) serves as a blunt measure of economic risks.[126] The mean value of 4.1 translates to over four times as

[118] Xinhua News Agency 2014b.

[119] He Xingxiang, a China Development Bank vice president, was pushed out September 2021.

[120] On slow-walking, see Wang and Yan 2020. On patronage networks, see Li and Manion 2019.

[121] H. Wang 2014; Zhou and Wang 2015.

[122] Meng 2014.

[123] Koetse 2014; Barboza 2012; Chin 2015; Lim and Blanchard 2014.

[124] Jacobs 2015.

[125] Obviously these could overlap or be correlated.

[126] The data are "Floor Space of Residential Buildings Completed" from the National Bureau of Statistics and compiled by Wind Financial Information.

Figure 7.1 Anticorruption Investigations Normalized by GDP, 2013–14. Investigations per 1 trillion yuan GDP. Source: 726 investigations from ccdi.gov.cn, GDP data from stats.gov.cn

much residential construction taking place in the later period than in the earlier. Political connections run in two directions. First, areas associated with Xi should see fewer investigations than expected, all else equal.[127] Second, areas linked with political rivals or cliques should see more investigations than expected, all else equal. Following others, these locales are coded as significant corrupt cliques: Sichuan and Zhou Yongkang; Shanxi and Ling Jihua; Yunnan and Bai Enpei; Jiangxi and Su Rong; and Guangdong and Wan Qingliang.[128] A basic count model of investigations across China's provinces finds a strong positive relationship with the cliques but little else.

Using investigations per unit of GDP, a simple regression points in favor of economic risk affecting the pattern of investigations. Residential construction growth is positively associated with more investigations over GDP, while neither Xi's presence nor that of his rivals differentiates itself from zero, suggestive of the

[127] Xi's provincial work history is predominantly in Fujian and Zhejiang; Shaanxi is his birthplace as well as the locale where he was sent to do manual labor during the Cultural Revolution.

[128] Of course, the *South China Morning Post* is looking at the investigations and their location in the creation of their lists (Feng 2014).

importance of accumulated risk in the early anticorruption crusade.[129] This analysis of the campaign's early targets is far from definitive on whether combating corruption or purging rivals dominates anticorruption actions. Some research comes down more strongly on one side or the other, but many see both factors playing a role.[130]

The neopolitical turn's attempt to simultaneously fix and hedge China's political economy is shown most clearly in the anticorruption campaign. Economically, markets are distorted as decisions are being made by officials pocketing benefits. These resources that could be broadly shared are not just distributed inequitably; opportunities are being squandered as firms win based on connections rather than efficiency or innovation. Reducing the incidence of corruption could be expected to both reduce inequality and produce greater returns to investments and resources. The universality of clean governance campaigns points to their utility as a hedge as well.

While the CCDI was initially the main avenue of centralization, it is not alone. The Fourth Plenum of the 18th Party Congress in October 2014 provided another example of the center's increasing efforts to monitor and control local officials, in this case through changes to the legal system's structure. That Plenum's communiqué called for concrete steps that would allow judges to hold local officials more strictly accountable for their actions.[131] In particular, the creation of circuit and regional courts with jurisdictions across extant subnational borders gave judges room to rule against local leaders without putting the court's resources and their own salaries at risk, since prior to this adjustment judges had dual horizontal and vertical authority relations and so were subordinate to local Party bosses.

Centralization can even be seen in domains that appear distant from the Party-state's institutional setup, such as urbanization policy. The regime has managed urbanization throughout its reign, promoting urban stability and attempting to restrict migration to and, ultimately, the size of the country's largest cities.[132] However, in recent years there has been a push in the opposite direction, toward building true megacities in and around Beijing, Shanghai, and Guangzhou. At the same time, Beijing demolished the residences of tens of thousands of migrants, referring to them as the "low-end population," and both Beijing and Shanghai have put into place ceilings on their population.[133]

[129] See Appendix 2.

[130] Wedeman 2017; Lu and Lorentzen 2016.

[131] CCP 2014. Members of the CCDI standing committee attended the Fourth Plenum as nonvoting delegates.

[132] For more on China's management of urbanization, see Wallace 2014.

[133] On Beijing's 2017 demolitions, see Friedman 2017; Ma and Wallace 2022. On population caps, see Roxburgh 2018.

Yet this push appears to be more closely related to the desire for increased central control—assaulting the "fortress economies" of the different regions—than being purely about urban planning.[134] As Zhang Gui, a researcher at Hebei Technology University, remarked, "Right now, every official will think of his own region first—from the construction of projects to investment"; heretofore officials had been judged primarily on such metrics.[135] This localism pervaded the system of limited, quantified vision as statistics were territorially bounded.

A reenergized CCP is the third prong of the internal remaking of the Party-state under Xi. Beyond Xi's Party leadership and the critical place for the Party's discipline inspection apparatus in generating the clean governance that the neopolitical turn proselytizes, the Party's growing strength is evident. Ideological work, including Marxist studies, is emphasized. The number and power of leading small groups has exploded.[136] Their proliferation has extended beyond the personal ambit of the Chairman of Everything, and they have wrestled some control of reform agendas away from existing state or other entities.[137] To be certain, leading small groups have significant liabilities and limits as governance providers in the long run, as they lack the full-time attention of their members and bureaucratic personnel addressing the complicated intricacies of managing economic entities and their complex, shifting environments.[138]

The Party's presence is also being deeply felt in the economic domain, where many had seen it as vestigial. The overall ideological environment shapes all manner of policy decisions, either to encourage delay of various projects or to reorient them to be more accommodating of the center's political priorities. But the neopolitical turn's economic governance can be observed in more direct fashion as well. The regime has more aggressively used its existing appointment powers to affect the personnel and business decisions of state-owned firms.[139] Similarly, Party committees that had become afterthoughts in the operations of state-owned enterprises have become power centers making key decisions.[140]

The reforged machinery of the regime's internal mechanisms is only one part of the neopolitical turn. While dramatic to actors inside it, such efforts to invigorate moribund political institutions and movements are common—if not always successful—in a wide variety of political and economic systems. What is more particular to the Chinese case is the neopolitical turn's relationship

[134] Reuters 2014.

[135] Reuters 2014.

[136] For example, see Johnson, Kennedy, and Qiu 2017 on leading small groups.

[137] Leutert 2018a.

[138] Leutert 2018a.

[139] Leutert 2018a.

[140] Leutert 2018a. The post-COVID crackdowns on private enterprise associated with the common prosperity slogan are briefly discussed in the conclusion.

with society broadly. With few exceptions, twenty-first-century authoritarianism has been seen as fundamentally demobilizational. Neoliberalism reigned hegemonically. Politically, electoral authoritarianism, with its democratic façade, became a dominant trend within authoritarian systems, while systems without elections either remained closed off, such as in North Korea, or justified themselves through technocratically derived outcome-based legitimacy, as China had. Xi's neopolitical turn did not occur in a contested political arena, as the CCP scrubs any inklings of organized political opposition off the field; instead it borrows methods of technocratically inclined Singapore and nationalist-nihilist Russia.

The regime's changing presentation involves rhetorical shifts and repressive actions along with policy moves. Beyond the anticorruption campaign, the regime has attempted to rein in credit markets to fix the country's debt problems and launched a campaign to "eradicate poverty." In 2014, with outside observers believing that official debt data masked the extent of the problem, the center made debt levels a hard target for cadres and attempted to shift from LGFVs to on-budget borrowing.[141] However, credit growth continued as these barriers were evaded, and high-level officials cautioned about debt buildups and the threat of sudden asset price collapses.[142] In May 2016, *Renmin Ribao* ran a long article with an "authoritative person," suspected to be Politburo member Liu He, arguing that "the country should make deleveraging a priority, and . . . needs to be proactive in dealing with rising bad loans, rather than hiding them."[143] People's Bank of China governor Zhou Xiaochuan cautioned against "excessive optimism" and raised the possibility of a "Minsky moment," when built-up tensions snap and an economy falls into a sharp correction.[144] By July 2018, credit growth was as slow as it had been in a decade, although it still continued to grow faster than the overall economy.[145]

While wrangling with the complexities of the financial sector, Xi also promised to eliminate rural poverty, which on its face appeared simpler. The targeted population was the desperate, estimated at around 70 million people living below China's poverty line of approximately one dollar a day.[146] But as in other campaigns, implementation quickly jumped to quantification. The 70 million number was divided up into provinces and then on down the political hierarchy, generating quotas for officials, the end result often being the forcible moving of

[141] Wildau 2014a, 2014b.
[142] Mitchell and Wildau 2017.
[143] Gong, Xu, and Wu 2016; Wolf 2018.
[144] Wildau 2017.
[145] Wang 2018; Wildau 2018.
[146] Zeng 2020. Hernández 2017 suggests just 43 million.

poor populations from villages to urban apartments regardless of their desire to do so.[147] The center attempted to inspect local compliance, and many observers were faced with Potemkin villages, but Xi's technophile inclinations also led to the creation of a big data platform to aid supervision.[148]

Rhetorically, the regime, and Xi as its exemplary figure, pushes the view that it operates from a moral high ground based in a mélange of Chinese traditions and Marxism. The mass line operates to increase contact and build sympathy between state and society at the grassroots, and thereby improve normative steering of governance. The anticorruption campaign symbolizes the regime's turn away from self-extraction toward broadly based betterment. The information environment that it controls has also been narrowed, in line with the "Seven Nos" from 2013's Document 9, as the regime sees Western values as threatening.[149] Censorship is not just for international voices, however, as significant efforts to limit the ability of independent voices to reach great audiences have buffeted the media environment. Verified social media accounts with large followings were targeted until political messages disappeared from their posts, and individuals and groups were arrested on a variety of legal charges, such as tax evasion, to diminish their appeal and credibility.[150]

The regime's traditionalism is most ostentatiously presented in Xi's incessant quotations of classical Chinese works. In 2015, the People's Daily Press published a book, *Classical Aphorisms of Xi Jinping*, that highlighted this source of his words, if not necessarily his ideas. Often simplified as "Confucian," a broader range of Chinese thought traditions is present in his speeches, especially legalist works.[151] Emphasizing that officials should be judged by their morality fits into the Party's centralization efforts, as it can inculcate obedience to central dictates and reduce monitoring costs.[152] This traditionalism can often be seen in the regime's gender politics. Far from echoing the revolutionary slogan "Women hold up half the sky," the regime's propaganda apparatus has been used to amplify the role of women as procreators and caregivers. Feminist activists have been targeted, and women have been encouraged to settle down lest they become "leftovers."[153] The one-child policy was abandoned in 2015, and increasingly strident pro-natalist rumblings emanate from the propaganda apparatus.[154]

[147] Zeng 2020.

[148] Zeng 2020; Xinhua News Agency 2016.

[149] *ChinaFile* 2013.

[150] Gallagher and Miller 2021.

[151] For example, Crane 2018. For a deeper investigation, see Zha Jianying's 2020 "China's Heart of Darkness."

[152] For example, see Tatlow 2014 for Xi's calls to Chinese classics in defining virtue.

[153] See Fincher 2016 and Fu 2017 on feminists.

[154] Fincher 2018, 185.

But far from being universalist, the targets of these messages are overwhelmingly middle-class, college-educated, ethnically Han women.[155]

Gender nonconformity has been policed even in reality television, where censors have blurred out men's earrings. While some of this retrenchment to traditionalist patriarchy comes from demographic pressures that the regime believes it faces—that is, after decades of attempting to control human reproduction to limit childbirths, now the regime is hoping to increase their number (especially for "high-quality people")—some of it also connects to a "crisis of masculinity" that some, likely including Xi, believe the country faces.[156] Famously, Xi argued that "no one was man enough to stand up" and save the Soviet Union when it collapsed in 1991. His masculinity is far from the bare-chested horse-riding of Russia's Vladimir Putin, but it is also present in media discourse.[157]

While the regime uses nationalism as a pillar for its popular support and self-identity, the regime's Chineseness, especially when ostracizing "Western ideas," is always in tension with its Communist label, given Marxism's European origins. The regime's market-based economy is not likely to disappear as it did in the late 1950s, but Marxism's revival goes beyond rhetorical flourishes and ignored theoretical works. The regime's anticapitalist impulse is mainly aimed at controlling ostensibly for-profit corporations to pursue the regime's interests ahead of their own bottom lines through the Party-based systems of control described above.[158] Intellectually, Marxism institutes and study sessions are having revivals,[159] yet the potential or desire for indoctrination is limited, as the contradiction between the regime's legitimating economic development fundamentally rests on capitalist profit-seeking and exploitation of labor. The rights of workers, such as to organize themselves to create independent unions, are abrogated, as the All-China Federation of Trade Unions is the legal union of record inside the political system. Those staffing the Federation's branches in various companies and factories are in nearly all situations as committed to order preservation and promotion possibilities as they are to the laborers' concerns, and efforts to create independent workers' unions or agitate on behalf of workers outside of a formal organizational context have been squashed, especially in the

[155] Fincher 2018. These women are a "high-quality" population, in contrast to the migrant populations driven out of Beijing in 2017.

[156] See, for example, May 2021.

[157] See the discussion on the "personality cult" below.

[158] These systems are not perfectly successful. Firms retain abilities to act on their own and pursue their own interests, even in contravention of state or Party directives (see Shi 2020). But also see the discussion on the post-COVID crackdowns and common prosperity.

[159] AP 2014; C. Huang 2015a.

Xi era.[160] When in 2018 student activists at elite universities took up the cause of workers at Shenzhen Jasic Technology, they found themselves harassed and disappeared from campuses extralegally.[161]

The pattern of activist detentions noted in the description of Xi's first year has, if anything, grown over time in depth and in demonstration. The repression of Hong Kong booksellers, rights lawyers, and feminist activists exemplify this return to more aggressive treatment for those outsiders trying to push agendas. A sensational aspect of China's neopolitical repression has been its use of televised confessions, notably in its efforts against the booksellers.[162] In 2013, highly successful corporate executives and public intellectuals appeared on CCTV to confess their crimes, behavior that had been nearly absent during the prior decades of the Reform Era. These humiliation rituals then expanded to include a number of booksellers from Hong Kong, including one who had vanished while traveling in Thailand, only to reappear in PRC custody.[163] Rather than silently impose costs on activists or opponents or generate self-censoring actions through fear, the state blasted messages of its power, authority, and willingness to attack those deemed critical. Some compatriots of the university Marxists who supported Jasic felt a strong chill when one of their members publicly confessed to working with an "illegal organization."[164] Paired with the publicized efforts at anticorruption and subsequent confessions of political figures both major and minor, these presentations show the regime's propagandists to be confident in their willingness to use shame, to name names, to draw the line of acceptable behavior, and to mete out punishments for failure to comply. The shrinking political space ensnared more and more Chinese attempting to advocate for their interests in a system less inclined to allow their voices to be heard. Over 140 rights lawyers were detained in a sweep in July 2015.[165] Five leading feminist activists were detained on the night of March 6, 2015, before International Women's Day (March 8) and were brutally interrogated while in captivity, despite their cause going viral on international social media.[166]

The neopolitical turn's increased repression and monitoring of officials has made many wary of efforts to observe citizens' actions more closely as well. Efforts to establish a "social credit system" show that the regime is rejecting not quantification per se but the idea of *limited* quantification. Some international

[160] On the All-China Federation of Trade Unions, see Friedman 2014. On the crushing of labor NGOs under Xi, see the final chapter of Diana Fu's 2018 *Mobilizing without the Masses*.
[161] Chan 2018. On the harassment, see Shih 2019.
[162] Goldkorn et al. 2016; Yoon 2015.
[163] Wong, Forsythe, and Jacobs 2016; *Bloomberg* 2016b.
[164] Shepherd 2019.
[165] Amnesty International 2015; Buckley 2015; Tang 2015.
[166] Fincher 2016; Tatlow 2016; Zeng 2015.

media and politicians[167] have portrayed the project in Orwellian terms, depicting a state-controlled artificial intelligence able to recover all of the digital crumbs that our technologically enhanced lives give off, assemble and assess them for political loyalty, and exact punishments or distribute rewards accordingly.[168]

In fact, the germs of the social credit system can be traced as far back as 1989 as an idea to help "[address] problems in commercial and financial sectors,"[169] but it was not until the State Council published the "Planning Outline" for constructing a social credit system in 2014 that it drew serious public attention. Broadly, the term describes a range of efforts to improve trust and security in markets. Despite survey results that depict Chinese as possessing high levels of overall trust, the proliferation of scams and frauds are seen as an endemic threat to the country's continued development.[170] Three kinds of systems are often conflated: state-run plans for corporations, state-run pilots for individuals, and privately operated plans. The state-run plans are relatively simple, building blacklists of actors who have violated various policies, regulations, or court orders. The private operations, such as Sesame Credit, do integrate with online platforms such as WeChat, but are voluntary and produce credit scores closer to those in the United States than some universalizing "Citizen Score."[171] Governmental technology projects are notoriously unsuccessful, and creating such a score for 1.4 billion people that includes different kinds of data from unique sources would be a daunting technical challenge.

While the social credit system has not yet become the Orwellian nightmare that it is often depicted as, the regime's governance practices in Xinjiang do deserve the label. The cutting-edge technology—such as iris scanners, AI-powered facial recognition cameras, and mandated smartphone apps—has excited the public imagination, but the stark reality is that ubiquitous security forces attempt to police and control behavior of those not in detention facilities. Officially referred to as "reeducation centers," these massive prison-like complexes have sprung up all over the territory and appear to be filled with hundreds of thousands of Uyghurs and others from Xinjiang.[172] After months of denying the

[167] Horsley 2018a cites Pence 2018.

[168] These depictions seem closer to the 2016 *Black Mirror* episode "Nosedive."

[169] Liang et al. 2018; Kostka 2019.

[170] Creemers 2018; Daum 2021. See also Tang's 2016 survey work on trust. Kostka 2019. Xu, Kostka, and Cao n.d. emphasize that the social credit system retains broad public support in surveys but that such support erodes when information about potential repressive capacities in the system is conveyed.

[171] Creemers 2018.

[172] Rajagopalan 2017. Literally, "transformation through education work" (*jiaoyu zhuanhua gongzuo*) (Zenz 2019, 4). Other language includes "de-extremification" (*qu jiduanhua*) campaign (Zenz 2019, 12).

existence of such facilities despite considerable evidence from satellite imagery, former inmate testimony, government contracts and budgets, and street photography, state media did an about-face in mid-October 2018, when "the CCTV prime-time program 'Focus Talk' (焦点访谈) dedicated a 15-minute episode to the topic of Xinjiang's 'vocational skills educational training centers' (职业技能教育培训中心)."[173] Some estimates of the numbers detained exceed 1 million, nearly 10% of the Uyghur population.[174]

Finally, Xi's personalization of power has generated use of the term "cult of personality" and comparisons to the cult of Mao.[175] However, while there has been intense pushing of Xi's personal vision and capital-T Thought inside the Party, his incipient cult bears little resemblance to those more storied fever dreams. Liangen Yin and Terry Flew suggest that cults of personality tend to possess four common features: "the use of ideology as a surrogate 'political religion'; using various symbols to dominate social life; the turn to charismatic authority; and the use of media to amplify the cult."[176] Yet there is little evidence of the regime's promoting such conversations. Indeed, some early efforts by local officials—such as Xi badges worn by Tibetan officials in 2013—were hushed up. Viral songs touching on Xi's love for his celebrity singer-wife, Peng Liyuan—"Xi Dada Loves Peng Mama"—have bubbled up from individuals and not been quashed, but these materials humanize rather than deify him. In that these materials fit Xi's desired narratives of courageous anticorruption efforts and suggest his success in performing the traditional roles of father, husband, and son, they have political utility. Even with Xi apps, the cult of Xi is perhaps more a bottom-up reflection of society's anxieties and a desire by some for leadership beyond the numerical.

Dividing Lines

China's neopolitical turn responds to the political failures of the prior system but comes with its own downsides. As recent research on Russia demonstrates, political insulation has benefits for dictators. Taking advantage of differences in the ways in which mayors come to office—either appointed from above by regional leaders or elected by the population—Quintin H. Beazer and Ora John Reuter show that the higher-level leadership takes more blame when the economic tides turn in communities governed by appointed leaders.[177]

[173] Koetse 2018; Zhang 2018; Zenz 2019.
[174] Zenz 2019.
[175] *The Economist* 2016; Nathan 2016; Landreth 2016; Yin and Flew 2018.
[176] Yin and Flew 2018.
[177] Beazer and Reuter 2019.

It can be useful for the emperor to be seen as far away when troubles arise. Centralizing authority may increase control and allow the center to eliminate some problems at the local level, but it also increases central ownership of any subsequent issues that might arise. That ownership could be harmful should those issues threaten the arguments that the regime uses to justify its continued rule. Free lunches, as ever, remain hard to find. Further, Beazer and Reuter show that the blaming effect is targeted to the level that conducts the appointments (regions) rather than generically affecting the central government in Moscow. This may suggest that Xi's efforts at centralization and personalization could place blame on his shoulders personally should crises come to pass.

China's neopolitical turn highlights the types of transitions that nondemocratic regimes experience and initiate but remain underexamined in the literature. Rhetorical changes put politics front and center instead of masked in technocratic jargon. Institutional changes give the center more ability to oversee the activities of lower-level officials but also reduce its ability to slough off responsibility to local bad actors for problems or malfeasance. Systems of governance and justification strategies are decisions with consequences that respond to perceived threats and opportunities of the moment. When they succeed, they eventually come to find themselves in a transformed world simply as a matter of time or their own success in remaking the political landscape. The old threats fade, while others loom large. Remaking governance and justification—that is, reform—is perilous but preferred to lapsing into irrelevance or decay.

Beyond Count

The GDP growth rate could not serve as the sole yardstick of success for development.
—CCP Central Committee Resolution on History, November 11, 2021

The regime that Chairman Mao left behind faced many political difficulties. Without him to legitimate and guide the ship of state, the regime could have found itself adrift. Yet within half a decade of his departure, a transformed Party-state was decentralized and put forward a new purpose to be pragmatically pursued: development. Output boomed, heralding the return of China to the global stage and the effectiveness of this strategy. Difficulties mounted, and the regime has again embarked in a new direction. In broad terms, this tale is well-known and well-worn, the harrowing moments forgotten or smoothed away by time and the repetition of simple narratives. The reanalysis here is less an attempt to refute this conventional wisdom than to refract it. The lens of the regime's limited, quantified vision illuminates China's navigation of reform's treacherous waters, clarifying parts of the history that have been obscured, and highlights quantification as a political technology in the authoritarian toolkit.

This final chapter concludes by diving into the COVID-19 crisis before moving to the ways China's boom has remade the world beyond its borders. Despite the presence of technical systems and Xi's efforts to centralize authority, information problems led a few initial infections to spread and seed a global pandemic. The furor hit a fever pitch that threatened the regime, but it broke as coercive countermeasures contained the virus's spread domestically while the outbreak devastated the United States, Europe, and much of the rest of the world. China's "post-COVID" economic stimulus revisited the old real estate investment playbook, but crackdowns on companies amid calls for common prosperity suggest that the neopolitical turn continues. China's successes have forced serious reassessments of political assumptions globally. Censorship and propaganda's role in politics raise questions of what we truly know of the world

Seeking Truth and Hiding Facts. Jeremy L. Wallace, Oxford University Press. © Oxford University Press 2023.
DOI: 10.1093/oso/9780197627655.003.0008

and the role facts play in politics. China's development has directly shaped beliefs about how economies work, as seen in its role in the global rise and fall of neoliberalism, where quantified politics ruled.

COVID-19

Understanding the problems of hidden information that bedeviled its 2003 response to SARS, the Chinese regime constructed institutions to prevent the same response from happening again. Yet these systems failed to operate. Local authorities retained the power to control functionaries in their jurisdictions. In the moment of crisis, they believed their interests to be best served by downplaying potential risks until after critical meetings were held. Bureaucracies built ostensibly to facilitate information flows instead created hurdles. The old agency problems refused to be disappeared by technical systems even under Xi's centralized authority.[1] Indeed, because of that very centralization, blowback was directed not solely at low-level officials but also at the regime's top leadership. The timely combination of virus cases dropping domestically and exploding internationally defused a moment as dangerous as any the regime has faced in decades. But by focusing on quantification and limited vision, one can see underlying patterns in both dictatorships and democracies as problems emerge from uncounted blind spots.

Initial Outbreak and Chinese Response

Allowing one's people to die is delegitimizing for a political regime. In the wake of the 2003 SARS crisis, the Chinese state invested in early detection and information mechanisms to reduce the chances of such an outbreak recurring and finding the regime denying reality or flailing in its face.[2] Yet, when a cluster of atypical pneumonia cases broke out in the central city of Wuhan in December 2019, the regime's preparations proved insufficient. Crises are stressors, and the COVID-19 crisis pushed China and the global economy as close to their breaking points as anything had in generations.[3]

While the precise zoonotic origins of the virus remain somewhat shrouded at the time of writing, the general outlines of the outbreak's start in Wuhan are well-trod ground that align with the book's themes. First, authoritarianism is prone

[1] Yang 2020a, 2020b; Jaros 2020.

[2] Yang 2020a.

[3] The following discussion builds on Neblo and Wallace 2021. See also Tooze 2021.

to opacity and information problems, despite all of China's recent efforts and even specific preparations for precisely this kind of a potential crisis. Second, in a fast-moving situation, timing, speed, and political leadership play crucial roles. Third, material reality matters but also interacts with existing political narratives and institutional and information environments to produce outcomes.

As the wave of unexplained pneumonia cases hit Wuhan in December 2019, investigations began.[4] The coronavirus was identified, and it was initially believed—according to Chinese government statements—that humans could be infected only through contact with animals, that is, not person-to-person. Such contacts centered around the Huanan Seafood Market in central Wuhan.[5] On December 13, a sixty-five-year-old, self-employed delivery man for the market began to feel sick with chills and a high fever.[6] On December 16, he visited an outpatient clinic for treatment. On December 18, he went to the emergency department of Wuhan Central Hospital (WCH), where Dr. Ai Fen served as director, before being transferred to the hospital's respiratory department on December 22, then to a different hospital, before ending up at Jinyintan Hospital. On December 24, a sample from a pneumonia patient at WCH was sent to a Guangzhou-based gene-sequencing company.[7] Dr. Lu Xiaohong, a gastroenterologist at Wuhan Fifth Hospital, heard that there were suspected infections among medical staff.[8] On December 27, Dr. Zhang Jixian observed unusual CT scans in four pneumonia patients, including a family of three, and alerted hospital authorities.[9] That same day, WCH sent a sample to CapitalBio, a Beijing-based lab; Ai Fen of WCH treated a man in his forties with the same symptoms; and the Guangzhou lab BGI sequenced the novel coronavirus.[10]

As the year came to an end, hospitals in Wuhan began receiving multiple cases of a pneumonia of unknown origin (PUO).[11] On December 30, Jinyintan Hospital's Zhang Dingyu had samples from seven patients collected and sent for analysis to the Wuhan Institute of Virology.[12] Also on December 30, the Wuhan Health Commission issued an internal notice acknowledging multiple cases

[4] The technical term was acronymized as pneumonia of unknown origin (PUO).

[5] The market is next to the Wuhan Institute of Virology, which has led to suspicion that a lab leak may be to blame (ODNI 2021).

[6] Narrative of patient is from Sina 2020. *Wuhan Memo* 2020 has a different timeline.

[7] *Caixin* 2020a.

[8] Wang 2020.

[9] Reference to a family of three is from Roach and Shan 2020; Brennan 2020. Zhang is at a different hospital than Ai Fen.

[10] Zhang 2020; Sina 2020; *Caixin* 2020b. Dr. Zhao Su of WCH tells *Caixin* that Weiyuan Gene (a Guangzhou-based company) identified it as a novel coronavirus.

[11] Sina 2020.

[12] *Caixin* 2020b.

of a new pneumonia, which it linked to the wet market, and CapitalBio's analysis described a SARS-like new disease, which WCH's Dr. Li Wenliang shared on WeChat.[13] Li's post proceeded to be widely disseminated. On the last day of 2019, the National Health Commission (NHC) dispatched an inspection team to Wuhan to investigate the outbreak; the Wuhan Health Commission announced that there were twenty-seven cases of unexplained pneumonia in the city, but no obvious human-to-human transmission had been found; and the World Health Organization was informed of the PUO.[14]

The winds appeared to shift with the arrival of the new year. A testing company was told by an official to destroy samples from Wuhan and not share the results of anything they had already received.[15] The Huanan Seafood Market was closed. Authorities punished Dr. Li and seven healthcare workers for spreading rumors. On January 3, the city's health commission announced forty-four cases of PUO but still claimed no evidence of human-to-human transmission. The NHC told hospitals not to publicly report on illnesses and issued a notice that only provincial and central-level laboratories should be trusted with the sequencing and analysis of the virus; thus, the various labs that had worked on samples had to cease their analyses and destroy their samples.[16] On January 6, the Wuhan government's local "two sessions" meetings began, scheduled to continue until January 11, at which point the Hubei provincial-level meetings would commence, ending on January 17. These sessions are the cornerstone of the political calendar in Chinese localities, but also represented a critical moment when the outbreak became destined to be a pandemic. Throughout this period, the drumbeat of "No New Cases Reported" was repeated by the Wuhan authorities, indicating that the outbreak was contained and not spreading.[17]

However, evidence of human-to-human transmission accumulated, and despite the reassurances of the Wuhan Health Commission, the outbreak grew uncontrolled. A doctor at Xinhua Hospital was shown abnormalities on a CT scan on January 6, but hospital authorities emphasized that this information should not be disclosed to the public or shared with the media.[18] Outpatient and emergency

[13] The SARS coronavirus and SARS-COV-2 are genetically quite similar, prompting Li Wenliang to post that a SARS virus was spreading. Of course, there are major differences in the biology and behavior of the virus that led COVID-19 to become a global pandemic while SARS killed 774 globally, namely that it is more highly communicable (higher R_0); has a longer presymptomatic but contagious period; produces a greater variety of symptoms, leading to difficulties in diagnoses; and results in lower lethality. See, e.g., U.S. CDC 2017; Liu et al. 2020.

[14] Sina 2020.

[15] *Caixin* 2020a.

[16] Jaros 2020; *Caixin* 2020b.

[17] Yang 2020b.

[18] Zhang 2020; *Caixin* 2020a.

departments around the city received many suspected cases.[19] Xi Jinping stated that he "issued demands during a [Politburo Standing Committee] meeting on 7 January for work to contain the outbreak."[20] Li Wenliang's symptoms developed on January 10, making him at least the second symptomatic healthcare worker infected, and emergency departments at some hospitals were becoming full.[21] But the next day the Wuhan Health Commission stated that there was no evidence of medical worker infections, and an NHC expert issued a statement claiming that the outbreak was "preventable and controllable."[22] A major cluster emerged at Union Hospital, where a single operation was linked to fourteen healthcare workers being infected, their symptoms starting to appear on January 12.[23] Yet these infections failed to meet the strict criteria for diagnosis as PUO that the Wuhan Health Commission had created.[24] Further, health commission authorities at different local levels inserted themselves into the bureaucratic process of adding records to the national health database.[25] On January 13, a Wuhan resident who traveled to Bangkok became the first official infection case outside of China.[26]

The following day, January 14, the head of the NHC, Ma Xiaowei, held a teleconference with provincial health officials.[27] Internal documents showed that, akin to the SARS situation nearly two decades before, internationalization of the outbreak had shifted its dynamics for the regime. The call explicitly acknowledged that "clustered cases suggest that human-to-human transmission is possible."[28] However, even after this acknowledgment, no public statements about the grave situation facing the people of the country and the world were offered for six more days. During those six days, Wuhan hosted a mass banquet for forty thousand families, millions traveled for Lunar New Year, and the virus seeded itself for the global pandemic to come with thousands more confirmed infections.[29]

[19] Wang 2020.
[20] Bishop 2020; *Washington Post* 2020.
[21] Wang 2020.
[22] Xinhua News Agency 2020b, 2020c. On January 16, another Xinhua Hospital doctor, Liang Wudong, shows abnormal CT scan and severe infection; he dies on January 25, the first medical worker victim. On January 20, Dr. Wang Guangfa tests positive (Zhang 2020).
[23] Yang 2020b; *China News Weekly* 2020.
[24] Yang 2020b.
[25] Jaros 2020.
[26] Mitchell 2020. The COVID vaccine developed by Moderna was also designed by January 13, 2020 (Wallace-Wells 2020).
[27] The AP acquired documents confirming this session and corroborated them with multiple separate sources (AP 2020).
[28] AP 2020.
[29] AP 2020.

On January 20, CCTV broadcast an interview with the widely respected Dr. Zhong Nanshan, who had earned strong praise during 2003's SARS crisis. In the interview, he confirmed human-to-human transmission of the novel coronavirus. Following Dr. Zhong's public admission, the official confirmed case count in China began growing exponentially. The NHC's expert who pooh-poohed the outbreak himself tested positive on January 20. On January 23, greater Wuhan shut down, and the vast majority of China remained locked down until April.

The number of confirmed infections skyrocketed into the thousands, emergency hospitals were erected, and deaths accumulated. Fury peaked on February 6 with Dr. Li Wenliang's passing, as the silenced whistleblower succumbed to the virus. Dr. Li's face filled newspaper covers and websites, many including his statement "[A] healthy society cannot just have one voice."[30] Millions of posts flooded the Chinese internet, demanding freedom of speech and criticizing the government for silencing experts. Prominent Tsinghua law professor Xu Zhangrun further lambasted the "systemic impotence" of Xi's neopolitical turn, an "organizational discombobulation" manned by "slavishly obeying Party hacks" that "rendered hollow" the "ethical core" of the "nation's technocracy."[31] While the government tried to claim him as a self-sacrificing worker hero, Dr. Li became a martyr for those incensed at the regime for concealing the threat. Dr. Zhong's legitimacy as a whistleblower allowed him to shield the regime and serve as a safe conduit for public grief, such as when he tearfully said of Li, "I'm so proud of him. He told people the truth."[32]

By the time Li Wenliang died, China had reported over 28,000 cases and 564 deaths. But despite the human tragedy encapsulated in those figures, these statistics contained hopeful information as well. Of those 564 deaths, 549 of them were in Hubei. Wuhan alone would suffer 3,869 of China's 4,636 deaths as of May 25, 2020.[33] Restrictions on movement, enforced social distancing, universal masking, and widespread testing allowed China's other cities to escape community spread. Rather than condemning China, the Lunar New Year appears to have aided in controlling the virus.[34] People had supplies prepared in advance; offices and factories were already closed. While the holiday typically is associated with billions of trips, the vast majority involve people visiting their hometowns, where they remain for its duration. China reported declining case counts for weeks, culminating in a March 22 statement that Wuhan had seen no

[30] *China Media Project* 2020.
[31] Xu 2020.
[32] Feng 2020; Bandurski 2020.
[33] This includes the April 17 revision that increased Wuhan's death count by 50% (Qin 2020).
[34] Hollingsworth 2020.

new local cases for four days in a row.[35] Of the forty-six new cases China reported on March 22, all but one were attributed to travelers arriving from abroad.

Having been shamed domestically and internationally for its handling of the 2003 SARS outbreak, China built institutional incentives and informational architecture to reduce the risk of recurrence. But despite centralization of authority in Beijing and the medical reporting network, local incentives to hide damaging data won out. Days turned into weeks before authorities grasped the situation, and then more waiting occurred before that information was shared with the public.

On the other hand, the cordon sanitaire imposed around Wuhan and then the broad lockdown imposed countrywide kept Hubei the primary hotspot. These draconian measures kept carriers of the virus from traveling to different cities and provinces and allowed them to be tested, traced, and isolated.[36] This first success also allowed additional resources to be directed to Wuhan and Hubei rather than held in reserve for secondary outbreaks. Then, within the core hotspot, China's intensive central quarantining reduced the total number of infections, hospitalizations, and, ultimately, deaths. While the full extent of the spread in Wuhan remains debated,[37] the mandatory quarantining was extensive and kept that spread down.[38] Approximately twenty thousand beds across nearly two dozen facilities kept those with mild symptoms and those at high risk for infection, such as family members of those who tested positive, in isolation for two weeks.[39]

Chinese political leadership during the crisis is difficult to parse. The public presentation of leadership in the wake of the first wave differed radically from the presentation in the moment. In particular, whereas Xi has come to be seen as leading the "People's War" against the virus from the beginning, he virtually disappeared from state media broadcasts and newspapers between late January and early February. Initial presentations of Xi's knowledge of the coronavirus dated it only to January 20, with the public announcement from Dr. Zhong of its human-to-human transmission capability.[40] But a *Qiushi* piece from February 15 described an early February speech in which Xi claimed that he had, as quoted above, made demands about containing the outbreak at a January 7 Politburo

[35] Xinhua News Agency 2020a; Wallace 2020.

[36] The initial outbreak was characterized by a high "k" value; that is, it is highly connected to superspreading events, with 80% of infections connected to 10% of cases (Tufecki 2020).

[37] For example, see this serological examination in Wu et al. 2020.

[38] On case count debates, see Wallace 2020. On the presence of pre-vaccine antibodies in the Wuhan population, see Wu et al. 2020. Quarantining seems critical to prevent spread inside households (Minzner 2020).

[39] Mild symptoms are defined as not needing oxygen (McNeil 2020; Minzner 2020).

[40] Mitchell et al. 2020.

Standing Committee meeting.[41] Xi had been absent from public view for three weeks before a February 10 appearance in Beijing.[42] This was the longest he had been out of view since his ascension and even exceeded his mysterious two-week absence from the public eye in the summer of 2012, just prior to taking power.[43] Premier Li Keqiang stood at the front of the regime's response, and interpretations of this presentation generated discussion as well: Was Li being set up to fail if it went poorly? Did it reflect assessments of the course of the virus? Was it simply seen as too dangerous to expose Xi to the virus?

Local leaders in Wuhan were removed, and much of the blame for the outbreak was placed on their shoulders.[44] Those local leaders suggested that they were in fact attempting to follow orders from higher levels, and thus that the blame should not fall on them but on the center itself.[45] However, those claims were unlikely to ever win the day in a stark authoritarian hierarchy, especially once the global context allowed China's response to the outbreak to switch from a political liability to a triumphant success worthy of emulation and adulation.

While an overall assessment at this time points to transparency in Chinese coronavirus statistics after the initial cover-up, spikes in counts are associated with personnel changes.[46] Still, one could see this as further evidence of transparency, with those attempting to hide outbreaks being penalized and the information coming out. On the other hand, the existence of these spikes indicates that at least some officials thought that hiding outbreaks best served their interests, and suggests that perhaps others also hid infections or are continuing to do so now.

Having already pushed blame onto local officials for hushing up the initial outbreak in Wuhan, the national government has repeatedly voiced a need for localities to be transparent and not lie about the spread of the virus. Premier Li laid out these arguments on March 23 at a meeting of the Central Leading Group for Coronavirus Work. In a statement that all but acknowledged that the system trains officials to hit quantitative targets by any means necessary, including by fudging the numbers, he cautioned that despite a strong desire to "pursue zero cases," officials must not conceal or underreport infections.[47]

[41] Mitchell et al. 2020.

[42] Mitchell 2020.

[43] On Xi's 2012 absence, see Fisher 2012; Fenby 2012.

[44] Zheng 2020.

[45] Chin 2020.

[46] *The Economist* 2020.

[47] Li 2020.

A Global Pandemic

From 2019 through the first two months of 2020, the coronavirus outbreak was a "China story," overwhelmingly playing out in Hubei and then inside the PRC's borders. This narrative frame broke in March, when COVID-19 became a true global pandemic. That shift radically altered the politics, both inside and outside of China.

According to the initial statistics, China's peak daily death count was 254 on February 12.[48] On February 24, less than two weeks later, China reported 150 deaths, and the official death count dropped below 50 on February 27.[49] On March 13, China was no longer among the top five countries in reported daily deaths. Three days later, Italy reported 370 deaths in a single day as cumulative deaths outside of China surpassed those inside it. By the end of April, China's deaths from COVID-19 were less than 2% of the global toll.[50] Life in China returned to normal while the rest of the world suffered wave after wave of viral spread. Many in China have compared their country's performance with the even more disastrous ones of other countries and declared the triumph of China's superior system.[51]

Measuring the pandemic's size in a given country is not as simple as plotting officially reported confirmed case or death counts. For instance, Iran's early outbreak hit its political class, and security forces instructed healthcare workers to keep mum.[52] Its subsequent pandemic trajectory is globally abnormal, reflecting this nontransparency as well as early imposition and relaxation of lockdowns.[53] Differences in factors such as testing, demography, and medical system capacity all make cross-national comparison very difficult.[54]

Yet amid the tumult and tragedy, considering quantification and limited vision can illuminate patterns in both authoritarian and democratic settings. First, Singapore had a strong claim to one of the world's most successful responses to the coronavirus in early 2020. Having dealt with SARS in 2003, the technocratic Singaporean regime had devised response plans should another virus arrive at their door.[55] With its first confirmed case on January 23, impressive dashboards

[48] The seven-day average peaked at 177 on February 18. FT Visual & Data Journalism Team 2020.

[49] These figures are from the initial releases. The April 17 revision is coded in these data sets as occurring on April 17, when in fact the deaths occurred much earlier. So these initial reports would have to be adjusted to include the revision data.

[50] By November 2021, China's 4,636 deaths represented less than 0.1% of the globe's 5 million.

[51] Buckley 2020.

[52] Fassihi and Kirkpatrick 2020.

[53] Fassihi 2020.

[54] Lipscy 2020.

[55] Normile 2020.

and temperature checks kept the population informed and the virus under control. The national leadership was widely praised for its cool-headed and honest presentation of the risks and requests for citizen compliance.[56] By the end of March, total confirmed cases were still just 879, and only three people had died. But the vaunted political system overlooked its foreign-born migrant underclass, who tend to live in cramped, crowded dormitories, the precise kind of locale where the virus has seen some of its most explosive growth. Dr. Dale Fisher of the National University Hospital of Singapore told CNBC that the country's response "overlooked a crucial segment of the population—the hundreds of thousands of foreign workers upon whom the nation depends for low-wage labor. The virus began to spread throughout the overcrowded and unsanitary dormitories that house these workers."[57] To counter this new threat, the government further separated this underclass from the rest of society, using closed factories as huge quarantine centers and keeping migrants from leaving and infecting the rest of the city.[58] Singapore's political system's limited vision neglected to consider these residents with as much care or dignity as those it sees as its real community.

In the United States, as the pandemic's death toll grew exponentially, Donald Trump pushed the blame onto China. As noted, China's political system undoubtedly played a role in allowing the virus to fester and multiply in December 2019 and especially January 2020. Yet by the end of that month, the magnitude of the danger was abundantly clear to many outside the PRC. For instance, Mongolia, South Korea, and Taiwan imposed swift measures to slow the outbreak even before the World Health Organization declared an international public health emergency on January 30.[59] Rather than follow these or other strong examples, like Germany, the Trump administration worried more about managing "the numbers" than about the health of Americans.[60]

COVID-19 initially illuminated weaknesses in China's governance, and the regime faced moments of jeopardy at the height of the crisis. But the regime's relative success in delivering the population from the virus's threat seems to have triggered a Hobbesian investment of legitimacy in its protective leviathan.[61] The narrative turned from Chernobyl to Sputnik.[62]

[56] Barron 2020.
[57] Feuer 2020.
[58] Feuer 2020.
[59] Joseph 2020.
[60] Rostan 2020.
[61] Wu 2020.
[62] For example, Anderlini 2020; Tharoor 2020; Milanovic 2020.

"Post"-COVID Economy, "Common Prosperity,"
and Crackdowns

China's success in containing COVID-19 paid economic dividends. The country's economy, alone among the world's twenty largest, grew in 2020.[63] As its factories were able to manufacture goods without endangering people's health, industrial production and exports provided ballast to a consumer and retail economy that had cratered in the first half of the year. Debt-fueled investment also spurred growth, an updated version of China's response to the 2008 global financial crisis. As discussed in Chapters 6 and 7, Xi's neopolitical turn has attempted to address issues related to local debt, especially those that emerged during the global financial crisis.

The government's stimulus was less aggressive than in that prior period of peak pressure, but household debt still rose dramatically in 2020.[64] Much of this debt came from mortgages as households continued to buy real estate; the *Wall Street Journal* referred to the sector as "the $52 trillion bubble" in a July 2020 feature.[65] A dynamic similar to the stock market fiasco of 2015 has unfolded, with the population finding a market that the government is unwilling to let falter, as even modest price declines for homes would "wipe out most citizens' primary source of wealth."[66] Major warning signs of a bubble have emerged, including high vacancy rates and the average price-to-income ratio exceeding 9.0, even higher than famously expensive San Francisco's rate of 8.4.[67] In late 2020, the central government drew "three red lines," restricting access to credit for particularly indebted property developers in an effort to calm markets without popping the bubble.[68]

In November 2020, the Chinese government canceled the initial public offering for Jack Ma's Ant Group, which had been expected to raise $37 billion.[69] This crackdown was the first of many affecting technology, finance, e-commerce, video games, and for-profit tutoring, among others.[70] By some estimates, these moves caused Chinese shares to lose over a trillion dollars of value during 2020.[71]

[63] OECD 2020.

[64] Bird 2020.

[65] Xie and Bird 2020.

[66] Xie and Bird 2020.

[67] Xie and Bird 2020. The 2017 China Household Finance Survey estimates 21% vacancy rate for urban residences—fully 65 million units. To be sure, not everyone is alarmist about Chinese real estate (e.g., Orlik 2020).

[68] *Bloomberg* 2020; Whiting 2021.

[69] Zhong 2020.

[70] *SupChina* 2021 tracked nineteen distinct crackdowns as of October 22, 2021.

[71] Yu and Mookerjee 2021.

In August 2021, Xi gave a speech to the Central Financial and Economic Affairs Commission exhorting his audience "to firmly drive common prosperity."[72] Xi connected high inequality in other countries to the collapse of the middle class, social disintegration, and political polarization before acknowledging that China faced similar threats because of significant income gaps, especially between rural and urban areas. He called for "dividing the cake well" instead of just relying on growth to trickle down to the poor. And he expressed a desire to build a large middle class where workers have opportunities to move forward and avoid the burnout of "endless, meaningless competition" of involution—and not opt out of contributing to society by simply "lying flat."[73] Xi described efforts to equalize basic social services as critical to such endeavors, and he pushed for strengthening pensions, basic poverty-alleviation assistance, and the education system. He criticized the "unreasonable wealth" of the rich and suggested a property tax might finally be in the offing, although there is serious resistance to this idea.[74]

Although Xi took potshots at capitalism's excesses, there's little in the speech to suggest anticapitalism or anticonsumerism. Far from the government's seizing the means of production, Xi emphasized the vital role of China's entrepreneurs and called for lower taxes on small businesses. Even if China became richer, he cautioned, "excessive guarantees" could become a problem, as the country could "fall into the trap of supporting lazy people through welfarism."

The end of his speech curiously included an admission of deficiencies in the antipoverty campaign, one of Xi's signature victories. Pursuing common prosperity is "unlike the poverty eradication campaign," he said, in that China "should not adopt a uniform quantitative target."[75] He expressed real concern that despite the campaign's hitting its numerical goal, the Chinese government still needed to make sure to "prevent those lifted from poverty from returning to poverty *en masse*." Xi's tacit admission that statistical success might differ from the poverty campaign's real effect on people's lives shows that China continues to govern in quantitative terms despite intimate knowledge of the approach's limitations.

For decades China's leaders have understood the need to shift their economic model. After all, Premier Wen Jiabao described China's economy with the "four uns"—unstable, uncoordinated, unbalanced, and unsustainable—in 2007.[76]

[72] *Qiushi* published a transcript in October 2021 (Xi 2021).

[73] For more on contemporary uses of involution, see Wang and Ge 2020. For its prior use in agricultural spaces, see Zhou 2019. For more on "lying flat," see Bandurski 2021.

[74] Wei 2021.

[75] Thanks to Yuen Yuen Ang for pointing this out.

[76] Xinhua News Agency 2007; International Monetary Fund 2007.

In 2021, Xi's common prosperity offers a stronger treatment for a similar diagnosis: China's government seems prepared to accept real short-term economic harm in the hopes of improving economic stability and sustainability moving forward.

The big test will come in the real estate sector, where the heavily indebted property developer Evergrande appears almost certain to go into default unless the government intercedes.[77] China's fiscal and financial systems have long relied on land sales and property development to prop up economic growth, even if there's little demand actually to live in the buildings being constructed. This pattern is particularly harmful because construction is extremely carbon-intensive.[78] In his August 2021 speech, Xi admonished the country that housing is for living, not speculation—but the true challenge is not speculators. The difficult fact is that real estate is exorbitantly expensive, which makes buying a home challenging. At the same time, however, the wealth of the Chinese middle class that Xi seeks to support is bound up in real estate, which makes deflating the housing bubble perilous.

Xi's common prosperity rhetoric is wide-ranging and ambitious. Major government policies have targeted economically significant sectors and pushed, albeit in limited fashion, against inequality. The savings and investment–heavy economic model might finally be fading. However, the extent to which the CCP and the Chinese people share this vision of common prosperity remains a question. Will the elite and the broader population get on board, or will they push back when their own prerogatives are pinched? While the Chinese regime continues to feel for stones to cross the river, its track record of success has already remade global political economy beyond its borders.

Information Environment

The information environment is both the terrain on which contestation about the regime's identity takes place as well as a critical component of that contestation, but increasingly China's information control apparatus has international consequences. From the Democracy Wall activism through the tumult of the Tiananmen period up to Xi's neopolitical turn, China's information environment shifted in dramatic fashion. However, core tenets of its limits were laid out in Deng's Four Cardinal Principles, mainly that true political opposition to continued CCP rule would not be countenanced. But censorship is more

[77] Whiting 2021.
[78] Downie 2021.

than deletion or erasure, and globally fear, friction, and flooding have altered assessments of the political terrain and reality itself.

Flooding the zone, or, to use the more pungent expression attributed to American political operative Steve Bannon, "flood[ing] the zone with shit," has become a political tactic beyond its authoritarian origins.[79] Putin's Russia has become a major source of and inspiration for this kind of post-truth practice.[80] Peter Pomerantsev argues that Putin's Russia exudes more and more positive stories about itself, spreads conspiracies about its enemies, and generates a society where no one believes anything.[81] He sees coherence and factuality, far from being universally desirable for politicians, as dominant only in societies with a strong sense of purpose or, more specifically, an aim to build.[82] Having suffered the failure of Communism as well as the calamity of post-Communism in its 1990s democratic dalliance under Yeltsin, Russia gave up this future sense. Such lack of belief in a better future has spread widely, with climate change shifting the world's environment away from the optimum that underlay human civilizational development.[83]

The question of how far from factuality politicians can travel remains unanswered. Under most normal circumstances, people's experiences of national-level politics—in the United States or even in China—are mostly discursive, reading about issues or decisions, rather than directly material. Digital platforms like Facebook and WeChat wield tremendous power to shape perceptions of reality by what they choose to amplify and ignore.[84] And even when decisions lead to changes that likely affect one's material conditions, those conditions are mediated through various narratives of these events and other intermediate causal processes.[85] For instance, the Chinese 2008 Labor Contract Law signaled to the whole population, and indeed the outside world as well, that China was expanding labor protections for workers who had been without them. Yet, in practice, if the law failed to be followed in a particular circumstance, the central leadership was usually spared from critique, which would be placed at the feet of the law's local implementers.[86] That the Cossacks work for the tsar is easy to hide when the tsar's pronouncements are generous and various Cossacks

[79] Illing 2020.

[80] Paul and Matthews 2016.

[81] Pomerantsev 2014.

[82] Contra Downs 1957. See also Rozenas and Stukal 2019.

[83] For example, Leiserowitz et al. 2021.

[84] Roberts 2018; Zuboff 2019. See also Bernstein 2021 on the platforms' surprising admissions about misinformation's power.

[85] For a fascinating analysis of attitudes toward immigrants in the United States, contrasting with Chinese experiences and perceptions, see Goldstein and Peters 2014.

[86] Friedman and Kuruvilla 2015; Gallagher et al. 2015.

are occasionally punished by him. Centralization such as Xi's neopolitical turn makes it harder to hide, as is seen in China's COVID crisis.

As censorship has moved beyond deletion, it has also moved beyond borders. Chinese efforts to regulate the speech and actions of other entities, including private businesses, have a long history but rarely make global headlines. However, on October 4, 2019, the general manager of the NBA's Houston Rockets, Daryl Morey, tweeted an image declaring, "Fight for Freedom/Stand with Hong Kong." For a tweet to hurt the feelings of the Chinese people is a strange thing, since the Chinese government blocks access to Twitter. And yet this endorsement of Hong Kong protestors against the Beijing regime ignited controversy among Chinese internet users. The NBA waffled before grudgingly acknowledging its employees' free speech rights, but few if any league denizens joined Morey in this public stance; he himself deleted the tweet. Reports emerged that the Rockets' owner, Tilman Fertitta, wished to fire Morey for the remark. The Rockets had been a staple of the national television broadcasts of NBA games in China, carried by CCTV-5. Following Morey's tweet, the team became a nonentity in China.[87]

China is a major market for the NBA, arguably the country's favorite sports league.[88] The NBA's relationship with China is worth hundreds of millions of dollars annually through contracts with CCTV-5 and online broadcasts through Tencent, and uncountable billions more for NBA partners like Nike. While NBA players, coaches, and executives regularly opine on U.S. politics, China's effort to use access to its market to constrain the speech of others appears to have been successful.[89] The dust-up, however, led to significant coverage of the NBA's cravenness to sports fans that had otherwise been unlikely to see the Hong Kong protests, which had not received sustained coverage in much U.S. media.

In the short run, then, public attention on Chinese efforts to silence criticism and awareness of those contending with the regime increased in ways that are dangerous for that regime. But, assuming that it can weather that storm, the long-run effects appear to be in the regime's favor. Businesses—certainly the NBA and those associated with it—will engage in self-censorship out of fear of loss of access to the market or negative reaction by Chinese audiences. Fewer criticisms and even mentions of these issues will shape public attitudes toward them as voices challenging Beijing's position will be shunted aside. Further, self-censorship undermines solidarity and increases cynicism. While many have

[87] White 2021. Morey's new team, the Philadelphia 76ers, remains on the China blacklist.

[88] McNicol 2017.

[89] Arsenal's Mesut Özil suffered "erasure" following his raising concerns about Xinjiang (Smith and Panja 2020). The NBA's Enes Kanter, who has spoken out against Turkey's president Erdoğan, railed against the CCP, especially actions in Xinjiang in 2021 (Harker 2021; Kanter 2018).

lauded the NBA for calling attention to the marginalized and disadvantaged—in its charity actions as well as overtly political speech acts supporting specific policies or candidates—the silence in the wake of Chinese backlash has led some to devalue those prior acts.[90] If one is demonstrating an unwillingness to send a costly signal of support—to compromise one's actions for money—in one context, then other actions can be seen as branding exercises rather than genuine activism.[91]

Power, including market power, shapes the information environment regardless of the political systems at play. If vast financial resources are used to support ideas of one kind rather than another, they will be supplied at subsequently higher rates; similarly, if such financial resources are intent on stopping the publication of other ideas, those will be more scarcely supplied.[92] Corporate consolidation in media also intersects with this trend. ESPN, the global sports media giant, is a division of the Walt Disney Company, the movie studio and theme park operator, with massive business dealings in and thus exposure to China, and its coverage of the underlying grievances of the Hong Kong protestors was marginal to nonexistent.[93] The website Deadspin reported on an internal memo from ESPN's senior news director "mandating that any discussion of the Daryl Morey story avoid any political discussions about China and Hong Kong, and instead focus on the related basketball issues."[94] Deadspin itself was decimated less than three weeks later when its private equity-backed leadership gave an order to "stick to sports," leading its entire staff to resign.[95]

Another vision of state and corporate power shaping and censoring of information can be seen in the case of the "Sony Hack." North Korean agents hacked Sony Pictures in an attempt to prevent the release of *The Interview*, a farcical comedy that included negative portrayals of Kim Jong-un, his assassination,

[90] The NBA had a separate Xinjiang scandal (running a basketball camp amid the growing detention facilities), which perhaps suggests that the NBA's political deftness fails it in the PRC (Fish 2018).

[91] This kind of purity critique is present on the American political right as well, but seems more common on the left, which is often caught up in internecine or doctrinal conflicts.

[92] Wealth inequality and billionaires' funding ideas can shape the marketplace of ideas through a wide variety of mechanisms (e.g., Mayer 2016; Mahler and Rutenberg 2019). The wealthy have also used their financial power to apply legal pressure on outlets they disapprove of, such as Peter Thiel's vendetta with *Gawker* and VanderSloot's with *Mother Jones* (Thompson 2018; Jeffery and Bauerlein 2015). Outright purchase of said outlets is another path, such as Jeff Bezos buying the *Washington Post* and Shelden Adelson acquiring the *Las Vegas Review-Journal*. Internationally, Berlusconi remains a crucial example (e.g., Ginsborg 2005).

[93] Cowen 2019.

[94] Wagner 2019.

[95] Booker 2019; Curtis 2019.

and North Korean democratization.[96] The hacked messages revealed a subtler form of self-censorship. Sony's film *Concussion* dramatized the links between American football and degenerative brain disease from repeated head trauma, and the emails detailed efforts to blunt potential actions by the NFL and make the film appear less threatening.[97] Power will create justifications for itself. That is, power creates ideas. But, obviously, ideas affect power, which is implicit in the idea that power needs justifications and invests in their production and dissemination. The powers that be—companies, wealthy elites, universities, and states, whether democratic or authoritarian—all attempt to manage and massage their images.

Neoliberalism

Economically, China's singular success raised questions of how to square its economic policies with dominant ideas about optimal organization of an economy.[98] Whether framed as the "Beijing Consensus" or a "China model," these arguments focus on the differences between the systems of political economy that China has developed and those dominant in "the West." Despite the significant variation across European and North American states, these societies are often seen as being under the sway of neoliberalism, a project of state design stressing "the necessity and desirability of transferring economic power and control from governments to private markets."[99] Yet before China was seen as producing a potential rival to neoliberalism, its actions undergirded that system's rise in ways that fit the limited quantified vision thesis but are often overlooked in the literature on neoliberalism. Over the decades, China served as an example, a cause, and an undermining force for global neoliberalism.

Neoliberalism's intellectual origins are much discussed, and the factors behind its rise much debated.[100] Frustrations with left-wing policies in the surprising strongholds of the United States and United Kingdom interacted with stagflation emerging from OPEC's 1973 oil embargo to produce a shift in orientation toward deregulation and private market control of activity.[101] While most associate neoliberalism with the policies of Margaret Thatcher and Ronald

[96] Sanger and Perlroth 2014.
[97] Belson 2015.
[98] For example, Montinola, Qian, and Weingast 1995; Huang 2008.
[99] Centeno and Cohen 2012, 318. See also Hall and Soskice 2001.
[100] See, e.g., Slobodian 2018; Centeno and Cohen 2012.
[101] Prasad 2006. Harvey 2005, 7 points to Pinochet's September 1973 coup before the oil crisis as significant. This broad claim of course oversimplifies. For instance, the French government responded to the 1973 oil crisis with massive investment in nuclear electricity generation (Roche

Reagan, the deregulatory actions of Jimmy Carter's administration and the anti-inflationary zeal of Chairman Paul Volcker, Carter's appointee to the U.S. Federal Reserve, reflected the growing currency of these arguments. But beyond the North Atlantic, governing practices from around the world were crucial for neoliberalism's consolidation.[102] For instance, news trickling out of some of China's early Reform Era actions supported arguments that giving a greater role to markets was a recipe for growth.[103] In February 1978, the *New York Times* headlined a piece "China's New Dialectic: Growth" and stated that "the leadership's pragmatic program of more worker discipline, better management, higher production, and tighter accounting procedures" would have been "labeled capitalism" a year before.[104] The "ascendance" of Hua Guofeng and Deng Xiaoping had, the *Times* journalist Fox Butterfield wrote, "rekindled visions American businessmen have had since the days of the Yankee clippers: millions of Chinese customers for American products."[105] On December 27, 1979, a story on provinces opening up for foreign business was titled "China's Trade Plan Has a Capitalist Tinge";[106] by August 14, 1980, a blunter headline had appeared: "China Tries Capitalism, and It Works."[107] This framing of the measures as capitalism was, of course, explicitly rejected by the Chinese leaders who attempted to navigate these fraught waters—and their rejection was occasionally acknowledged in foreign papers as well.[108]

These early examples are indicative of how Chinese shifts away from Maoist planning were interpreted by American elites, helping to cement hegemonic beliefs in markets in the field of economics.[109] These early examples cut against David Harvey's claims in *A Brief History of Neoliberalism* in two ways. First, despite acknowledging that global hegemony is not something that happens by accident,[110] Harvey uses the same word to describe the "coincidence" of China moving at the same time as the United Kingdom and the United States: "[I]t is very hard to consider this as anything other than a conjectural accident of

2011). More broadly, the historiography of capitalism is highly Eurocentric, although newer works, like Liu 2020, have tried to complicate this.

[102] See Neveling 2017.

[103] This description focuses on how China's changes were part of the global shift toward neoliberalism. For a nice analysis of how non-Chinese economists influenced some critical Reform Era decisions, see Gewirtz 2017.

[104] Butterfield 1978.

[105] Butterfield 1978. The article mentions Exxon, U.S. Steel, and the Continental Group.

[106] Butterfield 1979a.

[107] AP 1980.

[108] For example, Terrill 1980.

[109] Centeno and Cohen 2012, section 3.

[110] "Transformations of this scope and depth do not occur by accident" (Harvey 2005, 1).

world-historical significance."[111] To be sure, there was no imposition of neoliberalism on China by those associated with the West, and even less causal power in the reverse direction. However, the shape of Chinese moves away from Maoist planning were in part inspired by the relative economic success of its East Asian neighbors and the West and compared with prior Chinese economic history or that of the Eastern Bloc. Chinese elites conducted foreign tours, and Western economists, including the ur-neoliberal Milton Friedman, visited China.[112] Further, that China was moving away from state planning and that it was finding success in doing so strengthened beliefs in marketization, reduced expectations of alternatives to capitalism, and stymied efforts to stop neoliberalism's rise.

Harvey also argues that the global rise of neoliberalism was key to China's success, rather than China's growth amplifying the global rise of neoliberalism.[113] While of course a more globalized economy aided China's own economic growth and so the success of its reforms, the reverse narrative should not be underestimated. Abundant Chinese labor entering the scene shifted the relative balance of power between labor and capital globally. Even before Hua Guofeng was sidelined, American capitalists were trying to reach China's billion people and turn them into workers and ultimately consumers of their goods and services.[114] When China was much more open, the profit possibilities of offshoring production—moving manufacturing activities out of the "developed countries" to China—became difficult to argue against, given a purpose for the corporation solely focused on maximizing shareholder value.[115] First, locating production facilities in China would give firm access to cheaper Chinese labor and perhaps a cost advantage over firms relying on domestic laborers who demanded higher wages. Second, opening production facilities would likely be helpful for entering and extracting profits from the Chinese market. These pressures pushed firms to outsource, disinvest in domestic industrial facilities, and focus more narrowly on the quantitative metrics of share prices and returns rather than a more holistic view of significant stakeholders.

After serving as an example that supported the intellectual movement of neoliberalism at the moment of its rising hegemony and then providing pressure for the deepening of neoliberalism in corporate worlds, China became a political liability and undermining force for neoliberalism. Trade with China generated

[111] Harvey 2005, 120.

[112] Gewirtz 2017; Weber 2021.

[113] Harvey 2005, 121: "These reforms would not have assumed the significance we now accord to them, nor would China's extraordinary subsequent economic evolution have taken the path and registered the achievements it did, had there not been significant and seemingly unrelated parallel shifts in the advanced capitalist world with respect to how the world market worked."

[114] Butterfield 1978.

[115] Friedman 1970.

broad but diffuse benefits, principally through cheaper goods to consumers across a range of products, while the costs of the trade remained relatively narrow but deep, as individual factories shuttered and moved abroad, desolating the towns and rural areas they had supported. These costs were rarely imposed on the politically powerful, as private-sector unions were already broken as a force in U.S. politics, in part because of the prior waves of neoliberal policymaking in the Carter years.[116]

As employment in the manufacturing sectors of the United States and Europe eroded thanks to a combination of automation and international competition, offshoring such labor to China became extremely unpopular, and pressure for Western governments to change the terms of trade with China increased.[117] Labor and capital had different critiques, with workers concerned about currency revaluation and dumping, while corporations focused on issues like intellectual property rights protection and joint venture requirements for investment in China.[118] Efforts to shift trade away from China for electoral reasons intersected with concerns that China's rise would remake the international order, leading to the Obama-era Trans-Pacific Partnership arrangements that directly excluded China as well as Trump's trade war with China.

China's undermining of neoliberalism also comes from its presentation of an alternative system of political economy to neoliberalism with substantially more state involvement in the economy, particularly in the form of industrial policy for favored firms and industries. Chinese state capitalism, and its macroeconomic success as measured by conventional aggregate economic statistics, posed difficulties for the hegemonic status of neoliberalism as the correct way to govern an economy. Similar to other East Asian developmental states, China's growth experience faced efforts to shove it into a more neoliberal-friendly interpretation to preserve the dominant paradigm.[119] But after decades of attempting to separate the deep linkages between the Chinese state and its economy, many observers have concluded that their own prioritization of efficiency over effectiveness has gone too far. In particular, industrial policies have shifted from pariah to a needed piece of the puzzle, even for developed countries.[120]

However, as with the post-2008 experience, domestic and international narratives about China's economic path differ. Based on the numbers, China's

[116] To be sure, anti-labor actions ramped up significantly under Reagan.

[117] Margalit 2011; Weiss and Wichowsky 2018.

[118] For example, Weiss and Wichowsky 2018.

[119] For example, Wade 1990; Huang 2008. Huang's *Capitalism with Chinese Characteristics* argues that the rapid economic growth of China was reliant on early entrepreneurial actions in the countryside and access to Hong Kong's rule-bound financial and legal systems.

[120] Deese 2021; Ip 2021. See Kennedy 2018 on the inefficiency of China's industrial policy.

growth appears enviable. While rich countries endeavor to emulate it and subsidize industries to reduce their reliance on China, China itself is dealing with massive debts incurred from inefficient investments, including in industrial policies, that were attempts to hit quantified GDP targets. The correctness of these conclusions and policy moves will never be absolute, given uncertainty, which has become omnipresent with the COVID-19 pandemic and proliferation of climate change–induced disasters.[121]

In the end, quantification's weaknesses should not lead us to throw the baby out with the bathwater. It encourages precise thinking, fair comparisons, informed plans, and subsequent evaluations. What is needed is the understanding that different values and different priorities are deeply embedded in the measures governments choose. Those differences should be treated seriously and honestly, neither ignored as arcana nor tossed aside as irrelevant in an uncertain world. In the end, underneath it all, numbers lie and rest.

[121] For example, Myers, Bradsher, and Buckley 2021.

Appendix 1

EVALUATION DOCUMENT DATABASE LIST

Document Name/Source	Year	Province	Level of Government	Policy Area	Form Type
嘉委发 (1989) 8号	1989	Shanghai	County	Comprehensive	Guideline w/ score sheet
汕头经济特区年鉴	1990	Guangdong	Special economic zone	Democracy	Guideline
萧山市委 (1990) 22号	1990	Zhejiang	District/ County/ Township	Comprehensive	Guideline w/ score sheet
嘉委发 (1995) 16号	1995	Shanghai	State-owned enterprise/ Township	Economy	Guideline
华委发 (1999) 6号	1999	Guangdong	County	Birth control	Guideline
菏泽地区年鉴	1999	Shandong	County	Comprehensive	Guideline
浙委办 (2001) 15号	2001	Zhejiang	City	Party-building/ anticorruption	Guideline
穗宁 (2008) 11号	2008	Guangdong	District/ County	Comprehensive	Guideline w/ score sheet
2009、2010年清远市连山县副县长陈静基础教育工作责任考核自评说明	2010	Guangdong	County	Education	Self-evaluation
韶关市乳源瑶族自冶县县长基础教育工作责任考核自评说明	2012*	Guangdong	County	Education	Self-evaluation

Document	Year	Province	Level	Topic	Type
湖北省市(州)党政领导班子年度考核指标百分制计分办法[&]赋分一览表	2012	Hubei	City	Comprehensive	Guideline w/ score sheet
新疆中小学书记、校长工作年度考核方案及指标体系	2014	Xinjiang	School	Education	Guideline w/ score sheet
新疆维吾尔自治区县(市、区)党政领导班子目标责任制考核指标及评分标准	2014*	Xinjiang	District/County	Technology innovation	Score sheet
扬州市关于下达2017年度县(市、区)、功能区党(工)委书记科技创新指标考核细则的通知	2017	Jiangsu	District/County	Technology innovation	Guideline w/ score sheet
中共周口市委办公室 周口市人民政府办公室关于印发《周口市管领导班子和领导干部年度综合考评办法》的通知	2018	Henan	City	Comprehensive/Economy	Guideline w/ score sheet
常德市2018年区县(市)委书记抓基层党建工作责任清单及考核细则	2018	Hunan	District/County	Party-building	Guideline w/ score sheet
关于印发《泗水镇2018年度村(社区)党组织书记管理考核方案》的通知	2018	Guangdong	Township	Party-building	Guideline w/ score sheet

Note: The two documents with years marked with asterisks are undated but likely of the year noted.

Appendix 2

INVESTIGATIONS CORRELATED
WITH ECONOMIC RISK

	Model 1	Model 2	Model 3
Residential Construction Growth	3.59*	3.61*	3.84*
	(1.78)	(1.81)	(1.96)
Corrupt Clique Locales		2.01	2.68
		(3.83)	(4.15)
Xi Jinping Connected Provinces			4.84
			(6.62)
Constant	3.56	3.13	1.60
	(6.67)	(6.89)	(8.19)
Observations	30	30	30
R-squared	0.28	0.29	0.30

Note: * $p < 0.1$, ** $p < 0.05$, *** $p < 0.01$. Robust standard errors in parentheses.
The dependent variable is investigations per 1 trillion RMB, as described in Chapter 7. The measure for residential construction growth is the ratio of "Floor Space of Residential Buildings Completed" completed from 2010 to 2012 to that data from a decade prior (2000–2).[1] Its mean, 4.1, means that over four times as much residential construction took place in the early 2010s than did in the early 2000s.

Political connections run in two directions. First, areas linked with political rivals or cliques should see more investigations than expected, all else equal.

[1] The data are from the National Bureau of Statistics and compiled by Wind Financial Information.

Following the *South China Morning Post*, these locales are coded as significant corrupt cliques: Sichuan and Zhou Yongkang; Shanxi and Ling Jihua; Yunnan and Bai Enpei; Jiangxi and Su Rong; and Guangdong and Wan Qingliang (Feng 2014). A basic count model of investigations across China's provinces finds a strong positive relationship with the cliques but little else.

Second, areas associated with President Xi Jinping should see fewer investigations than areas without such connections, all else equal.[2]

Investigations are from 2013 to 2014. The data were scraped from the CCDI website independently by the author and from the *South China Morning Post* in 2014 (Feng 2014).

The takeaways from this simple regression are suggestive of a multiplicity of factors driving investigations instead of a simple story of connections, but they are merely suggestions rather than strong claims of identified causal effects.

[2] Xi's provincial work history is predominantly in Fujian and Zhejiang; Shaanxi is his birthplace as well as the locale where he was sent to do manual labor during the Cultural Revolution.

REFERENCES

Acemoglu, Daron, and James A. Robinson. 2005. *Economic Origins of Dictatorship and Democracy*. Cambridge: Cambridge University Press.

Adena, Maja, Ruben Enikolopov, Maria Petrova, Veronica Santarosa, and Ekaterina Zhuravskaya. 2015. "Radio and the Rise of the Nazis in Prewar Germany." *Quarterly Journal of Economics* 130, no. 4: 1885–939.

Agence France-Presse. 1979. "100 Peasants Stage Peking Protest, Are Barred from Hua's Residence." *New York Times*, September 15. https://www.nytimes.com/1979/01/15/archi ves/100-peasants-stage-peking-protest-are-barred-from-huas-residence.html.

Ai Weiwei. 2018. "Ai Weiwei: The Artwork That Made Me the Most Dangerous Person in China." *The Guardian*, February 15. https://www.theguardian.com/artanddesign/2018/feb/15/ai-weiwei-remembering-sichuan-earthquake.

Albertus, Michael, Sofia Fenner, and Dan Slater. 2019. *Coercive Distribution*. Cambridge: Cambridge University Press.

Amnesty International. 2015. "China: Lawyers and Activists Detained or Questioned by Police Since 9 July 2015." https://www.amnesty.org/en/documents/document/?indexNumber= asa17%2f2094%2f2015&language=en.

Anderlini, Jamil. 2020. "Xi Jinping Faces China's Chernobyl Moment." *Financial Times*, February 10. https://www.ft.com/content/6f7fdbae-4b3b-11ea-95a0-43d18ec715f5.

Anderson, Benedict. 1983. *Imagined Communities: Reflections on the Origin and Spread of Nationalism*. London: Verso,.

Andreas, Joel. 2009. *Rise of the Red Engineers: The Cultural Revolution and the Origins of China's New Class*. Stanford, CA: Stanford University Press.

Andrews, Steven Q. 2013. "How Beijing Hid the Smog." *Wall Street Journal*, February 5. http://onl ine.wsj.com/article/SB10001424127887324445904578285560136861562.html?mod= googlenews_wsj.

Ang, Audra. 2009. "China Book on Sichuan Quake Counters Gov't Stance." *San Diego Union-Tribune*, June 2. https://www.sandiegouniontribune.com/sdut-china-quake-book-060209-2009jun02-story.html.

Ang, Yuen Yuen. 2016. *How China Escaped the Poverty Trap*. Ithaca, NY: Cornell University Press.

Ang, Yuen Yuen. 2020. *China's Gilded Age: The Paradox of Economic Boom and Vast Corruption*. Cambridge: Cambridge University Press.

Ansfield, Jonathan. 2007. "Green GDP Praying for Hu's Help." *China Digital Times* (blog), August 9. https://chinadigitaltimes.net/2007/08/green-gdp-praying-for-hus-help/.

AP. 1980. "China Tries Capitalism, and It Works." *New York Times*, August 14.

AP. 2014. "Chinese President Signals Tightening of Control over Universities." *The Guardian*, December 30. http://www.theguardian.com/world/2014/dec/30/chinese-president-sign als-tightening-of-control-over-universities.

AP. 2020. "China Didn't Warn Public of Likely Pandemic for 6 Key Days." *AP Top News*, April 15. https://apnews.com/68a9e1b91de4ffc166acd6012d82c2f9.

Areddy, James. 2013. "China Absent from Corruption Report." *China Real Time Report* (blog). *Wall Street Journal*, July 12. http://blogs.wsj.com/chinarealtime/2013/07/10/china-abs ent-from-global-corruption-report/.

Arendt, Hannah. 1971. "Lying in Politics: Reflections on The Pentagon Papers." *New York Review*, November 18. https://ww.nybooks.com/articles/1971/11/18/lying-in-politics-reflecti ons-on-the-pentagon-pape/.

Arendt, Hannah. 1973. *The Origins of Totalitarianism*. New York: Harcourt Brace Jovanovich.

Arendt, Hannah. 2005. "Truth and Politics." In *Truth: Engagements across Philosophical Traditions*, edited by David Wood and Jose Medina, 295–314. Blackwell Readings in Continental Philosophy. Malden, MA: Blackwell.

Bai Nanfeng. 1987. "改革的社会环境：变迁与选择." *经济研究*. 12: 56–63.

Bai Nanfeng (白南风) and Yang Guansan (杨冠三). 1986. "中国经济体制改革研究所的两次社会调查表明:人们对改革的心理承受能力在加强." 瞭望周刊. no. 33: 15–6 + 48.

Baik, Jiwon, and Jeremy L. Wallace. 2021. "Slums amidst Ghost Cities: Incentive and Information Problems in China's Urbanization." *Problems of Post-Communism*, February 18, 1–16. doi:10.1080/10758216.2020.1860690.

Bandurski, David. 2011. "Why China's Left Is Up in Arms." *China Media Project* (blog), May 18. http://chinamediaproject.org/2011/05/18/why-chinas-left-is-up-in-arms/.

Bandurski, David. 2013a. "Thoughts on 'Black Friday.'" *China Media Project* (blog), September 23. http://chinamediaproject.org/2013/09/23/thoughts-on-black-friday/.

Bandurski, David. 2013b. "Xi Jinping, Playing with Fire." *China Media Project* (blog), October 17. http://chinamediaproject.org/2013/10/17/xi-jinping-playing-with-fire/.

Bandurski, David. 2020. "Reclaiming Doctor Li." *China Media Project* (blog), March 19. http://chinamediaproject.org/2020/03/19/reclaiming-doctor-li/.

Bandurski, David. 2021. "The 'Lying Flat' Movement Standing in the Way of China's Innovation Drive." *Tech Stream | Brookings* (blog), July 8. https://www.brookings.edu/techstream/the-lying-flat-movement-standing-in-the-way-of-chinas-innovation-drive/.

Bandurski, David, and Martin Hala. 2010. *Investigative Journalism in China: Eight Cases in Chinese Watchdog Journalism*. Hong Kong: Hong Kong University Press.

Banister, Judith. 1987. *China's Changing Population*. Stanford, CA: Stanford University Press.

Barboza, David. 2007. "China Reportedly Urged Omitting Pollution-Death Estimates." *New York Times*, July 5. https://www.nytimes.com/2007/07/05/world/asia/05china.html.

Barboza, David. 2008. "Former Party Boss in China Gets 18 Years." *New York Times*, April 12. https://www.nytimes.com/2008/04/12/world/asia/12shanghai.html.

Barboza, David. 2012. "Billions in Hidden Riches for Family of Chinese Leader." *New York Times*, October 25. https://www.nytimes.com/2012/10/26/business/global/family-of-wen-jia bao-holds-a-hidden-fortune-in-china.html.

Barboza, David. 2013. "Coin of Realm in China Graft: Phony Receipts." *New York Times*, August 3. https://www.nytimes.com/2013/08/04/business/global/coin-of-realm-in-china-graft-phony-receipts.html.

Barboza, David, and Sharon LaFraniere. 2012. "'Princelings' in China Use Family Ties to Gain Riches." *New York Times*, May 17. https://www.nytimes.com/2012/05/18/world/asia/china-princelings-using-family-ties-to-gain-riches.html.

Barmé, Geremie R., and Yuwen Deng. 2012. "The Ten Grave Problems Facing China." The China Story. September 8. https://www.thechinastory.org/yearbooks/yearbook-2013/chapter-7-fitting-words/deng-yuwen/.

Barmé, Geremie, and Jeremy Goldkorn, eds. 2013. *Civilising China*. Australian Centre on China in the World. The China Story. http://www.thechinastory.org/yearbooks/yearbook-2013/.

Barnett, A. Doak. 1974. *Uncertain Passage: China's Transition to the Post-Mao Era*. Washington, DC: Brookings Institution.

Barreda, David, and Cong Yan. 2014. "Spoils of the 'Tiger' Hunt." *ChinaFile*, July 3. http://www. chinafile.com/spoils-tiger-hunt.

Barron, Laignee. 2020. "Coronavirus Lessons from Singapore, Taiwan and Hong Kong." *Time*, March 13. https://time.com/5802293/coronavirus-covid19-singapore-hong-kong-taiwan/.

Baum, Richard. 1994. *Burying Mao: Chinese Politics in the Age of Deng Xiaoping*. Princeton, NJ: Princeton University Press.

Beach, Sophie. 2012. "Hu Jintao: Corruption Could Be 'Fatal' to Party." *China Digital Times*, November 7. https://chinadigitaltimes.net/2012/11/hu-jintao-corruption-could-be-fatal-to-communist-party/.

Beazer, Quintin H., and Ora John Reuter. 2019. "Who Is to Blame? Political Centralization and Electoral Punishment under Authoritarianism." *Journal of Politics* 81, no. 2 (April 1): 648–62.

Beetham, David. 2013. *The Legitimation of Power*. London: Palgrave Macmillan.

Bell, Daniel A. 2016. *The China Model: Political Meritocracy and the Limits of Democracy*. Princeton, NJ: Princeton University Press.

Belson, Ken. 2015. "Sony Altered 'Concussion' Film to Prevent N.F.L. Protests, Emails Show." *New York Times*, September 1. https://www.nytimes.com/2015/09/02/sports/football/makers-of-sonys-concussion-film-tried-to-avoid-angering-nfl-emails-show.html.

Bendor, Jonathan, Amihai Glazer, and Thomas Hammond. 2001. "Theories of Delegation." *Annual Review of Political Science* 4, no. 1: 235–69.

Berliner, Joseph S. 1957. *Factory and Manager in the USSR*. Vol. 27. Cambridge, MA: Harvard University Press.

Bernstein, Joseph. 2021. "Bad News: Selling the Story of Disinformation." *Harper's Magazine*, August 9. https://harpers.org/archive/2021/09/bad-news-selling-the-story-of-disinfo rmation/.

Bernstein, Thomas, and Xiaobo Lü. 2002. *Taxation without Representation in Rural China*. Cambridge: Cambridge University Press.

Best, Joel. 2001. *Damned Lies and Statistics: Untangling Numbers from the Media, Politicians, and Activists*. Berkeley: University of California Press.

Bird, Mike. 2020. "Chinese Household Debt Surges through the Pandemic." *Wall Street Journal*, December 8. https://www.wsj.com/articles/chinese-household-debt-surges-through-the-pandemic-11607417329.

Birney, Mayling. 2014. "Decentralization and Veiled Corruption under China's 'Rule of Mandates.'" *World Development* 53: 55–67.

BIS. 2021. "Table F1.1: Total Credit to the Non-Financial Sector (Core Debt)." Bank of International Settlements. https://stats.bis.org/statx/srs/table/f1.1.

Bishop, Bill. 2020. "Official Data on Outbreak Continues Trending Positive; Xi Urges More Support for Frontline Medical Workers; WSJ Reporters Expelled." *Sinocism* (blog), February 19. https://sinocism.com/p/official-data-on-outbreak-continues.

Blaydes, Lisa. 2010. *Elections and Distributive Politics in Mubarak's Egypt*. Cambridge: Cambridge University Press.

Blaydes, Lisa. 2018. *State of Repression: Iraq under Saddam Hussein*. Princeton, NJ: Princeton University Press.

Bloomberg. 2016a. "China's Old Economy Is Roaring Back to Life." November 29. https://www. bloomberg.com/news/articles/2016-11-29/li-keqiang-index-jumps-as-china-s-old-econ omy-comes-roaring-back.

Bloomberg. 2016b. "Hong Kong Bookseller Who Vanished in Thailand Held in China." January 17. https://www.bloomberg.com/news/articles/2016-01-17/hong-kong-bookseller-who-disa ppeared-from-thailand-held-in-china.

Bloomberg. 2020. "What China's Three Red Lines Mean for Property Firms." October 8. https://www.bloomberg.com/news/articles/2020-10-08/what-china-s-three-red-lines-mean-for-property-firms-quicktake.

Boix, Carles. 2003. *Democracy and Redistribution.* Cambridge: Cambridge University Press.

Boix, Carles, and Milan Svolik. 2013. "The Foundations of Limited Authoritarian Government: Institutions, Commitment, and Power-Sharing in Dictatorships." *Journal of Politics* 75, no. 2: 300–6.

Booker, Brakkton. 2019. "After Days of Resignations, the Last of the Deadspin Staff Has Quit." NPR, November 1. https://www.npr.org/2019/11/01/775548069/after-days-of-resignations-the-last-of-the-deadspin-staff-have-quit.

Bourdieu, Pierre. 1977. *Outline of a Theory of Practice.* Cambridge Studies in Social and Cultural Anthropology. New York: Cambridge University Press.

Brady, Anne-Marie. 2008. *Marketing Dictatorship: Propaganda and Thought Work in Contemporary China.* Lanham, MD: Rowman & Littlefield.

Brady, Anne-Marie, ed. 2012. *China's Thought Management.* New York: Routledge.

Brennan, David. 2020. "Wuhan Doctor Who First Raised Coronavirus Alarm Defends China's Secrecy, Insists Country's Response Was 'Very Timely.'" *Newsweek,* April 20. https://www.newsweek.com/wuhan-doctor-who-first-raised-coronavirus-alarm-defends-chinas-secrecy-insists-countrys-response-1498864.

Brødsgaard, Kjeld E. 1981. "The Democracy Movement in China, 1978–1979: Opposition Movements, Wall Poster Campaigns, and Underground Journals." *Asian Survey* 21, no. 7: 747–74.

Brown, Jeremy. 2012. *City versus Countryside in Mao's China: Negotiating the Divide.* Cambridge: Cambridge University Press.

Buckley, Chris. 2013a. "A Leading Chinese Human Rights Advocate Is Detained in Beijing." *New York Times,* July 17. https://www.nytimes.com/2013/07/18/world/asia/china-detains-a-leading-human-rights-advocate.html.

Buckley, Chris. 2013b. "Portrait of Deng as Reformer in 1978 Plenum Ignores History." *Sinosphere* (blog). *New York Times,* November 11. http://sinosphere.blogs.nytimes.com/2013/11/09/portrait-of-deng-as-reformer-in-1978-plenum-ignores-history/.

Buckley, Chris. 2013c. "Vows of Change in China Belie Private Warning." *New York Times,* February 15. https://www.nytimes.com/2013/02/15/world/asia/vowing-reform-chinas-leader-xi-jinping-airs-other-message-in-private.html.

Buckley, Chris. 2015. "Chinese Authorities Detain and Denounce Rights Lawyers." *New York Times,* July 11. https://www.nytimes.com/2015/07/12/world/asia/china-arrests-human-rights-lawyers-zhou-shifeng.html.

Buckley, Chris. 2020. "China's Combative Nationalists See a World Turning Their Way." *New York Times,* December 14. https://www.nytimes.com/2020/12/14/world/asia/china-nationalists-covid.html.

Bueno de Mesquita, Bruce, Alastair Smith, Randolph M. Siverson, and James D. Morrow. 2003. *The Logic of Political Survival.* Cambridge, MA: MIT Press.

Bunce, Val. 1985. "The Empire Strikes Back: The Evolution of the Eastern Bloc from a Soviet Asset to a Soviet Liability." *International Organization* 39, no. 1: 1–46.

Bunce, Val. 1999. *Subversive Institutions: The Design and the Destruction of Socialism and the State.* Cambridge: Cambridge University Press.

Butterfield, Fox. 1978. "China's New Dialectic: Growth." *New York Times,* February 5. https://www.nytimes.com/1978/02/05/archives/chinas-new-dialectic-growth.html.

Butterfield, Fox. 1979a. "China's Trade Plan Has Capitalist Tinge." *New York Times,* December 27. https://www.nytimes.com/1979/12/27/archives/chinas-trade-plan-has-capitalist-tinge-chinas-new-trade-plan-has-a.html.

Butterfield, Fox. 1979b. "Freer Expression Typifies a New Dynamism in China." *New York Times,* January 14. https://www.nytimes.com/1979/01/14/archives/freer-expression-typifies-a-new-dynamism-in-china-freer-expression.html.

Cai, Hongbin, and Joseph Tao-Yi Wang. 2006. "Overcommunication in Strategic Information Transmission Games." *Games and Economic Behavior* 56, no. 1: 7–36.

Cai, Yongshun. 2004. "Managed Participation in China." *Political Science Quarterly* 119, no. 3: 425–51.

Caixin. 2014. "Zhou Yongkang." August 25. https://web.archive.org/web/20140802041916/http://english.caixin.com/2014/ZhouYongkang/.

Caixin. 2020a. "封面报道之一|现场篇：武汉围城." February 3. https://weekly.caixin.com/2020-02-01/101510145.html.

Caixin. 2020b. "独家|新冠病毒基因测序溯源：警报是何时拉响的." February 27. https://web.archive.org/web/20200227021117/http://china.caixin.com/2020-02-26/101520972.html.

Callahan, William A. 2013. *China Dreams: 20 Visions of the Future.* Oxford: Oxford University Press.

Campbell, Donald T. 1979. "Assessing the Impact of Planned Social Change." *Evaluation and Program Planning* 2, no. 1 (January 1): 67–90.

Carbon Brief. 2021. "Analysis: Nine Key Moments That Changed China's Mind about Climate Change." October 25. https://www.carbonbrief.org/analysis-nine-key-moments-that-changed-chinas-mind-about-climate-change.

CCP. 1981. *Resolution on CPC History (1949–1981).* Beijing: Foreign Languages Press.

CCP. 2014. "Official Central Committee Communiqué on 4th Plenum." Translated by China Copyright and Media. http://chinacopyrightandmedia.wordpress.com/2014/10/23/official-central-committee-communique-on-4th-plenum/.

CCP.2016.《我是谁》--庆祝中国共产党成立95周年公益广告.https://www.youtube.com/watch?v=2m-9NnLF-Tw&feature=youtu.be.

CCTV. 2013. 批评和自我批评是一剂良药_新闻频道. September 25. http://news.cntv.cn/2013/09/26/VIDE1380140758843768.shtml.

CECC. 2008. "China's Earthquake Coverage More Open but Not Uncensored." https://www.cecc.gov/publications/commission-analysis/chinas-earthquake-coverage-more-open-but-not-uncensored.

CEIC. 2019. "Gross Domestic Product: Prefecture Level City." CEIC China Premium Database. www.ceicdata.com.

Centeno, Miguel A., and Joseph N. Cohen. 2012. "The Arc of Neoliberalism." *Annual Review of Sociology* 38, no. 1: 317–40.

Central Committee. 2021. "Resolution of the CPC Central Committee on the Major Achievements and Historical Experience of the Party over the Past Century." *Xinhua*, November 16. http://www.news.cn/english/2021-11/16/c_1310314611.htm.

Central Personnel Office. 1991. 中国人事年鉴. Beijing: China Personnel Publishing.

CESRRI. 1986a. 改革: 我们面临的挑战与选择. Di 1 ban. Beijing: Zhongguo jing ji chu ban she.

CESRRI. 1986b. "群众拥护改革 要求进一步改革." *Renmin Ribao*, August 26. http://data.people.com.cn/rmrb/19860826/2.

CESRRI and Bruce L. Reynolds. 1987. *Reform in China: Challenges and Choices: A Summary and Analysis of the CESRRI Survey.* Armonk, NY: M. E. Sharpe.

Chan, Jenny. 2018. "Shenzhen Jasic Technology: The Birth of a Worker-Student Coalition in China?" *Hong Kong Free Press*, September 1. https://hongkongfp.com/2018/09/01/shenzhen-jasic-technology-birth-worker-student-coalition-china/.

Chan, Kam Wing. 1994. *Cities with Invisible Walls: Reinterpreting Urbanization in Post-1949 China.* New York: Oxford University Press.

Chan, Kam Wing, and Will Buckingham. 2008. "Is China Abolishing the Hukou System?" *China Quarterly*, no. 195: 582–606.

Chander, Ramesh. 2014. *China's Statistical System: Three Decades of Change and Transformation.* Kuala Lumpur: Penerbitan Universiti Malaya.

Chang, Gordon G. 2001. *The Coming Collapse of China.* New York: Random House.

Changjiang Commercial Daily. 2008. "6.7万家中小企业倒闭　发改委拟建中小企业银行." August 5. http://finance.sina.com.cn/roll/20080805/08372361106.shtml.

Cheibub, Jose A., Jennifer Gandhi, and James R. Vreeland. 2010. "Democracy and Dictatorship Revisited." *Public Choice* 143, no. 1: 67–101.

Chen, Ruoxi. 1982. *Democracy Wall and the Unofficial Journals.* Berkeley: Center for Chinese Studies, Institute of East Asian Studies, University of California.

Chen, Sally, and Joong S. Kang. 2018. "Credit Booms—Is China Different?" IMF Working Paper. Washington, DC: International Monetary Fund.

Chen, Ting, and James Kai-sing Kung. 2019. "Busting the 'Princelings': The Campaign against Corruption in China's Primary Land Market." *Quarterly Journal of Economics* 134, no. 1 (February 1): 185–226.

Chen Xiaoheng (陈晓恒) and Bao Hongjun (鲍洪俊). 2006. "浙江干部考核引入 '民评官.'" *Renmin Ribao,* August 4. http://data.people.com.cn/rmrb/20060804/10/.

Chen, Yun. 1994. *Selected Works of Chen Yun.* Vol. 3: *1956–1994.* Beijing: Foreign Languages Press.

Cheng, Li, and Lynn White. 1990. "Elite Transformation and Modern Change in Mainland China and Taiwan: Empirical Data and the Theory of Technocracy." *China Quarterly,* no. 121: 1–35.

Cheng, Tiejun, and Mark Selden. 1994. "The Origins and Social Consequences of China's Hukou System." *China Quarterly,* no. 139 (February 12): 644–68.

Cheng Zhongyuan, Zhengxiang Wang, and Zhenghua Li. 1998. *1976–1981年的中国.* Beijing: Central Document Publishing.

Chin, Josh. 2015. "5 Things about the Fall of Zhou Yongkang." *Wall Street Journal,* June 11. https://www.wsj.com/articles/BL-263B-4893.

Chin, Josh. 2020. "Wuhan Mayor Says Beijing Rules Partially Responsible for Lack of Transparency." *Wall Street Journal,* January 28. https://www.wsj.com/articles/chinas-premier-tours-virus-epicenter-as-anger-bubbles-at-crisis-response-11580109098.

China Central Television. 2016. *Always on the Road.* https://youtu.be/qbgsWn5gMDs.

China Copyright and Media. 2014. "Official Central Committee Communiqué on 4th Plenum." October 24. http://chinacopyrightandmedia.wordpress.com/2014/10/23/official-central-committee-communique-on-4th-plenum/.

China Council for International Cooperation on Environment and Development. 2012. "CCICED 2011 Annual Report." http://www.cciced.net/ccicedPhoneEN/Events/AGMeeting/2011_3967/meetingplace_3968/201609/P020160922381707223558.pdf.

China Daily. 2008. "Each Lesson Counts." May 14. http://www.chinadaily.com.cn/opinion/2008-05/14/content_6683437.htm.

China Economic Review. 2013. "Four Dishes One Soup." August 21. http://www.chinaeconomicreview.com/four-dishes-one-soup.

ChinaHush. 2009. "Chinese Farmers Are 'Growing Houses' Instead of Growing Food." Blog. December 18. http://www.chinahush.com/2009/12/18/chinese-farmers-are-growing-houses-instead-of-growing-food/.

China Law Translate. 2018. "Supervision Law of the PRC." https://www.chinalawtranslate.com/en/supervision-law-of-the-prc-2018/.

China Media Project. 2010. "How Should We Read China's 'Discourse of Greatness'?" Blog. February 23. https://chinamediaproject.org/2010/02/23/reading-the-political-climate-in-chinas-discourse-of-greatness/.

China Media Project. 2013a. "Guilt and Shame in China's Media." Blog. October 30. https://chinamediaproject.org/2013/10/30/guilt-and-shame-in-chinas-media/.

China Media Project. 2013b. "Paper Goes Public over Reporter's Detention." Blog. October 23. https://chinamediaproject.org/2013/10/23/paper-goes-public-over-reporters-arrest/.

China Media Project. 2013c. "Parsing the 'Public Opinion Struggle.'" Blog. September 24. http://chinamediaproject.org/2013/09/24/parsing-chinas-public-opinion-struggle/.

China Media Project. 2020. "The Li Wenliang Storm." Blog. February 18. http://chinamediaproject.org/2020/02/18/the-li-wenliang-storm/.

China News Weekly. 2020. "'超级传播者': 他转移4次病房，传染了14名医护人员." January 25. https://page.om.qq.com/page/O1SIomsExWLw_cj4D92gbN3Q0.

China Real Time. 2013. "China NPC 2013: The Reports." *Wall Street Journal* (blog), March 5. http://blogs.wsj.com/chinarealtime/2013/03/05/china-npc-2013-the-reports/.

China Real Time. 2014. "China's Ghost Cities Are About to Get Spookier." *Wall Street Journal* (blog), May 15. http://blogs.wsj.com/chinarealtime/2014/05/16/chinas-ghost-cities-are-about-to-get-spookier/.

China Youth Daily. 2007a. "85.2%的人反對所在地 '犧牲環境換取GDP增長.'" July 30. http://big5.china.com.cn/environment/2007-07/30/content_8597810.htm.

China Youth Daily. 2007b. "民意調查顯示：96.4%公眾支援進行綠色GDP核算." July 30. http://big5.china.com.cn/economic/txt/2007-07/30/content_8597872.htm.

ChinaFile. 2013. "Document 9: A ChinaFile Translation." November 8. https://www.chinafile.com/document-9-chinafile-translation.

ChinaFile. 2014. "His Start in Oil Fuelled Zhou's Rise to Top Cop." August 25. http://www.chinafile.com/reporting-opinion/caixin-media/His-Start-in-Oil-Fuelled-Zhou-Rise-to-Top-Cop.

Chinese Posters. 2018. "Hua Guofeng." https://chineseposters.net/themes/huaguofeng.

Chongqing Daily. 2011. "重庆宣传部长解读把卫视打造成红色频道." March 3. http://news.sina.com.cn/m/2011-03-03/054522043321.shtml.

Chrystal, Alec. 2003. "Goodhart's Law: Its Origins, Meaning and Implications for Monetary Policy." In *Central Banking, Monetary Theory and Practice: Essays in Honor of Charles Goodhart,* edited by Paul Mizen, 221–43. Northampton, MA: Edward Elgar.

Chung, Jae Ho. 2016. *Centrifugal Empire: Central-Local Relations in China.* New York: Columbia University Press.

Chung, Jae Ho, Hongyi Lai, and Jang-Hwan Joo. 2009. "Assessing the 'Revive the Northeast' (Zhenxing Dongbei) Programme: Origins, Policies and Implementation." *China Quarterly,* no. 197: 108–25.

Coale, Ansley J., and Judith Banister. 1994. "Five Decades of Missing Females in China." *Demography* 31, no. 3: 459–79.

Cohen, David. 2012. "The Curious Case of Zhan Haite." *The Diplomat* (blog), December 19. https://thediplomat.com/2012/12/the-curious-case-of-zhan-haite/.

Cowen, Tyler. 2019. "Daryl Morey vs. ESPN." *Marginal REVOLUTION* (blog), October 8. https://marginalrevolution.com/marginalrevolution/2019/10/daryl-morey-vs-espn.html.

Coyle, Diane. 2014. *GDP: A Brief but Affectionate History.* Princeton, NJ: Princeton University Press.

Crane, Sam. 2018. "Why Xi Jinping's China Is Legalist, Not Confucian." *China Channel* (blog), June 29. https://chinachannel.org/2018/06/29/legalism/.

Creemers, Rogier. 2018. "China's Social Credit System: An Evolving Practice of Control." SSRN Scholarly Paper ID 3175792. https://papers.ssrn.com/abstract=3175792.

Cui, Jianming, and Boqi Shao, eds. 1990. 党政领导谈审计. Beijing: China Audit Press.

Cui, Zhiyuan. 2011. "Partial Intimations of the Coming Whole: The Chongqing Experiment in Light of the Theories of Henry George, James Meade, and Antonio Gramsci." *Modern China* 37, no. 6: 646–60.

Cui, Zhiyuan. 2012. "Making Sense of the Chinese 'Socialist Market Economy': A Note." *Modern China* 38, no. 6: 665–76.

Curtis, Bryan. 2019. "Deadspin and the Mavening of Sportswriting." *The Ringer,* October 31. https://www.theringer.com/2019/10/31/20942249/deadspin-g-o-media-fired-quit-sports-illustrated-maven-sports-media.

Cyranoski, David. 2003. "Taiwan Left Isolated in Fight against SARS." *Nature* (blog), April 17. https://www.nature.com/articles/422652a.

Daum, Jeremy. 2021. "Far from a Panopticon, Social Credit Focuses on Legal Violations." *China Brief* (blog), October 8. https://jamestown.org/program/far-from-a-panopticon-social-credit-focuses-on-legal-violations/.

Davies, Gloria. 2013. "Fitting Words." In *Civilising China*, edited by Geremie Barmé and Jeremy Goldkorn, 382–407. Canberra: ANU Press. http://www.thechinastory.org/yearbooks/yearbook-2013/.

Davies, Gloria. 2018. "To Prosper or Perish." In *China Story Yearbook 2017: Prosperity*, edited by Jane Golley and Linda Jaivin, 224–44. Canberra: ANU Press.

Davis, Bob. 2014. "China Growth Seen Slowing Sharply over Decade." *Wall Street Journal*, October 20. http://online.wsj.com/articles/china-growth-seen-slowing-sharply-over-decade-141 3778141.

Dazhai Joint Reporting Group. 1978. "昔阳调动农民社会主义积极性的经验好." *Renmin Ribao*, May 13. http://data.people.com.cn/rmrb/19780513/1.

Deese, Brian. 2021. "The Biden White House Plan for a New US Industrial Policy." Atlantic Council. June 23. https://www.atlanticcouncil.org/commentary/transcript/the-biden-white-house-plan-for-a-new-us-industrial-policy/.

deLisle, Jacques. 2009. "Taiwan in the World Health Assembly: A Victory, with Limits." Brookings (blog), May 13. https://www.brookings.edu/opinions/taiwan-in-the-world-health-assembly-a-victory-with-limits/.

Demick, Barbara. 2011. "U.S. Embassy Air Quality Data Undercut China's Own Assessments." *Los Angeles Times*, October 29. http://articles.latimes.com/2011/oct/29/world/la-fg-china-air-quality-20111030.

Demick, Barbara. 2013. "Mao-Era Style of Self-Criticism Reappears on Chinese TV." *Los Angeles Times*, September 26. http://www.latimes.com/world/la-fg-china-self-criticism-20130 927,0,6461672.story.

Deng Xiaoping. 1981. "Remarks on Successive Drafts of the 'Resolution on Certain Questions in the History of Our Party Since the Founding of the People's Republic of China." June 22. http://english.peopledaily.com.cn/dengxp/vol2/text/b1420.html.

Deng Xiaoping. 1984. *Selected Works of Deng Xiaoping, 1975–1982*. Beijing: Foreign Languages Press.

Dickson, Bruce J. 2003. *Red Capitalists in China: The Party, Private Entrepreneurs, and Prospects for Political Change*. Cambridge: Cambridge University Press.

Dikötter, Frank. 2010. *Mao's Great Famine: The History of China's Most Devastating Catastrophe, 1958–1962*. New York: Walker.

Dikötter, Frank. 2015. *The Tragedy of Liberation: A History of the Chinese Revolution 1945–1957*. New York: Bloomsbury.

Dimitrov, Martin, ed. 2013. *Why Communism Did Not Collapse: Understanding Authoritarian Regime Resilience in Asia and Europe*. New York: Cambridge University Press.

Dimitrov, Martin. 2015. "Internal Government Assessments of the Quality of Governance in China." *Studies in Comparative International Development* 50, no. 1: 50–72.

Dimitrov, Martin. 2017. "The Political Logic of Media Control in China." *Problems of Post-Communism* 64, nos. 3–4: 121–7.

Dimitrov, Martin. 2019. "Internal Information and Theory Generation in the Study of Autocracies." Paper presented at American Political Science Association Annual Meeting, Washington, DC.

Ding, X. L. 1994. *The Decline of Communism in China : Legitimacy Crisis, 1977–1989*. Cambridge: Cambridge University Press.

Distelhorst, Greg. 2012. "Publicity-Driven Accountability in China: Qualitative and Experimental Evidence." Unpublished manuscript.

Dittmer, Lowell, and Yu-Shan Wu. 1995. "The Modernization of Factionalism in Chinese Politics." *World Politics* 47, no. 4 (July): 467–94.

Dobbs, Richard, Susan Lund, Jonathan Woetzel, and Mina Mutafchieva. 2015. "Debt and (Not Much) Deleveraging." McKinsey Global Institute. http://www.mckinsey.com/global-the mes/employment-and-growth/debt-and-not-much-deleveraging.

Downie, Edmund. 2014. "One City, Many Models: The Chinese Left's Debates over Chongqing." Senior thesis, Yale University.

Downie, Edmund. 2021. "Getting to 30-60: How China's Biggest Coal Power, Cement, and Steel Corporations Are Responding to National Decarbonization Pledges." Report, Center on Global Energy Policy. https://www.energypolicy.columbia.edu/research/report/getting-30-60-how-china-s-biggest-coal-power-cement-and-steel-corporations-are-responding-national.

Downs, Anthony. 1957. *An Economic Theory of Democracy*. New York: Harper and Row.

Doyon, Jerome. 2014. "The End of the Road for Xi's Mass Line Campaign: An Assessment." *China Brief* (blog), October 23. https://jamestown.org/program/the-end-of-the-road-for-xis-mass-line-campaign-an-assessment/.

Dukalskis, Alexander. 2017. *The Authoritarian Public Sphere: Legitimation and Autocratic Power in North Korea, Burma, and China*. London: Taylor & Francis.

Dutton, Michael. 2005. *Policing Chinese Politics: A History. Policing Chinese Politics*. Durham, NC: Duke University Press.

The Economist. 2013a. "Bear in the China Shop; China's Cash Crunch." June 29. http://search.proquest.com/docview/1372754013/1BAEE60FFC2249FCPQ/3?accountid=10267.

The Economist. 2013b. "Critical Masses." October 5. http://www.economist.com/news/china/21587248-party-tries-rein-officials-campaign-self-criticism-critical-masses.

The Economist. 2013c. "What Caused China's Cash Crunch? The Economist Explains." July 4. http://search.proquest.com/docview/1398214708/1BAEE60FFC2249FCPQ/1?accountid=10267.

The Economist. 2015. "GDP Apostasy." January 31. http://www.economist.com/news/china/21641282-chinas-biggest-city-leads-way-jettisoning-its-annual-target-gdp-apostasy.

The Economist. 2016. "Beware the Cult of Xi." April 2. http://www.economist.com/leaders/2016/04/02/beware-the-cult-of-xi.

The Economist. 2020. "China's Data Reveal a Puzzling Link between Covid-19 Cases and Political Events." April 7. https://www.economist.com/graphic-detail/2020/04/07/chinas-data-reveal-a-puzzling-link-between-covid-19-cases-and-political-events.

Economy, Elizabeth. 2004. *The River Runs Black: The Environmental Challenge to China's Future*. Ithaca, NY: Cornell University Press.

Economy, Elizabeth C. 2018. *The Third Revolution: Xi Jinping and the New Chinese State*. New York: Oxford University Press.

Edin, Maria. 2003a. "Remaking the Communist Party-State: The Cadre Responsibility System at the Local Level in China." *China: An International Journal* 1, no. 1: 1–15.

Edin, Maria. 2003b. "State Capacity and Local Agent Control in China: CCP Cadre Management from a Township Perspective." *China Quarterly*, no. 173: 35–52.

Egorov, Georgy, Sergei Guriev, and Konstantin Sonin. 2009. "Why Resource-Poor Dictators Allow Freer Media: A Theory and Evidence from Panel Data." *American Political Science Review* 103, no. 4 (November): 645–68.

Egorov, Georgy, and Konstantin Sonin. 2011. "Dictators and Their Viziers: Endogenizing the Loyalty-Competence Trade-Off." *Journal of the European Economic Association* 9, no. 5: 903–30.

Eisenman, Joshua. 2018. *Red China's Green Revolution Technological Innovation, Institutional Change, and Economic Development under the Commune*. New York: Columbia University Press.

Ekiert, Grzegorz, Elizabeth J. Perry, and Xiaojun Yan, eds. 2020. *Ruling by Other Means: State-Mobilized Movements*. Cambridge: Cambridge University Press.

Elvidge, C. D., K. E. Baugh, S. J. Anderson, P. C. Sutton, and T. Ghosh. 2012. "The Night Light Development Index (NLDI): A Spatially Explicit Measure of Human Development from Satellite Data." *Journal of the Royal Geographical Society of London* 7, no. 1: 23–35.

Elvidge, C. D., F. C. Hsu, K. E. Baugh, and T. Ghosh. (2014). "National Trends in Satellite-Observed Lighting, 1992–2012." In *Global Urban Monitoring and Assessment through Earth Observation*, edited by Qihao Weng, 97–118. Boca Raton, FL: CRC Press.

Enikolopov, Ruben, Maria Petrova, and Ekaterina Zhuravskaya. 2011. "Media and Political Persuasion: Evidence from Russia." *American Economic Review* 101, no. 7: 3253–85.

Espeland, Wendy Nelson, and Mitchell L. Stevens. 1998. "Commensuration as a Social Process." *Annual Review of Sociology* 24, no. 1: 313–43.

Eurasia Group. 2011. "China's Great Rebalancing Act." http://eurasiagroup.net/item-files/China's%20Great%20Rebalancing%20Act/China%20Rebalancing.pdf.

Fallows, James. 2008. "Be Nice to the Countries That Lend You Money." *The Atlantic*, December 1. http://www.theatlantic.com/magazine/archive/2008/12/be-nice-to-the-countries-that-lend-you-money/307148/.

Fang, Qiang. 2013. *Chinese Complaint Systems: Natural Resistance*. London: Routledge.

Fardoust, Shahrokh, Justin Yifu Lin, and Xubei Luo. 2012. *Demystifying China's Fiscal Stimulus*. Policy Research Working Papers. Washington, DC: World Bank.

Fassihi, Farnaz. 2020. "Iran Sees New Surge in Virus Cases after Reopening Country." *New York Times*, May 18. https://www.nytimes.com/2020/05/18/world/middleeast/iran-coronavirus-surge.html.

Fassihi, Farnaz, and David D. Kirkpatrick. 2020. "Iran's Coronavirus Response: Pride, Paranoia, Secrecy, Chaos." *New York Times*, May 3. https://www.nytimes.com/2020/03/03/world/middleeast/coronavirus-iran.html.

FBIS. 1986. "FBIS-CHI-86-151." Foreign Broadcast Information Servce. August 6: K4–K8. https://archive.org/details/fbis-reports_fbis-chi-86-151/page/n17/mode/2up

FBIS. 1988. "FBIS-CHI-88-201." Foreign Broadcast Information Servce. October 18: 20–22. https://archive.org/details/fbis-reports_fbis-chi-88-201/page/n23/mode/2up

Fenby, Jonathan. 2012. "Opinion: The Missing Mr. Xi and the Price of Official Secrecy." *New York Times*, September 17. https://www.nytimes.com/2012/09/18/opinion/the-missing-mr-xi-and-the-price-of-official-secrecy.html.

Feng, Emily. 2020. "Meet Dr. Zhong Nanshan, the Public Face of the COVID-19 Fight in China." NPR, April 15. https://www.npr.org/2020/04/15/835308147/meet-dr-zhong-nanshan-the-public-face-of-the-covid-19-fight-in-china.

Feng, Wang. 2014. "Tigers and Flies: How Two Years of Graft Probes Have Shaken China's Political Elite." *South China Morning Post*, November 3. http://multimedia.scmp.com/china-corruption/.

Fenner, Sofia. 2016. "Life after Co-optation: Incorporation and Neutralization under Authoritarianism." Paper presented at American Political Science Association Annual Meeting, Philadelphia, PA.

Ferchen, Matt. 2013. "Whose China Model Is It Anyway? The Contentious Search for Consensus." *Review of International Political Economy* 20, no. 2: 390–420.

Ferguson, James. 1994. *The Anti-Politics Machine: Development, Depoliticization, and Bureaucratic Power in Lesotho*. Minneapolis: University of Minnesota Press.

Fernald, John, Israel Malkin, and Mark Spiegel. 2015. "On the Reliability of Chinese Output Figures." *FRBSF Economic Letter*, March 25. http://basement.frbsf.org/publications/economics/letter/2013/el2013-08.pdf.

Feuer, Will. 2020. "Parts of Asia That Relaxed Restrictions without a Resurgence in Coronavirus Cases Did These Three Things." CNBC, May 7. https://www.cnbc.com/2020/05/07/coronavirus-lessons-learned-in-asia-show-us-is-at-risk-of-a-resurge-in-cases-as-states-reopen-businesses.html.

Fewsmith, Joseph. 2001. *China since Tiananmen: The Politics of Transition*. Cambridge: Cambridge University Press.

Fewsmith, Joseph. 2010. "Bo Xilai Takes on Organized Crime." *China Leadership Monitor*, no. 32: 1–8.

Fewsmith, Joseph. 2012. "De Tocqueville in Beijing." *China Leadership Monitor*, no. 39 (October 1): 1–6.

Fewsmith, Joseph. 2013. *The Logic and Limits of Political Reform in China*. Cambridge: Cambridge University Press.

Fewsmith, Joseph. 2018. "The 19th Party Congress: Ringing in Xi Jinping's New Age." *China Leadership Monitor*, no. 55 (Winter). https://www.hoover.org/research/19th-party-congr ess-ringing-xi-jinpings-new-age.

Fifield, Anna. 2004. "The Week in Economics: Black Gold." *Financial Times*, August 19. https:// www.ft.com/content/bd80582a-f21d-11d8-861d-00000e2511c8.

Fincher, Leta Hong. 2016. "China's Feminist Five." *Dissent Magazine*, Fall. https://www.dissentm agazine.org/article/china-feminist-five.

Fincher, Leta Hong. 2018. *Betraying Big Brother: The Feminist Awakening in China*. London: Verso.

Finkel, Evgeny, Scott Gehlbach, and Tricia D. Olsen. 2015. "Does Reform Prevent Rebellion? Evidence from Russia's Emancipation of the Serfs." *Comparative Political Studies* 48, no. 8: 984–1019.

Fish, Isaac Stone. 2018. "Why Is the NBA in Xinjiang?" *Slate*, August 20. https://slate.com/news-and-politics/2018/08/xinjiang-the-nba-is-running-a-training-camp-in-the-middle-of-one-of-the-worlds-worst-humanitarian-atrocities.html.

Fisher, Max. 2012. "The Secret Story behind Xi Jinping's Disappearance, Finally Revealed?" *Washington Post*, November 1. https://www.washingtonpost.com/news/worldviews/wp/2012/11/01/the-secret-story-behind-xi-jinpings-disappearance-finally-revealed/.

Fisman, Raymond, and Yongxiang Wang. 2017. "The Distortionary Effects of Incentives in Government: Evidence from China's 'Death Ceiling' Program." *American Economic Journal: Applied Economics* 9, no. 2 (April): 202–18.

Focus Interview《焦点访谈》. 2013. "批评和自我批评是一剂良药_新闻频道."《焦点访谈》. CNTV, November 21. http://news.cntv.cn/2013/09/26/VIDE1380140758843768. shtml.

Focus Report (焦点访谈). 2013. "批评和自我批评是一剂良药." CNTV, September 26. http://news.cntv.cn/2013/09/26/VIDE1380140758843768.shtml.

Forsythe, Michael. 2012. "Xi Jinping Millionaire Relations Reveal Fortunes of Elite." *Bloomberg*, June 29. https://www.bloomberg.com/news/articles/2012-06-29/xi-jinping-millionaire-relations-reveal-fortunes-of-elite.

Forsythe, Michael. 2014. "As China's Leader Fights Graft, His Relatives Shed Assets." *New York Times*, June 17. https://www.nytimes.com/2014/06/18/world/asia/chinas-president-xi-jinping-investments.html.

Forsythe, Michael. 2015. "Zhou Yongkang, Ex-Security Chief in China, Gets Life Sentence for Graft." *New York Times*, June 11. http://www.nytimes.com/2015/06/12/world/asia/zhou-yongkang-former-security-chief-in-china-gets-life-sentence-for-corruption.html.

Foucault, Michel. 1977. *Discipline and Punish: The Birth of the Prison*. New York: Pantheon Books.

Freedom House. 2013. "Special Feature: The 'Southern Weekly' Controversy." https://freedomho use.org/report/china-media-bulletin/special-feature-southern-weekly-controversy.

Friedman, Eli. 2012. "Getting through the Hard Times Together? Chinese Workers and Unions Respond to the Economic Crisis." *Journal of Industrial Relations* 54, no. 4: 459–75.

Friedman, Eli. 2014. *Insurgency Trap: Labor Politics in Postsocialist China*. Ithaca, NY: ILR Press.

Friedman, Eli. 2017. "Evicting the Underclass." *Jacobin*, December 6. http://jacobinmag.com/2017/12/beijing-fire-migrant-labor-urbanization.

Friedman, Eli. 2018. "Just-in-Time Urbanization? Managing Migration, Citizenship, and Schooling in the Chinese City." *Critical Sociology* 44, no. 3: 503–18.

Friedman, Eli. 2022. *The Urbanization of People: The Politics of Development, Labor Markets, and Schooling in the Chinese City*. New York: Columbia University Press.

Friedman, Eli, and Sarosh Kuruvilla. 2015. "Experimentation and Decentralization in China's Labor Relations." *Human Relations* 68, no. 2: 181–95.

Friedman, Milton. 1970. "The Social Responsibility of Business Is to Increase Its Profits." *New York Times*, September 13. https://www.nytimes.com/1970/09/13/archives/article-15-no-title.html.

FT Visual & Data Journalism Team. 2020. "Coronavirus Tracked: Has the Epidemic Peaked Bear You?" Financial Times, April 22. https://ig.ft.com/coronavirus-chart.

Fu, Diana. 2017. "Why Is Beijing Afraid of Chinese Feminists?" *Washington Post*, July 27. https://www.washingtonpost.com/news/monkey-cage/wp/2017/07/27/why-is-beijing-afraid-of-chinese-feminists/.

Fu, Diana. 2018. *Mobilizing without the Masses: Control and Contention in China.* Cambridge: Cambridge University Press.

Fukuyama, Francis. 2011. *The Origins of Political Order: From Prehuman Times to the French Revolution.* New York: Farrar, Straus and Giroux.

Gallagher, Mary, John Giles, Albert Park, and Meiyan Wang. 2015. "China's 2008 Labor Contract Law: Implementation and Implications for China's Workers." *Human Relations* 68, no. 2: 197–235.

Gallagher, Mary, and Blake Miller. 2021. "Who Not What: The Logic of China's Information Control Strategy." *China Quarterly*, no. 248: 1011–36.

Gan, Nectar. 2017. "Ex-Aide of Disgraced China Security Tsar Zhou Yongkang Jailed." *South China Morning Post*, February 15. https://www.scmp.com/news/china/policies-politics/article/2071053/ex-aide-disgraced-china-security-czar-zhou-yongkang.

Gandhi, Jennifer. 2008. *Political Institutions under Dictatorship.* Cambridge: Cambridge University Press.

Gandhi, Jennifer, and Jane Lawrence Sumner. 2020. "Measuring the Consolidation of Power in Nondemocracies." *Journal of Politics* 82, no. 4: 1545–58.

Gandhi, Jennifer, and Ellen Lust-Okar. 2009. "Elections under Authoritarianism." *Annual Review of Political Science* 12, no. 1: 403–22.

Gao, Jie. 2016. "'Bypass the Lying Mouths': How Does the CCP Tackle Information Distortion at Local Levels?" *China Quarterly*, no. 228: 950–69.

Garnaut, Anthony. 2013. "Hard Facts and Half-Truths: The New Archival History of China's Great Famine." *China Information* 27, no. 2: 223–46.

Garnaut, Anthony. 2014a. "The Geography of the Great Leap Famine." *Modern China* 40, no. 3: 315–48.

Garnaut, Anthony. 2014b. "The Mass Line on a Massive Famine." The China Story, October 8. http://www.thechinastory.org/2014/10/the-mass-line-on-a-massive-famine/.

Garnaut, John. 2012. *The Rise and Fall of the House of Bo: How a Murder Exposed the Cracks in China's Leadership.* London: Penguin.

Garside, Roger. 1981. *Coming Alive: China after Mao.* New York: McGraw-Hill.

Geddes, Barbara. 1999. "Authoritarian Breakdown: Empirical Test of a Game Theoretic Argument." Paper presented at American Political Science Association Annual Meeting, Atlanta, GA.

Geddes, Barbara. 2003. *Paradigms and Sand Castles: Theory Building and Research Design in Comparative Politics.* Ann Arbor: University of Michigan Press.

Geddes, Barbara, Joseph Wright, and Erica Frantz, E. 2014. "Autocratic Breakdown and Regime Transitions: A New Data Set." *Perspectives on Politics* 12, no. 2: 313–31.

Geddes, Barbara, Joseph Wright, and Erica Frantz. 2018. *How Dictatorships Work: Power, Personalization, and Collapse.* New York: Cambridge University Press.

Gehlbach, Scott, and Alberto Simpser. 2013. "Electoral Manipulation as Bureaucratic Control." SSRN Scholarly Paper. Rochester, NY: Social Science Research Network.

Gerschewski, Johannes. 2013. "The Three Pillars of Stability: Legitimation, Repression, and Co-optation in Autocratic Regimes." *Democratization* 20, no. 1: 13–38.

Gerth, Karl. 2020. *Unending Capitalism: How Consumerism Negated China's Communist Revolution.* Cambridge: Cambridge University Press.

Gewirtz, Julian B. 2017. *Unlikely Partners: Chinese Reformers, Western Economists, and the Making of Global China.* Cambridge, MA: Harvard University Press.

Ghosh, Arunabh. 2018. "Lies, Damned Lies, and (Bourgeois) Statistics: Ascertaining Social Fact in Midcentury China and the Soviet Union." *Osiris* 33, no. 1: 149–68.

Ghosh, Arunabh. 2020. *Making It Count: Statistics and Statecraft in the Early People's Republic of China.* Princeton, NJ: Princeton University Press.

Ghosh, T., R. L. Powell, C. D. Elvidge, K. E. Baugh, P. C. Sutton, and S. Anderson. 2010. "Shedding Light on the Global Distribution of Economic Activity." *Open Geography Journal* 3, no. 1: 148–61.

Gibson, John, and Chao Li. 2017. "The Erroneous Use of China's Population and Per Capita Data: A Structured Review and Critical Test." *Journal of Economic Surveys* 31, no. 4: 905–22.

Gill, Graeme. 2011. *Symbols and Legitimacy in Soviet Politics.* Cambridge: Cambridge University Press.

Ginsborg, Paul. 2005. *Silvio Berlusconi: Television, Power and Patrimony.* London: Verso.

Glasius, Marlies. 2018. "What Authoritarianism Is . . . and Is Not: A Practice Perspective." *International Affairs* 94, no. 3: 515–33.

GlobalPost. 2012. "Meet the Top 11 Wealthiest People in China." *The World*, September 25. https://theworld.org/stories/2012-09-25/meet-top-11-wealthiest-people-china.

Goldkorn, Jeremy, David Bandurski, Joshua Rosenzweig, and Alvin Y. H. Cheung. 2016. "Beijing's Televised Confessions." *ChinaFile*, January 20. https://www.chinafile.com/conversation/beijings-televised-confessions.

Goldman, Merle. 1991. "Hu Yaobang's Intellectual Network and the Theory Conference of 1979." *China Quarterly*, no. 126: 219–42.

Goldman, Merle. 1994. *Sowing the Seeds of Democracy in China: Political Reform in the Deng Xiaoping Era.* Cambridge, MA: Harvard University Press.

Goldstein, Judith L., and Margaret E. Peters. 2014. "Nativism or Economic Threat: Attitudes toward Immigrants during the Great Recession." *International Interactions* 40, no. 3: 376–401.

Goldstone, Jack A. 1995. "The Coming Chinese Collapse." *Foreign Policy*, no. 99: 35–53.

Gong Wen (龚雯), Xu Zhifeng (许志峰), and Wu Qiuyu (吴秋余). 2016. "开局首季问大势——权威人士谈当前中国经济" *Renmin Ribao*, May 9. http://data.people.com.cn/rmrb/20160509/2.

Goodhart, Charles. 1981. "Problems of Monetary Management: The U.K. Experience." In *Inflation, Depression, and Economic Policy in the West*, edited by Anthony S. Courakis, 91–121. Lanham, MD: Rowman & Littlefield.

Goodman, David S. G., and Gerald Segal, eds. 1995. *China Deconstructs: Politics, Trade and Regionalism.* London: Routledge.

Gramsci, Antonio, and Quitin Hoare. 1971. *Selections from the Prison Notebooks.* London: Lawrence and Wishart.

Greene, Scott. 2012. "Amid Exit, Hu Jintao Faces Mixed Legacy." *China Digital Times* (blog), November 8. https://chinadigitaltimes.net/2012/11/amid-exit-hu-jintao-faces-mixed-legacy/.

Greenhalgh, Susan. 2003. "Science, Modernity, and the Making of China's One-Child Policy." *Population and Development Review* 29, no. 2: 163–96.

Greenhalgh, Susan. 2005. "Missile Science, Population Science: The Origins of China's One-Child Policy." *China Quarterly*, no. 182: 253–76.

Greenhalgh, Susan. 2008. *Just One Child: Science and Policy in Deng's China.* Berkeley: University of California Press.

Greitens, Sheena C. 2016. *Dictators and Their Secret Police: Coercive Institutions and State Violence.* Cambridge: Cambridge University Press.

Grindle, Merilee S. 1977. *Bureaucrats, Politicians, and Peasants in Mexico: A Case Study in Public Policy.* Berkeley: University of California Press.

Guo, Gang. 2009. "China's Local Political Budget Cycles." *American Journal of Political Science* 53, no. 3: 621–32.

Guo, Xuezhi. 2012. *China's Security State: Philosophy, Evolution, and Politics.* Cambridge: Cambridge University Press.

Guo, Xuezhi. 2014. "Controlling Corruption in the Party: China's Central Discipline Inspection Commission." *China Quarterly*, no. 219: 597–624.

Guriev, Sergei, and Daniel Treisman. 2019. "Informational Autocrats." *Journal of Economic Perspectives* 33, 4: 100–27. https://doi.org/10.1257/jep.33.4.100.

Hadenius, Axel, and Jan Teorell. 2007. "Pathways from Authoritarianism." *Journal of Democracy* 18, no. 1: 143–56.

Hall, Peter A., and David Soskice, eds. 2001. *Varieties of Capitalism: The Institutional Foundations of Comparative Advantage*. Oxford: Oxford University Press.

Hall, Todd H., and Andrew A. G. Ross. 2015. "Affective Politics after 9/11." *International Organization* 69, no. 4: 847–79.

Han, Han. 2013. "There Is Always a Power: A Tribute to Southern Weekly." *South China Morning Post* (blog), January 7. https://www.scmp.com/comment/blogs/article/1122061/there-always-power-tribute-southern-weekly.

Han, Rongbin, Du Juan, and Li Shao. 2019. "Unlawful Bargaining: Negotiating Distribution in China." Paper presented at American Political Science Association Annual Meeting, Washington, DC.

Harding, Harry. 1981. *Organizing China: The Problem of Bureaucracy, 1949–1976*. Stanford, CA: Stanford University Press.

Harker, Gerry. 2021. "Enes Kanter Doubles Down on China Criticism, Calls Out Other Athletes." *SupChina*, October 25. https://supchina.com/2021/10/25/enes-kanter-doubles-down-on-china-criticism-calls-out-other-athletes/.

Harvey, David. 2005. *A Brief History of Neoliberalism*. Oxford: Oxford University Press.

Hassid, Jonathan. 2008. "China's Contentious Journalists: Reconceptualizing the Media." *Problems of Post-Communism* 55, no. 4: 52–61.

Havel, Václav. 1985. *The Power of the Powerless: Citizens against the State in Central-Eastern Europe*. Translated by John Keane. Armonk, NY: M. E. Sharpe.

He, Jiahong. 1995. *Criminal Prosecution in the People's Republic of China and the United States of America: A Comparative Study*. Beijing: China Procuratorial Press.

Heilmann, Sebastian, and Elizabeth J. Perry, eds. 2011. *Mao's Invisible Hand: The Political Foundations of Adaptive Governance in China*. Cambridge, MA: Harvard University Asia Center.

Hellman, Joel S. 1998. "Winners Take All: The Politics of Partial Reform in Postcommunist Transitions." *World Politics* 50, no. 2: 203–34.

Henderson, J. Vernon, Adam Storeygard, and David N Weil. 2012. "Measuring Economic Growth from Outer Space." *American Economic Review* 102, no. 2: 994–1028.

Hernández, Javier C. 2017. "Xi Jinping Vows No Poverty in China by 2020. That Could Be Hard." *New York Times*, October 31. https://www.nytimes.com/2017/10/31/world/asia/xi-jinp ing-poverty-china.html.

Herrera, Yoshiko M. 2010. *Mirrors of the Economy: National Accounts and International Norms in Russia and Beyond*. Ithaca, NY: Cornell University Press.

Herring, Cedric. 2009. "Does Diversity Pay? Race, Gender, and the Business Case for Diversity." *American Sociological Review* 74, no. 2: 208–24.

Hinton, Harold C. 1980. *The People's Republic of China, 1949–1979: A Documentary Survey*. Wilmington, DE: Scholarly Resources.

Holbig, Heike. 2013. "Ideology after the End of Ideology. China and the Quest for Autocratic Legitimation." *Democratization* 20, no. 1: 61–81.

Hollingsworth, Julia. 2020. "China Canceling Lunar New Year Festivities Is a Massive Deal." CNN, January 24. https://www.cnn.com/2020/01/24/china/virus-lunar-new-year-intl-hnk-scli/index.html.

Hollyer, James R., Peter B. Rosendorff, and James R. Vreeland. 2011. "Democracy and Transparency." *Journal of Politics* 73, no. 4: 1191–205.

Horsley, Jamie. 2018a. "China's Orwellian Social Credit Score Isn't Real." *Foreign Policy* (blog), January 2. https://foreignpolicy.com/2018/11/16/chinas-orwellian-social-credit-score-isnt-real/.

Horsley, Jamie. 2018b. "What's So Controversial about China's New Anti-Corruption Body?" *The Diplomat* (blog), May 30. https://thediplomat.com/2018/05/whats-so-controversial-about-chinas-new-anti-corruption-body/.

Hsieh, Chang-Tai, and Zheng (Michael) Song. 2015. "Grasp the Large, Let Go of the Small: The Transformation of the State Sector in China." Working Paper. Cambridge, MA: National Bureau of Economic Research.

Hsing, You-tien. 2010. *The Great Urban Transformation: Politics of Land and Property in China.* Oxford: Oxford University Press.

Hu Jintao (胡锦涛). 2016. *胡锦涛文选*. Beijing Shi: Ren min chu ban she.

Hu Jintao. 2012. "Report of Hu Jintao to the 18th CPC National Congress." Chinese Communist Party. http://www.china.org.cn/china/18th_cpc_congress/2012-11/16/content_27137 540.htm.

Hu, Jiusi. 2010. "Huge Demolition in Wuhan." *China Daily*, November 18. http://www.chinadaily. com.cn/china/2010-11/18/content_11566587.htm.

Hu, Yinbin. 2010. "更应反思'武汉史上最大规模拆违建.'" 新京报, November 19. https:// www.bjnews.com.cn/detail/155143710114799.html.

Hu, Yue. 2009. "2009 Hurun Rich List Released." *Beijing Review*, October 13. http://www.bjrev iew.com/exclusive/txt/2009-10/13/content_223837.htm.

Huang, Cary. 2013a. "Tocqueville's Advice on French Revolution Captures Chinese Leaders' Attention." *South China Morning Post*, February 22. http://www.scmp.com/news/china/ article/1133212/tocquevilles-advice-french-revolution-captures-chinese-leaders-attention.

Huang, Cary. 2013b. "Xi Jinping Oversees Self-Criticism Sessions in Hebei." *South China Morning Post*, September 26. http://www.scmp.com/news/china/article/1317934/xi-jinping-overs ees-self-criticism-sessions-hebei.

Huang, Cary. 2015a. "China President Stresses Marxist Materialism in Effort to Silence Critics." *South China Morning Post*, January 26. https://www.scmp.com/news/china/article/1692 861/silencing-hiscritics-presidentcites-his-marx.

Huang, Cary. 2015b. "Shanghai's Shunning of GDP Obsession Seen as a Welcome Move towards Quality Growth." *South China Morning Post*, February 1. http://www.scmp.com/comm ent/insight-opinion/article/1697388/shanghais-shunning-gdp-obsession-seen-welcome-move-towards.

Huang, Hai. 2011. "重庆卫视全新改版 《天天红歌会》推广红歌." Hualong, March 1. https://news.qq.com/a/20110301/001567.htm.

Huang, Haifeng. 2015a. "International Knowledge and Domestic Evaluations in a Changing Society: The Case of China." *American Political Science Review* 109, no. 3: 613–34.

Huang, Haifeng. 2015b. "Propaganda as Signaling." *Comparative Politics* 47, no. 4: 419–37.

Huang, J., H. Zhi, Z. Huang, S. Rozelle, and J. Giles. 2011. "The Impact of the Global Financial Crisis on Off-Farm Employment and Earnings in Rural China." *World Development* 39, no. 5: 797–807.

Huang, Kim. 2009. "3 Held over Shooting Murder in Chongqing." *South China Morning Post*, June 17. https://advance-lexis-com/api/document?collection=news&id=urn:contentI tem:7VYC-3C31-2R52-W33T-00000-00&context=1516831.

Huang, Philip C. C. 2010. "Beyond the Right-Left Divide: Searching for Reform from the History of Practice." *Modern China* 36, no. 1: 115–33.

Huang, Philip C. C. 2011. "Chongqing: Equitable Development Driven by a 'Third Hand'?" *Modern China* 37, no. 6: 569–622.

Huang, Philip C. C. 2015. "How Has the Chinese Economy Developed So Rapidly? The Concurrence of Five Paradoxical Coincidences." *Modern China* 41, no. 3: 239–77.

Huang, Yasheng. 1996. *Inflation and Investment Controls in China: The Political Economy of Central-Local Relations during the Reform Era.* Cambridge: Cambridge University Press.

Huang, Yasheng. 2008. *Capitalism with Chinese Characteristics: Entrepreneurship and the State.* Cambridge: Cambridge University Press.

Huntsman, Jon. 2009. "Portrait of Vice President Xi Jinping: 'Ambitious Survivor' of the Cultural Revolution." Wikileaks Public Library of US Diplomacy 09BEIJING3128_a. https://wikile aks.org/plusd/cables/09BEIJING3128_a.html.

Hurst, William James. 2009. *The Chinese Worker after Socialism*. Cambridge: Cambridge University Press.

Illing, Sean. 2020. "'Flood the Zone with Shit': How Misinformation Overwhelmed Our Democracy." *Vox*, January 16. https://www.vox.com/policy-and-politics/2020/1/16/20991816/impeachment-trial-trump-bannon-misinformation.

International Monetary Fund. 2007. "China's Difficult Rebalancing Act." September 12. http://www.imf.org/external/pubs/ft/survey/so/2007/car0912a.htm.

Ip, Greg. 2021. "'Industrial Policy' Is Back: The West Dusts Off Old Idea to Counter China." *Wall Street Journal*, July 29. https://www.wsj.com/articles/subsidies-chips-china-state-aid-biden-11627565906.

Jacobs, Andrew. 2012. "Chinese Heroism Effort Is Met with Cynicism." *New York Times*, March 5. https://www.nytimes.com/2012/03/06/world/asia/lei-feng-day-draws-chinese-cynicism.html.

Jacobs, Andrew. 2013. "Arrests in China Show Limits of War on Graft." *New York Times*, April 4. https://www.nytimes.com/2013/04/05/world/asia/xi-jinpings-war-on-graft-appears-to-have-limits.html.

Jacobs, Andrew, and Chris Buckley. 2014. "25 Years Later, Details Emerge of Army's Chaos before Tiananmen Square." *New York Times*. June 2. http://www.nytimes.com/2014/06/03/world/asia/tiananmen-square-25-years-later-details-emerge-of-armys-chaos.html.

Jacobs, Harrison. 2015. "Here's the Ridiculous Loot That's Been Found with Corrupt Chinese Officials." *Business Insider*, January 22. https://www.businessinsider.com/the-ridiculous-loot-thats-been-found-with-corrupt-chinese-officials-2015-1.

Jameson, Fredric. 1984. "Postmodernism, or The Cultural Logic of Late Capitalism." *New Left Review* 1, no. 146: 53–92.

Jameson, Fredric. 2003. "Future City." *New Left Review*, June. https://newleftreview.org/issues/II21/articles/fredric-jameson-future-city.

Jaros, Kyle. 2020. "China's Early COVID-19 Missteps Have an All-Too-Mundane Explanation." *The Diplomat* (blog), April 9. https://thediplomat.com/2020/04/chinas-early-covid-19-struggles-have-an-all-too-mundane-explanation/.

Jayasuriya, Kanishka, and Garry Rodan. 2007. "Beyond Hybrid Regimes: More Participation, Less Contestation in Southeast Asia." *Democratization* 14, no. 5: 773–94.

Jeffery, Clara, and Monika Bauerlein. 2015. "A Billionaire Political Donor Sued Mother Jones. We Won. Here's What Happened." *Mother Jones* (blog), October 8. https://www.motherjones.com/media/2015/10/mother-jones-vandersloot-melaleuca-lawsuit/.

Jenne, Jeremiah. 2018. "Why Hua Guofeng Matters . . . No, Seriously." Blog. June 7. https://www.jeremiahjenne.com/the-archives/2018/4/9/why-hua-guofeng-mattersno-seriously.

Jerven, Morten. 2013. *Poor Numbers: How We Are Misled by African Development Statistics and What to Do about It*. Ithaca, NY: Cornell University Press.

Jia, Ruixue, Masayuki Kudamatsu, and David Seim. 2015. "Political Selection in China: The Complementary Roles of Connections and Performance." *Journal of the European Economic Association* 13, no. 4: 631–68.

Jiang, Junyan. 2018. "Making Bureaucracy Work: Patronage Networks, Performance Incentives, and Economic Development in China." *American Journal of Political Science* 62, no. 4: 982–99.

Jiang, Junyan, and Jeremy L. Wallace. n.d. "Informal Institutions and Authoritarian Information Systems: Theory and Evidence from China." SSRN Scholarly Paper. Rochester, NY: Social Science Research Network.

Jiang, Zhuqing. 2004. "Prevention Key to Lowering Accidents." *China Daily*, February 20. http://www.chinadaily.com.cn/english/doc/2004-02/20/content_307974.htm.

Johnson, Christopher. 2013. "China Announces Sweeping Reform Agenda at Plenum." *Critical Questions* (blog), November 15. https://www.csis.org/analysis/china-announces-sweeping-reform-agenda-plenum.

Johnson, Christopher, Scott Kennedy, and Mingda Qiu. 2017. "Xi's Signature Governance Innovation: The Rise of Leading Small Groups." Commentary. Washington, DC: Center for

Strategic and International Studies. https://www.csis.org/analysis/xis-signature-governa
nce-innovation-rise-leading-small-groups.

Johnson, Simon, Daniel Kaufmann, and Andrei Shleifer. 1997. "The Unofficial Economy in
Transition." *Brookings Papers on Economic Activity*, no. 2: 159–239.

Jones, Terril. 2011. "Witness: Nostalgia for Mao Era Lives on 35 Years after His Death." Reuters,
September 8. https://www.reuters.com/article/us-china-mao-idUSTRE7872EY20110908.

Joseph, Andrew. 2020. "WHO Declares Coronavirus Outbreak a Global Health Emergency."
STAT (blog), January 30. https://www.statnews.com/2020/01/30/who-declares-coronavi
rus-outbreak-a-global-health-emergency/.

Jowitt, Kenneth. 1975. "Inclusion and Mobilization in European Leninist Regimes." *World Politics*
28, no. 1: 69–96.

Kahn, Joseph. 2006. "China Shuts Down Influential Weekly Newspaper in Crackdown on Media."
New York Times, January 25. https://www.nytimes.com/2006/01/25/world/asia/china-
shuts-down-influential-weekly-newspaper-in-crackdown-on.html.

Kahneman, Daniel. 2011. *Thinking, Fast and Slow*. New York: Farrar, Straus and Giroux.

Kalyvas, Stathis N. 1999. "The Decay and Breakdown of Communist One-Party Systems." *Annual
Review of Political Science* 2, no. 1: 323–43.

Kanter, Enes. 2018. "NBA Player Enes Kanter: Why Turkey's President Erdogan Banned Me from
Going Home." *Time*, September 11. https://time.com/5389792/enes-kanter-erdogan-
gulen/.

Kazer, William. 2013. "Getting a Different Reading from Chinese Tea Leaves at the Third Plenum."
Wall Street Journal (blog), November 20. https://blogs.wsj.com/chinarealtime/2013/11/
21/getting-a-different-reading-from-chinese-tea-leaves-at-the-third-plenum/.

Kelley, Judith G., and Beth A. Simmons. 2015. "Politics by Number: Indicators as Social Pressure
in International Relations." *American Journal of Political Science* 59, no. 1: 55–70.

Kennedy, John James, and Yaojiang Shi. 2019. *Lost and Found: The Missing Girls in Rural China*.
Oxford: Oxford University Press.

Kennedy, Scott. 2018. "The Beijing Playbook: Chinese Industrial Policy and Its Implications for
the United States." In *Meeting the China Challenge: Responding to China's Managed Economy*,
edited by James Andrew Lewis, 1–9. Washington, DC: Center for Strategic and International
Studies.

Kennedy, Scott, and Christopher K. Johnson. 2016. "Perfecting China, Inc." Center for Strategic
and International Studies. https://www.csis.org/analysis/perfecting-china-inc.

King, Gary, Jennifer Pan, and Margaret E. Roberts. 2013. "How Censorship in China Allows
Government Criticism but Silences Collective Expression." *American Political Science Review*
107, no. 2: 326–43.

King, Gary, Jennifer Pan, and Margaret E. Roberts. 2014. "Reverse-Engineering Censorship
in China: Randomized Experimentation and Participant Observation." *Science* 345, no.
6199: 1251722-1-10.

King, Gary, Jennifer Pan, and Margaret E. Roberts. 2017. "How the Chinese Government
Fabricates Social Media Posts for Strategic Distraction, Not Engaged Argument." *American
Political Science Review* 111, no. 3: 484–501.

Koesel, Karrie J. 2020. "Legitimacy, Resilience, and Political Education in Russia and
China: Learning to Be Loyal." In *Citizens and the State in Authoritarian Regimes: Comparing
China and Russia*, edited by Karrie J. Koesel, Val J. Bunce, and Jessica C. Weiss, 250–78.
New York: Oxford University Press.

Koetse, Manya. 2014. "Money, Money, Money: General Xu Caihou's House Filled with Cash and
Jade." *What's on Weibo* (blog), November 10. https://www.whatsonweibo.com/money-
money-money-general-xu-caihous-house-filled-with-cash-jade/.

Koetse, Manya. 2018. "CCTV Airs Program on Xinjiang's 'Vocational Training Centers': Criticism
and Weibo Responses." *What's on Weibo* (blog), October 19. https://www.whatsonwe
ibo.com/cctv-airs-program-on-xinjiangs-vocational-training-centers-criticism-weibo-
responses/.

Kostka, Genia. 2019. "China's Social Credit Systems and Public Opinion: Explaining High Levels of Approval." *New Media & Society* 21, no. 7: 1565–93.

Kotkin, Stephen. 2017. *Stalin: Waiting for Hitler, 1929–1941.* New York: Penguin Press.

Kou, Chien-wen, and Wen-Hsuan Tsai. 2014. "'Sprinting with Small Steps' towards Promotion: Solutions for the Age Dilemma in the CCP Cadre Appointment System." *China Journal* 71: 153–71.

Kroeber, Arthur. 2013. "Xi Jinping's Ambitious Agenda for Economic Reform in China." Brookings Institution (blog), November 17. https://www.brookings.edu/opinions/xi-jinpings-ambiti ous-agenda-for-economic-reform-in-china/.

Kumar, Komala. 2013. "Tocqueville in China." *Times Literary Supplement,* November 1. https:// www.the-tls.co.uk/articles/private/tocqueville-in-china/.

Kung, James Kai-Sing, and Shuo Chen. 2011. "The Tragedy of the Nomenklatura: Career Incentives and Political Radicalism during China's Great Leap Famine." *American Political Science Review* 105, no. 1: 27–45.

Kuo, Lily, and Jake M. Watts. 2013. "These Gilded Government Buildings Explain Exactly Why Beijing Is Banning New Ones. *Quartz,* July 25. http://qz.com/107661/three-gilded-gov ernment-buildings-that-explain-beijings-ban-on-office-construction/.

Kuran, Timur. 1991a. "The East European Revolution of 1989: Is It Surprising That We Were Surprised?" *American Economic Review* 81, no. 2: 121–5.

Kuran, Timur. 1991b. "Now Out of Never: The Element of Surprise in the East European Revolution of 1989." *World Politics* 44, no. 1: 7–48.

Kuran, Timur. 1995. *Private Truths, Public Lies: The Social Consequences of Preference Falsification.* Cambridge, MA: Harvard University Press.

Laitin, David D. 1986. *Hegemony and Culture Politics and Religious Change among the Yoruba.* Chicago: University of Chicago Press.

Lam, Tong. 2011. *A Passion for Facts: Social Surveys and the Construction of the Chinese Nation-State, 1900–1949.* Berkeley: University of California Press.

Lam, Willy. 2016. "Xi Jinping's Ideology and Statecraft." *Chinese Law & Government* 48, no. 6: 409–17.

Lampland, Martha, and Susan L. Star. 2009. *Standards and Their Stories: How Quantifying, Classifying, and Formalizing Practices Shape Everyday Life.* Ithaca, NY: Cornell University Press.

Landreth, Jonathan. 2016. "Xi Jinping: A Cult of Personality?" *ChinaFile,* March 4. https://www. chinafile.com/conversation/xi-jinping-cult-personality.

Landry, Pierre F. 2008. *Decentralized Authoritarianism in China: The Communist Party's Control of Local Elites in the Post-Mao Era.* Cambridge: Cambridge University Press.

Landry, Pierre F., Xiaobo Lü, and Haiyan Duan. 2018. "Does Performance Matter? Evaluating Political Selection along the Chinese Administrative Ladder." *Comparative Political Studies* 51, no. 8: 1074–105.

Langfitt, Frank. 2012. "After a Forced Abortion, a Roaring Debate in China." NPR, July 5. https:// www.npr.org/2012/07/05/156211106/after-a-forced-abortion-a-roaring-debate-in-china.

Lardy, Nicholas R. 2014. *Markets over Mao: The Rise of Private Business in China.* Washington, DC: Institute for International Economics.

Lau, Lawrence J., Yingyi Qian, and Gerald Roland. 2000. "Reform without Losers: An Interpretation of China's Dual-Track Approach to Transition." *Journal of Political Economy* 108, no. 1: 120–43.

Lee, Ching Kwan. 2007. *Against the Law: Labor Protests in China's Rustbelt and Sunbelt.* Berkeley: University of California Press.

Lee, Ching Kwan, and Yonghong Zhang. 2013. "The Power of Instability: Unraveling the Microfoundations of Bargained Authoritarianism in China." *American Journal of Sociology* 118, no. 6: 1475–508.

Lee, Hong Yung. 1991. *From Revolutionary Cadres to Party Technocrats in Socialist China.* Berkeley: University of California Press.

Lee, P. 2012. "Lies, Damned Lies and Statistics." University of York. https://www.york.ac.uk/depts/maths/histstat/lies.htm.

Leese, Daniel. 2011. *Mao Cult: Rhetoric and Ritual in China's Cultural Revolution.* Cambridge: Cambridge University Press.

Lei, Zhenhuan, and Junlong Aaron Zhou. 2022. "Private Returns to Public Investment: Political Career Incentives and Infrastructure Investment in China." *Journal of Politics* 84, no. 1: 455–69.

Leiserowitz, Anthony, Edward Maibach, Seth Rosenthal, John Kotcher, Jennifer Carman, Xiran Wang, Jennifer Marlon, Karine Lacroix, and Matthew Goldberg. 2021. "Climate Change in the American Mind, March 2021." Yale Program on Climate Change Communication. https://climatecommunication.yale.edu/publications/climate-change-in-the-american-mind-march-2021/.

Leng, Ning, and Cai (Vera) Zuo. 2022. "Tournament Style Bargaining within Boundaries: Setting Targets in China's Cadre Evaluation System." *Journal of Contemporary China* 31, no. 133: 116–35.

Leonard, Mark, ed. 2012. *China 3.0.* London: ECFR.

Leutert, Wendy. 2018a. "Firm Control: Governing the State-Owned Economy under Xi Jinping." *China Perspectives*, nos. 1–2: 27–36.

Leutert, Wendy. 2018b. "The Political Mobility of China's Central State-Owned Enterprise Leaders." *China Quarterly*, no. 233: 1–21.

Leutert, Wendy. 2021. "Innovation through Iteration: Policy Feedback Loops in China's Economic Reform." *World Development* 138: 105173-1-11.

Levin, Dan. 2013. "In China, Cinematic Flops Suggest Fading of an Icon." *New York Times*, March 11. https://www.nytimes.com/2013/03/12/world/asia/in-china-unpopular-films-suggest-fading-of-icon.html.

Levitsky, Steven R., and Lucan A. Way. 2010. *Competitive Authoritarianism: Hybrid Regimes after the Cold War.* New York: Cambridge University Press.

Levitsky, Steven R., and Lucan A. Way. 2012. "Beyond Patronage: Violent Struggle, Ruling Party Cohesion, and Authoritarian Durability." *Perspectives on Politics* 10, no. 4: 869–89.

Levitsky, Steven R., and Lucan A. Way. 2013. "The Durability of Revolutionary Regimes." *Journal of Democracy* 24, no. 3: 5–17.

Li Bin, Zhang Tao, and Qi Leijie. 2013. "大胆使用批评和自我批评有力武器." *Renmin Ribao*, September 27.

Li, Cheng. 2009. "Intra-Party Democracy in China: Should We Take It Seriously?" *China Leadership Monitor*, no. 30: 1–14.

Li, Cheng, and Lynn White. 1990. "Elite Transformation and Modern Change in Mainland China and Taiwan: Empirical Data and the Theory of Technocracy." *China Quarterly*, no. 121: 1–35.

Li, Choh-Ming. 1962a. *The Statistical System of Communist China.* Berkeley: University of California Press.

Li, Choh-Ming. 1962b. "Statistics and Planning at the Hsien Level in Communist China." *China Quarterly*, no. 9: 112–23.

Li, Hongbin, Junjian Yi, and Junsen Zhang. 2011. "Estimating the Effect of the One-Child Policy on the Sex Ratio Imbalance in China: Identification Based on the Difference-in-Differences." *Demography* 48, no. 4: 1535–57.

Li, Hongbin, and Li-An Zhou. 2005. "Political Turnover and Economic Performance: The Incentive Role of Personnel Control in China." *Journal of Public Economics* 89, nos. 9–10: 1743–62.

Li, Jun, and Joseph Cheng. 2012. "Cadre Performance Appraisal and Fabrication of Economic Achievement in Chinese Officialdom." In *China: A New Stage of Development for an Emerging Superpower*, edited by Joseph Cheng, 117–48. Hong Kong: City University of Hong Kong Press.

Li, Keqiang. 2020. "李克強：各地要實事求是公開透明發佈疫情信息，不得瞞報漏報_總理_中國政府網." Goverment of the People's Republic of China, March 4. http://big5.www.gov.cn/gate/big5/www.gov.cn/premier/2020-03/24/content_5494917.htm.

Li, Lianjiang, and Kevin O'Brien. 1996. "Villagers and Popular Protest in Contemporary China." *Modern China* 22, no. 1: 28–61.

Li, Raymond. 2012. "Six Politburo Standing Committee Members Are Not Technocrats." *South China Morning Post*, August 21. http://www.scmp.com/news/china/article/1086358/six-politburo-standing-committee-members-are-not-technocrats.

Li, Vic, and Graeme Lang. 2010. "China's 'Green GDP' Experiment and the Struggle for Ecological Modernisation." *Journal of Contemporary Asia* 40, no. 1: 44–62.

Li, Weidong. 2013. "李伟东：走不通的'红色帝国之路'." *Boxun* (blog), October 19. https://news.boxun.com/news/gb/pubvp/2013/10/201310190845.shtml.

Li, Zeren, and Melanie Manion. 2019. "The Impact of Political Purge on Political Decisionmaking: Political Selection under Extreme Uncertainty." SSRN Scholarly Paper. https://ssrn.com/abstract=3446354

Liang, Fan, Vishnupriya Das, Nadiya Kostyuk, and Muzammil M. Hussain. 2018. "Constructing a Data-Driven Society: China's Social Credit System as a State Surveillance Infrastructure." *Policy & Internet* 10, no. 4: 415–53.

Liang Xiaoqin (梁小琴) and Zhu Huiqing (朱慧卿). 2010. "四川不再下达GDP增长率指标." *Renmin Ribao*, September 21. http://data.people.com.cn/rmrb/20100921/7.

Lieberthal, Kenneth, and Michael Oksenberg. 1988. *Policy Making in China: Leaders, Structures, and Processes*. Princeton, NJ: Princeton University Press.

Lim, Benjamin Kang, and Ben Blanchard. 2014. "Exclusive: China Seizes $14.5 Billion Assets from Family." Reuters, March 30. https://www.reuters.com/article/us-china-corruption-zhou-idUSBREA2T02S20140330.

Lim, Louisa. 2011. "'Cake Theory' Opens Up China's Political Debate." NPR, November 6. https://www.npr.org/2011/11/06/142047654/cake-theory-has-chinese-eating-up-political-debate.

Lin Chun and Li Yinhe. 1978. "要大大发扬民主和加强法制." *People's Daily*, November 13. http://data.people.com.cn/rmrb/19781113/3.

Lin, Justin Yifu. 2012. "China's Potential for Sustained Dynamic Growth." In *China 3.0*, edited by Mark Leonard, 46–53. London: ECFR.

Lin, Liwen, and Curtis J. Milhaupt. 2013. "We Are the (National) Champions: Understanding the Mechanisms of State Capitalism in China." Hein Online. http://heinonlinebackup.com/hol-cgi-bin/get_pdf.cgi?handle=hein.journals/stflr65§ion=24.

Link, Perry. 1993. *Evening Chats in Beijing: Probing China's Predicament*. New York: W. W. Norton.

Link, Perry. 2002. "China: The Anaconda in the Chandelier." *New York Review of Books*, April 11. https://www.nybooks.com/articles/2002/04/11/china-the-anaconda-in-the-chandelier/.

Lipscy, Phillip. 2020. "We Need to Be Very Cautious about Attributing Variation in COVID Intensity to Government Policy, Social Practices, Culture, Etc. We Just Don't Have a Good Sense Yet about What Other Factors Need to Be Controlled for. (1)." *Tweet*. @PhillipLipscy (blog), April 21. https://twitter.com/PhillipLipscy/status/1252620763242299392.

Little, Andrew T. 2017. "Propaganda and Credulity." *Games and Economic Behavior* 102: 224–32.

Little, Andrew T. 2012. "Elections, Fraud, and Election Monitoring in the Shadow of Revolution." *Quarterly Journal of Political Science* 7, no. 3: 249–83.

Liu, Andrew B. 2020. *Tea War: A History of Capitalism in China and India*. New Haven, CT: Yale University Press.

Liu, Derek Tai-wei. 2018. "The Effects of Institutionalization in China: A Difference-in-Differences Analysis of the Mandatory Retirement Age." *China Economic Review* 52: 192–203.

Liu, Hongjie, and Wenping Li. 2011. "打造公益频道不是重庆的独创." 齐鲁晚报, March 5. https://epaper.qlwb.com.cn/html/2011-03/05/content_92296.htm?div=-1.

Liu, Mingxing, Victor Shih, and Dong Zhang. 2018. "The Fall of the Old Guards: Explaining Decentralization in China." *Studies in Comparative International Development* 53, no. 4: 379–403.

Liu, Xin. 2016. "8-Part Documentary Features Corrupt Officials' Confessions." *Global Times,* October 19. https://www.globaltimes.cn/content/1012244.shtml.

Liu Xinyan (刘鑫焱). 2007. "三江源：不考核GDP，考什么？（调查.真实引发思考）." *Renmin Ribao,* November 20. http://data.people.com.cn/rmrb/20071120/10.

Liu, Ying, Albert A. Gayle, Annelies Wilder-Smith, and Joacim Rocklöv. 2020. "The Reproductive Number of COVID-19 Is Higher Compared to SARS Coronavirus." *Journal of Travel Medicine* 27, no. 2: 1–4.

Lorentzen, Peter. 2013. "Regularizing Rioting: Permitting Public Protest in an Authoritarian Regime." *Quarterly Journal of Political Science* 8, no. 2: 127–58.

Lorentzen, Peter. 2014. "China's Strategic Censorship." *American Journal of Political Science* 58, no. 2: 402–14.

Lorentzen, Peter. 2017. "Designing Contentious Politics in Post-1989 China." *Modern China* 43, no. 5: 459–93

Lorentzen, Peter, Pierre Landry, and John Yasuda. 2014. "Undermining Authoritarian Innovation: The Power of China's Industrial Giants." *Journal of Politics,* 76, no. 1: 182–94.

Löwenheim, Oded. 2008. "Examining the State: A Foucauldian Perspective on International 'Governance Indicators.'" *Third World Quarterly* 29, no. 2 (February 1): 255–74.

Lu, Xi, and Peter L. Lorentzen. 2016. "Rescuing Autocracy from Itself: China's Anti-Corruption Campaign." SSRN Scholarly Paper. Rochester, NY: Social Science Research Network.

Lü, Xiaobo, and Pierre Landry. 2014. "Show Me the Money: Interjurisdiction Political Competition and Fiscal Extraction in China." *American Political Science Review* 108, no. 3: 706–22.

Lu, Yinqiu, and Tao Sun. 2013. "Local Government Financing Platforms in China: A Fortune or Misfortune?" IMF Working Paper. Washington, DC: International Monetary Fund.

Luo, Wangshu. 2015. "Public Employees Get Salary Increase." *China Daily,* January 20. http://www.chinadaily.com.cn/china/2015-01/20/content_19353528.htm.

Lynch, Daniel C. 1999. *After the Propaganda State: Media, Politics, and "Thought Work" in Reformed China.* Stanford, CA: Stanford University Press.

Ma, Shiqi, and Jeremy L. Wallace. 2022. "Cities for Whom? The 2017 Beijing Demolitions in Context." In *China Urbanizing,* edited by Weiping Wu and Qin Gao, 38–60. Philadelphia: University of Pennsylvania Press.

Machiavelli, Niccolò. (1513) 2005. *The Prince: With Related Documents.* Translated by William J. Connell. Bedford Series in History and Culture. Boston: Bedford/St. Martin's.

Magaloni, Beatriz. 2006. *Voting for Autocracy: Hegemonic Party Survival and Its Demise in Mexico.* New York: Cambridge University Press.

Magee, Christopher S. P., and John A. Doces. 2014. "Reconsidering Regime Type and Growth: Lies, Dictatorships, and Statistics." *International Studies Quarterly* 59, no. 2: 223–37.

Mahler, Jonathan, and Jim Rutenberg. 2019. "How Rupert Murdoch's Empire of Influence Remade the World." *New York Times,* April 3. https://www.nytimes.com/interactive/2019/04/03/magazine/rupert-murdoch-fox-news-trump.html.

Malesky, Edmund, and Jonathan London. 2014. "The Political Economy of Development in China and Vietnam." *Annual Review of Political Science* 17, no. 1: 395–419.

Mamudi, Sam. 2018. "Lehman Folds with Record $613 Billion Debt." *MarketWatch,* September 15. http://www.marketwatch.com/story/lehman-folds-with-record-613-billion-debt.

Manion, Melanie. 1985. "The Cadre Management System, Post-Mao." *China Quarterly,* no. 102: 203–33.

Manion, Melanie. 1993. *Retirement of Revolutionaries in China: Public Policies, Social Norms, Private Interests.* Princeton, NJ: Princeton University Press.

Manion, Melanie. 2004. *Corruption by Design: Building Clean Government in Mainland China and Hong Kong.* Cambridge, MA: Harvard University Press.

Manion, Melanie. 2016. *Information for Autocrats: Representation in Chinese Local Congresses.* Cambridge: Cambridge University Press.

Margalit, Yotam. 2011. "Costly Jobs: Trade-Related Layoffs, Government Compensation, and Voting in U.S. Elections." *American Political Science Review* 105, no. 1: 166–88.

Markovits, Daniel. 2019. *The Meritocracy Trap: How America's Foundational Myth Feeds Inequality, Dismantles the Middle Class, and Devours the Elite.* New York: Penguin Press.

Marquez, Xavier. 2012. "'Ten Thousand Melodies Cannot Express Our Boundless Hot Love for You': The Cult of Personality in Mao's China." Abandoned Footnotes, October 26. http://abandonedfootnotes.blogspot.com/2012/10/ten-thousand-melodies-cannot-express.html.

Marquez, Xavier. 2016a. "The Irrelevance of Legitimacy." *Political Studies* 64, no. 1 suppl.: 19–34.

Marquez, Xavier. 2016b. *Non-Democratic Politics: Authoritarianism, Dictatorship and Democratization.* London: Palgrave.

Mass Line Leading Small Group. 2013. "中共中央关于在全党深入开展党的群众路线教育实践活动的意见." 中央党的群众路线教育实践活动领导小组办公室. http://qzlx.people.com.cn/n/2013/0930/c365007-23090188.html.

May, Tiffany. 2021. "A 'Masculinity Crisis'? China Says the Boys Are Not All Right." *New York Times*, February 5. https://www.nytimes.com/2021/02/05/world/asia/china-masculinity-schoolboys.html.

Mayer, Jane. 2016. *Dark Money: The Hidden History of the Billionaires behind the Rise of the Radical Right.* New York: Doubleday.

McCubbins, Mathew D., and Thomas Schwartz. 1984. "Congressional Oversight Overlooked: Police Patrols versus Fire Alarms." *American Journal of Political Science* 28, no. 1: 165–79.

McGregor, Richard. 2019. *Xi Jinping: The Backlash.* Docklands, Australia: Penguin.

McNeil, Donald G. 2020. "Inside China's All-Out War on the Coronavirus." *New York Times*, March 4. https://www.nytimes.com/2020/03/04/health/coronavirus-china-aylward.html.

McNicol, Andrew. 2017. "How the NBA Became the Most Popular Sports League in China." *South China Morning Post*, September 27. https://www.scmp.com/sport/china/article/2112972/how-nba-became-chinas-most-popular-sports-league-boost-tech-giants-such.

Mearsheimer, John J. 2011. *Why Leaders Lie: The Truth about Lying in International Politics.* New York: Oxford University Press.

Mei, Ciqi, and Margaret M. Pearson. 2014. "Killing a Chicken to Scare the Monkeys? Deterrence Failure and Local Defiance In China." *China Journal* 72: 75–97.

Mei, Ciqi, and Margaret M. Pearson. 2017. "The Dilemma of 'Managing for Results' in China: Won't Let Go." *Public Administration and Development* 37, no. 3: 203–16.

Mei, Xiao. 2013. "The Banality of Singing Red: Secondary Production of Everyday Life in Chongqing's Red Culture Campaign." *China Perspectives* 4: 59–65.

Meng, Angela. 2014. "Gold, Liquor, and Houses: New Details Emerge of Disgraced General Gu Junshan's Graft Loot." *South China Morning Post*, January 15. http://www.scmp.com/news/china/article/1406027/new-details-emerge-disgraced-general-gu-junshans-graft-loot.

Meng, Anne. 2020. *Constraining Dictatorship: From Personalized Rule to Institutionalized Regimes.* Cambridge: Cambridge University Press.

Mennicken, Andrea, and Wendy Nelson Espeland. 2019. "What's New with Numbers? Sociological Approaches to the Study of Quantification." *Annual Review of Sociology* 45, no. 1: 223–45.

Merry, Sally E. 2011. "Measuring the World: Indicators, Human Rights, and Global Governance: With CA comment by John M. Conley." *Current Anthropology* 52, no. S3: S83–S95.

Merry, Sally E. 2016. *The Seductions of Quantification: Measuring Human Rights, Gender Violence, and Sex Trafficking.* Chicago: University of Chicago Press.

Mertha, Andrew C. 2005. "China's Soft Centralization: Shifting Tiao/Kuai Authority Relations." *China Quarterly*, no. 184: 791–810.

Mertha, Andrew C. 2009. "'Fragmented Authoritarianism 2.0': Political Pluralization in the Chinese Policy Process." *China Quarterly*, no. 200: 995–1012.

Mertha, Andrew C. 2017. "'Stressing Out': Cadre Calibration and Affective Proximity to the CCP in Reform-Era China." *China Quarterly*, no. 229: 64–85.

Milanovic, Branko. 2020. "Is the Pandemic China's Sputnik Moment?" *Foreign Affairs*, May 13. https://www.foreignaffairs.com/articles/united-states/2020-05-12/pandemic-chinas-sput nik-moment.

Miller, Gary J. 1992. *Managerial Dilemmas: The Political Economy of Hierarchy*. Cambridge: Cambridge University Press.

Miller, Tom. 2012. *China's Urban Billion: The Story behind the Biggest Migration in Human History*. London: Zed Books.

Millward, James A. 2009. "Introduction: Does the 2009 Urumchi Violence Mark a Turning Point?" *Central Asian Survey* 28, no. 4: 347–60.

Ming, Ruan. 1994. *Deng Xiaoping: Chronicle of an Empire*. Translated by Nancy Liu, Peter Rand, and Lawrence R. Sullivan. Boulder, CO: Westview Press.

Minzner, Carl F. 2006. "Xinfang: An Alternative to Formal Chinese Legal Institutions." *Stanford Journal of International Law* 42, no. 1: 103–80.

Minzner, Carl. 2009. "Riots and Cover-Ups: Counterproductive Control of Local Agents in China." *University of Pennsylvania Journal of International Law* 31. http://papers.ssrn.com/sol3/papers.cfm?abstract_id=1502943.

Minzner, Carl. 2014. "China Is Again Slowly Turning In on Itself." *Los Angeles Times*, October 18. http://www.latimes.com/opinion/op-ed/la-oe-1019-minzner-end-of-china-reform-20141 019-story.html#page=1.

Minzner, Carl. 2020. "Opinion: Quarantine the Sick in New York's Hotels." *New York Times*, March 30. https://www.nytimes.com/2020/03/30/opinion/coronavirus-new-york-qua rantine.html.

Mitchell, Tom. 2020. "What Xi Knew: Pressure Builds on China's Leader." *Financial Times*, May 21. https://www.ft.com/content/3a294233-6983-428c-b74b-3cc58c713eb8.

Mitchell, Tom, Christian Shepherd, Robin Harding, and John Reed. 2020. "China's Xi Jinping Knew of Coronavirus Earlier Than First Thought." *Financial Times*, February 16. https://www.ft.com/content/3da73290-5067-11ea-8841-482eed0038b1.

Mitchell, Tom, and Gabriel Wildau. 2017. "World Bank Warns of China Debt Risk from Backdoor Local Borrowing." *Financial Times*, May 7. https://www.ft.com/content/799a1afa-3135-11e7-9555-23ef563ecf9a.

Montinola, Gabriella, Yingyi Qian, and Barry R. Weingast. 1995. "Federalism, Chinese Style: The Political Basis for Economic Success in China." *World Politics* 48, no. 1: 50–81.

Myers, Steven Lee, Keith Bradsher, and Chris Buckley. 2021. "As China Boomed, It Didn't Take Climate Change into Account. Now It Must." *New York Times*, July 26. https://www.nytimes.com/2021/07/26/world/asia/china-climate-change.html.

Nathan, Andrew J. 1973. "A Factionalism Model for CCP Politics." *China Quarterly*, no. 53: 34–66.

Nathan, Andrew J. 2016. "Who Is Xi?" *New York Review of Books*, May 12. https://www.nybooks.com/articles/2016/05/12/who-is-xi/.

National Audit Office. 2011. "全国地方政府性债务审计结果." http://www.gov.cn/zwgk/2011-06/27/content_1893782.htm.

National People's Congress. 2018. "中华人民共和国监察法." http://www.npc.gov.cn/npc/xin wen/2018-03/21/content_2052362.htm.

Naughton, Barry. 1993. "Deng Xiaoping: The Economist." *China Quarterly*, no. 135: 491–514.

Naughton, Barry. 1995. *Growing Out of the Plan: Chinese Economic Reform, 1978–1993*. Cambridge: Cambridge University Press.

Naughton, Barry. 2007. *The Chinese Economy*. Cambridge, MA: MIT Press.

Naughton, Barry. 2008. "A New Team Faces Unprecedented Economic Challenges." *China Leadership Monitor* 26. http://www.hoover.org/publications/clm/issues/27770769.html.

Naughton, Barry. 2009a. "China's Emergence from Economic Crisis." *China Leadership Monitor* 29. http://www.hoover.org/publications/clm/issues/52971317.html.

Naughton, Barry. 2009b. "Loans, Firms, and Steel: Is the State Advancing at the Expense of the Private Sector?" *China Leadership Monitor*, no. 30: 1–10.

Naughton, Barry. 2009c. "The Scramble to Maintain Growth." *China Leadership Monitor*, no. 27: 1–11. http://www.hoover.org/publications/clm/issues/70535412.html.

Naughton, Barry. 2009d. "Understanding the Chinese Stimulus Package." *China Leadership Monitor*, no. 28: 1–12. http://www.hoover.org/publications/clm/issues/44613157.html.

Naughton, Barry. 2010. "Reading the NPC: Post-Crisis Economic Dilemmas of the Chinese Leadership." *China Leadership Monitor*, no. 32: 1–10.

Naughton, Barry. 2012. "China's Response to the Global Crisis, and the Lessons Learned." In *The Global Recession and China's Political Economy*, edited by Dali L. Yang, 15–32. New York: Palgrave Macmillan.

Naughton, Barry. 2014. "After the Third Plenum: Economic Reform Revival Moves toward Implementation." *China Leadership Monitor*, no. 43: 1–14. http://www.hoover.org/resea rch/after-third-plenum-economic-reform-revival-moves-toward-implementation.

Naughton, Barry, and Dali Yang, eds. 2004. *Holding China Together: Diversity and National Integration in the Post-Deng Era*. Cambridge: Cambridge University Press.

NBS. 2010a. "中国统计与时俱进成就辉煌——写在首个'世界统计日'到来之际." October 22. http://www.stats.gov.cn/ztjc/zthd/sjtjr/zgtjfz/201010/t20101022_71159.htm.

NBS. 2010b. 新中国六十年统计资料汇编. Beijing Shi: Zhongguo tong ji chu ban she.

NBS. Various years. *China Labour Statistical Yearbook*. Beijing: China Statistics Press.

NBS. Various years. *China Statistical Yearbook*. Beijing: China Statistics Press.

NDRC. 2007. "东北地区振兴规划." http://www.gov.cn/gzdt/2007-08/20/content_721 632.htm.

Neblo, Michael A., and Jeremy L. Wallace. 2021. "A Plague on Politics? The COVID Crisis, Expertise, and the Future of Legitimation." *American Political Science Review* 115, no. 4: 1524–9.

Nee, Victor. 1989. "A Theory of Market Transition: From Redistribution to Markets in State Socialism." *American Sociological Review* 54, no. 5: 663–81.

Neveling, Patrick. 2017. "The Global Spread of Export Processing Zones, and the 1970s as a Decade of Consolidation." In *Contesting Deregulation: Debates, Practices and Developments in the West since the 1970s*, edited by Knud Andresen and Stefan Müller, 23–40. New York: Berghahn Books.

Nordhaus, William D. 1975. "The Political Business Cycle." *Review of Economic Studies* 42, no. 2: 169–90.

Normile, Dennis. 2020. "'Suppress and Lift': Hong Kong and Singapore Say They Have a Coronavirus Strategy That Works." *Science*, April 13. https://www.sciencemag.org/news/ 2020/04/suppress-and-lift-hong-kong-and-singapore-say-they-have-coronavirus-strat egy-works.

New York Times. 1979a. "China Backs Poster as Citizens' Forum; Party Says 'Heavens Will Not Fall' If Variety of Views Is Allowed." January 4. https://www.nytimes.com/1979/01/04/ archives/china-backs-poster-as-citizens-forum-party-says-heavens-will-not.html.

New York Times. 1979b. "Marchers in Peking Demand Democracy; Thousands Demonstrate in Square as Others Praise Chou on 3d Anniversary of His Death." January 9. https://www. nytimes.com/1979/01/09/archives/marchers-in-peking-demand-democracy-thousands- demonstrate-in-square.html.

O'Brien, Kevin J. 1996. "Rightful Resistance." *World Politics* 49, no. 1: 31–55.

O'Brien, Kevin J., and Lianjiang Li. 1999. "Selective Policy Implementation in Rural China." *Comparative Politics* 31, no. 2: 167.

O'Brien, Kevin J., and Lianjiang Li. 2006. *Rightful Resistance in Rural China*. Cambridge: Cambridge University Press.

O'Brien, Matt. 2016. "What's Really Important about China's Stock Market Disaster, and What's Not." *Washington Post*, January 7. https://www.washingtonpost.com/news/wonk/wp/2016/01/07/whats-really-important-about-chinas-stock-market-disaster-and-whats-not/.

O'Donnell, Guillermo, and Phillippe Schmitter. 1986. *Transitions from Authoritarian Rule.* Baltimore, MD: Johns Hopkins University Press.

O'Neill, Mark. 2011. "The Story of an Army Commander Who Disobeyed Deng." *South China Morning Post*, March 13. https://www.scmp.com/article/740799/story-army-commander-who-disobeyed-deng.

ODNI. 2021. "Unclassified Summary of Assessment on COVID-19 Origins." https://www.dni.gov/files/ODNI/documents/assessments/Unclassified-Summary-of-Assessment-on-COVID-19-Origins.pdf.

OECD. 2020. *OECD Economic Outlook, Volume 2020 Issue 2: Preliminary Version.* Vol. 108. Paris: OECD Publishing.

Oi, Jean C. 1989a. "Market Reforms and Corruption in Rural China." *Studies in Comparative Communism* 22, nos. 2–3: 221–33.

Oi, Jean C. 1989b. *State and Peasant in Contemporary China: The Political Economy of Village Government.* Berkeley: University of California Press.

Oi, Jean C. 1999. *Rural China Takes Off: Institutional Foundations of Economic Reform.* Berkeley: University of California Press.

Oliver, Steven. 2014. "The Politics of Poor Air Quality in Contemporary China." PhD dissertation, University of California, San Diego.

Ong, Lynette H. 2012. *Prosper or Perish: Credit and Fiscal Systems in Rural China.* Ithaca, NY: Cornell University Press.

Orlik, Thomas. 2011. *Understanding China's Economic Indicators: Translating the Data into Investment Opportunities.* Upper Saddle River, NJ: FT Press.

Orlik, Thomas. 2020. *China: The Bubble That Never Pops.* New York: Oxford University Press.

Osnos, Evan. 2012. "Boss Rail." *The New Yorker*, October 15. https://www.newyorker.com/magazine/2012/10/22/boss-rail.

Osnos, Evan. 2013. "Solzhenitsyn, Yao Chen, and Chinese Reform." *The New Yorker* (blog), January 8. https://www.newyorker.com/news/evan-osnos/solzhenitsyn-yao-chen-and-chinese-reform.

Osnos, Evan. 2014. "Abortion and Politics in China." *The New Yorker*, June 15. http://www.newyorker.com/news/evan-osnos/abortion-and-politics-in-china.

Page, Jeremy, Brian Spegele, and Wayne Ma. 2013. "Powerful Oil Clique at Center of Chinese Probes." *Wall Street Journal*, September 5. http://online.wsj.com/articles/SB10001424127887323623304579056883184524514.

Pan, Jennifer. 2020. *Welfare for Autocrats: How Social Assistance in China Cares for Its Rulers.* New York: Oxford University Press.

Pan, Jennifer, and Kaiping Chen. 2018. "Concealing Corruption: How Chinese Officials Distort Upward Reporting of Online Grievances." *American Political Science Review* 112, no. 3: 602–20.

Pang, Baoqing, Shu Keng, and Lingna Zhong. 2018. "Sprinting with Small Steps: China's Cadre Management and Authoritarian Resilience." *China Journal* 80, no. 1: 68–93.

Pantsov, Alexander V., and Steven I. Levine. 2015. *Deng Xiaoping: A Revolutionary Life.* Oxford: Oxford University Press.

Park, Albert, Scott Rozelle, Christine Wong, and Changqing Ren. 1996. "Distributional Consequences of Reforming Local Public Finance in China." *China Quarterly* 147, no. 1: 751–78.

Patty, John W., and Roberto A. Weber. 2007. "Letting the Good Times Roll: A Theory of Voter Inference and Experimental Evidence." *Public Choice* 130, nos. 3–4: 293–310.

Paul. "Chinese Mourning Mao Zedong's Death in 1976." 2011. *ChinaSMACK*, December 21. http://www.chinasmack.com/2011/pictures/chinese-mourning-mao-zedongs-death-in-1976.html.

Paul, Christopher, and Miriam Matthews. 2016. "The Russian 'Firehose of Falsehood' Propaganda Model." Perspectives. RAND Corporation. https://www.rand.org/content/dam/rand/pubs/perspectives/PE100/PE198/RAND_PE198.pdf.

Pearlman, Wendy. 2013. "Emotions and the Microfoundations of the Arab Uprisings." *Perspectives on Politics* 11, no. 2: 387–409.

Pence, Mike. 2018. "Remarks by Vice President Pence on the Administration's Policy Toward China." The White House, October 4. https://trumpwhitehouse.archives.gov/briefings-statements/remarks-vice-president-pence-administrations-policy-toward-china/.

People's Daily. 2009. "Chen Xiwen: Financial Crisis Claims Jobs and Sends about 20 Million Migrant Workers Home." February 3. http://english.peopledaily.com.cn/90001/90776/90882/6584511.html.

People's Republic of China. 1978. Constitution. USC Annenberg. https://china.usc.edu/1978-constitution-peoples-republic-china.

Pepinsky, Thomas B. 2014. "The Institutional Turn in Comparative Authoritarianism." *British Journal of Political Science* 44, no. 3: 631–53.

Pepinsky, Thomas B. 2018. "Malaysia's Anti-Fake News Bill." *Tom Pepinsky* (blog), March 26. https://tompepinsky.com/2018/03/26/malaysias-anti-fake-news-bill/

Pepinsky, Thomas B. 2019. "How Dictatorships Work: Power, Personalization, and Collapse." *Perspectives on Politics: Cambridge* 17, no. 2: 594–95.

Pepinsky, Thomas B., and Jeremy L. Wallace. 2016. "Hard Landings and Political Change in Nondemocracies." Unpublished manuscript.

Perry, Elizabeth J. 1993. "China in 1992: An Experiment in Neo-Authoritarianism." *Asian Survey* 33, no. 1: 12–21.

Piketty, Thomas, Li Yang, and Gabriel Zucman. 2019. "Capital Accumulation, Private Property, and Rising Inequality in China, 1978–2015." *American Economic Review* 109, no. 7: 2469–96.

Policzer, Pablo. 2009. *The Rise and Fall of Repression in Chile*. Notre Dame, IN: University of Notre Dame Press.

Pomerantsev, Peter. 2014. *Nothing Is True and Everything Is Possible: The Surreal Heart of the New Russia*. New York: PublicAffairs.

Pomfret, James. 2009. "Ethnic Tensions Spark Brawl at China Factory-Report." Reuters, June 27. http://www.reuters.com/article/2009/06/27/idUSHKG364598.

Poovey, Mary. 1998. *A History of the Modern Fact: Problems of Knowledge in the Sciences of Wealth and Society*. Chicago: University of Chicago Press.

Porter, Theodore M. 1995. *Trust in Numbers: The Pursuit of Objectivity in Science and Public Life*. Princeton, NJ: Princeton University Press.

Prasad, Monica. 2006. *The Politics of Free Markets: The Rise of Neoliberal Economic Policies in Britain, France, Germany, and the United States*. Chicago: University of Chicago Press.

Qiao Shi. 1990. "乔石同志关于依法审计和加强内部审计，社会审计问题的指示"(1988). In 党政领导谈审计, edited by Jianmin Cui and Boqi Shao. Beijing: China Audit Press.

Qin, Amy. 2020. "China Raises Coronavirus Death Toll by 50% in Wuhan." *New York Times*, April 17. https://www.nytimes.com/2020/04/17/world/asia/china-wuhan-coronavirus-death-toll.html.

Qiu, Jane. 2007. "China's Green Accounting System on Shaky Ground." *Nature* 448, no. 2: 518–9.

Quinlivan, James T. 1999. "Coup-Proofing: Its Practice and Consequences in the Middle East." International Security 24, no. 2: 131–65.

Rajagopalan, Megha. 2017. "This Is What a 21st-Century Police State Really Looks Like." *BuzzFeed*, October 19. https://www.buzzfeed.com/meghara/the-police-state-of-the-future-is-already-here.

Ranger, Terence O., and Eric J. Hobsbawm. 1983. *The Invention of Tradition*. Cambridge: Cambridge University Press.

Rasul, Imran, and Daniel Rogger. 2018. "Management of Bureaucrats and Public Service Delivery: Evidence from the Nigerian Civil Service." *Economic Journal* 128, no. 608: 413–46.

Rauch, Jason N., and Ying F. Chi. 2010. "The Plight of Green GDP in China." *Consilience* 3, no. 1: 102–16.

Ren Guojun. 1989. "中国社会主义四十年." *Renmin Ribao,* September 19. http://data.people. com.cn/rmrb/19890919/1.

Renmin Ribao. 1978a. "华主席和党中央、中央军委领导同志再次出席全军政工会议邓副主席精辟阐述毛主席实事求是光辉思想." June 3. http://data.people.com.cn/rmrb/ 19780603/1.

Renmin Ribao. 1978b. "实践是检验真理的唯一标准（特约评论）." May 12. http://data.peo ple.com.cn/rmrb/19780512/2.

Renmin Ribao. 1978c. "中共北京市委宣布天安门事件完全是革命行动." November 16. http://data.people.com.cn/rmrb/19781116/1/.

Renmin Ribao. 1979. "加强法制　发扬民主　促进四化." July 5. http://data.people.com.cn/ rmrb/19790705/1/.

Renmin Ribao. 1989. "改革开放的总方针不会改变（社论）." September 22. http://data.peo ple.com.cn/rmrb/19890922/1/.

Reuter, Ora John, and David Szakonyi. 2019. "Elite Defection under Autocracy: Evidence from Russia." *American Political Science Review* 113, no. 2: 552–68.

Reuters. 2014. "Beijing-Hebei-Tianjin Integration to Challenge Local Leaders' Power. *South China Morning Post,* July 23. http://www.scmp.com/business/china-business/article/1557443/ beijing-hebei-tianjin-integration-challenge-local-leaders.

Riker, William H. 1980. "Implications from the Disequilibrium of Majority Rule for the Study of Institutions." *American Political Science Review* 74, no. 2: 432–46.

Rithmire, Meg E. 2015. *Land Bargains and Chinese Capitalism: The Politics of Property Rights under Reform.* Cambridge: Cambridge University Press.

Roach, Stephen S., and Weijian Shan. 2020. "The Fable of the Chinese Whistleblower." Project Syndicate, May 18. https://www.project-syndicate.org/commentary/trump-charges-agai nst-china-covid19-alternative-facts-by-stephen-s-roach-and-weijian-shan-2020-05.

Roberts, Margaret E. 2018. *Censored: Distraction and Diversion inside China's Great Firewall.* Princeton, NJ: Princeton University Press.

Robertson, Graeme B. 2011. *The Politics of Protest in Hybrid Regimes: Managing Dissent in Post-Communist Russia.* New York: Cambridge University Press.

Robinson, James A. 2006. "Economic Development and Democracy." *Annual Review of Political Science* 9, no. 1: 503–27.

Roche, Bernard. 2011. "The French Nuclear Program : EDF's Experience." Electricité de France. http://apw.ee.pw.edu.pl/tresc/-eng/08-FrenchNucleamProgram.pdf.

Rodrik, Dani. 2014. "When Ideas Trump Interests: Preferences, Worldviews, and Policy Innovations." *Journal of Economic Perspectives* 28, no. 1: 189–208.

Roeder, Philip G. 1993. *Red Sunset: The Failure of Soviet Politics.* Princeton, NJ: Princeton University Press.

Rosen, Daniel H., and Beibei Bao. 2015. *Broken Abacus? A More Accurate Gauge of China's Economy.* Washington, DC: Center for Strategic & International Studies.

Rosen, Stanley. 1989. "Public Opinion and Reform in the People's Republic of China." *Studies in Comparative Communism* 22, no. 2: 153–70.

Rosen, Stanley. 1995. "Women and Political Participation in China." *Pacific Affairs* 68, no. 3: 315–41.

Rostan, Tim. 2020. "Trump on Allowing Grand Princess Cruise Passengers to Disembark: 'I'd Rather Have Them Stay on, Personally.'" *MarketWatch,* March 9. https://www.marketwatch. com/story/trump-on-allowing-grand-princess-cruise-passengers-to-disembark-id-rather-have-them-stay-on-personally-2020-03-07.

Rothman, Joshua. 2018. "Are Things Getting Better or Worse?" *New Yorker,* July 16. https://www. newyorker.com/magazine/2018/07/23/are-things-getting-better-or-worse.

Rousseau, Jean-Jacques. (1762) 1893. *The Social Contract: Or, The Principles of Political Rights.* Translated by Rose M. Harrington. New York: G. P. Putnam's Sons.

Roxburgh, Helen. 2018. "China's Radical Plan to Limit the Populations of Beijing and Shanghai." *The Guardian*, March 19. https://www.theguardian.com/cities/2018/mar/19/plan-big-city-disease-populations-fall-beijing-shanghai.

Rozenas, Arturas, and Denis Stukal. 2019. "How Autocrats Manipulate Economic News: Evidence from Russia's State-Controlled Television." *Journal of Politics* 81, no. 3: 982–96.

Salidjanova, Nargiza, and Iacob Koch-Weser. 2013. "Third Plenum Economic Reform Proposals— A Scorecard." USCC. https://www.uscc.gov/sites/default/files/Research/Backgrounder_Third%20Plenum%20Economic%20Reform%20Proposals--A%20Scorecard%20(2).pdf.

Sandel, Michael J. 2020. *The Tyranny of Merit: What's Become of the Common Good?* New York: Farrar, Straus and Giroux.

Sanderson, Helen. 2013. "China Slowdown Brings Ordos Bust as Li Grapples with Credit." *Bloomberg*, July 16. http://www.bloomberg.com/news/2013-07-15/china-slowdown-sends-ordos-to-bust-as-li-grapples-with-credit.html.

Sanger, David E., and Nicole Perlroth. 2014. "U.S. Said to Find North Korea Ordered Cyberattack on Sony." *New York Times*, December 17. https://www.nytimes.com/2014/12/18/world/asia/us-links-north-korea-to-sony-hacking.html.

Sautman, Barry. 1992. "Sirens of the Strongman: Neo-Authoritarianism in Recent Chinese Political Theory." *China Quarterly*, no. 129: 72–102.

Schedler, Andreas, and Bert Hoffmann. 2016. "Communicating Authoritarian Elite Cohesion." *Democratization* 23, no. 1: 93–117.

Schedler, Andreas. 2013. *Politics of Uncertainty: Sustaining and Subverting Electoral Authoritarianism*. Oxford: Oxford University Press.

Schell, Orville, and John Delury. 2013. *Wealth and Power: China's Long March to the Twenty-First Century*. New York: Random House.

Schoenhals, Michael. 1991. "The 1978 Truth Criterion Controversy." *China Quarterly*, no. 126: 243–68.

Schram, Stuart R. 1984. " 'Economics in Command?' Ideology and Policy since the Third Plenum, 1978–84." *China Quarterly*, no. 99: 417–61.

Schurmann, Franz. 1966. *Ideology and Organization in Communist China*. Berkeley: University of California Press.

Scott, James C. 1998. *Seeing Like a State: How Certain Schemes to Improve the Human Condition Have Failed*. New Haven, CT: Yale University Press.

SEPA. 2004. "关于征集开展绿色GDP核算和环境污染经济损失调查工作试点省市的通知." October 20. http://www.mep.gov.cn/gkml/zj/bgth/200910/t20091022_174136.htm.

Shanghai Stocks News. 2007. "绿色GDP核算小组称有些省份GDP实际零增长." August 3. http://www.china.com.cn/news/txt/2007-08/03/content_8625660.htm.

Shapiro, Susan P. 2005. "Agency Theory." *Annual Review of Sociology*, no. 31: 263–84.

Shen, Dingli. 2014. "With Xi's New Power Is Collective Leadership Over?" East Asia Forum, October 19. http://www.eastasiaforum.org/2014/10/19/with-xis-new-power-is-collective-leadership-over/.

Shepherd, Christian. 2019. "At a Top Chinese University, Activist 'Confessions' Strike Fear into Students." Reuters, January 21. https://www.reuters.com/article/us-china-rights-confessions-idUSKCN1PF0RR.

Shi Delian (石德连) and Liu Jianchu (刘见初). 1978. "对先进不护短 着重批和帮湖南省委帮助安乡县委从虚报粮食产量的错误中分清路线是非，吸取经验教训，清除"四人帮"的流毒，恢复和发扬党的优良传统和作风." *Renmin Ribao*, July 17. http://data.people.com.cn/rmrb/19780717/1.

Shi, Weiyi. 2020. "Delegation, Subsidization, and Control: A State-Driven Model of China's Outbound Investment." Paper presented at American Political Science Association Annual Meeting.

Shih, Gerry. 2019. " 'If I Disappear': Chinese Students Make Farewell Messages amid Crackdowns over Labor Activism." *Washington Post*, May 25. https://www.washingtonpost.com/world/

asia_pacific/if-i-disappear-chinese-students-make-farewell-messages-amid-crackdowns-over-labor-activism-/2019/05/25/6fc949c0-727d-11e9-9331-30bc5836f48e_story.html.

Shih, Victor C. 2009. *Factions and Finance in China: Elite Conflict and Inflation.* Cambridge: Cambridge University Press.

Shih, Victor. 2020. "Pathways to Stability and Instability in the Midst of Prolonged Slowdown: The Case of China." In *Economic Shocks and Authoritarian Stability,* edited by Victor Shih, 145–66. Ann Arbor: University of Michigan Press.

Shih, Victor, Christopher Adolph, and Mingxing Liu. 2012. "Getting Ahead in the Communist Party: Explaining the Advancement of Central Committee Members in China." *American Political Science Review* 106, no. 1: 166–87.

Shirk, Susan L. 1993. *The Political Logic of Economic Reform in China.* California Series on Social Choice and Political Economy. Berkeley: University of California Press.

Shirk, Susan L. 2008. *China: Fragile Superpower.* New York: Oxford University Press.

Shirk, Susan L. 2018. "The Return to Personalistic Rule." *Journal of Democracy* 29, no. 2: 22–36.

Shlapentokh, Vladimir. 1988. "The Stakhanovite Movement: Changing Perceptions over Fifty Years." *Journal of Contemporary History* 23, no. 2: 259–76.

Shue, Vivienne. 1988. *The Reach of the State: Sketches of the Chinese Body Politic.* Stanford, CA: Stanford University Press.

Shum, Desmond. 2021. *Red Roulette: An Insider's Story of Wealth, Power, Corruption, and Vengeance in Today's China.* New York: Scribner.

Simpser, Alberto. 2013. *Why Governments and Parties Manipulate Elections: Theory, Practice, and Implications.* Cambridge: Cambridge University Press.

Sina. 2013. "中小企业应对经济降温_财经_新浪网." May 8. http://finance.sina.com.cn/focus1/zxqydjw/index.shtml.

Sina. 2015. "习大大10年前写的《之江新语》你知道多少_手机新浪网." May 27. https://news.sina.cn/gn/2015-05-27/detail-ichzzmnf0762052.d.html?fofd.

Sina. 2020. "亲历者讲述：武汉市中心医院医护人员被感染始末." 中国新闻周刊, Febuary 17. https://news.sina.com.cn/c/2020-02-17/doc-iimxyqvz3653366.shtml.

Slater, Dan. 2003. "Iron Cage in an Iron Fist: Authoritarian Institutions and the Personalization of Power in Malaysia." *Comparative Politics* 36, no. 1: 81–101.

Slater, Dan, and Joseph Wong. 2013. "The Strength to Concede: Ruling Parties and Democratization in Developmental Asia." *Perspectives on Politics* 11, no. 3: 717–33.

Slobodian, Quinn. 2018. *Globalists: The End of Empire and the Birth of Neoliberalism.* Cambridge, MA: Harvard University Press.

Smith, Graeme. 2009. "Political Machinations in a Rural County." *China Journal,* no. 62: 29–59.

Smith, Graeme. 2013. "Measurement, Promotions and Patterns of Behavior in Chinese Local Government." *Journal of Peasant Studies* 40, no. 6: 1027–50.

Smith, Rory, and Tariq Panja. 2020. "The Erasure of Mesut Özil." *New York Times,* October 26. https://www.nytimes.com/2020/10/26/sports/soccer/mesut-ozil-arsenal-china.html.

Solinger, Dorothy J. 1991. *From Lathes to Looms: China's Industrial Policy in Comparative Perspective, 1979–1982.* Stanford, CA: Stanford University Press.

Solinger, Dorothy J. 2003. "State and Society in Urban China in the Wake of the 16th Party Congress." *China Quarterly,* no. 176: 943–59.

Solinger, Dorothy J. 1999. *Contesting Citizenship in Urban China: Peasant Migrants, the State, and the Logic of the Market.* Berkeley: University of California Press.

Solnick, Steven L. 1998. *Stealing the State: Control and Collapse in Soviet Institutions.* Cambridge: Cambridge University Press.

Solomon, Richard H. 1999. "The Chairman's Historic Swim." *Time,* September 27. http://content.time.com/time/world/article/0,8599,2054250,00.html.

Sorace, Christian P. 2017. *Shaken Authority: China's Communist Party and the 2008 Sichuan Earthquake.* Ithaca, NY: Cornell University Press.

Sorace, Christian, and William Hurst. 2016. "China's Phantom Urbanisation and the Pathology of Ghost Cities." *Journal of Contemporary Asia* 46, no. 2: 304–22.

Steger, Isabella, and Echo Huang. 2016. "Coming to You in an Eight-Part TV Series: Forced Confessions by Allegedly Corrupt Chinese Officials." *Quartz,* October 18. https://qz.com/811931/coming-to-you-in-an-eight-part-tv-series-forced-confessions-by-allegedly-corrupt-chinese-officials/.

Stern, Rachel E., and Jonathan Hassid. 2012. "Amplifying Silence Uncertainty and Control Parables in Contemporary China." *Comparative Political Studies* 45, no. 10: 1230–54.

Stockmann, Daniela. 2010. "Who Believes Propaganda? Media Effects during the Anti-Japanese Protests in Beijing." *China Quarterly,* no. 202: 269–89.

Stockmann, Daniela. 2013. *Media Commercialization and Authoritarian Rule in China.* Cambridge: Cambridge University Press.

Stockmann, Daniela, and Mary E. Gallagher. 2011. "Remote Control: How the Media Sustain Authoritarian Rule in China." *Comparative Political Studies* 44, no. 4: 436–67.

Stone, Deborah A. 1988. *Policy Paradox and Political Reason.* Glenview, IL: Scott, Foresman.

SunLiping.2011."【两会前瞻】社会失序是当下的严峻挑战_编者按_经济观察网_2011-02-28_孙立平." *Economic Observer,* February 28. http://www.eeo.com.cn/zt/lhqh/bza/2011/02/28/194614.shtml.

Sun, Liping. 2012a. "The Wukan Model and China's Democratic Potential." In *China 3.0,* edited by Mark Leonard, translated by Na Zhu, 74–79. London: ECFR. https://ecfr.eu/wp-content/uploads/ECFR66_CHINA_30_final.pdf.

Sun Liping. 2012b. "这一次，变化真的发生了 - 经济观察网 — 专业财经新闻网站." *Economic Observer,* February 18. http://www.eeo.com.cn/2012/0218/221051.shtml.

SupChina. 2021. "China's Red New Deal: Tracking All the Different Crackdowns on Companies Going on Right Now." September 9. https://supchina.com/2021/09/09/chinas-red-new-deal-a-guide-to-all-the-different-crackdowns-on-companies-going-on-right-now/.

Svolik, Milan W. 2012. *The Politics of Authoritarian Rule.* Cambridge: Cambridge University Press.

Tam, Fiona, and Huifeng He. 2012. "Echoes of Deng Xiaoping as Xi Jinping Heads to Shenzhen on First Inspection Trip." *South China Morning Post,* December 17. https://www.scmp.com/news/china/article/1099413/new-party-leader-xi-jinping-heads-shenzhen-first-inspection-trip.

Tang, Nancy. 2015. "China's 'Rule by Law' Takes an Ugly Turn." *ChinaFile,* July 14. http://www.chinafile.com/conversation/chinas-rule-law-takes-ugly-turn.

Tang, Paul. 2011. "Chinese Mourning Mao Zedong's Death in 1976." *ChinaSMACK* (blog), December 21. http://www.chinasmack.com/2011/pictures/chinese-mourning-mao-zedongs-death-in-1976.html.

Tang, Wenfang. 2016. *Populist Authoritarianism: Chinese Political Culture and Regime Sustainability.* New York: Oxford University Press.

Tatlow, Didi. 2014. "Xi Jinping on Exceptionalism with Chinese Characteristics." *New York Times,* October 14. http://sinosphere.blogs.nytimes.com/2014/10/14/xi-jinping-on-exceptionalism-with-chinese-characteristics/.

Tatlow, Didi Kirsten. 2016. "Police Remove Bail Conditions on 5 Chinese Feminists Detained Last Year." *New York Times,* April 13. https://www.nytimes.com/2016/04/14/world/asia/china-feminist-five-beijing.html.

Teiwes, Frederick C. 1984. *Leadership, Legitimacy, and Conflict in China: From a Charismatic Mao to the Politics of Succession.* Armonk, NY: M. E. Sharpe.

Teiwes, Frederick C. 1997. "The Establishment and Consolidation of the New Regime, 1949–1957." In *The Politics of China: The Eras of Mao and Deng,* 2nd edition, edited by R. MacFarquhar, 5–86. Cambridge University Press.

Teiwes, Frederick C. 2015. "The Study of Elite Political Conflict in the PRC: Politics inside the 'Black Box.'" In *Handbook of the Politics of China,* edited by David Goodman, 21–41. Cheltenham: Edward Elgar.

Teiwes, Frederick C., and Warren Sun. 2007. *The End of the Maoist Era: Chinese Politics during the Twilight of the Cultural Revolution, 1972–1976.* Armonk, NY: M. E. Sharpe.

Teiwes, Frederick C., and Warren Sun. 2015. *Paradoxes of Post-Mao Rural Reform: Initial Steps toward a New Chinese Countryside, 1976–1981.* New York: Routledge.

Teiwes, Frederick C., and Warren Sun. 2019. "Hua Guofeng, Deng Xiaoping, and Reversing the Verdict on the 1976 'Tiananmen Incident.'" *China Review* 19, no. 4: 85–124.

Teorell, J., M. Samanni, S. Holmberg, and B. Rothstein. 2011. The Quality of Government Dataset, Version 6Apr11. http://www.qog.pol.gu.se.

Terrill, Ross. 1980. "In China, 'Liuism' Is Back, but Not Capitalism." *New York Times*, May 16.

Tharoor, Ishaan. 2020. "Analysis: China's Chernobyl? The Coronavirus Outbreak Leads to a Loaded Metaphor." *Washington Post*, February 12. https://www.washingtonpost.com/world/2020/02/12/chinas-chernobyl-coronavirus-outbreak-leads-loaded-metaphor/.

Thompson, Derek. 2018. "The Most Expensive Comment in Internet History?" *The Atlantic*, February 23. https://www.theatlantic.com/business/archive/2018/02/hogan-thiel-gawker-trial/554132/.

Thompson, Mark R. 2001. "To Shoot or Not to Shoot: Posttotalitarianism in China and Eastern Europe." *Comparative Politics* 34, no. 1: 63–83.

Thornton, Patricia M. 2007. *Disciplining the State: Virtue, Violence, and State-Making in Modern China*. Cambridge, MA: Harvard University Asia Center.

Thornton, Patricia M. 2011. "Retrofitting the Steel Frame: From Mobilizing the Masses to Surveying the Public." In *Mao's Invisible Hand: The Political Foundations of Adaptive Governance in China*, edited by Sebastian Heilmann and Elizabeth J. Perry, 237–68. Cambridge, MA: Harvard University Asia Center.

Tian Jiyun. 1990. "国务院副总理田纪云在审计署成立大会上的讲话" (1983). In 党政领导谈审计, edited by Jianmin Cui and Boqi Shao, 23–8. Beijing: China Audit Press.

Tocqueville, Alexis de. 1856. *The Old Regime and the Revolution*. New York: Harper & Brothers.

Tooze, Adam. 2001. *Statistics and the German State, 1900–1945: The Making of Modern Economic Knowledge*. New York: Cambridge University Press.

Tooze, Adam. 2018. *Crashed: How a Decade of Financial Crises Changed the World*. New York: Viking.

Tooze, Adam. 2021. *Shutdown: How Covid Shook the World's Economy*. New York: Viking.

Top News. 2016. 庆祝中国共产党成立95周年公益广告 《我是谁》. YouTube, July 26. https://www.youtube.com/watch?v=2m-9NnLF-Tw&feature=youtu.be.

Truex, Rory. 2016. *Making Autocracy Work: Representation and Responsiveness in Modern China*. New York: Cambridge University Press.

Tsai, Lily L. 2008. "Understanding the Falsification of Village Income Statistics." *China Quarterly*, no. 196: 805–26.

Tsou, Tang, Marc Blecher, and Mitch Meisner. 1982. "The Responsibility System in Agriculture: Its Implementation in Xiyang and Dazhai." *Modern China* 8, no. 1: 41–103.

Tu Qizhi (涂启智). 2011. "取消GDP考核易遏制政绩冲动难（公民论坛）." *Renmin Ribao*, August 23. http://data.people.com.cn/rmrb/20110823/19.

Tufekci, Zeynep. 2020. "This Overlooked Variable Is the Key to the Pandemic." *The Atlantic*, September 30. https://www.theatlantic.com/health/archive/2020/09/k-overlooked-variable-driving-pandemic/616548/.

U.S. Bureau of Economic Analysis. 2021. Real Gross Domestic Product. Federal Reserve Bank of St. Louis, November 20. https://fred.stlouisfed.org/series/A191RO1Q156NBEA.

U.S. CDC. 2017. "SARS: Basics Factsheet." https://www.cdc.gov/sars/about/fs-sars.html.

U.S. State Department. 2017. "U.S. Department of State Air Quality Monitoring Program." http://www.stateair.net/web/historical/1/1.html.

Van de Walle, Nicolas. 2001. *African Economies and the Politics of Permanent Crisis, 1979–1999*. Cambridge: Cambridge University Press.

Veg, Sebastian. 2013. "China's Political Spectrum." In *Civilising China*, edited by Geremie Barmé and Jeremy Goldkorn, 66–73. Canberra: ANU Press. http://www.thechinastory.org/yearbooks/yearbook-2013/.

Veg, Sebastian. 2014. "Zhou Yongkang's Downfall." *ChinaFile*, July 31. http://www.chinafile.com/blog/zhou-yongkangs-downfall.

Vogel, Ezra F. 2011. *Deng Xiaoping and the Transformation of China*. Cambridge, MA: Belknap Press.

Vortherms, Samantha A. 2019. "Disaggregating China's Local Political Budget Cycles: 'Righting' the U." *World Development* 114 (February 1): 95–109.

Wachowski, Lana, and Lilly Wachowski. 1999. *The Matrix*. Warner Bros., Village Roadshow Pictures, Groucho Film Partnership.

Wade, Robert. 1990. *Governing the Market: Economic Theory and the Role of Government in East Asian Industrialization*. Princeton, NJ: Princeton University Press.

Wagner, Laura. 2019. "Internal Memo: ESPN Forbids Discussion of Chinese Politics When Discussing Daryl Morey's Tweet about Chinese Politics." *Deadspin* (blog), October 18. https://deadspin.com/internal-memo-espn-forbids-discussion-of-chinese-polit-183 8881032.

Walder, Andrew. 1986. *Communist Neo-Traditionalism: Work and Authority in Chinese Industry*. Berkeley: University of California Press.

Walder, Andrew G. 1991. "Workers, Managers and the State: The Reform Era and the Political Crisis of 1989." *China Quarterly*, no. 127: 467–92.

Walder, Andrew G. 2015. *China under Mao: A Revolution Derailed*. Cambridge, MA: Harvard University Press.

Wallace, Jeremy L. 2013. "Cities, Redistribution, and Authoritarian Regime Survival." *Journal of Politics* 75, no. 3: 632–45.

Wallace, Jeremy L. 2014. *Cities and Stability: Urbanization, Redistribution, and Regime Survival in China*. New York: Oxford University Press.

Wallace, Jeremy L. 2015. "The Political Implications of China's Stock Market Crisis." *Washington Post*, August 26. https://www.washingtonpost.com/news/monkey-cage/wp/2015/08/26/ the-political-implications-of-chinas-stock-market-crisis/.

Wallace, Jeremy L. 2016. "Juking the Stats? Authoritarian Information Problems in China." *British Journal of Political Science* 46, no. 1: 11–29.

Wallace, Jeremy L. 2020. "China Is Reporting Big Successes in the Coronavirus Fight. Should We Trust the Numbers?" *Washington Post*, March 23. https://www.washingtonpost.com/polit ics/2020/03/23/china-is-reporting-big-successes-coronavirus-fight-dont-trust-numbers/.

Wallace-Wells, David. 2020. "We Had the Vaccine the Whole Time." *Intelligencer* (blog), December 7. https://nymag.com/intelligencer/2020/12/moderna-covid-19-vaccine-design.html.

Wan Li. 1986. "决策民主化和科学化是政治体制改革的一个重要课题——在全国软科学研究工作座谈会上的讲话（１９８６年７月３１日）." *Renmin Ribao*, August 15. https://data.people.com/rmrb/19860815/1.

Wan, William. 2013. "Police Link Fatal SUV Crash in Tiananmen Square to Ethnic Uighurs; Incident May Have Been Deliberate." *Washington Post*, October 19. https://www.washing tonpost.com/world/fiery-suv-crash-in-tiananmen-square-may-have-been-protest-by-eth nic-uighurs/2013/10/29/cc6f2372-4086-11e3-a624-41d661b0bb78_story.html.

Wang, Alex. 2006. "The Role of Law in Environmental Protection in China: Recent Developments." *Vermont Journal of Environmental Law* 8, 195.

Wang, Alex. 2013. "The Search for Sustainable Legitimacy: Environmental Law and Bureaucracy in China." SSRN Scholarly Paper No. ID 2128167. http://papers.ssrn.com/abstract= 2128167.

Wang Guan. 2018. "结构性去杠杆稳步推进（经济形势年中看）." *Renmin Ribao*, July 23. http://data.people.com.cn/rmrb/20180723/1.

Wang, Heyan. 2014. "How a PLA General Built a Web of Corruption to Amass a Fortune." *Caixin Online*, January 16. http://english.caixin.com/2014-01-16/100630028.html?p1uncovered.

Wang Huimin (王慧敏). 2010. "卸掉不合理的 '政绩枷锁.'" *Renmin Ribao*, November 1. http://data.people.com.cn/rmrb/20101101/11.

Wang Jianxin (王建新). 2005. "北京：GDP增长率不再列为调控目标." *Renmin Ribao*, January 13. http://data.people.com.cn/paper/rmrb/20050113/6.

Wang Jiaxing. 2020. "钟南山发话前，武汉这位医生向附近学校发出疫情警报." 冰点周刊, January 28. http://mp.weixin.qq.com/s?__biz=MjM5MDQ3MTEyMQ==&mid=265 3326293&idx=1&sn=1ed3e933e3ac32c910fd1c9e4eb933d8&chksm=bd966d6b8ae1e47 d045ab64cadbea33dcb42e511c14ceaf291274677f12562b2f108bdaaafe9#rd.

Wang, Jiaxing, F. Yu, D. Cao, H. Jiang, Y. Zhao, and W. Pan. 2006. "A Study Report on China Environmental and Economic Accounting in 2004." Xinhuanet, September 12. http://news.xinhuanet.com/english/2006-09/12/content_5080599.htm.

Wang, Joseph Tao-yi, Michael Spezio, and Colin F. Camerer. 2010. "Pinocchio's Pupil: Using Eyetracking and Pupil Dilation to Understand Truth Telling and Deception in Sender-Receiver Games." *American Economic Review* 100, no. 3: 984–1007.

Wang, Juntao, and Anne-Marie Brady. 2012. "Sword and Pen: The Propaganda System of the People's Liberation Army." In *China's Thought Management*, edited by Anne-Marie Brady, 122–45. New York: Routledge.

Wang, Nanfu, and Jialing Zhang. 2019. *One Child Nation*. Chicago Media Project, Westdeutscher Rundfunk (WDR).

Wang, Peng, and Xia Yan. 2020. "Bureaucratic Slack in China: The Anti-Corruption Campaign and the Decline of Patronage Networks in Developing Local Economies." *China Quarterly*, no. 243 (September): 611–34.

Wang, Qianni, and Shifan Ge. 2020. "How One Obscure Word Captures Urban China's Unhappiness." *Sixth Tone*, November 4. https://www.sixthtone.com/news/1006391/https%3A%2F%2Fwww.sixthtone.com%2Fnews%2F1006391%2Fhow-one-obscure-word-captures-urban-chinas-unhappiness.

Wang, Qinghua. 2014. "Crisis Management, Regime Survival and 'Guerrilla-Style' Policy-Making: The June 1999 Decision to Radically Expand Higher Education in China." *China Journal* 71 (January): 132–52.

Wang, Shaoguang. 2012. "Chinese Socialism 3.0." In *China 3.0*, edited by Mark Leonard, 60–67. London: ECFR.

Wang, Xiaofang. 2012. *The Civil Servant's Notebook*. New York: Viking.

Wang Zhenhua (汪振华) and Chen Yexuan (陈业轩). 1978. "减轻生产队负担 加强农业生产第一线广东省委制订十六条措施." *Renmin Ribao*, May 13. http://data.people.com.cn/rmrb/19780513/2.

Ward, Michael. 2004. *Quantifying the World: UN Ideas and Statistics*. United Nations Intellectual History Project. Bloomington: Indiana University Press.

Washington Post. 2020. "Opinion: What Did Xi Jinping Know about the Coronavirus, and When Did He Know It?" February 19. https://www.washingtonpost.com/opinions/global-opinions/what-did-xi-jinping-know-about-the-coronavirus-and-when-did-he-know-it/2020/02/19/35482fe2-5340-11ea-b119-4faabac6674f_story.html.

Watson, Andrew, Christopher Findlay, and Du Yintang. 1989. "Who Won the 'Wool War'? A Case Study of Rural Product Marketing in China." *China Quarterly*, no. 118: 213–41.

Weber, Isabella M. 2018. "China and Neoliberalism: Moving beyond the China Is/Is Not Neoliberal Dichotomy." In *The Sage Handbook of Neoliberalism*, edited by Damien Cahill, Melinda Cooper, Martijn Konings, and David Primrose, 219–33. London: Sage.

Weber, Isabella. 2021. *How China Escaped Shock Therapy: The Market Reform Debate*. Routledge Studies on the Chinese Economy. Abingdon, UK: Routledge, Taylor & Francis Group.

Wedeen, Lisa. 1999. *Ambiguities of Domination: Politics, Rhetoric, and Symbols in Contemporary Syria*. Chicago: University of Chicago Press.

Wedeen, Lisa. 2019. *Authoritarian Apprehensions: Ideology, Judgment, and Mourning in Syria*. Chicago: University of Chicago Press.

Wedeman, Andrew. 2003. *From Mao to Market: Rent Seeking, Local Protectionism, and Marketization in China*. Cambridge: Cambridge University Press.

Wedeman, Andrew. 2004. "The Intensification of Corruption in China." *China Quarterly*, no. 180: 895–921.

Wedeman, Andrew. 2005. "Anticorruption Campaigns and the Intensification of Corruption in China." *Journal of Contemporary China* 14, no. 42: 93–116.

Wedeman, Andrew. 2012. *Double Paradox: Rapid Growth and Rising Corruption in China*. Ithaca, NY: Cornell University Press.

Wedeman, Andrew. 2017. "Xi Jinping's Tiger Hunt: Anti-Corruption Campaign or Factional Purge?" *Modern China Studies* 24, no. 2: 35–94.

Wee, Sui-Lee, and Ben Blanchard. 2012. "China's Hu Says Graft Threatens State, Party Must Stay in Charge." Reuters, November 8. https://www.reuters.com/article/us-china-congress-idUSBRE8A62LZ20121108.

Weeks, Jessica L. 2012. "Strongmen and Straw Men: Authoritarian Regimes and the Initiation of International Conflict." *American Political Science Review* 106, no. 2: 326–47.

Wei, Lingling. 2021. "In Tackling China's Real-Estate Bubble, Xi Jinping Faces Resistance to Property-Tax Plan; After Negative Feedback from within the Party, an Initial Proposal to Test a Property Tax in Some 30 Cities Has Been Significantly Scaled Down." *Wall Street Journal,* October 19. https://www.proquest.com/docview/2583074865/citation/ABBBF1A2D2D E4B4CPQ/17.

Weiss, Jessica Chen. 2019. "A World Safe for Autocracy: China's Rise and the Future of Global Politics." Foreign Affairs 98, no. 4: 92–108.

Weiss, Jessica Chen, and Amber Wichowsky. 2018. "External Influence on Exchange Rates: An Empirical Investigation of US Pressure and the Chinese RMB." *Review of International Political Economy* 25, no. 5: 596–623.

Weisskopf, Michael. 1982. "China Cracks the 'Iron Rice Bowl.'" *Washington Post,* December 30. https://www.washingtonpost.com/archive/politics/1982/12/30/china-cracks-the-iron-rice-bowl/440bad97-7bdb-4375-aab1-31192833a5b9/.

Wen Jiabao. 2007. *Government Work Report.* State Council, Beijing, March 5. http://www.npc.gov.cn/zgrdw/englishnpc/Special_11_5/2010-03/03/content_1690626.htm.

Wen Jiabao. 2013. *Government Work Report.* State Council, Beijing, March 5. http://online.wsj.com/public/resources/documents/WenWorkReport_Eng_2013.pdf.

Weyland, Kurt. 2016. "Crafting Counterrevolution: How Reactionaries Learned to Combat Change in 1848." *American Political Science Review* 110, no. 2: 215–31.

White, Jonathan. 2021. "Rockets Return to China Screens, 15 Months after Hong Kong Tweet." *South China Morning Post,* January 11. https://www.scmp.com/sport/china/article/3117 175/houston-rockets-return-china-screens-15-months-after-hong-kong-tweet.

White, Tyrene. 2006. *China's Longest Campaign: Birth Planning in the People's Republic, 1949–2005.* Ithaca, NY: Cornell University Press.

Whiting, Susan H. 2000. *Power and Wealth in Rural China: The Political Economy of Institutional Change.* Cambridge: Cambridge University Press.

Whiting, Susan H. 2004. "The Cadre Evaluation System at the Grass Roots: The Paradox of Party Rule." In *Holding China Together: Diversity and National Integration in the Post-Deng Era,* edited by Barry Naughton and Dali Yang, 101–19. Cambridge: Cambridge University Press.

Whiting, Susan H. 2021. "China's Evergrande Is in Trouble. But So Is China's Top-Down Political Economy." *Washington Post,* October 21. https://www.washingtonpost.com/politics/2021/10/21/chinas-evergrande-is-trouble-so-is-chinas-top-down-political-economy/.

Whyte, Martin King, Wang Feng, and Yong Cai. 2015. "Challenging Myths about China's One-Child Policy." *China Journal* 74: 144–59.

Wildau, Gabriel. 2014a. "China to Cap Local Government Debt." *Financial Times,* October 2. https://www.ft.com/content/a2fb9fec-4a18-11e4-8de3-00144feab7de.

Wildau, Gabriel. 2014b. "Official Data Mask China's Banking Problems." *Financial Times,* August 31. http://www.ft.com/intl/cms/s/0/836a46cc-2f7b-11e4-a79c-00144feabdc0.html.

Wildau, Gabriel. 2014c. "Small Chinese Cities Steer Away from GDP as Measure of Success." *Financial Times,* August 13. http://www.ft.com/intl/cms/s/0/a0288bd4-22b0-11e4-8dae-00144feabdc0.html?ftcamp=published_links%2Frss%2Fworld_asia-pacific_china%2Ff eed%2F%2Fproduct#axzz3E98wgsWs.

Wildau, Gabriel. 2017. "China Central Bank Chief Warns of 'Minsky Moment.'" *Financial Times,* October 19. https://www.ft.com/content/4bcb14c8-b4d2-11e7-a398-73d59db9e399.

Wildau, Gabriel. 2018. "China Easing Threatens to Derail Debt-Cutting Efforts." *Financial Times,* August 1. https://www.ft.com/content/54259f08-8ff1-11e8-b639-7680cedcc421.

Willerton, John P. 1992. *Patronage and Politics in the USSR.* Cambridge: Cambridge University Press.

Wolf, Martin. 2018. "China's Debt Threat: Time to Rein in the Lending Boom." *Financial Times*, July 25. https://www.ft.com/content/0c7ecae2-8cfb-11e8-bb8f-a6a2f7bca546.

Wong, Alan, Michael Forsythe, and Andrew Jacobs. 2016. "Defying China, Hong Kong Bookseller Describes Detention." *New York Times*, June 16. https://www.nytimes.com/2016/06/17/world/asia/hong-kong-bookseller-lam-wing-kee.html.

Wong, Christine. 1991. "Central-Local Relations in an Era of Fiscal Decline: The Paradox of Fiscal Decentralization in Post-Mao China." *China Quarterly*, no. 128: 691–715.

Wong, Christine. 2002. "China: National Development and Sub-National Finance.". Report 22951-CHA. Washington, DC: World Bank. https://openknowledge.worldbank.org/handle/10986/15423.

Wong, Christine. 2005. "Can China Change Development Paradigm for the 21st Century? Fiscal Policy Options for Hu Jintao and Wen Jiabao after Two Decades of Muddling Through." Working Paper. Berlin: German Institute for International and Security Affairs. https://www.swp-berlin.org/publications/products/arbeitspapiere/2005_03Wng___DevelopmentParadigm_ks.pdf.

Wong, Christine, Christopher John Heady, and Wing Thye Woo. 1995. *Fiscal Management and Economic Reform in the People's Republic of China*. New York: Oxford University Press.

Wong, Edward. 2012a. "New Communist Party Chief in China Denounces Corruption in Speech." *New York Times*, November 19. https://www.nytimes.com/2012/11/20/world/asia/new-communist-party-chief-in-china-denounces-corruption.html.

Wong, Edward. 2012b. "习近平警告纵容腐败必然亡党亡国." 纽约时报中文网, November 21. https://cn.nytimes.com/china/20121120/c20corruption/.

Wong, Edward. 2012c. "Signals of a More Open Economy in China." *New York Times*, December 10. https://www.nytimes.com/2012/12/10/world/asia/chinese-leaders-visit-to-shenzhen-hints-at-reform.html.

Wong, Edward. 2013. "China Lets Media Report on Air Pollution Crisis." *New York Times*, January 14. https://www.nytimes.com/2013/01/15/world/asia/china-allows-media-to-report-alarming-air-pollution-crisis.html.

Woodworth, Max D., and Jeremy L. Wallace. 2017. "Seeing Ghosts: Parsing China's 'Ghost City' Controversy." *Urban Geography* 38, no. 8 (September 14): 1270–81.

World Bank. 2009. "The Urban Development Investment Corporations (UDICs) in Chongqing, China (English)." Technical Assistance Report. https://openknowledge.worldbank.org/handle/10986/2888.

World Bank. 2013. "China 2030: Building a Modern Harmonious and Creative High Income Society." Development Research Center of the State Council. https://openknowledge.worldbank.org/handle/10986/12925.

World Bank. 2017. "Electricity Production from Coal Sources (% of Total)." https://data.worldbank.org/indicator/EG.ELC.COAL.ZS?locations=CN.

Wright, Joseph. 2008. "Do Authoritarian Institutions Constrain? How Legislatures Impact Economic Growth and Foreign Aid Effectiveness." *American Journal of Political Science* 52, no. 2: 322–43.

Wright, Tim. 2004. "The Political Economy of Coal Mine Disasters in China: 'Your Rice Bowl or Your Life.'" *China Quarterly*, no. 179 (September): 629–46.

Wright, Tim. 2022. "The Political Economy of China's Dramatically Improved Coal Safety Record." *China Quarterly*, no. 249: 91–113.

Wu, Cary. 2020. "How Chinese Citizens View Their Government's Coronavirus Response." *The Conversation*, June 4. http://theconversation.com/how-chinese-citizens-view-their-governments-coronavirus-response-139176.

Wu, Weizheng. 2013. "美丽中国，从健康呼吸开始（人民时评）." *Renmin Ribao*, January 14. http://data.people.com.cn/rmrb/20130114/1.

Wu, Xiaodong, Bo Fu, Lang Chen, and Yong Feng. 2020. "Serological Tests Facilitate Identification of Asymptomatic SARS-CoV-2 Infection in Wuhan, China." *Journal of Medical Virology* 92, no. 10: 1795–96.

Wuhan Memo. 2020. "Timeline." Blog. May 22. https://wuhanmemo.com/?page_id=230929.

Xi Jinping. 2006. "激浊扬清 正字当头." 浙江日报, February 20. http://zjrb.zjol.com.cn/html/2006-02/20/content_43409.htm.

Xi Jinping. 2013. "习近平：坚持节约资源和保护环境基本国策 努力走向社会主义生态文明新时代--新闻报道-人民网." *People's Daily*, May 25. http://cpc.people.com.cn/n/2013/0525/c64094-21611332.html.

Xi Jinping. 2015. "习近平：经济增长必须是实实在在和没有水分的增长." 习近平系列重要讲话数据库, July 30. http://jhsjk.people.cn/article/27383618.

Xi Jinping. 2018. "习近平系列重要讲话数据库." 人民网, February 28. http://jhsjk.people.cn/article/29838811.

Xi Jinping. 2021. "扎实推动共同富裕." 求是, October 15. http://www.qstheory.cn/dukan/qs/2021-10/15/c_1127959365.htm.

Xiao Bin. 2011. "演变中的广东模式:一个分析框架." 公共行政评论 4, no. 6: 9–47, 176.

Xiao, Bin. 2012. "The Guangdong Model in Transition." In *China 3.0*, edited by Mark Leonard, 32–39. London: ECFR.

Xie, Stella Yifan, and Mike Bird. 2020. "The $52 Trillion Bubble: China Grapples with Epic Property Boom." *Wall Street Journal*, July 17. https://www.wsj.com/articles/china-property-real-estate-boom-covid-pandemic-bubble-11594908517.

Xie, Yu, and Xiang Zhou. 2014. "Income Inequality in Today's China." *Proceedings of the National Academy of Sciences* 111, no. 19 (May 13): 6928–33.

Xie, Yu, and Yongai Jin. 2015. "Household Wealth in China." *Chinese Sociological Review* 47, no. 3 (July 3): 203–29.

Xinhua Insight. 2013. "Yearender: CPC Gets Closer to Masses to Ensure a 'Red China.'" Xinhuanet, August 25. http://news.xinhuanet.com/english/china/2013-12/21/c_132986046.htm.

Xinhuanet. 2007. "內蒙古自治區主席:我們非常渴望綠色GDP出台! --環保--人民網." July 26. http://env.people.com.cn/BIG5/6032515.html.

Xinhua News Agency. 1978. "华主席为《天安门诗抄》题写书名." *People's Daily*, November 19. http://data.people.com.cn/rmrb/19781119/1.

Xinhua News Agency. 2007. "Wen Confident in Maintaining Economic Growth." *China Daily*, March 16. https://www.chinadaily.com.cn/bizchina/2007-03/16/content_829815.htm.

Xinhua News Agency. 2008. "央行调增地方商行信贷规模10%救急中小企业." Sina, August 5. http://finance.sina.com.cn/g/20080805/03405166413.shtml.

Xinhua News Agency. 2009a. "Debt-Laden East Star Airlines Goes Bankrupt." *China Daily*, August 28. https://www.chinadaily.com.cn/bizchina/2009-08/28/content_8627893.htm.

Xinhua News Agency. 2009b. "Guangdong Toy Factory Brawl Leaves 2 Dead, 118 Injured." China, June 27. http://www.china.org.cn/china/news/2009-06/27/content_18023576.htm.

Xinhua News Agency. 2013a. 党的群众路线教育实践活动工作会议召开习近平发表重要讲话-群众路线网--人民网. June 18.http://qzlx.people.com.cn/n/2013/0618/c364565-21884589.html.

Xinhua News Agency. 2013b. "Premier Wen Stresses Concrete Action in Addressing Environmental Woes." *Global Times*, March 5. http://www.globaltimes.cn/content/765921.shtml.

Xinhua News Agency. 2013c. 习近平主持中共中央政治局会议 部署开展党的群众路线教育实践活动工作. *Renmin Ribao*, April 20. http://data.people.com.cn/rmrb/20130420/1.

Xinhua News Agency. 2014a. "China Central Authority Calls for Implementation of 'Mass Line.'" Xinhuanet, August 22. http://news.xinhuanet.com/english/china/2014-08/05/c_133534505.htm.

Xinhua News Agency. 2014b. "New Accounting Regime Ends 'GDP Supremacy.'" *China Daily*, September 22. http://usa.chinadaily.com.cn/business/2014-09/22/content_18641511.htm.

Xinhua News Agency. 2014c. "Xi Urges Further 'Mass Line' Efforts." Xinhuanet, August 21. http://news.xinhuanet.com/english/china/2014-01/20/c_133060488.htm.

Xinhua News Agency. 2016. "China Stresses Officials' Poverty-Relief Responsibilities." *State Council—News*, October 18. http://english.www.gov.cn/news/top_news/2016/10/18/content_281475469144338.htm.

Xinhua News Agency. 2020a. "Wuhan Reports Zero Increase in COVID-19 Cases for 4th Day." *China Daily*, March 22. https://www.chinadailyhk.com/article/125120#%E2%80%8BWu han-reports-zero-increase-in-COVID-19-cases-for-4th-day.

Xinhua News Agency. 2020b. "专家称武汉不明原因的病毒性肺炎可防可控." Xinhuanet, January 11. http://www.xinhuanet.com/local/2020-01/11/c_1125448549.htm.

Xinhua News Agency. 2020c. "武汉确诊41例感染新型冠状病毒肺炎患者." Xinhuanet, January 11. http://www.xinhuanet.com/2020-01/11/c_1125448269.htm.

Xu, Chenggang. 2011. "The Fundamental Institutions of China's Reforms and Development." *Journal of Economic Literature* 49, no. 4: 1076–151.

Xu, Xu. 2021. "To Repress or to Co-Opt? Authoritarian Control in the Age of Digital Surveillance." *American Journal of Political Science* 65, no. 2: 309–25.

Xu, Xu, Genia Kostka, and Xun Cao. 2021. "Information Control and Public Support for Social Credit Systems in China." *Journal of Politics*. doi:https://doi.org/10.1086/718358.

Xu, Yuanshuo. 2019. "Shrinking Cities, Ghost Cities and High-Debt Cities in Rapidly Urbanized China: The Asymmetric State Rescaling." Ph.D. dissertation, Cornell University. http://www.proquest.com/docview/2303232600/abstract/9ECAA324646F4104PQ/1.

Xu, Zhangrun. 2020. "Viral Alarm: When Fury Overcomes Fear." Translated by Geremie Barmé. *ChinaFile*, February 10. http://www.chinafile.com/reporting-opinion/viewpoint/viral-alarm-when-fury-overcomes-fear.

Xue Li (薛黎). 2007. "绿色GDP核算小组称有些省份GDP实际零增长." 上海证券报, August 23. http://www.china.com.cn/news/txt/2007-08/03/content_8625660.htm.

Xue, Muqiao. 2011. *Chinese Economists on Economic Reform: Collected Works of Xue Muqiao*. Abingdon, UK: Routledge.

Yan, Kai, ed. 2008. 诸葛亮兵书. Beijing: Beijing Yanshan Publishing.

Yan, Weijue. 2010. "11 Chengguan Hit by Car at Demolition Site." *China Daily*, November 17. http://www.chinadaily.com.cn/china/2010-11/17/content_11562733.htm.

Yanagizawa-Drott, David. 2014. "Propaganda and Conflict: Evidence from the Rwandan Genocide." *Quarterly Journal of Economics* 129, no. 4: 1947–94.

Yang, Dali. 1996. *Calamity and Reform in China: State, Rural Society, and Institutional Change since the Great Leap Famine*. Stanford, CA: Stanford University Press.

Yang, Dali. 2004. *Remaking the Chinese Leviathan: Market Transition and the Politics of Governance in China*. Stanford, CA: Stanford University Press.

Yang, Dali. 2006. "Economic Transformation and Its Political Discontents in China: Authoritarianism, Unequal Growth, and the Dilemmas of Political Development." *Annual Review of Political Science* 9, no. 1: 143–64.

Yang, Dali., ed. 2012. *The Global Recession and China's Political Economy*. New York: Palgrave Macmillan.

Yang, Dali. 2020a. "China's Early Warning System Didn't Work on Covid-19. Here's the Story." *Washington Post*, February 24. https://www.washingtonpost.com/politics/2020/02/24/chi nas-early-warning-system-didnt-work-covid-19-heres-story/.

Yang, Dali. 2020b. "Wuhan Officials Tried to Cover Up Covid-19—and Sent It Careening Outward." *Washington Post*, March 10. https://www.washingtonpost.com/politics/2020/03/10/wuhan-officials-tried-cover-up-covid-19-sent-it-careening-outward/.

Yang, Dali, and Junyan Jiang. 2012. "Guojin Mintui: The Global Recession and Changing State-Economy Relations in China." In *The Global Recession and China's Political Economy*, edited by Dali Yang, 33–69. New York: Palgrave Macmillan.

Yang, Dali, Huayu Xu, and Ran Tao. 2014. "A Tragedy of the Nomenklatura? Career Incentives, Political Loyalty and Political Radicalism during China's Great Leap Forward." *Journal of Contemporary China* 23, no. 89 (September 3): 864–83.

Yang, Jisheng. 2012. *Tombstone: The Great Chinese Famine, 1958–1962*. Edited by E. Friedman, S. Mosher, and J. Guo. Translated by S. Mosher and J. Guo. New York: Farrar, Straus and Giroux.

Yardley, Jim. 2006a. "Fired Editors of Chinese Journal Call for Free Speech in Public Letter." *New York Times*, February 18. https://www.nytimes.com/2006/02/18/world/asia/fired-editors-of-chinese-journal-call-for-free-speech-in-public.html.

Yardley, Jim. 2006b. "Journal Shut by Beijing Censors Will Return." *New York Times*, February 17. https://www.nytimes.com/2006/02/17/world/asia/journal-shut-by-beijing-censors-will-return.html.

Ye Jianying. 1979. "在庆祝中华人民共和国成立三十周年大会上的讲话" *Renmin Ribao*, September 30. http://data.people.com.cn/rmrb/19790930/1/.

Ye Xuanji. 2008. "叶帅在十一届三中全会前后 ——读于光远著《1978:我亲历的那次历史大转折》有感." December 18. http://www.infzm.com/content/19143.

Yin, Liangen, and Terry Flew. 2018. "Xi Dada Loves Peng Mama: Digital Culture and the Return of Charismatic Authority in China." *Thesis Eleven* 144, no. 1: 80–99.

Yoon, Joanna. 2015. "Orange as the New Black." In *Shared Destiny: China Story Yearbook* 2015, edited by Geremie Barmé, Jeremy Goldkorn, and Linda Jaivin, 317–22. Canberra: ANU Press. https://www.thechinastory.org/yearbooks/yearbook-2014/forum-the-rights-and-wrongs-of-the-law/orange-as-the-new-black/.

Young, Michael Dunlop. 1959. *The Rise of the Meritocracy, 1870–2033: The New Elite of Our Social Revolution*. New York: Random House.

Yu, Guangyuan. 2004. *Deng Xiaoping Shakes the World: An Eyewitness Account of China's Party Work Conference and the Third Plenum (November–December 1978)*. Edited by S. I. Levine and E. F. Vogel. Norwalk, CT: EastBridge.

Yu, Guangyuan. 2014. *Chinese Economists on Economic Reform: Collected Works of Yu Guangyuan*. New York: Routledge.

Yu Guangyuan (于光远) et al. 1998. 改变中国命运的41天: 中央工作会议, 十一届三中全会亲历记. Shenzhen: Haitian Publishing.

Yu, Jeanny, and Isihika Mookerjee. 2021. "Even after $1.5 Trillion Rout, China Tech Traders See More Pain." *Bloomberg*, August 21. https://www.bloomberg.com/news/articles/2021-08-21/even-after-1-5-trillion-rout-china-tech-traders-see-more-pain.

Yuen, Samson. 2014. "Disciplining the Party: Xi Jinping's Anti-Corruption Campaign and Its Limits." *China Perspectives*, no. 3: 41–47.

Zeng, Jinghan. 2014. "The Debate on Regime Legitimacy in China: Bridging the Wide Gulf between Western and Chinese Scholarship." *Journal of Contemporary China* 23, no. 88: 612–35.

Zeng, Jinyan. 2015. "China's Feminist Five: 'This Is the Worst Crackdown on Lawyers, Activists and Scholars in Decades.'" *The Guardian*, April 17. http://www.theguardian.com/lifeandstyle/2015/apr/17/chinas-feminist-five-this-is-the-worst-crackdown-on-lawyers-activists-and-scholars-in-decades.

Zeng, Qingjie. 2020. "Managed Campaign and Bureaucratic Institutions in China: Evidence from the Targeted Poverty Alleviation Program." *Journal of Contemporary China* 29, no. 123: 400–15.

Zenz, Adrian. 2019. "'Thoroughly Reforming Them towards a Healthy Heart Attitude': China's Political Re-education Campaign in Xinjiang." *Central Asian Survey* 38, no. 1: 102–28.

Zha, Jianying. 2020. "China's Heart of Darkness—Prince Han Fei and Chairman Xi Jinping (Part I)." *China Heritage*, July 17. https://chinaheritage.net/journal/chinas-heart-of-darkness-prince-han-fei-chairman-xi-jinping-part-i/.

Zhang Bin (张滨) and Jiang Jie (姜洁). 2005. "沈阳：不一样的'政绩考核.'" *Renmin Ribao*, July 12. http://data.people.com.cn/rmrb/20050712/9/.

Zhang, Chenchen. 2020. "Covid-19 Timeline: Early Development." *Time*, March 29. https://time.graphics/line/360578.

Zhang, Fengling. 2017. "In Beijing, Sham Marriages to Bypass Government Policies." Translated by Lisa Lane. *Economic Observer/WorldCrunch*, August 25. https://www.worldcrunch.com/culture-society/in-beijing-sham-marriages-to-bypass-government-policies.

Zhang Guangyou (张广友). 1981. "实践使他们提高了认识——国家农委和农口各部门领导干部农村调查汇报会侧记." *Renmin Ribao*, August 4. http://data.people.com.cn/rmrb/19810804/2.

Zhang, Hong. 2013. "Sweating and on the Verge of Tears: Chinese Officials Carry Out Self-Criticism on TV." *South China Morning Post*, September 28. http://www.scmp.com/news/china/article/1319552/senior-chinese-officials-face-mao-style-self-criticism-sessions.

Zhang, Junsen. 2017. "The Evolution of China's One-Child Policy and Its Effects on Family Outcomes." *Journal of Economic Perspectives* 31, no. 1: 141–60.

Zhang, Shawn. 2018. "List of Re-education Camps in Xinjiang 新疆再教育集中营列表." *Shawn Zhang on Medium* (blog), May 20. https://medium.com/@shawnwzhang/list-of-re-education-camps-in-xinjiang-%E6%96%B0%E7%96%86%E5%86%8D%E6%95%99%E8%82%B2%E9%9B%86%E4%B8%AD%E8%90%A5%E5%88%97%E8%A1%A8-99720372419c.

Zhao, Dingxin. 2001. *The Power of Tiananmen: State-Society Relations and the 1989 Beijing Student Movement*. Chicago: University of Chicago Press.

Zhao, Suisheng. 2004. *A Nation-State by Construction: Dynamics of Modern Chinese Nationalism*. Stanford, CA: Stanford University Press.

Zhao Ziyang. 2009. *Prisoner of the State: The Secret Journal of Zhao Ziyang*. Translated by Pu Bao, Renee Chiang, and Adi Ignatius. New York: Simon & Schuster.

Zheng, Caixiong. 2010. "Guangdong to Go Public with Budget." *China Daily*, March 5. http://www.chinadaily.com.cn/china/2010-03/25/content_9640431.htm.

Zheng, William. 2020. "Beijing's Purge over Virus Response Removes Top Hubei Communist Party Officials." *South China Morning Post*, February 13. https://www.scmp.com/news/china/politics/article/3050372/coronavirus-beijings-purge-over-virus-takes-down-top-communist.

Zhong, Raymond. 2020. "In Halting Ant's I.P.O., China Sends a Warning to Business." *New York Times*, November 6. https://www.nytimes.com/2020/11/06/technology/china-ant-group-ipo.html.

Zhou, D. 2014. "Market Reforms, Fight against Corruption Go Hand in Hand, Expert Says." *Caixin*, July 22. http://english.caixin.com/2014-07-22/100707495.html.

Zhou, Li-An. 2019. "Understanding China: A Dialogue with Philip Huang." *Modern China* 45, no. 4: 392–432.

Zhou, Wei, and Heyan Wang. 2015. "How Disgraced Military Official Led Murky Property Development." *Caixin Online*, August 12. http://english.caixin.com/2015-08-12/100838759.html.

Zhou, X. 2013. "China's Ordos Struggles to Repay Debt: Xinhua Magazine." *Bloomberg News*, July 9. http://www.bloomberg.com/news/2013-07-08/china-s-ordos-struggles-to-repay-debt-xinhua-magazine.html.

Zhou, Xueguang, and Hong Lian. 2020. "Modes of Governance in the Chinese Bureaucracy: A 'Control Rights' Theory." *China Journal* 84 (July): 51–75.

Zhu, Rongji. 2013. *Zhu Rongji on the Record: The Road to Reform, 1991–1997*. Translated by June Mei. Washington, DC: Brookings Institution Press.

Zhu, Rongji. 2015. *Zhu Rongji on the Record: The Road to Reform: 1998–2003*. Washington, DC: Brookings Institution Press.

Zuboff, Shoshana. 2019. *The Age of Surveillance Capitalism: The Fight for a Human Future at the New Frontier of Power*. New York: PublicAffairs.

Zweig, David. 1983. "Opposition to Change in Rural China: The System of Responsibility and People's Communes." *Asian Survey* 23, no. 7: 879–900.

Zweig, David. 1986. "Prosperity and Conflict in Post-Mao Rural China." *China Quarterly*, no. 105: 1–18.

Zweig, David. 1997. *Freeing China's Farmers: Rural Restructuring in the Reform Era*. Socialism and Social Movements. Armonk, NY: M. E. Sharpe.

INDEX

For the benefit of digital users, indexed terms that span two pages (e.g., 52–53) may, on occasion, appear on only one of those pages.

COVID-19
 blowback from, 194
 case count in, 198–99, 200, 201–2
 CCP response to, 194–200
 centralization and, 194, 199
 coercive countermeasures for, 193–94, 199
 economic effects of, 203–5
 global pandemic phase of, 201–2
 information environment and, 44–45, 193–
 99, 200
 initial outbreak of, 194–200
 limited quantified vision and, 194, 200, 201–2
 local officials blamed during, 200
 neopolitical turn and, 193–94, 198
 political leadership during, 199–201, 202
 real estate and, 193–94, 203
 reforms following, 203–5
 SARS outbreak as precursor to, 194, 197–
 98, 199
 stimulus response to, 193–94, 203
 transmission of, 195–98, 199–200
 Xi and, 196–97, 199–200
CPWC. See Central Party Work Conference
Cultural Revolution (1966-76)
 aims of, 19
 causes of, 19
 CPWC and, 55–56
 criticism of, 57–58, 59, 70, 72–73
 Deng and, 51–52, 59, 82–83
 Gang of Four and, 56, 60–61
 Hua and, 60–61
 reassessment following, 3, 52, 57–58, 59, 82–83
 Reform Era and, 3, 63
 rehabilitation of elites following, 82–85
 split of elites resulting from, 56, 82
 Tiananmen Incident and, 60
 Xi and, 176–77

Dazhai model of agriculture, 55–56, 75–76, 77
debt
 CCP and, 186
 dual-track pricing and, 145
 GDP and, 114–15, 146–47, 212–13
 global financial crisis and, 110–11, 145–46, 203
 LGFVs and, 146–47, 186
 limited quantified vision and, 4, 16, 109–10,
 114–15, 129, 164
 neopolitical turn and, 186, 203
 property sector and, 146–47
 real estate and, 143, 146–47, 203, 205
 Reform Era and, 145–47
 SOEs and, 145, 167–68
 Xi and, 203
decentralization
 cadre evaluation system and, 111–12
 Central Committee and, 63–64
 corruption and, 147

Deng and, 58–59, 64, 72–73, 111–12
 fiscal reforms of 1994 and, 100–1, 126–27
 GDP and, 98
 limited quantified vision and, 3, 68–69, 100–
 1, 147
 Reform Era and, 3, 10–11, 62–66, 98, 147
Democracy Wall (1978-79)
 backlash to, 73–74
 causes of, 57–58, 69–70
 Deng and, 57–58, 59–60, 70–74, 132
 end of, 74
 Four Cardinal Principles and, 74
 Four Modernizations and, 74
 Gang of Four and, 70–71
 influence in other cities of, 71–72
 information environment and, 71–72, 73, 79–
 80, 132, 205–6
 Mao criticized on, 70–71, 72–73
 officials debates on, 71–73
 rural reforms and, 71–72, 75
 Tiananmen Incident and, 70–71
 unofficial journals and, 71, 72
democratic reforms, 59, 69–70, 114–15, 171, 177
Deng Liqun, 73–74, 132
Deng Xiaoping. See also Reform Era
 anti-Rightist campaign and, 18
 cadre evaluation system and, 54–55
 CCP and, 58–59, 66, 68, 74
 collective responsibility criticized by, 64–65
 corruption and, 15
 CPWC and, 58–59, 64
 Cultural Revolution and, 51–52, 59, 82–83
 decentralization and, 58–59, 64, 72–73, 111–12
 Democracy Wall and, 57–58, 59–60, 70–
 74, 132
 democratic reforms emphasized by, 59, 69–70
 emancipation of mind emphasized by, 38–39,
 58, 64, 65–66, 69–70
 end of life-time tenure and, 83–85
 evaluation system emphasized by, 65–66,
 99, 111–12
 expertise and, 82
 Four Cardinal Principles and, 74, 205–6
 Four Modernizations and, 38–39, 58, 69–
 70, 121
 Great Leap Forward and, 18
 Hua and, infighting with, 12, 19, 80
 inequality and, 65–66
 information environment and, 205–6
 limited quantified vision and, 15, 38–40, 44–
 45, 64–65
 Mao criticized by, 18, 19–20, 51–52, 51–
 52n.29, 57–60, 179–80
 neoliberalism and, 209–10
 pragmatism of, 38–39, 51–52n.29, 52, 58, 64,
 65–66, 69–70
 Principles Forum and, 54–55